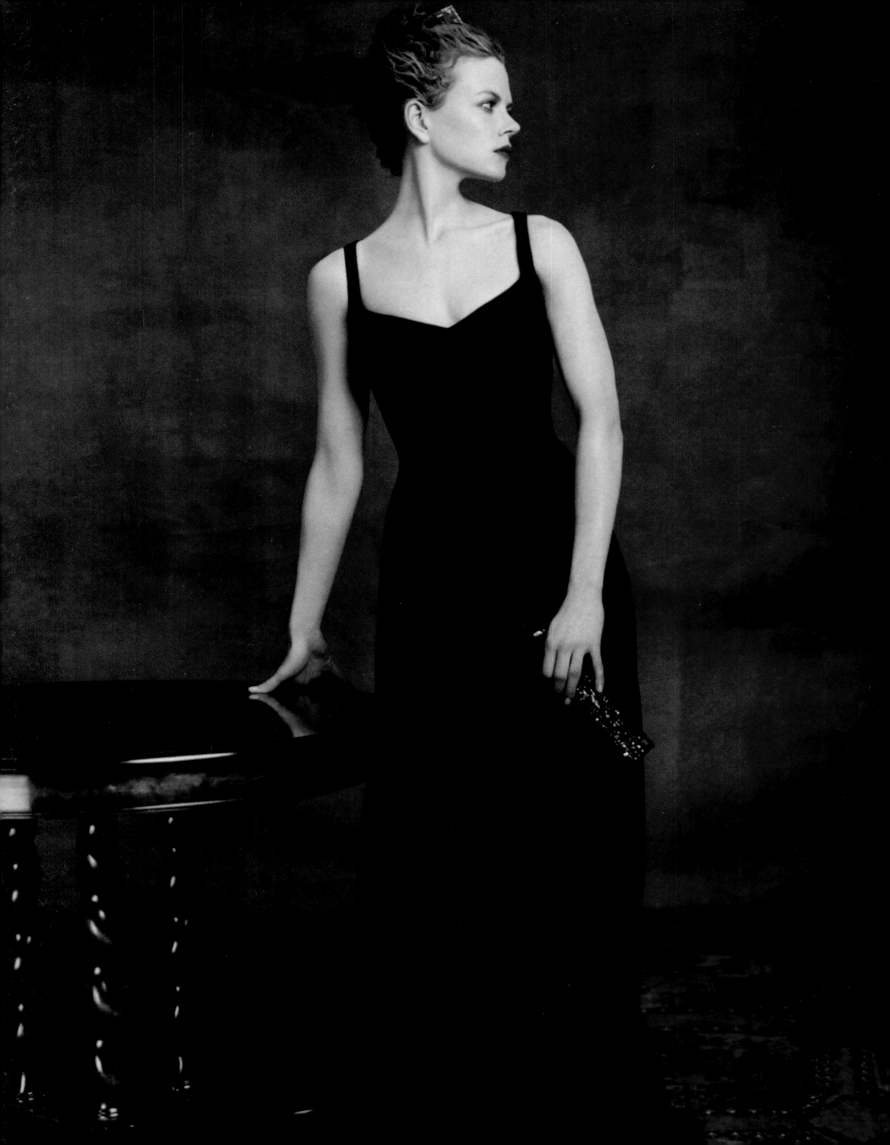

THE WORLD IN VOGUE

PEOPLE PARTIES PLACES

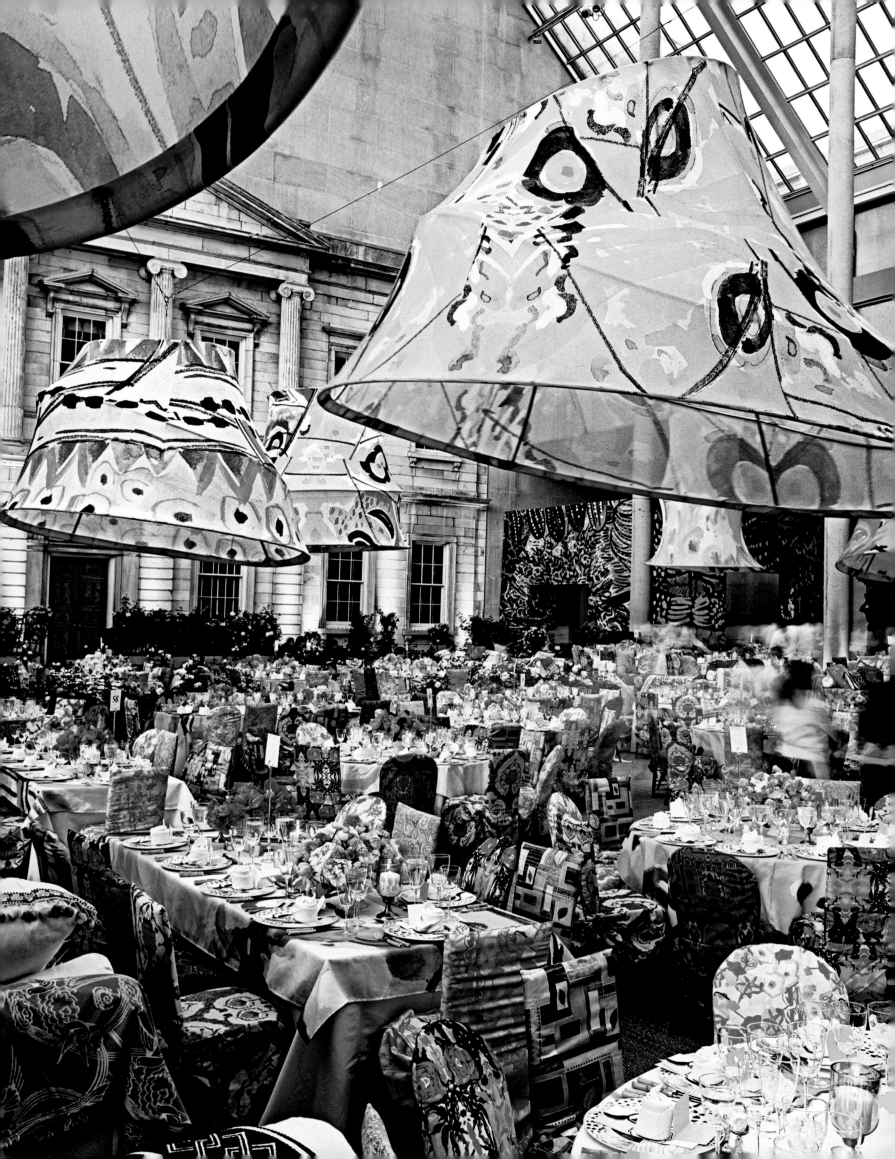

THE WORLD IN
VOGUE
PEOPLE
PARTIES
PLACES

INTRODUCTION BY HAMISH BOWLES
EDITED BY ALEXANDRA KOTUR

ALFRED A. KNOPF NEW YORK 2009

previous pages:
The elegant Australian actress Nicole Kidman
has been on the cover of *Vogue* six times. In
1999, the year Steven Meisel photographed her in
Oscar de la Renta as "Madame X," she would be
nominated for a Golden Globe for Stanley
Kubrick's *Eyes Wide Shut*—and her haute couture
star was very much on the ascendant.

Bakst-inspired prints on lanterns and chairs
transformed the Met's Charles Engelhard Court
in 2007 for the "Poiret: King of Fashion" Costume
Institute gala. Photographed by Michael Lisnet.

The New York sculptor, performance artist, and
painter Rachel Feinstein and her husband,
artist John Currin (*right*), posed before his work.
Photographed by Jonathan Becker, 2000.

following spread:
"Superheroes: Fashion and Fantasy" was the
2008 theme at the Metropolitan Museum
of Art's annual Costume Institute gala. Revelers
included Marina Rust (*left*) in Valentino,
Lauren Santo Domingo (*center*) in Nina Ricci, and
Piper Perabo (seated *right*) in Jonathan Saunders.
Photographed by Hannah Thomson.

THIS IS A BORZOI BOOK
PUBLISHED BY ALFRED A. KNOPF

This book was made possible by
CONDÉ NAST
PUBLICATIONS

Support has been provided by
Calvin Klein
collection

Most of the pieces in this book originally appeared in *Vogue*.

Library of Congress Control Number: 2009928081
ISBN: 978-0-307-27187-7

Design by CHARLES CHURCHWARD

Composition and layout by *Vogue*
Color separations by Quad Graphics, New York, NY
Printing and binding by C & C Offset Printing Co., Ltd., China

This book was set in Garamond, a type named for the famous Parisian type cutter
Claude Garamond (c. 1480–1561). Garamond, a pupil of Geoffroy Tory,
based his letter on the types of the Aldine Press in Venice, but he introduced a
number of important differences, and it is to him that we owe the letter
now known as "old style." The version of Garamond used for this book was first
introduced by the Monotype Corporation of London in 1922.

Manufactured in China
First Edition

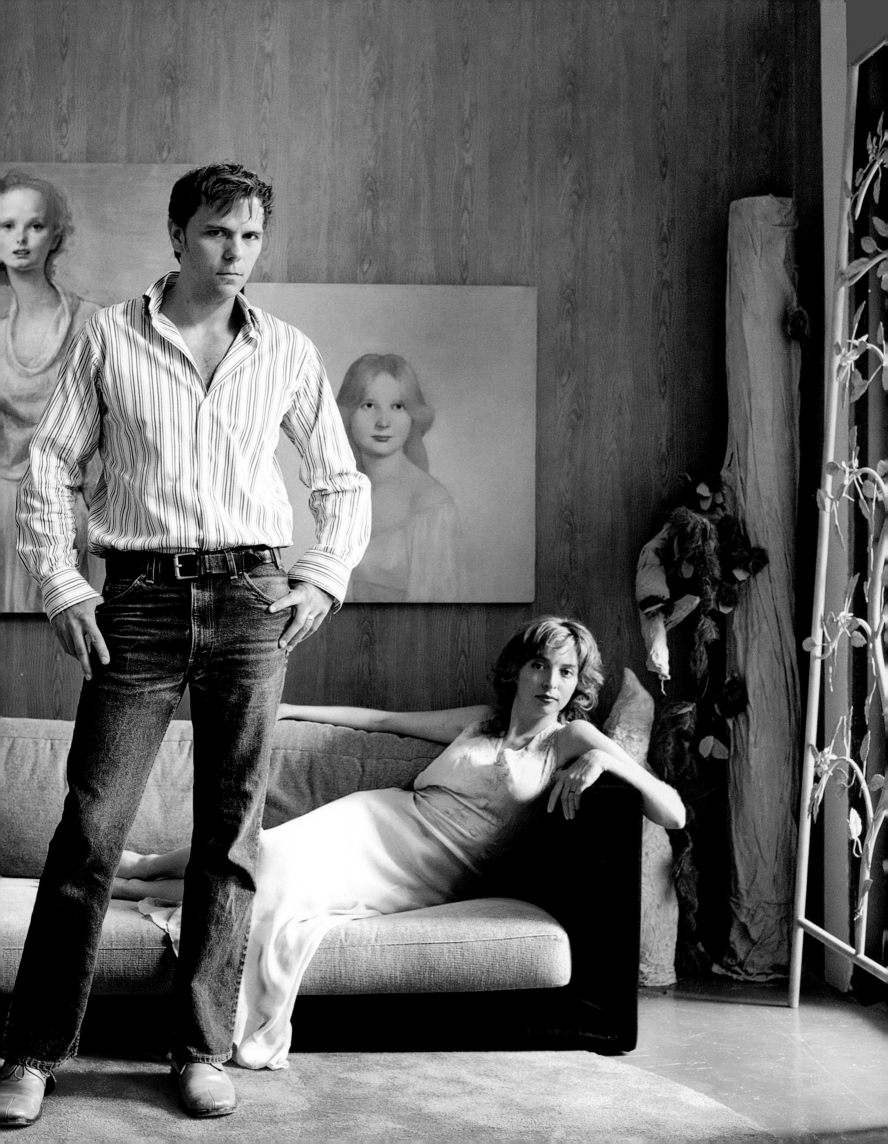

CONTENTS

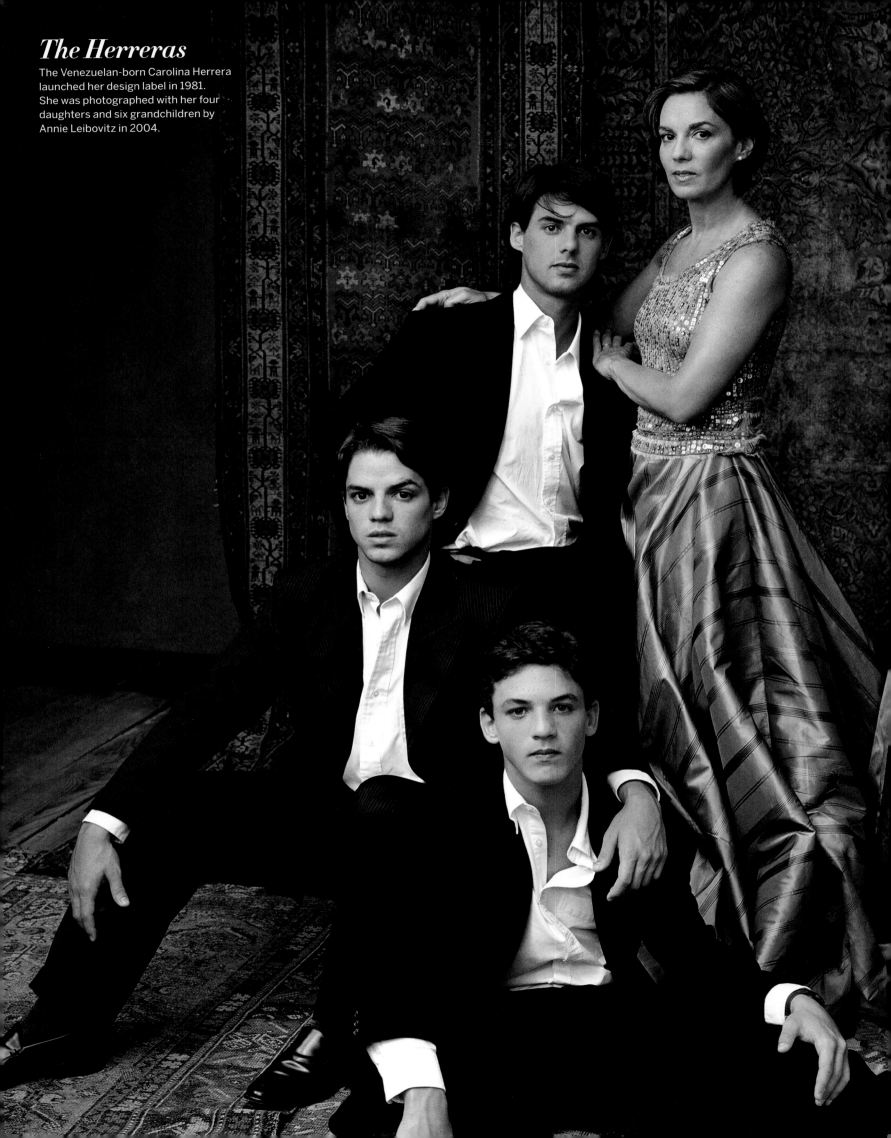

The Herreras

The Venezuelan-born Carolina Herrera launched her design label in 1981. She was photographed with her four daughters and six grandchildren by Annie Leibovitz in 2004.

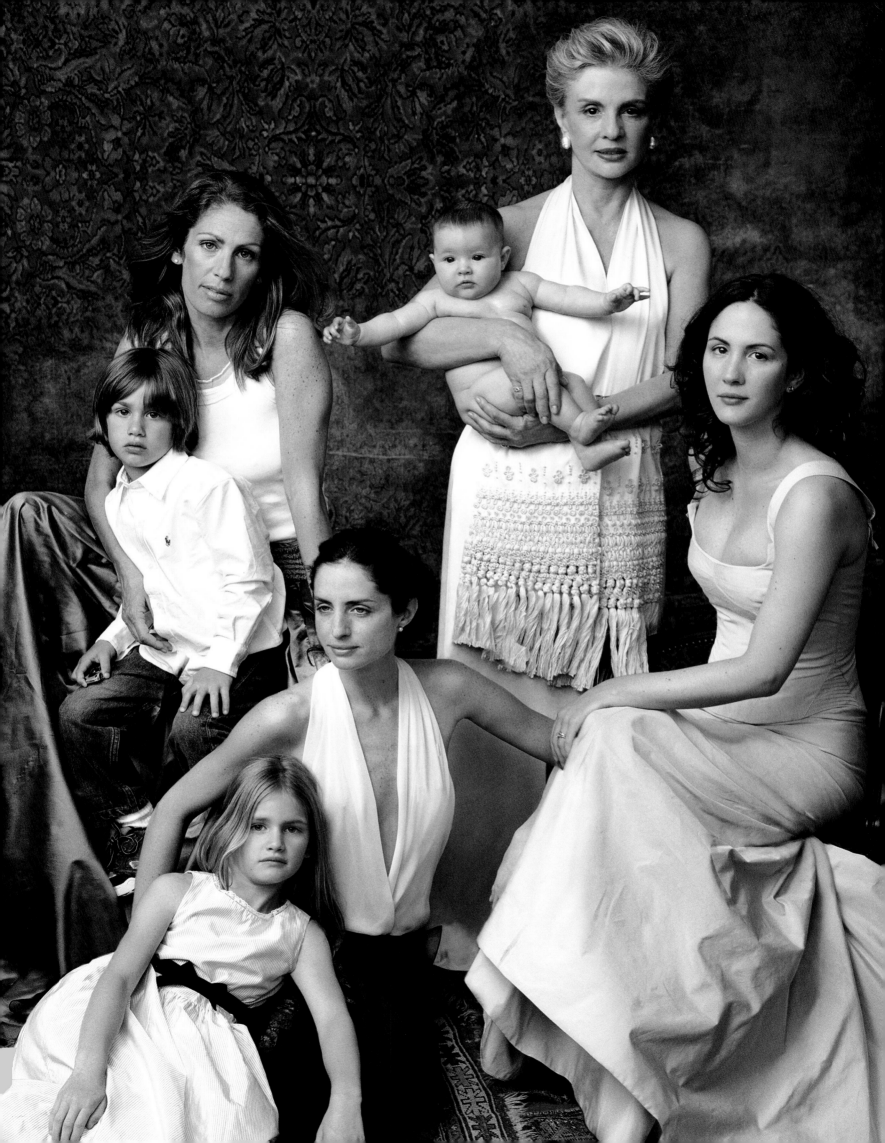

INTRODUCTION

BY HAMISH BOWLES

I n the teeming century that has passed since Condé Nast acquired *Vogue* in 1909, the magazine has held a mirror to its times, reflecting a nexus of beauty, talent, and glamour through the decades.

In the mistiness of the Baron Adolphe de Meyer's images, the glacial perfection of Edward Steichen's, or the acuity of Irving Penn's; against the fanciful backdrops of Cecil Beaton's elaborate studio sets or the cool emptiness of Richard Avedon's; under the elegant gaze of Horst P. Horst and George Hoyningen-Huene and Henry Clarke or the mischievous one of Helmut Newton; in the glamorizing visions of Steven Meisel and Herb Ritts and Mario Testino or via the all-seeing eye of Annie Leibovitz; and in the torrent of words from John McMullin, Truman Capote, Lesley Blanch, Valentine Lawford, Francis Wyndham, Plum Sykes, Joan Juliet Buck, André Leon Talley, and William Norwich, the chameleon worlds of fashion, society, and Hollywood have been memorialized by *Vogue* with wit and reverence. Tradition and innovation, fastidiousness and carefree nonchalance, have each been embodied at various turns by the men and women who made fashion, and *Vogue* has captured them all, celebrating their style and their surroundings, their parties and their philanthropy.

Two world wars and the Great Depression seismically shook the ordered societal hierarchies that a century ago seemed inviolate. But in their stead came new freedoms and liberations, and *Vogue* has been there to record the triumph of the unfettered imagination. The world as *Vogue*

began to document it between the wars—where beauty and talent were as potent as title and pedigree—was in no small measure the literal creation of the urbane and cultivated Condé Nast himself. "What Chanel did to free fashion from elaborate stuffiness, Condé Nast did for society," wrote his protégée Carmel Snow. In 1925, when Condé Nast gave the first of his legendary parties in his Park Avenue penthouse (lavishly decorated by Elsie de Wolfe), Snow noted, "he couldn't leave out his friend Mrs. Vanderbilt and he couldn't leave out his friend George Gershwin so he had them both—and thus café society was born."

As this book reveals, the social mix of people drawn from the fields of the arts, culture, fashion, "society," philanthropy, and politics continues to inform *Vogue*'s sensibility—both in the stories and portraits in the magazine's pages and in its glamorous satellite events, including the Metropolitan Museum's annual Costume Institute gala.

The social order of the magazine's earliest years, from its founding in 1892, was vividly evoked in a series of stories that appeared through the 1930s and 1940s, written by Frank Crowninshield, the Boston Brahmin editor of *Vanity Fair* (1914–1936) and subsequent Fine Arts Editor of *Vogue*. Crowninshield conjured the New York of Edith Wharton, when society, as he recalled, was ruled by "the imperial and really all-powerful Mrs. William Astor," its numbers strictly prescribed by the capacity of her ballroom (400 people).

> A mazurka, a white dress by Doucet, a whispered colloquy in a conservatory, the cut-crystal candelabra, the scent of orris on women's gloves and of Guerlain's lavender on their bodices and hair, the tap of a Venetian fan, a Hungarian band in wine-coloured jackets . . . flunkies in braided liveries, Strauss's *Lorelei* Waltz, the sound of light laughter, a hand pressed on the stairway, white violets, gold favors, black ostrich feathers, the gas-lights of Fifth Avenue, sleigh bells, and drifts of white snow— a debutante dance, as I remember it, 50 long years ago.

Money, beauty, and ambition might have been inadequate to penetrate the bastion of Mrs. Astor's ballroom, but the scions of the impoverished noble families of Europe were less impervious to these qualities. Flocks of so-called dollar

princesses formed matrimonial liaisons with the illustrious houses of England and France, of Spain, Portugal, and Italy, and *Vogue* was there to celebrate them. In 1895, the exquisite Consuelo Vanderbilt led the way, compelled into a loveless match with the sadistic ninth Duke of Marlborough. *Vogue* secured exclusive coverage of Consuelo's trousseau, including details of her wedding dress, made under the supervision of the famed society dressmaker Mme Donovan and rumored to have cost nearly $7,000, and even her lingerie and corsets. (The alliance of beauty and power remains an enduringly potent one: *Vogue* put the Slovenian beauty Melania Knauss on its February 2005 cover in the $200,000 Dior Haute Couture wedding gown that John Galliano designed for her wedding to Donald Trump—a dress so opulent and voluptuous it might have been fashioned for an Edwardian belle.)

After World War I, the magazine chronicled a universe in Europe where looks, flair, and brilliance were passports to a new fluid social order that thrived on novelty and amusement. It was this brave new world that Condé Nast would bring to America and that would shape *Vogue*'s worldview for the rest of the century and beyond. "New York has been small, conservative, shall we say provincial," wrote *Vogue* in 1930, "and only lately has she been able to mix society (exactly what does that word mean?) and the professional classes—artists, writers, actors, musicians, and playwrights—without the danger of boring both sets."

Parisian society, meanwhile, was in the vanguard of the social experiment that Condé Nast championed on the other side of the Atlantic. In France, the balletomane Comte Étienne de Beaumont and the visionary art patron the Vicomtesse Marie-Laure de Noailles were preeminent figures in the seamless mixing of aristocracy and the arts. At the de Noailleses' palatial town house on the Place des États-Unis, guests were entertained by everyone from Bricktop to Georges Auric, and Europe's aristocrats mingled with the city's most distinguished and exciting cultural figures—Breton, Sartre, Aragon, Picasso, Braque, Chagall, Klee, Stravinsky among them.

At the de Beaumonts' annual costumed Bal des Entrées, the highest French society mingled with haute bohemia, making their entrances in imaginatively costumed and carefully choreographed groups (Lady Abdy had Balanchine arrange hers). At the Bal Chinois at the Opéra (1923), for instance, the couturier Paul Poiret held court as a Chinese dignitary, and the Comtesse de Beaumont joined the Marquise de Polignac and the beautiful Duchesse de Gramont (whose fashion choices *Vogue* scrupulously documented) for the "pageant of Chinese crystals," wearing sensational costumes of silver cloth specially created by Vionnet and Chéruit. Another enterprising group "were costumed as the hideous maladies feared by the Empress of China—bubonic plague, cholera morbus, spotted typhus, and boils."

American socialites were quick to imitate, although a true original was the gargantuan pleasure-seeker Elsa Maxwell, from Keokuk, Iowa, who set the bar for entertaining in the modern manner. "Ruthlessness is the first attribute toward the achievement of a perfect party . . . ," Maxwell explained in 1930. "Guests should be selected with as much care as a new Reboux hat. . . ." Maxwell's guest lists also reflected the new social order. At a party at the Paris Ritz in honor of George Gershwin (1928), for instance, "the Cole Porters, the Duchess of Sutherland, Prince and Princess Serge Obolensky, Baron and Baroness Eugène de Rothschild, Michael Arlen, the Grand Duchess Marie, Princess Ilyinsky, Sir Charles Mendl, Allie Mackintosh, and Miss Fellowes-Gordon came. . . . After dinner, Gershwin and Cole Porter . . . vied with each other in playing and singing till the early hours of a clear Paris dawn."

If Maxwell was party planner extraordinaire, the period's social chronicler was the diminutive John McMullin. In the 1920s, he had re-created Walter Robinson's As Seen by Him rubric, from the turn of the century. For two decades McMullin reported the fashions and foibles of the day, as well as on the playgrounds—Saint-Moritz, Cannes, Le Touquet, Deauville, Biarritz, Venice, and Monte Carlo—made newly fashionable by Maxwell herself.

From the beginning, *Vogue*'s vision of fashion was shaped by It girls, drawn not merely from the sequestered ranks of society but from the realm of entertainment, too. By dint of their beauty, presence, and innate style, these women—socialites, performers, models—set the fashions of the day.

previous page:
The word *celebutante* was coined in reference
to Mrs. John Simms Kelly during her "debutante
of the century" days as the young Brenda
Frazier. She and Mrs. William Woodward, Jr. (*left*),
were paragons of mid-century party elegance
in 1952. Photographed by Nick De Morgoli.

Covered in Chanel faux pearls,
the ageless supermodel Naomi Campbell
conjured Josephine Baker for
Karl Lagerfeld's haute couture tribute of 1989.
Photographed by Peter Lindbergh.

In the teens, it was the willowy, bob-haired ballroom dancer Irene Castle who transformed the way women wanted to look, banishing the full-bosomed Edwardian Gibson Girl ideal. In the nineties it was Kate Moss, the waif from Croydon, who emerged to challenge the Amazonian magnificence of the reigning supermodels.

Baron de Meyer, *Vogue's* star photographer from the teens and the early twenties, found his perfect subjects in movie stars Mary Pickford and the sisters Lillian and Dorothy Gish. Onstage, Ina Claire did much to launch Chanel in twenties New York, eclipsing the former power of the socialite tastemakers, while Gertrude Lawrence embodied Molyneux's elegance in Noël Coward's plays and revues—and popularized the Antibes suntan. *Vogue* heralded Katharine Hepburn as "cinema's latest meteor" in 1933, and Joan Crawford, wearing Schiaparelli's extreme new broad-shoulder line, assumed "her most ambiguous look" for Steichen (1932). Meanwhile, the exaggerated glamour of Marlene Dietrich and Greta Garbo transformed the beauty industry in the thirties and inspired *Vogue's* fashion photographers, artists, and society ladies to new heights of artificiality.

The concept of a professional supermodel was first embodied by the fabled Dolores (née Kathleen Mary Rose), a statuesque six-foot-tall blonde who had been discovered by the visionary dressmaker Lucile (Lady Duff Gordon) in 1909. Florenz Ziegfeld spotted Dolores in a Lucile fashion show and put her in his *Follies* dressed as a white peacock. Throughout the decades other celebrity models have created lives and careers beyond the pages of *Vogue.*

Steichen shot Marion Morehouse's *Vogue* debut in 1924 and would continue to immortalize her haughty elegance for a decade. "When she came to the sittings she looked like something the cat dragged in," Carmel Snow recalled Steichen telling her. "Then she'd go into the dressing room and come out looking like a queen." Lee Miller first appeared in *Vogue* as the subject of a dramatic modernistic 1927 cover by the illustrator Georges Lepape, and as a photographic model when she was shot by Steichen (in yachting clothes) a year later. Morehouse settled into a life with the poet e. e. cummings, and Miller went on to become a Surrealist muse and a distinguished photographer herself, memorably sending *Vogue* photo essays and accompanying texts during World War II, documenting the war from the front lines, the Liberation of Paris, and, unforgettably, the horrors that were revealed when the Nazi death camps were liberated.

Alongside models, society women continued to pose in fashions for *Vogue*—and to set them. In London, Lady Diana Cooper was the acknowledged reigning beauty, admired in America when she portrayed the Nun and the Madonna in Max Reinhardt's sensational production of *The Miracle* (1923), while Lady Louis Mountbatten, with her idiosyncratic slouching posture, was the last word in chic. In Manhattan, 1,000 guests were invited to Mary Millicent Rogers's coming-out ball at the Ritz Carlton in 1920, and her innovative fashion sense would influence designers on both sides of the Atlantic—including Schiaparelli, Valentina, Mainbocher, and Charles James—for three decades. The Kentucky belle Mona Strader exploded like a comet into *Vogue's* constellation with her 1926 marriage to Harrison Williams, reputed to be the richest man in America at the time. "Her appearance is the paradox of strangeness allied to tradition," wrote Beaton in 1938. "Her eyes, the color of seawater, remind one of wild birds in flight." *Vogue* was fascinated for decades. In 1967, Horst photographed Mona (now the Countess Edward Bismarck) at Fortino, her house on the site of Caesar Augustus's villa in Capri, where Valentine Lawford found that "her garden is like a brilliant impromptu, a virtuosa cadenza, that one hopes will never stop."

When the classically beautiful and stylish Princess Marina of Greece married Prince George of England in 1934, *Vogue* rejoiced. The fashionable young couple, whose circle included Noël Coward and Cecil Beaton, brought Condé Nast's milieu to the highest rank of British society. But a former Baltimore belle would scale higher still.

By the mid-thirties, Wallis Simpson—"the most talked-about American in London," as *Vogue* coyly expressed it—was entwined with the magazine's world. "Since I can't be pretty, I try to look sophisticated," she told *Vogue* in 1943, and no detail of that sophisticated style escaped the magazine's scrutiny. After first meeting Mrs. Simpson, Cecil Beaton wrote in 1937, "She is tidy, neat, immaculate. Her hair, like a Japanese lady's hair, is brushed so that a fly would slip off it. . . . She reminds me of the neatest, newest luggage, as compact as a Vuitton traveling case." Later that year, Beaton documented in words and photographs the Windsors' subdued wedding at the Château de Candé—a great coup for the magazine. "The duke, with the enthusiasm of a schoolboy home for the holidays,

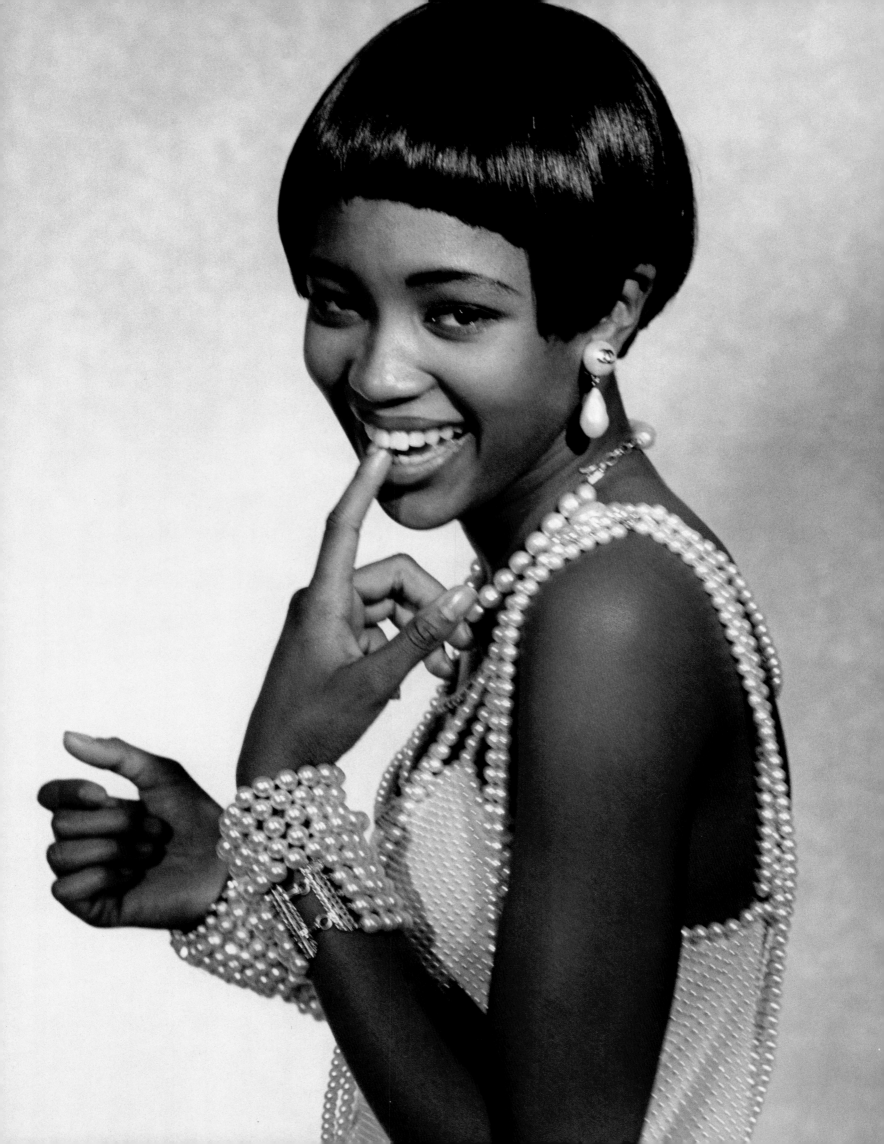

In 1960 Cecil Beaton photographed Eugenie Livanos, the third wife of the Greek shipping tycoon Stavros Niarchos, wearing Dior at the time she was overseeing the renovation of the Hôtel de Chanaleilles. The walls of the family's Paris town house were famously hung with such masterpieces as El Greco's *Pietà* and Van Gogh's *Portrait of Père Tanguy.*

One of Truman Capote's "swans," Gloria Guinness (*below*), with her daughter Dolores (Mrs. Patrick Guinness), sat for Henry Clarke in 1957. Both are dressed by Cristóbal Balenciaga.

gives instructions on a thousand different issues," noted Beaton, while his wife-to-be reviews "the latest batch of telegrams—mostly from America." Mainbocher's dress, Beaton observed, had been "made to give the bride-to-be the fluted lines of a Chinese statue of an early century."

Other notable women of style emerged to counterpoint the duchess's hard-edged chic. Mary Taylor, whose mother, Mrs. Francis H. McAdoo, was a prominent Manhattan socialite, was first photographed for *Vogue* as a debutante in 1932, " . . . singled out from all the very young girls for her exceptional chic and blonde, willowy grace." Her exotic looks helped transform the ideal of contemporary beauty. And the Russian émigré Princess Natalie Paley, daughter of the Grand Duke Paul of Russia, was at the center of Parisian social life and of the world of fashion after her 1927 marriage to the couturier Lucien Lelong, whose dashing modern clothes she did much to promote. After their divorce in 1937, she married Noël Coward's business manager, John C. Wilson, and would become the director of Mainbocher's Manhattan salon in the forties. Constantly photographed in his clothes, Paley was for Main something of a muse and an inspiration; Amanda Harlech would perform a similar role for John Galliano and then Karl Lagerfeld, and Isabella Blow for Alexander McQueen and milliner Philip Treacy a half-century and more later.

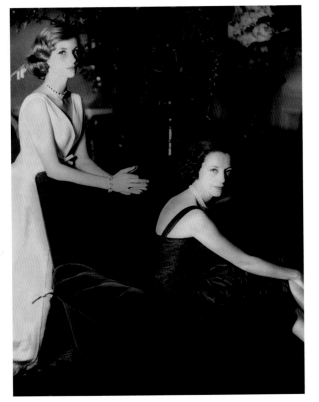

Another debutante first shot for the magazine by Beaton in 1937 (against a Surrealist backdrop of floating gardening gloves), Miss Barbara Cushing would also have an enduring impact on *Vogue*'s world. The fabulous Babe would become a *Vogue* fashion editor and, even after her 1940 wedding to Stanley Grafton Mortimer, Jr., a sought-after model for the magazine as well. "Her strength of coloring, her fascinating unevenness of feature have made her without question one of the interesting beauties of our day," wrote *Vogue* in 1949, "yet she might have faced the ages from a frame in the Uffizi Gallery in Florence." In 1947 she remarried, this time to CBS chairman William S. Paley, and as Babe Paley would remain *Vogue*'s paragon of elegance and aristocratic allure.

The Fête de Versailles (1938), the circus ball of Lady Mendl (professionally Elsie de Wolfe), had been the last hurrah for café society before World War II. Lady Mendl was "the pony master with a long whip," a Mainbocher cape, and her hair dyed blue by Antoine (he had experimented with the tone on his borzoi Da). Constance Spry brought the flowers, already arranged, from England; the sprung dance floor came from London and the performing ponies from Finland. By the late forties, after the privations and miseries of war and the Occupation, Europe once again showed itself *en fête.* Even Lady Mendl's extravagances were eclipsed in 1951, when Carlos de Beistegui, the heir to a Mexican silver fortune and a fastidious tastemaker, hosted the Venetian Ball.

Vogue had first applauded de Beistegui's taste when he commissioned Le Corbusier in 1931 to create a supremely modernist penthouse appointed with whimsical neoromantic furnishings, which served as a backdrop not only for the Parisian beau monde but also for several of the magazine's fashion stories and had a profound impact on contemporary taste. De Beistegui then revived Victorian country-house style when he lavished his considerable resources on the beautification of the Château de Groussay, in the countryside not far from Paris, where his improvements included an exquisite 250-seat theater and a dozen garden follies designed by Emilio Terry. The fashionable world that *Vogue* celebrated flocked to his Venetian revels—1,200 friends were invited to the Palazzo Labia, which he had newly and magnificently restored, and 10,000 Venetians to the *fête populaire.* As at the de Beaumonts' parties in the twenties, many of the guests organized themselves into fancifully costumed and staged

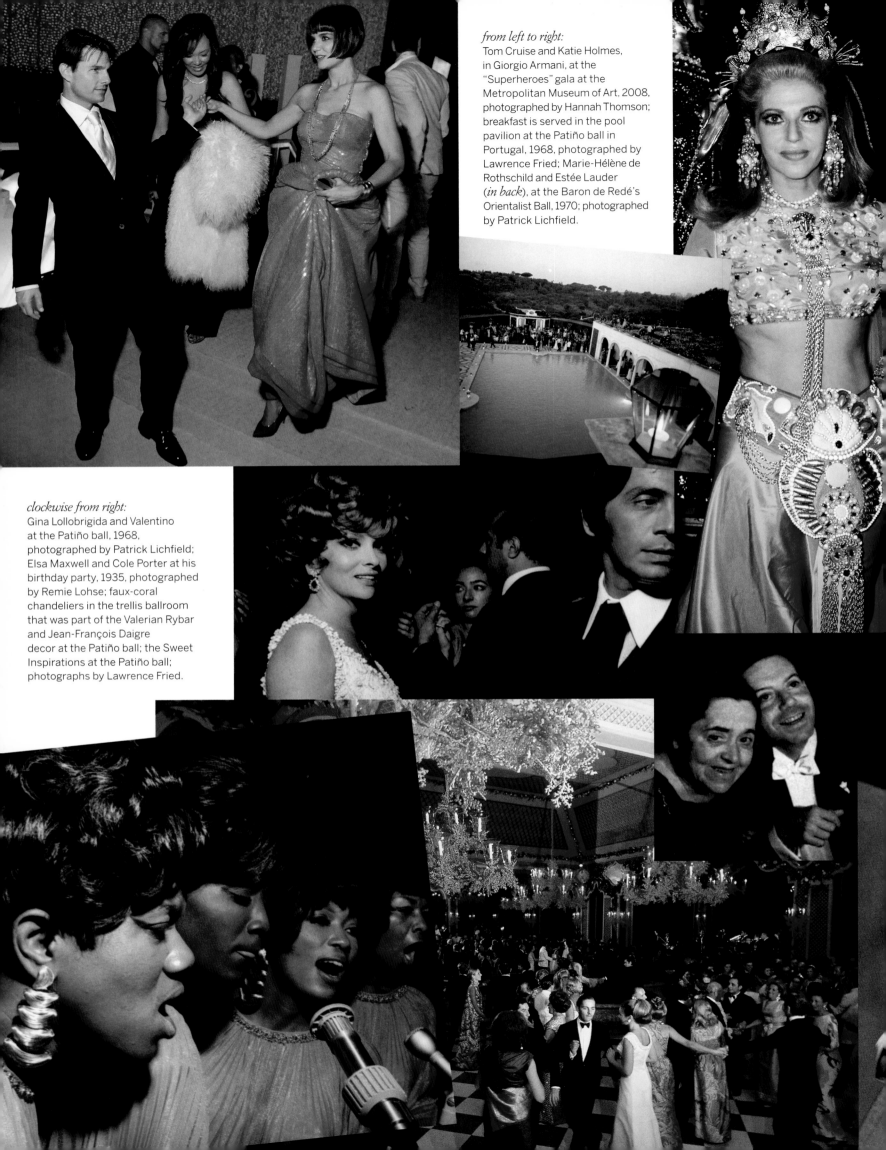

from left to right:
Tom Cruise and Katie Holmes, in Giorgio Armani, at the "Superheroes" gala at the Metropolitan Museum of Art, 2008, photographed by Hannah Thomson; breakfast is served in the pool pavilion at the Patiño ball in Portugal, 1968, photographed by Lawrence Fried; Marie-Hélène de Rothschild and Estée Lauder (*in back*), at the Baron de Redé's Orientalist Ball, 1970; photographed by Patrick Lichfield.

clockwise from right:
Gina Lollobrigida and Valentino at the Patiño ball, 1968, photographed by Patrick Lichfield; Elsa Maxwell and Cole Porter at his birthday party, 1935, photographed by Remie Lohse; faux-coral chandeliers in the trellis ballroom that was part of the Valerian Rybar and Jean-François Daigre decor at the Patiño ball; the Sweet Inspirations at the Patiño ball; photographs by Lawrence Fried.

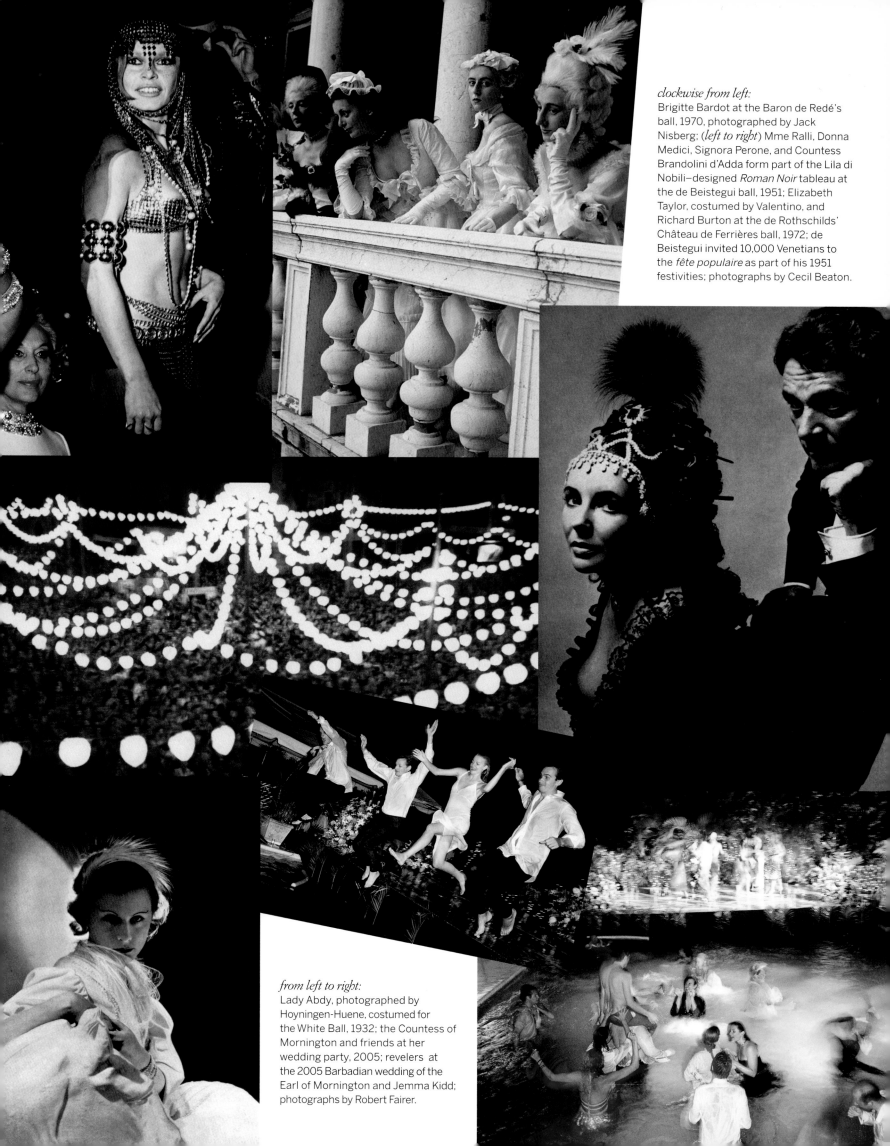

tableaux. Arturo Lopez-Willshaw came as the emperor of China, and his wife, Patricia, was brought in on a palanquin. Daisy Fellowes was dramatically dressed by Dior in a lyrebird-feather headdress and a vast crinoline ball gown swathed in leopard chiffon, to represent "America 1750."

In the years immediately following World War II, a new bevy of swans arrived to engage *Vogue*'s photographers and writers. In 1945, *Vogue* unveiled the Mexican beauty Mme Alfredo Rubio. "Her elegant dark head very, very straight on her shoulders, her long, slim legs, her pointed Goya-like feet are elegancies that Paris understands and enjoys." As Gloria Guinness (she married the banker Loel in 1951) she would continue to influence taste in fashion and living through the following two decades—not least in the innovative *palapa* she created with architect Marco Aldaco on Mexico's Costa Careyes in 1972. By the mid-1950s Guinness's swan-necked daughter, the Baroness Dolores von Furstenberg-Herdringen (who married her stepbrother Patrick Guinness in 1955), had become an iconic beauty herself. The Italian Marella Agnelli (whom Truman Capote described in 1969 as "taut and trim as well-made rope . . . lively and sophisticated, like a fast game of chemin de fer") and the enduring *Vogue* style icon C. Z. Guest (who first posed in 1943 as Boston debutante Lucy Cochrane), "tall, blonde, slender, with a sort of greyhound elegance," moving "with a tennis player's easy, unfettered stride" (1959), were the epitome of European and American taste.

Following a tradition of photographing First Ladies that *Vogue* initiated with Mrs. Herbert Hoover, Mrs. Dwight D. Eisenhower was photographed by Horst in the Nettie Rosenstein gown she wore for the second Inaugural Ball in 1957. "Mrs. Eisenhower has installed a Hammond organ, which she plays for her friends . . . ," wrote *Vogue*, "and sometimes varies the entertainment at White House dinners with a barbershop quartet." Small wonder that when Mrs. John Fitzgerald Kennedy—"a whole new image of the young American woman—gentle, informed, attractive" (1961)—became the subsequent First Lady, *Vogue* applauded. Beaton had photographed Jacqueline Bouvier and her sister, Caroline Lee, for the magazine in 1951 as debutantes in frothing Elizabeth Arden ball gowns. When Kennedy was First Lady, two of her style avatars were revered pillars of *Vogue* society: Bunny (Mrs. Paul) Mellon ("one of this country's finest gardeners . . . quietly connected with some of America's most enchanting and beautiful gardening ventures" [1965]) and the connoisseur Jayne (Mrs. Charles) Wrightsman ("her mind is as well dressed as her body. . . . She is controlled, driven, and definitely powerful like a small transistor" [1966]). In 2009, a new paradigm for First Lady style was celebrated when Michelle Obama was photographed by Annie Leibovitz for *Vogue*'s cover. "With her long, lean, athletic frame, she moves as if she could have danced with Alvin Ailey in another life," noted André Leon Talley, applauding her desire to reflect "the many facets of our

culture" in the White House's entertaining program. "If I can have any impact," Mrs. Obama told him, "I want women to feel good about themselves and have fun with fashion."

Under Diana Vreeland's dynamic editorship of *Vogue* (1963–1971), its pages were filled with idiosyncratic beauties. Vreeland dispatched Barbra Streisand to the Paris haute couture collections and applauded Cher's hieratic looks. At the same time, socially well-connected girls drawn from international society—and often second- and third-generation *Vogue* beauties—were transformed into celebrity models who helped break the mold of mid-century perfection. Veruschka was born Vera Gottliebe Anna Gräfin von Lehndorff-Steinort, and her Amazonian beauty and chameleon ability to transform her looks and visual identity made her a *Vogue* star.

Penelope Tree had been in *Vogue*'s orbit from birth. (Her father, Ronald, an American-born Conservative British M.P., had previously been married to the influential decorator Nancy Lancaster. Her mother, Marietta, a Peabody from Boston and a fabled prewar debutante, was the United States' delegate to the U.N.'s Human Rights Commission.) Tree's waifish, saucer-eyed beauty, brilliantly exploited by Avedon, transformed her into a symbol of the Youthquake decade.

The art-collecting Mrs. Leonard Holzer ("Baby Jane" to the Warhol set) possessed "the biggest head of hair this side of the jungle—honey-tawny hair built out further by hairpieces and brushing" (1964) and exploded into *Vogue*'s world, while Marisa Berenson had been on the magazine's radar all her life; her grandmother was Elsa Schiaparelli.

Loulou de La Falaise was third-generation *Vogue*, too. Her grandmother Rhoda Birley, the wife of the fashionable portraitist Sir Oswald, was "surely the most beautiful Irishwoman out of Ireland" (1928), and her mother, Maxime, the Comtesse Alain de La Falaise, was a sensation in late-forties Paris when *Vogue* shot her with her new Napoleonic haircut by Guillaume (1948). De La Falaise's intimate

collaboration with Yves Saint Laurent as accessory creator, design assistant, and muse kept her firmly in *Vogue*'s sights. Her niece Lucie de La Falaise would later emerge as a *Vogue* beauty. In 1992 Georgina Howell noted, "She is unsophisticated in the grandest English tradition, and her unworldliness is, at nineteen, positively royal."

With her strong, memorable features and dramatic fashion sense, Paloma Picasso, like de La Falaise and Berenson, would prove an enduring *Vogue* subject, as well as a muse for both Lagerfeld and Saint Laurent. Like Millicent Rogers in the forties, Halstonette Elsa Peretti in the seventies, and Tina Chow in the nineties, Picasso turned her design talents to jewelry, first for Saint Laurent and later for Tiffany & Co. In 1981, she told the magazine, "To look good and to dress up isn't just a favor you are doing for yourself— it's a favor you are doing for the people around you."

Edie Sedgwick also made an impression on *Vogue* at the time. "In Paris Warhol's gang startled the dancers at Chez Castel by appearing with fifteen rabbits and Edie Sedgwick in black leotard and a white mink coat," the magazine noted in 1965. "In her deep, campy voice, strained through smoke and Boston, she said: 'It's all I have to wear.' " Sedgwick wasn't the only quirky beauty of the era to burn out far too young. In 1970 the aristocratic Patrick Lichfield shot Talitha Getty—"molasses-blonde, with an almost Oriental dark and secret glance"—at the Gettys' magnificent Palais de la Zahia ("Pleasure Palace") in Marrakech. "You can wear anything marvelous and strange here," said Talitha. "Everyone looks beautiful in Marrakech." A year later, both she and Edie were dead from heroin overdoses.

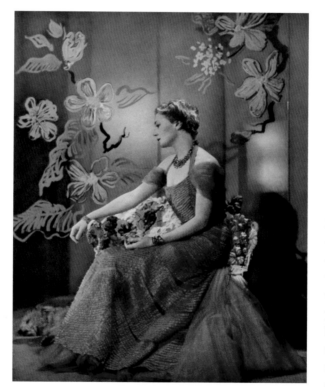

Pan-generational It girls, from Gloria Guinness, Marella Agnelli, and Tallulah Bankhead to Mia Farrow, Amanda Burden, and Penelope Tree, were all bidden to the defining party of the decade when Truman Capote, wearing a 39-cent mask from F.A.O. Schwarz, welcomed guests to his Black and White Ball, given in honor of *Washington Post* publisher Katharine Graham (1967). "So much beauty, power, talent, and celebrity hasn't been collected in one room since a great Inaugural Ball," wrote Gloria Steinem.

The European riposte was the Antenor Patiño ball in Portugal a year later. The Patiños set the date a year in advance, "checking the almanac for a night of full moon," then on the night itself had a plane "seed the air with dry ice to forestall mist." Guests who flew in from around the world for this and the Pierre Schlumbergers' party included the ex-king of Italy; Stavros Niarchos; Audrey Hepburn; the maharani of Baroda; Françoise Sagan; Vincente Minnelli; and Jacqueline de Ribes. The decorators Valerian Rybar and Jean-François Daigre created a Portuguese palace of trellis work—and hung the trees with coral-branch cages of white doves. The tablecloths were woven in Germany; the scarlet footmen's tunics were ordered from Italy; nine chefs were flown in from Paris; the hostess coruscated with "five rare diamonds, each a different color, in her hair"; and eight women wore the same Dior.

During this period de Beistegui's splendid mantle was assumed by Arturo Lopez-Willshaw's protégé the Baron Alexis de Redé. At the Guy de Rothschilds' magnificent seventeenth-century Hôtel Lambert on the Île St. Louis, in which he had sumptuous apartments, de Redé channeled the era's hippie de luxe exoticism when he threw an Oriental ball in 1969. Here the guests— Brigitte Bardot as a belly dancer, Marie-Hélène de Rothschild as a Cambodian dancer, the Vicomtesse de Ribes "a Napoleon III vision of Turquerie" in voluminous puffball pantaloons—were "greeted by volleys from Indian drummers in palanquins on top of two life-size white elephants. . . . Everywhere was the sound of sitar music, the flicker of lamps, lanterns, torches, the smell of jasmine and myrrh wafting from perfume burners, the changing tableau of the guests themselves, like many-colored birds of paradise."

The haute monde met Hollywood in 1972, when Marie-Hélène de Rothschild invited guests to the Château de Ferrières, the Rothschilds' palatial country house, for a Proustian ball. Cecil Beaton—dressed as Nadar, the fin de siècle society photographer—captured such luminaries as Richard Burton and Elizabeth Taylor (wearing the 69.42-carat Burton-Taylor diamond framed in her cleavage by Valentino's black taffeta and lace); Marisa Berenson, dressed by Visconti's costume designer Piero Tosi as the Marchesa Casati in a towering headdress of paradise plumes; and Audrey Hepburn in Valentino's Edwardian ruffles.

Audrey Hepburn, eternal style muse, was caught by Patrick Lichfield at lunch with Oscar de la Renta during the Patiño ball festivities, Portugal, 1968.

————————————

Philadelphian Grace Kelly (*below*) was photographed upon the release of her film *The Swan,* in which she played a princess. Not long after, she actually became one when she wed Prince Rainier III of Monaco. Photographed by Howell Conant, 1956.

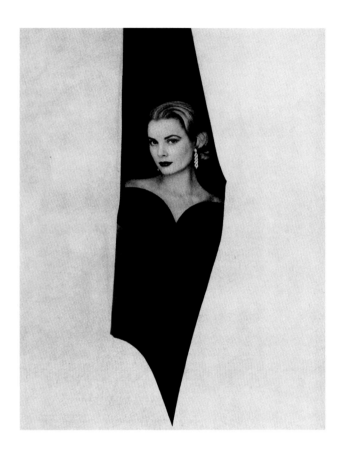

That same year, Liza Minnelli wowed Paris in Halston's scarlet crepe and was feted with "two whizzo good parties," one hosted by the Baron de Redé in the Hôtel Lambert's Galerie d'Hercule, the other by Marisa Berenson (who costarred with her in *Cabaret*) at the Club Privé. And in 1979, Karl Lagerfeld's disco-age take on an eighteenth-century ball brought 3,000 guests to Le Palace, with the host in a black taffeta domino and a tricorne hat. In Manhattan, Studio 54, which opened its doors in 1977, was the great social leveler. It girls Bianca Jagger, Grace Jones, and Jerry Hall mingled with a pantheon of celebrities, including Elizabeth Taylor, Vladimir Horowitz, Betty Ford, Rudolf Nureyev, Halston, and Andy Warhol.

The decadence and hedonism of the disco era ceded to the formality and conspicuous consumption of the glittering eighties, and wealth was the new passport. Entertaining revolved around subscription galas and earnest cultural and

philanthropic fund-raising, and a new order of sumptuously dressed mogul consorts dominated the social scene—Anne Bass, Susan Gutfreund, Carolyne Roehm, Gayfryd Steinberg, Judy Taubman, Blaine and Ivana Trump, and Lynn Wyatt preeminent among them. At the Metropolitan Museum of Art's 1987 Costume Institute Gala, "couples were kept at arm's length from each other by the pouf of a Lacroix skirt," and downtown Manhattan, with its nightlife mavens like Dianne Brill, Debbie Harry, Nell Campbell, and an emerging Madonna, was a scene as distant as the Cotton Club from the Colony Club in twenties New York—although *Vogue* proved a melting pot where both coexisted.

T he uptown-downtown mix was exemplified by Princess Gloria von Thurn und Taxis, the decade's most flamboyant hostess, who dazzled at Paris's Bains Douches nightclub in "pink Montana and marigold hair" and sent out Keith Haring–designed 45 rpm records, which, when played, found her singing an invitation to her guests to join her at her storied Bavarian schloss. Lucy Ferry, wife of the rocker Bryan Ferry, arrived "in a star-spangled tulle meringue from Christian Lacroix." Downtown in eighties Manhattan, Jacqueline Schnabel and Alba Clemente were the reigning beauties of the art scene (a decade and more later, Yvonne Force Villareal, Rachel Feinstein, and Anh Duong would become the art-world mavens du jour), but uptown, the social makeup of the city changed dramatically in this glittering decade.

After the giddy hedonism of the seventies, dominated by the whimsical beauties in Halston's and Saint Laurent's satellite tribes, the new wealth restored a status quo that Alva Vanderbilt might have recognized. In 1988, *Vogue* photographed Anne Bass—"an arts patron with clout"—at home on Fifth Avenue. "Perfection is everything to Anne Bass," wrote André Leon Talley. "Fresh linens are ironed and meticulously folded, carried to closet or bath in blond wicker trays lined in scalloped-edged French piqué. In the linen closets, towels and linens are layered with hand-woven fans laced with fresh vetiver from Louisiana."

In 1990, Georgina Howell found Carolyne Roehm exemplifying the spirit of the Working Rich. Designing

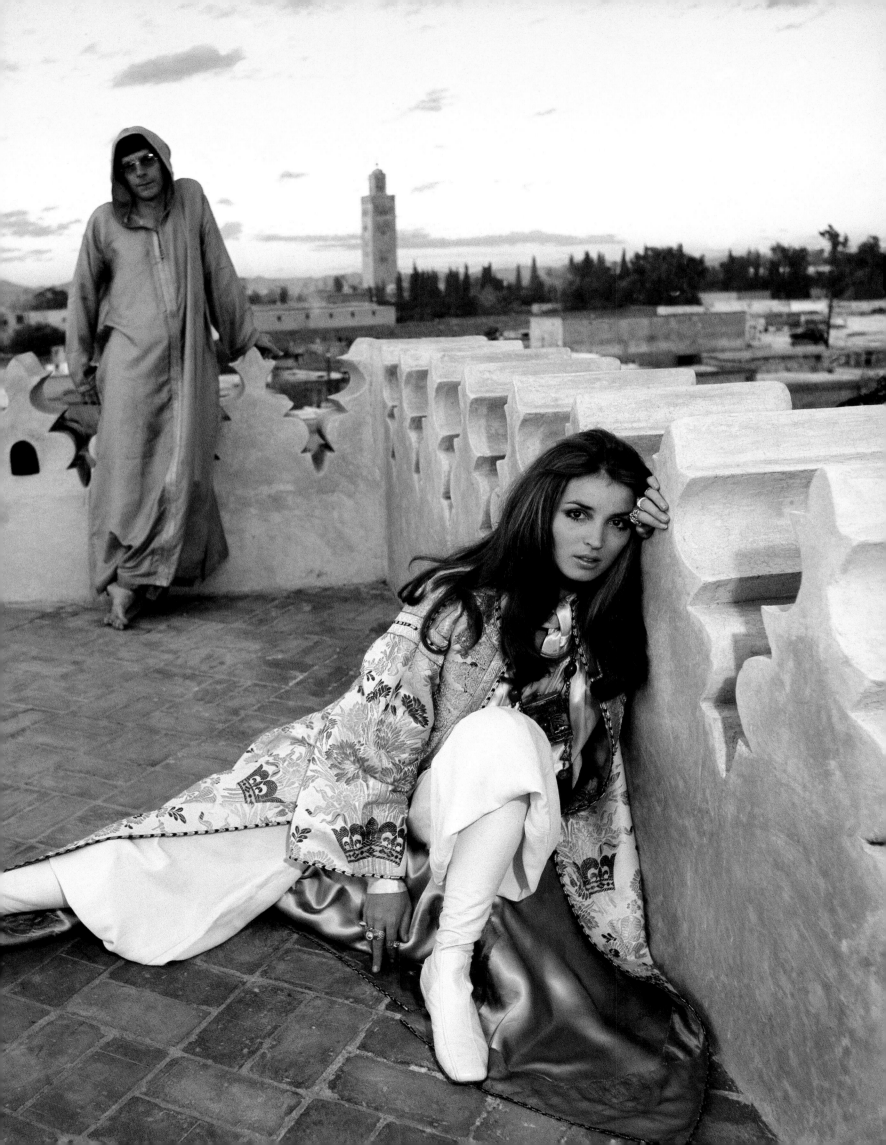

four fashion collections a year, Roehm was also the president of the Council of Fashion Designers of America (and organized, with *Vogue,* the Seventh on Sale event, which generated $4.2 million for AIDS research and care); raised funds for New York City Ballet; and was a chairman of the Metropolitan Opera benefit, a trustee of the New York Public Library, and a member of the steering committee of Carnegie Hall. "And don't forget," wrote Howell, "the lessons she periodically takes in French, cookery, wine, riding, exercise, and music."

At this moment, the women shaping fashion were a new breed of beauties. Thanks to designers like Gianni Versace and Karl Lagerfeld, with their sensitivity to contemporary celebrity culture and their command of extravagant budgets, Linda, Christy, Naomi, Cindy, Stephanie, Claudia, et al were emerging as a powerful clique of newly dubbed "supermodels." With Hollywood largely disengaged from fashion at the time, these Amazonian women, with looks iconic or chameleon, dictated fashion and beauty trends and set the bar for flamboyant self-presentation and, at times, behavior. Ultimately, Kate Moss, the waifish antidote to these women, through "the scrappy nonchalance that makes her so maddeningly, elusively glamorous," would find herself "up there on the Olympus of supermodeldom," wrote Sarah Mower in 2004, "inhabiting that special peak of fame reserved for the few who have crossed over to become pop-cultural goddesses."

At the sixty-seventh Academy Awards, in 1995, Uma Thurman (nominated for *Pulp Fiction*) wore ethereal lavender Prada on the Hollywood red carpet and in one fell swoop brought high fashion to Tinseltown. Since then, numerous actresses, including Nicole Kidman, Cate Blanchett, Jennifer Lopez, Renée Zellweger, Charlize Theron, Keira Knightley, and Tilda Swinton, have proved that an engagement with fashion is not incompatible with intelligent choices of roles, and have transformed the way *Vogue*'s covers and fashion spreads are planned, eclipsing the celebrity models of the eighties and the early nineties. "This was a year when I began to learn to trust myself," Anne Hathaway confided to *Vogue* in 2009, "to see fashion as something that could liberate you rather than define you in a negative way."

Meanwhile, the appearance in early-nineties Manhattan of the three internationalist Miller sisters—Pia, Marie-Chantal, and Alexandra—transformed the city's jeunesse dorée. Daughters of Robert W. Miller, the duty-free plutocrat, they embarked on a flurry of glamorous weddings the way the fabled Cushing sisters had 50 years before them. Pia married Christopher Getty, grandson of J. Paul Getty, in a Balinese ceremony complete with an elephant; Alexandra wed Alexandre von Furstenberg, son of the quintessential seventies It girl Diane von Furstenberg, wearing a Chanel couture satin crinoline embroidered with ears of wheat; while the middle sister, Marie-Chantal, scooped the dynastic prize when she exchanged rings under the cupola of the Greek Orthodox Cathedral of Saint Sophia with Crown Prince Pavlos of the Hellenes in the presence of Queen Elizabeth II and an embarrassment of European crowned heads.

Five years after Herb Ritts's 1995 shoot with the ironed-blonde Miller girls, *Vogue* sent art photographer Sarah Jones to document some Manhattan sisters who transformed the social landscape in a very different way. Plum Sykes discovered bickering teenagers Paris and Nicky Hilton living in "pastel perfection at the Waldorf Towers" with their parents, hotel heir Rick Hilton and mother Kathy—"as socially ambitious for her own daughters as *Pride and Prejudice*'s Mrs. Bennet was for hers two centuries ago." "What really thrills Paris and Nicky is escaping their luxurious captivity," noted Sykes acerbically. "They were at Puff Daddy's party at Orient. They go to Life. Veruka. Balthazar. Moomba. The Givenchy couture show in Paris. What's even more thrilling is doing it all dressed as twins."

The Hiltons were emblematic of a new cultural phenomenon. "Movie stars, reality-TV personalities, celebrity chefs, celebrity stylists, celebrity florists, celebrity party planners, and a couple of Hiltons . . . are stealing the cultural roles previously enjoyed by bona fide social arbiters," wrote William Norwich in 2005. "Will society masstige keep the vulgarians from the gate?" Norwich asked, citing a slew of *Vogue* tastemakers—Tory Burch, Aerin Lauder, Amanda Brooks, Brooke de Ocampo, Fernanda Niven, and Lauren Davis among them—who were "thinking big business, claiming their own territory in the trillion-dollar world of consumer products, where 'masstige' or 'affordable luxury' or, if you prefer, class plus mass, reigns."

The society cocktail with which Condé Nast shook and stirred Manhattan in the Jazz Age has been at its most refulgent in the past decade, at the Metropolitan Museum of Art's annual Costume Institute Gala, where the beau monde meets fashion, entertainment, politics, royalty, and culture. Katharine Graham and Madonna celebrated Gianni Versace (1997), and a characteristically eclectic mix at the "Goddess" show (2003) saw American society's Old Guard (C. Z. Guest, Pat Buckley, Lynn Wyatt) and a bevy of young swans (Marina Rust, Aerin Lauder, Plum Sykes, Lauren Bush) carousing alongside fashion's meteors Tom Ford, Stella McCartney, and Marc Jacobs; the art world's Francesco Clemente, John Currin, and Rachel Feinstein; the music industry's David Bowie (with Iman), Sean Combs, and Alicia Keys; Hollywood's Sofia Coppola, Kate Hudson, Kirsten Dunst, Charlize Theron, and cohost Nicole Kidman ("the evening's Aphrodite . . . with her complexion like sugar-glazed marzipan, a galaxy of sparkles on her nude Tom Ford gown").

At "AngloMania: Tradition and Transgression in British Fashion" (2006), Lady Gabriella Windsor twirled in Vivienne Westwood's Romney satin alongside Sex Pistol Johnny Rotten, and Andrea Casiraghi and Tatiana Santo Domingo arrived late to dance with the twelfth Duke of Devonshire and his duchess; Princess Mafalda of Hesse; the Rupert Murdochs; and Lord Mornington and his wife, Jemma Kidd. Sienna Miller, in a gold sequined mini, channeled Edie Sedgwick, the *Vogue* It girl whom she also embodied in George Hickenlooper's *Factory Girl.* And at "Superheroes: Fashion and Fantasy" (2008), Katie Holmes wore electric-blue Louboutins with her vintage scarlet Armani and danced the night away with husband Tom Cruise.

In December 2006, *Vogue* trumpeted EUROFLASH! as a headline. "There is a nostalgia for aristocrats and children with recognizable old family names," wrote William Norwich. "The welcome offered the nouvelle vague is also part of a European backlash against a kind of random celebrity worship that is considered anti-intellectual, probably a bit too American, and just generally not cool." Norwich noted that Tatiana Santo Domingo, girlfriend of Monégasque scion Andrea Casiraghi, was "one of the ascendant young women on the European scene whom people are most intrigued by, along with her friend Eugenie Niarchos, the 20-year-old granddaughter of the late shipping tycoon Stavros

Bunny Mellon wrote about her passion for miniature topiary in 1965: "A garden, like a library, is a whole made up of separate interests and mysteries." Horst photographed her in Upperville, Virginia, in December 1965.

The landscape architect and *Vogue* Contributing Editor Miranda Brooks (*below*) in the Cotswolds. Photographed by François Halard, 1995.

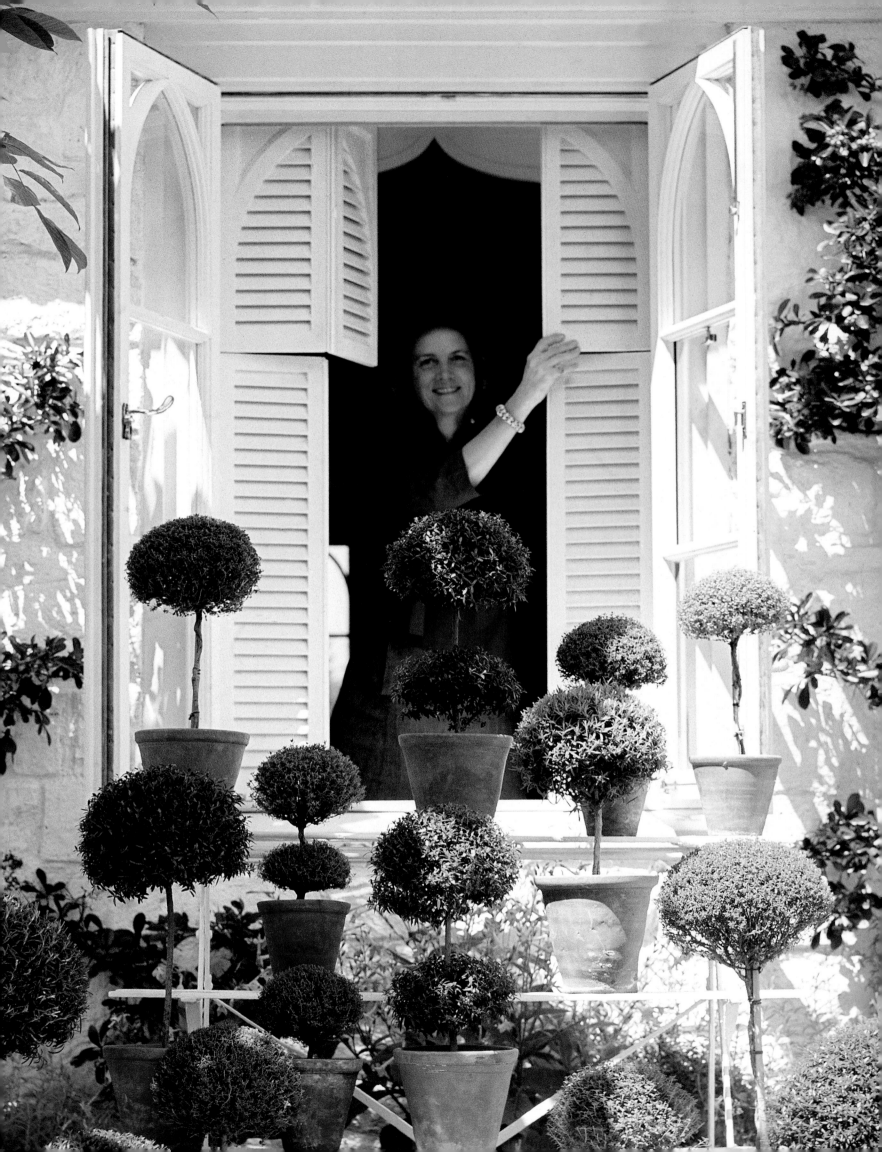

Niarchos, and Charlotte Casiraghi, 20, the daughter of Princess Caroline of Hanover (and Monaco)." *Vogue* noted that their "favorite restaurants are Caviar Kaspia in Paris, Nobu and Le Caprice in London, and, because it is all about the mix, McDonald's, which they call 'McDough. . . .' "

By 2007, the magazine was reporting on under-the-radar American social beauties whose female forebears had graced the pages of *Vogue* for a century—including Mellons and Vanderbilts—signaling a new mood of elegant reticence.

"Prompted by concerns for the environment, weakness in the financial markets, and the rising price of everything from petrol to perfume . . . the intoxicating days of the juggernaut New York socialite are on the wane," wrote Norwich in 2008, investigating the slower, more thoughtful lives of Maggie Betts, Olya Thompson, and Lauren Remington Platt, among others. This was a way of being that landscape architect and *Vogue* Contributing Editor Miranda Brooks had already been pursuing for a decade and more. In 1993, the magazine found this "Holly Golightly reimagined as a wood nymph" indulging her passions for gardening alongside those for "yoga, Spanish, and flamenco dancing."

"Life is not linear; it isn't about rushing to the finishing line," the Russian-born Thompson told Norwich in 2008, adding that when it comes to "your children, your relationships, how you dress, your food, and how you decorate, if you are racing against time you will always lose."

"I never thought this twenty-first-century version of the Jazz Age would last anyway," Betts said. "I always thought that this idea of 'the Socialite,' in 20 years' time, would be like the hula hoop—something funny and camp for my kids to laugh at, the way we laugh at our parents' bell-bottoms." ❧

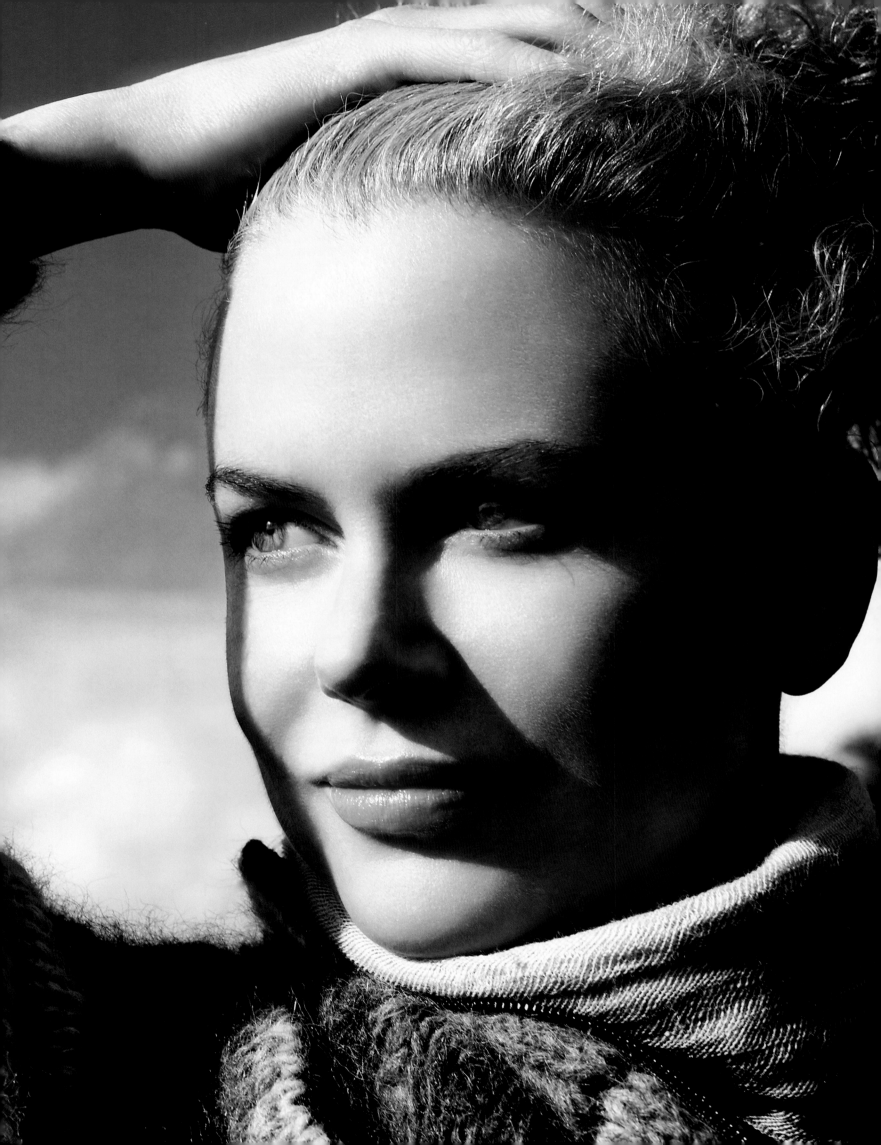

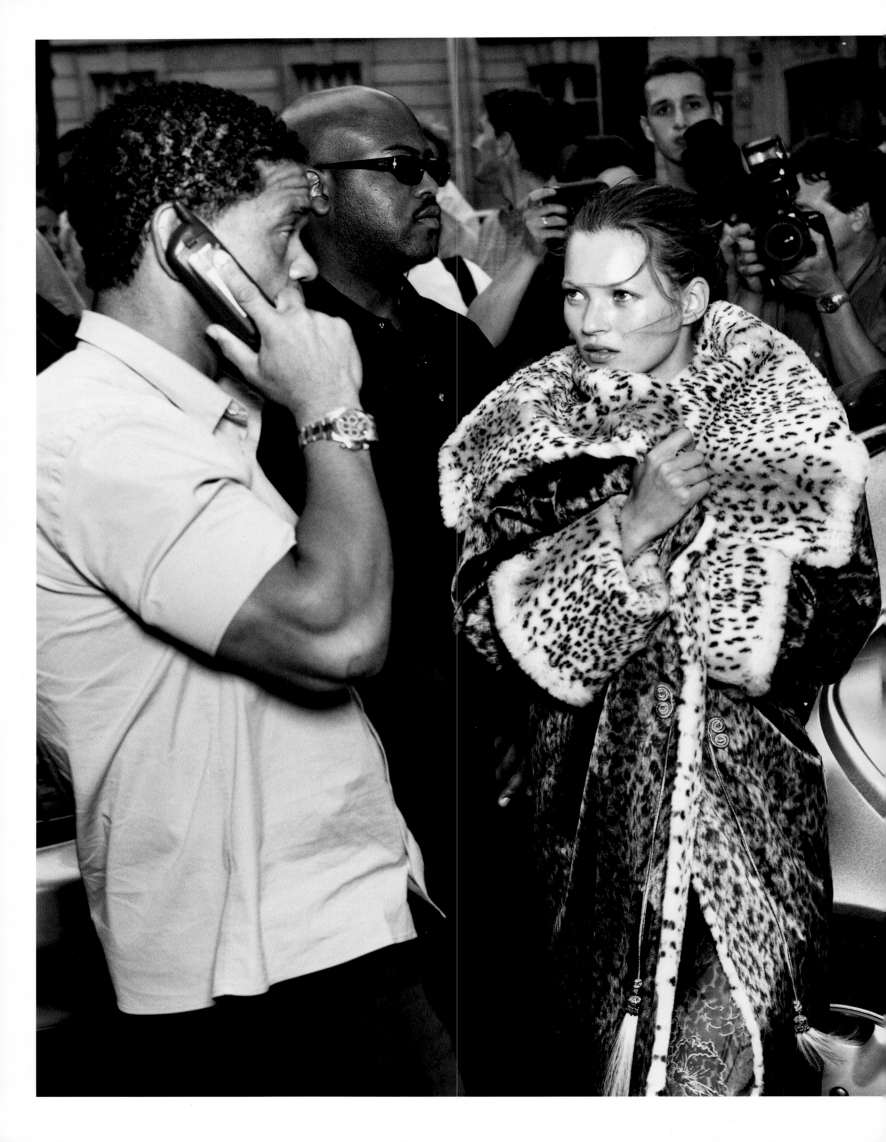

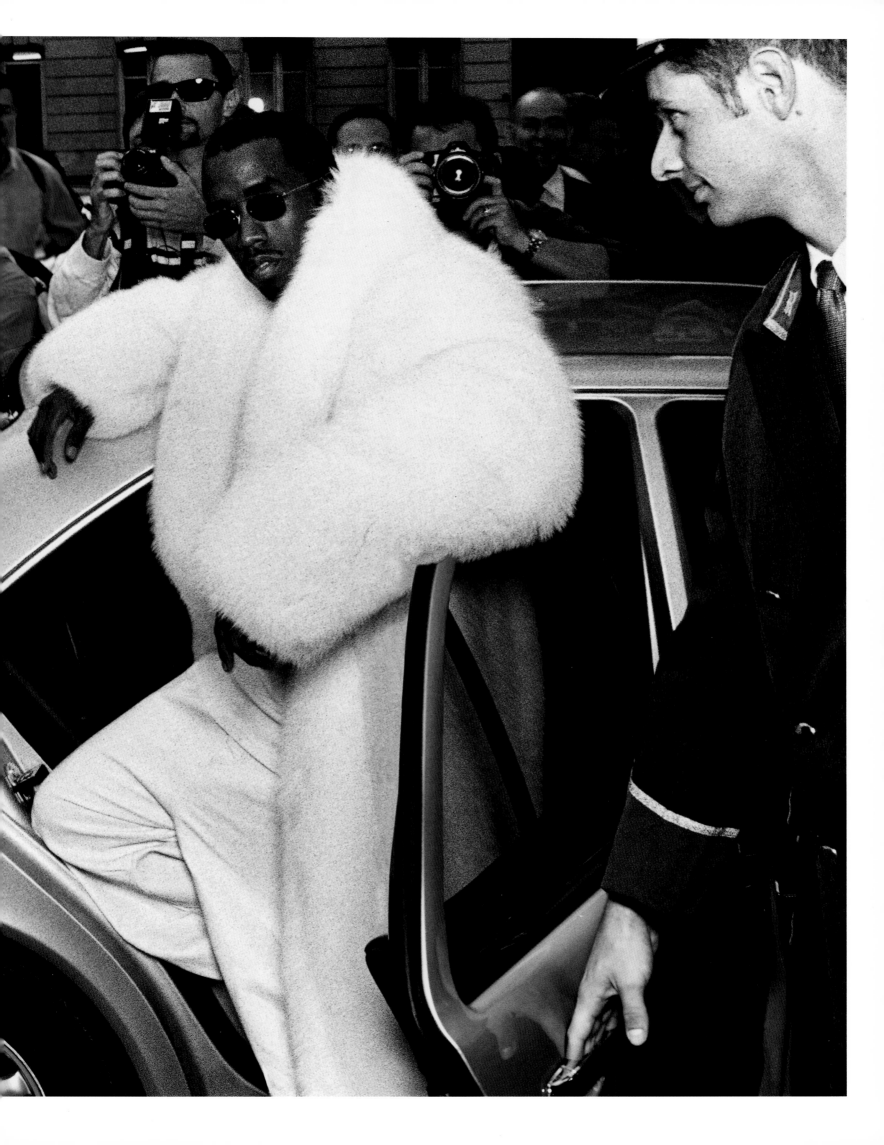

"You were never conscious of what she was wearing," said Bill Blass of Babe Paley, here at Kiluna Farm, Manhasset, New York. "You noticed Babe and nothing else." Photographed by Horst, 1964.

THE
WOMEN

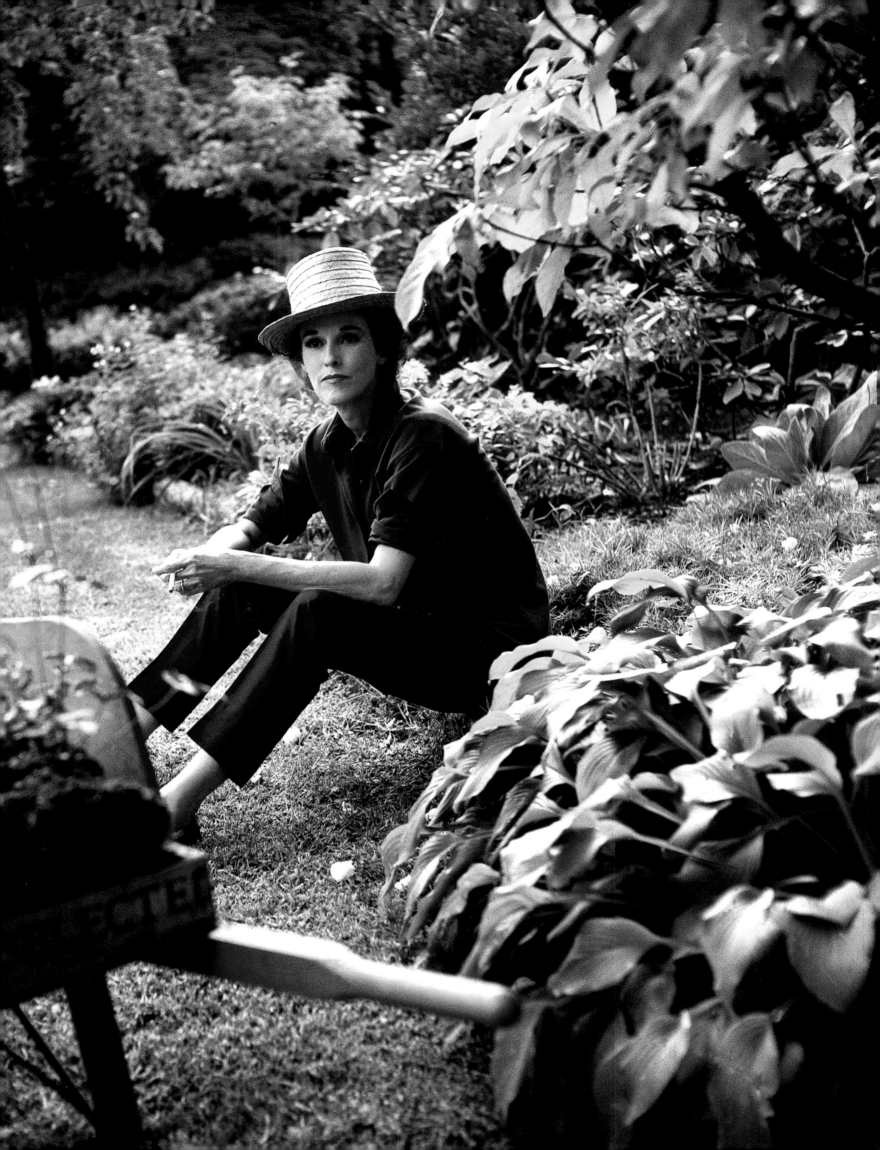

BABE PALEY

b arbara Cushing made her debut in *Vogue* in 1937, photographed by Cecil Beaton wearing "Talbot's famous little jacket of sky-blue velvet" against a faux-surrealist backdrop of floating gardening gloves. It was the beginning of a great and enduring romance with the magazine. The daughter of the distinguished surgeon and Pulitzer Prize–winning biographer Harvey Cushing and his socially ambitious wife, Kate, Babe, as she was known (she was the baby of the five Cushing siblings), would become a paradigm of mid-century patrician-American elegance.

By 1939 her innate instinct for clothes had secured her a job as a fashion editor at the magazine, and her long-limbed, whippet elegance and off-kilter beauty saw her frequently posing for the great photographers of the day (John Rawlings and Horst among them) and sitting for the artist Eric (Carl Erickson), who nimbly captured her air of hauteur touched with wry amusement. That year she embodied for *Vogue,* with chameleon flair, "The American Woman of Tomorrow" to celebrate the New York World's Fair, and the "dress sense of a queen" in Norman Hartnell's

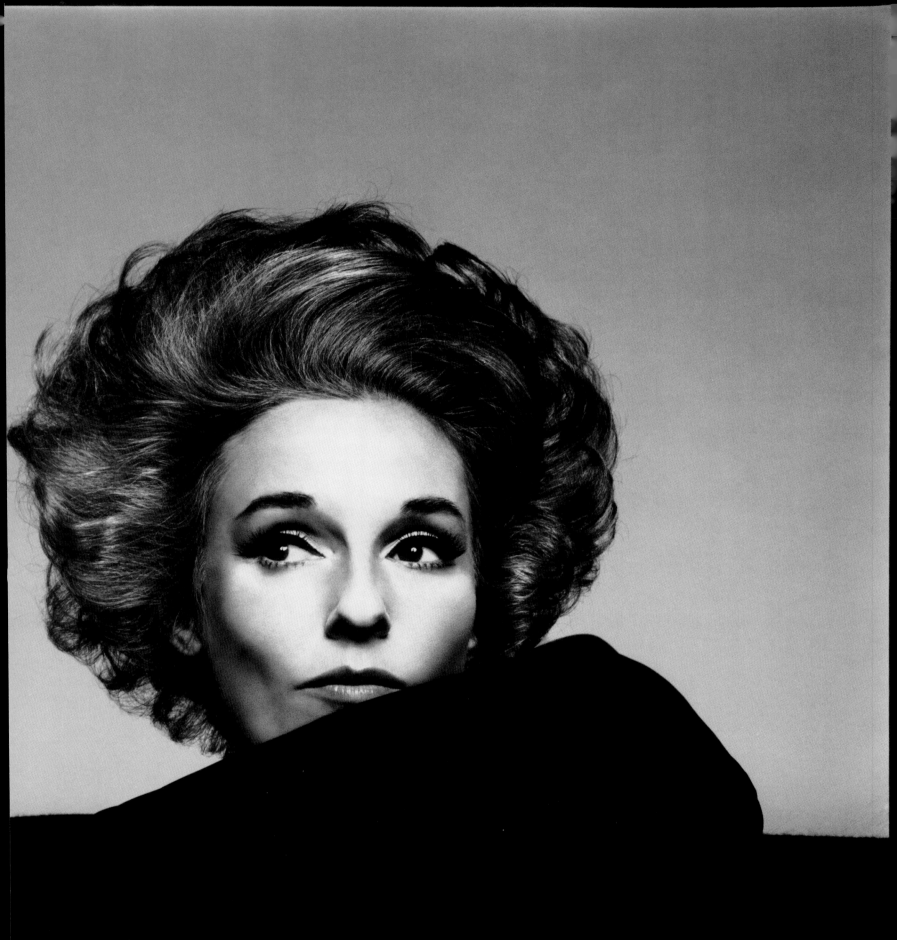

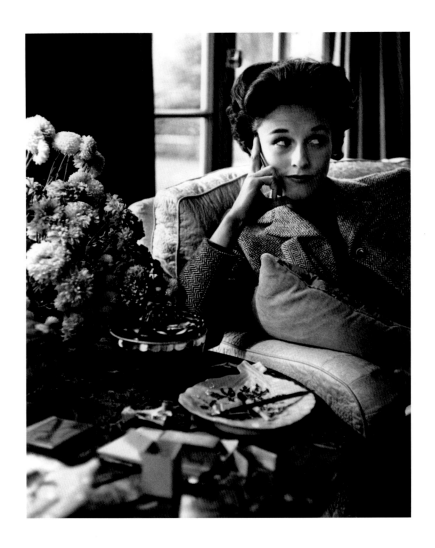

romantic spangled powder-blue tulle crinoline, similar to those he was creating for Great Britain's Queen Elizabeth.

In 1940 Babe married the dashing Stanley Grafton Mortimer, Jr., a Standard Oil heir, at "the little church on the village green" in East Hampton, wearing white jersey goddess draperies by Mabel McIlvain Downs. "Afterward, a wedding breakfast was served at their summer place, Heather Dune," wrote *Vogue,* with "guests sitting at a table on the blue tented veranda overlooking the sea, while a plane swooped down to carry the bride and groom on their wedding trip." A week later, her sister Mary married the curmudgeonly Vincent Astor. The third Cushing sister, Betsey, had married Franklin D. Roosevelt's eldest son, James, in 1930, and would marry John Hay "Jock" Whitney in 1942.

In 1944, in a story introducing readers to members of its fashion staff, *Vogue* described Babe as "one of the beauties of our day," who "makes even the simplest of costumes into something peculiarly her own by her choice of jewelry, which is always individual and frequently antique." Babe's jewelry

was a foil to the impeccable simplicity of her fashion choices and consistently idiosyncratic—although in her moneyed later life the idiosyncrasies became the devising of Fulco de Verdura and Jean Schlumberger. Norman Norell (then the designer at Traina-Norell), Mainbocher, the blue-chip American couturier who had made his name in thirties Paris, and later Valentino were all designers whose luxuriously understated work was the perfect complement to Babe's personality.

"The look of being too deliberately dressed, with everything cautiously matching, always bores me," wrote Babe in a 1944 fashion essay. "I like the sudden shock of non-sequitur color." Above all, Babe brought a nonchalant, thoroughly American elegance to her fashion choices; even if her grandest evening clothes might hint at an Edith Wharton ballroom, setting off her Boldini looks, they were defiantly unencumbered—very different from the fussy elaboration of the Paris couture. "I never saw her *not* grab anyone's attention—the hair, the makeup, the crispness," remembered Bill Blass. "You were never conscious of what she was wearing; you noticed Babe and nothing else."

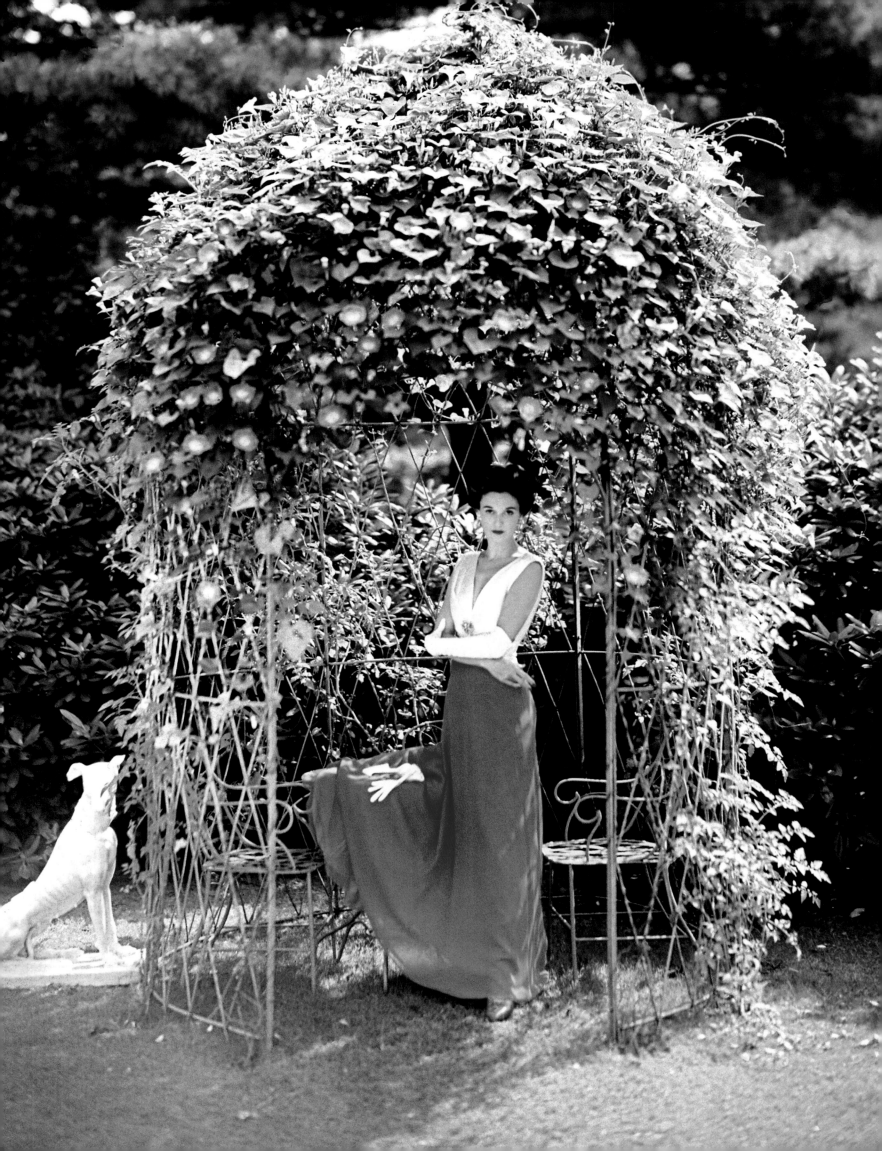

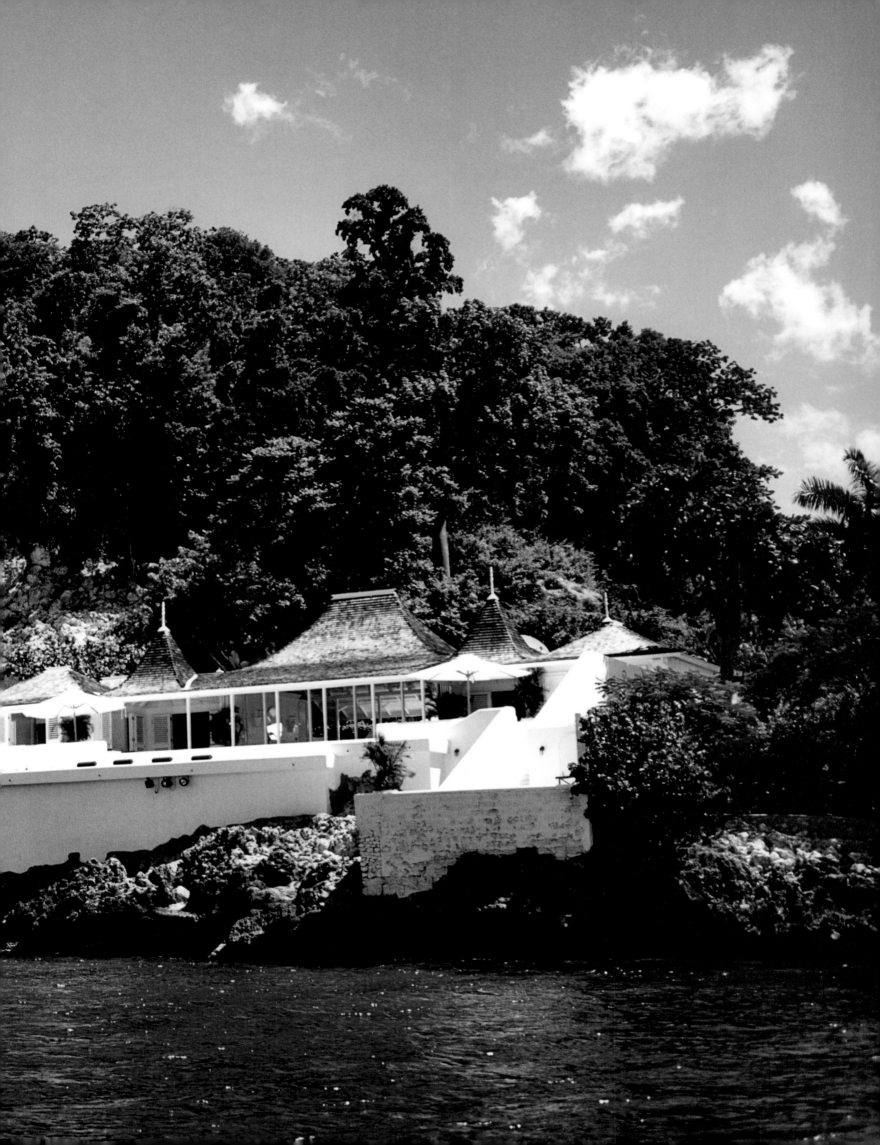

Babe divorced Mortimer in 1946 and a year later wed William S. Paley, the powerful and charismatic head of the Columbia Broadcasting System. Through Babe, Paley was granted entrée to the most rarefied circles of New York Café Society. She was one of Truman Capote's "swans," a bevy that included C. Z. Guest, Gloria Guinness, and Marella Agnelli (Babe would remain a Capote intimate until the first published excerpt of *Answered Prayers,* his unfinished society roman à clef, was found to contain a story strongly suggestive of Bill Paley's philandering). In turn, the marriage to Paley provided Babe with the means to indulge her taste in all aspects of her life, and *Vogue* assiduously documented the houses and gardens that she created around the world.

At Kiluna Farm, an 80-acre estate in Manhasset, New York, Babe worked with the landscape architect Russell Page and the decorator George Stacey, famed for his audacious color schemes (in 1975 the Paleys added an estate on Squam Lake in New Hampshire, which they dubbed Kiluna North). In Manhattan the Paleys lived at the St. Regis in an apartment decorated by Billy Baldwin, and later at 820 Fifth Avenue, where the distinguished decorator Stéphane Boudin of Jansen created a gracious framework that was vivified by Sister Parish and Albert Hadley—most notably in the drawing room, where the stately Louis XV boiseries were painted "taxi-cab-yellow."

In 1956 the Paleys created a holiday retreat at Round Hill, the newly fashionable resort in newly fashionable Jamaica, working with architect William F.R. Ballard (whose wife, Bettina, was *Vogue*'s revered fashion editor) to create a distinctive pavilion on a rocky promontory above the Caribbean, its great central living room opening to the elements. Conceived with "the instant look of the tropics," its bedroom wings flanked a "big parasol-roofed patio, used as porch, living room, and dining room, with a view in the morning of the pool and the Caribbean; in the afternoon, of the shaded tropical garden at the back of the house." This time Babe worked with Natalie Davenport of McMillen Inc. on the decor. "Against its white walls and cool tiled floor are cushions and chair covers in hot-pinks, printed reds, and yellows," wrote *Vogue,* "the whole, a pattern like a Bakst or Vuillard painting." A decade later, in the mid-sixties, the Paleys built the airy Regency moderne Lightbourne House

in the manicured Bahamian enclave of Lyford Cay, Nassau.

In 1948 Babe posed on a chaise longue in her bedroom at Kiluna, a spaniel at her feet. It was "a gallery for the objects of her wide-ranging taste," where, "against a series of greens, blues, whites, Mrs. Paley arranges bowls of fresh and brilliant flowers." In 1950 Rawlings shot her in the living room at Kiluna, dressed in Charles James's stately ball gown of "deep-ruby-red with different lights." The decorating scheme—"green-blue hand-screened canvas walls, green-blue carpet"; lemon sofa; framboise, duck-egg, scarlet, and billiard-green chairs—was suggested by the "prompting elements" of the significant art, including a Rousseau, a Toulouse-Lautrec, and a Matisse (unseen, on the stairwell, Picasso's *Boy Leading a Horse,* 1906). Here again, "great bunches of field flowers" punctured the grandeur.

In the gardens, a whimsical Victorian gazebo was twined with "Heavenly Blue morning glories and cherry tomatoes," but Russell Page's stately plan included an oval pond, a central element of Babe's "secret, sunken garden—all but invisible from the outside world," with "the unreality and enchantment of a clearing around with an arras of evergreens."

Vogue and its contributors vied for superlatives in describing Babe's looks. "The shape of her face is as attenuated as an El Greco," wrote the photographer Erwin Blumenfeld. "She has the most luminous skin imaginable, and only Velázquez could paint her coloring on canvas. Her mouth is like that of the fascinating Madame Arnoux in Flaubert's novel *L'Éducation Sentimentale.* She has the gentleness, the poise, and the dignity of one of those grandes dames whom Balzac described in his *La Comédie Humaine.*" Babe's looks transcended her clothes, which, though impeccable, were rigorously and deliberately understated. "Tradition is my taste," she wrote. "Instead of merely wearing them," wrote Blumenfeld of her outfits, "she carries them."

"She makes excellence look easy," said the text accompanying a striking 1967 portrait by Richard Avedon. "She is the most inscrutable of American women because she knows the root paradox: To be serene means working like the devil."

"Mrs P. had only one fault," wrote Truman Capote in one of his notebooks. "She was perfect; otherwise, she was perfect."
—HAMISH BOWLES, *2009*

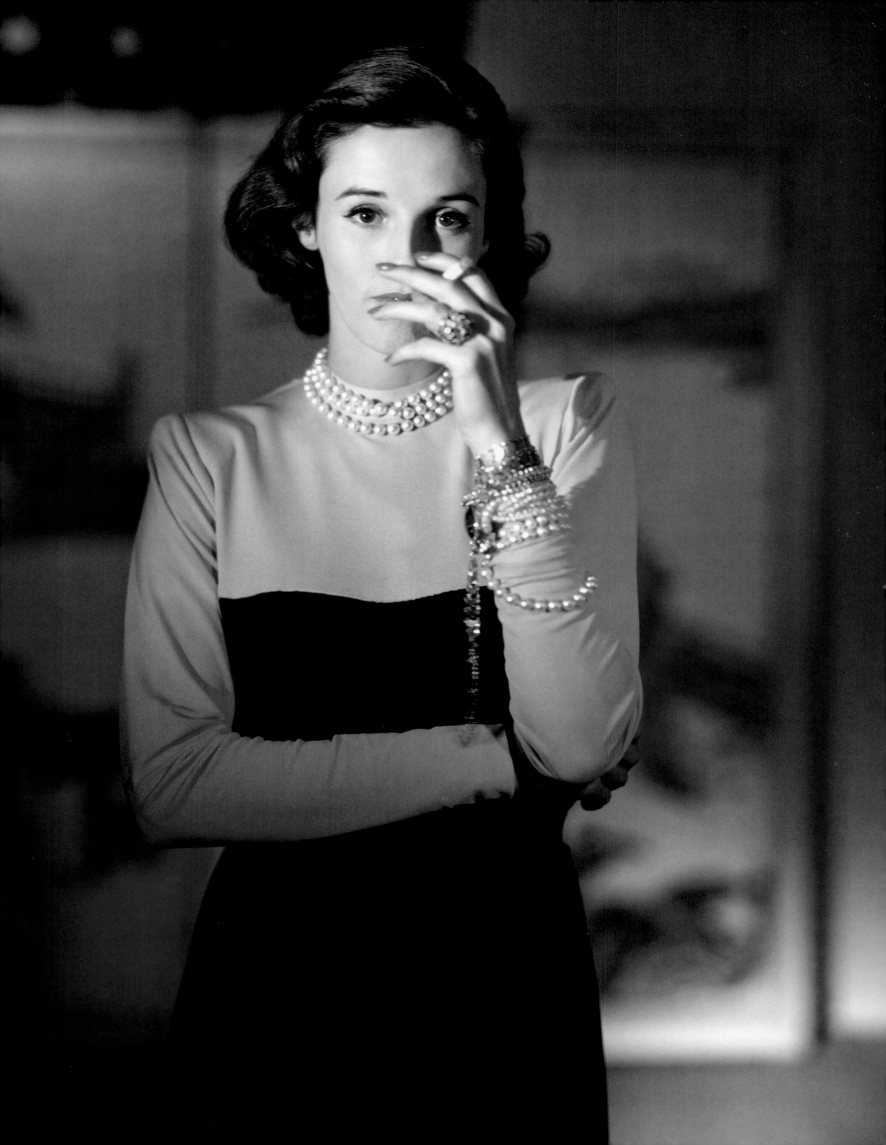

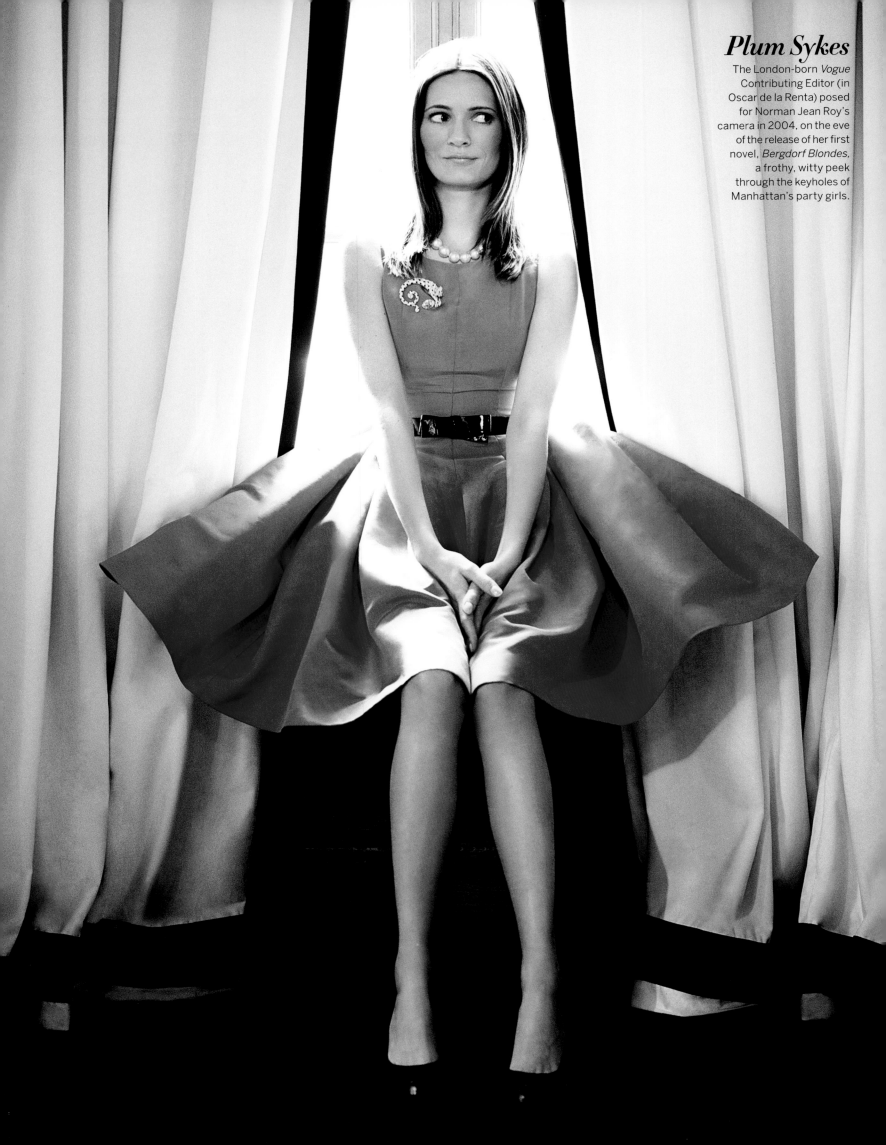

Plum Sykes

The London-born *Vogue* Contributing Editor (in Oscar de la Renta) posed for Norman Jean Roy's camera in 2004, on the eve of the release of her first novel, *Bergdorf Blondes,* a frothy, witty peek through the keyholes of Manhattan's party girls.

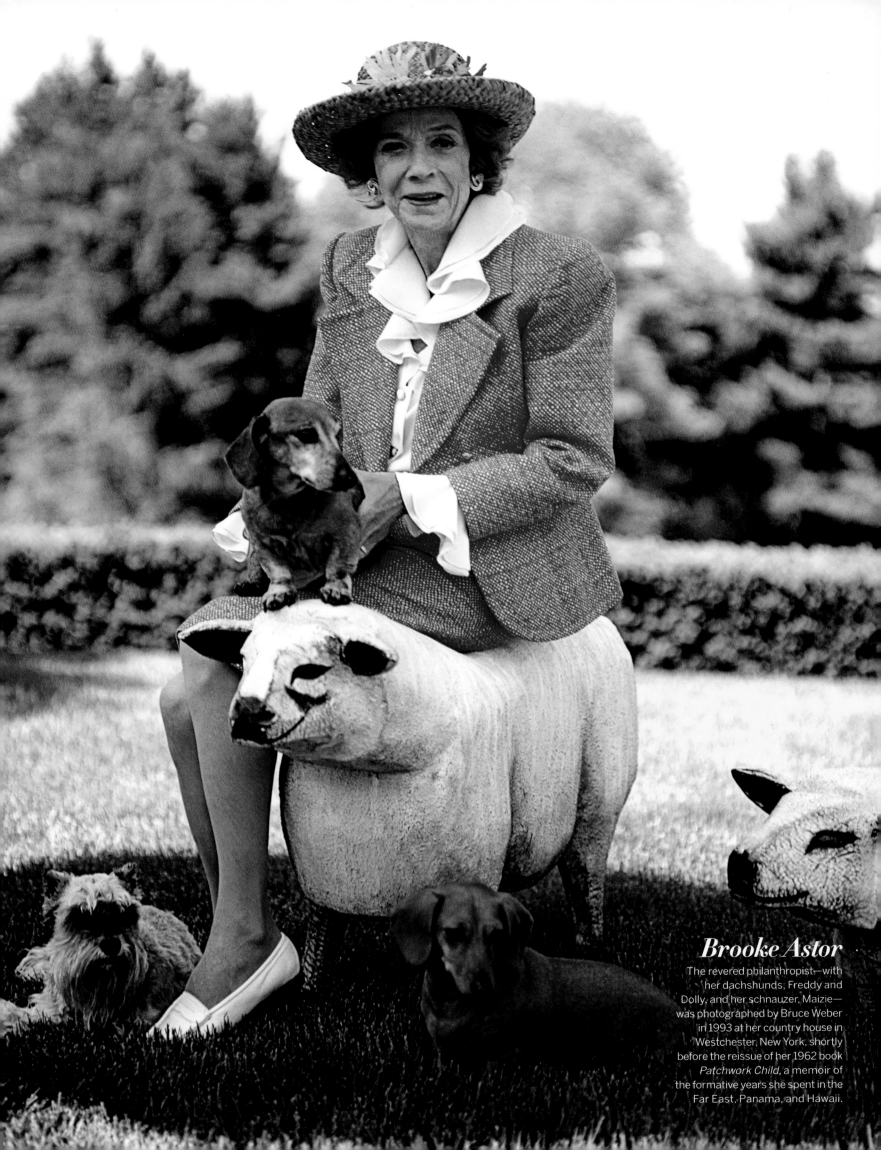

Brooke Astor

The revered philanthropist—with her dachshunds, Freddy and Dolly, and her schnauzer, Maizie— was photographed by Bruce Weber in 1993 at her country house in Westchester, New York, shortly before the reissue of her 1962 book *Patchwork Child*, a memoir of the formative years she spent in the Far East, Panama, and Hawaii.

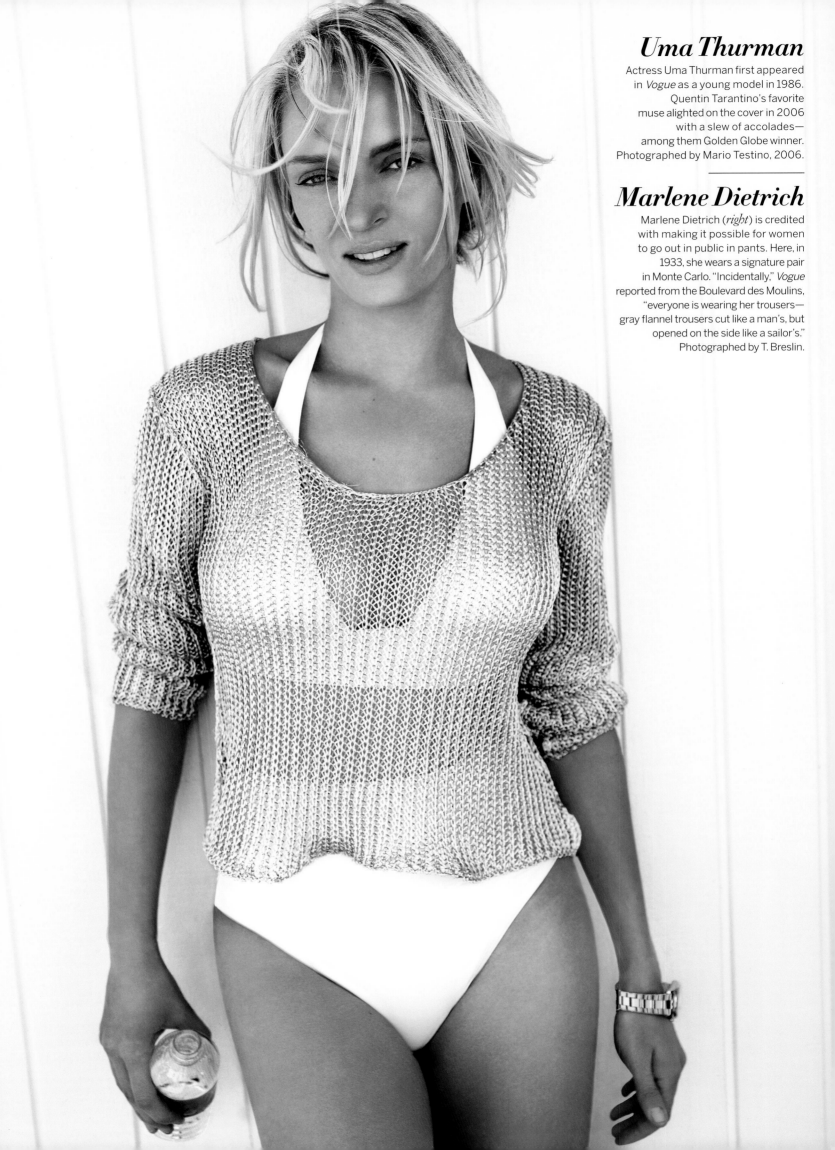

Uma Thurman

Actress Uma Thurman first appeared in *Vogue* as a young model in 1986. Quentin Tarantino's favorite muse alighted on the cover in 2006 with a slew of accolades— among them Golden Globe winner. Photographed by Mario Testino, 2006.

Marlene Dietrich

Marlene Dietrich (*right*) is credited with making it possible for women to go out in public in pants. Here, in 1933, she wears a signature pair in Monte Carlo. "Incidentally," *Vogue* reported from the Boulevard des Moulins, "everyone is wearing her trousers— gray flannel trousers cut like a man's, but opened on the side like a sailor's." Photographed by T. Breslin.

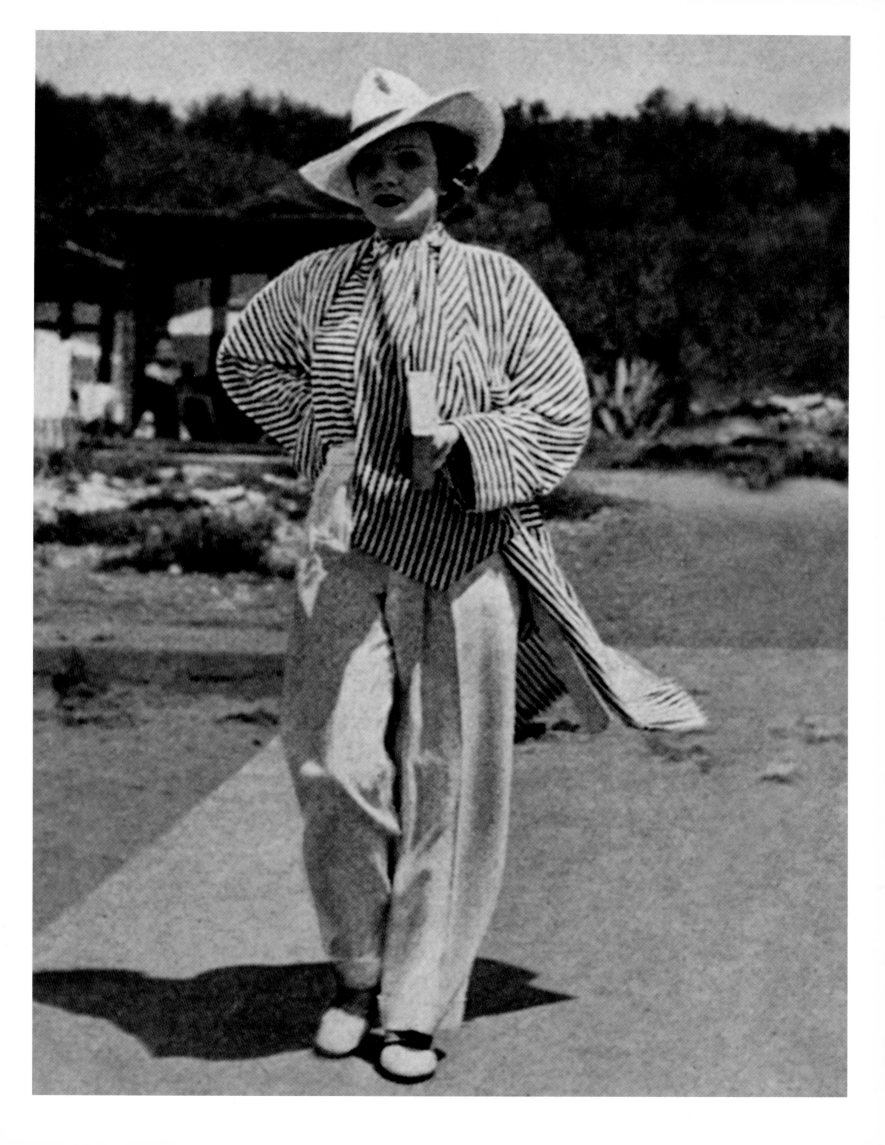

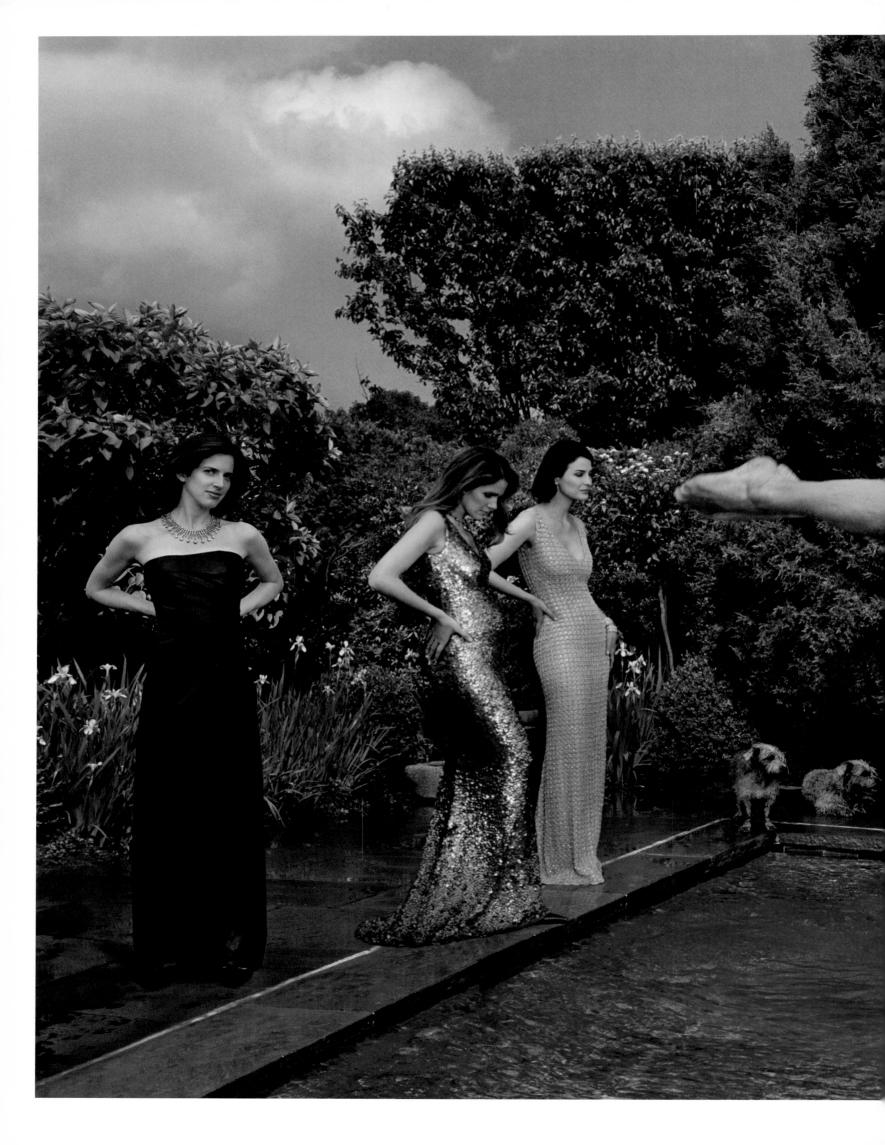

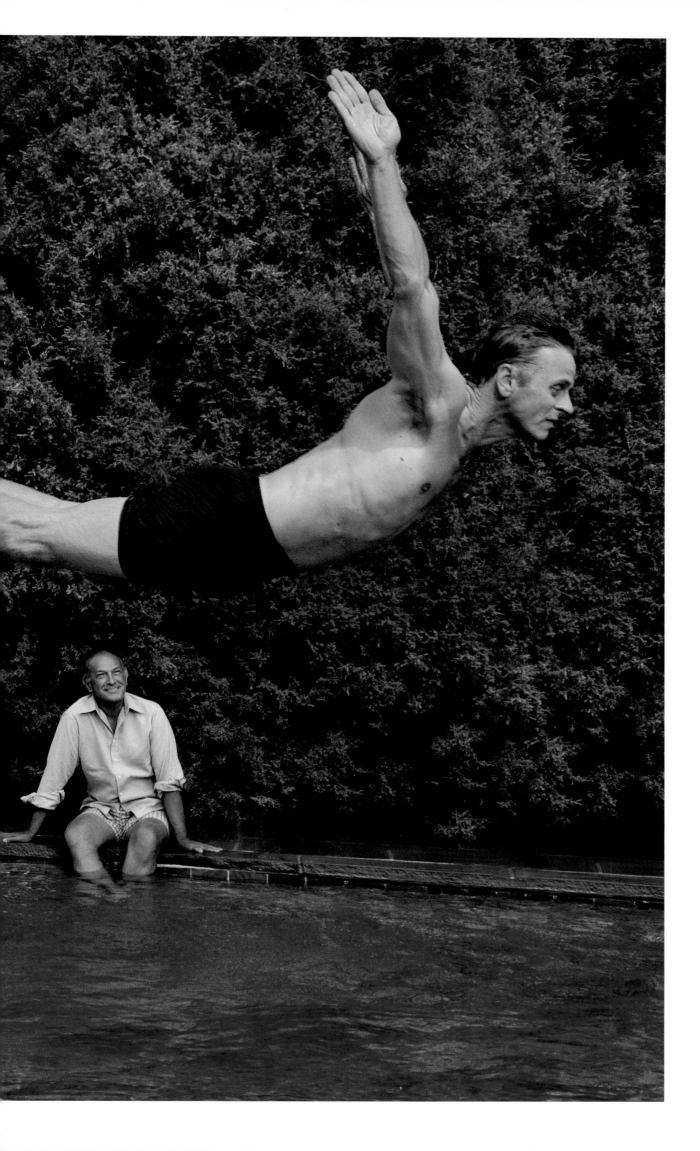

Oscar's Women

Oscar de la Renta, seated poolside with (*from left to right*) his stepdaughter Eliza Reed Bolen; the cosmetics executive Aerin Lauder; and author Marina Rust. Master dancer and choreographer Mikhail Baryshnikov executes a dive. Photographed by Annie Leibovitz, 2000.

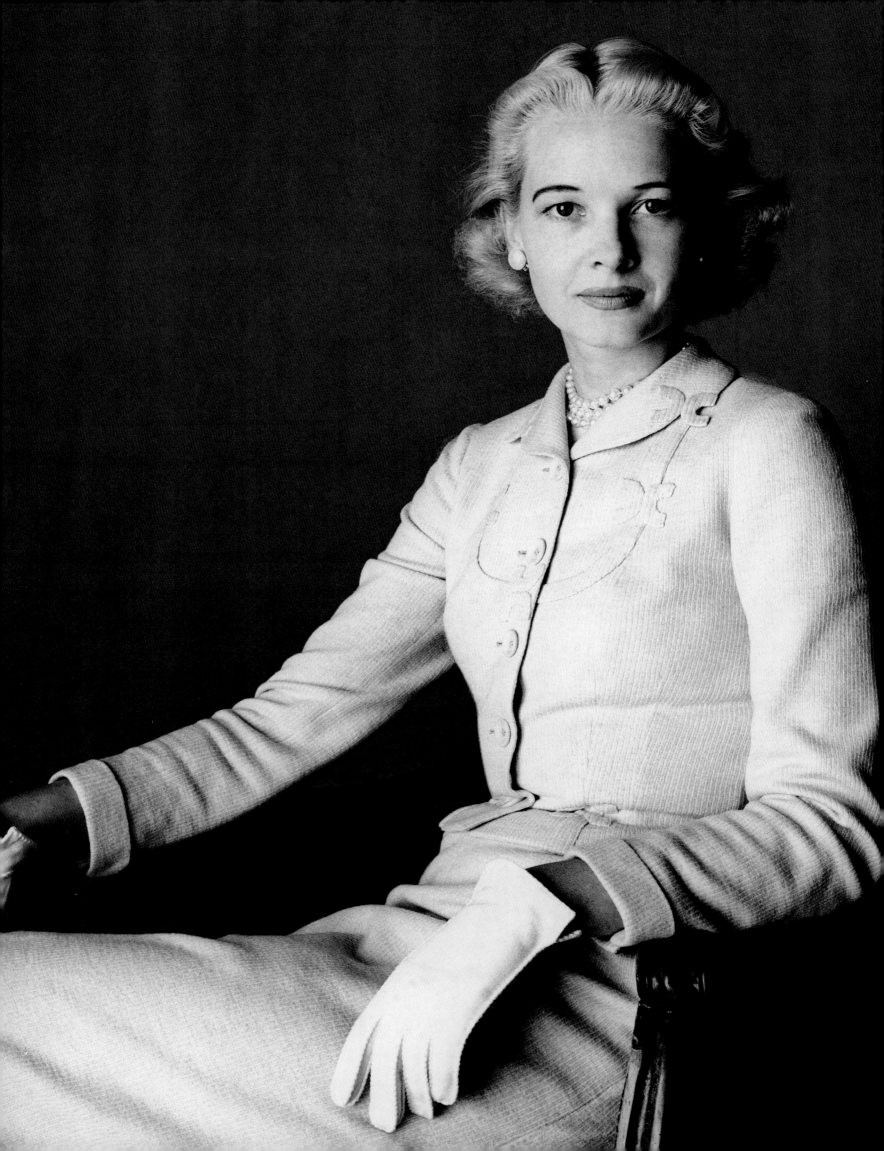

C. Z. GUEST

a woman
should dress to suit her own looks," pronounced C. Z. Guest
in an interview with *Vogue* in 1959, "*not* because something's
in fashion."

The fundamentals of C.Z.'s inspirational style, reflecting
the disciplined approach of a skilled equestrienne and the
discrimination of a connoisseur, were established as far back
as the nursery. Lucy Douglas Cochrane—"C.Z." was the result
of her baby brother's struggle to pronounce *sister*—was born
to a Boston Brahmin family. As a child, she was dressed by
Rowe's of Bond Street. "They used to come twice a year to
the Hotel Vendome in Boston and measure everybody," she
recalled. "It was sort of an institution. I used to have such
tantrums wearing those clothes."

This feisty and unexpectedly unconventional Boston belle,
who had also been provocatively painted by Diego Rivera and
who looked as good in a ballroom as she did in the horse ring in
Madison Square Garden, soon swept Manhattan's debutantes
aside to claim the eminently eligible Winston Frederick Churchill
Guest, a distinguished scion of the Phipps family and a dashing,
six-foot-four, ten-goal polo star. They would always keep glam-
orous company; Hemingway was the best man at their Havana
wedding in 1947. As a young wife and mother of two children,
Cornelia and Alexander, C.Z. continued to pursue her equine
interests, riding and racing Thoroughbreds. She also decorated
residences in Long Island (Old Templeton), Palm Beach, and
Manhattan (a Sutton Place aerie with two ballrooms); for this
she collaborated with Stéphane Boudin, the distinguished
decorator for the French firm of Jansen who had worked on
the restoration of the White House with Jacqueline Kennedy.

"Make it look easy, and make it look good" was always
C.Z.'s style mantra. For a portrait in the early fifties, she initi-
ated a trend when she asked her friend Cecil Beaton to hack
her shoulder-length straw-blonde hair into a schoolboy's crop
(he used paper-cutting scissors). "Mainbocher, with his life-
long, often-repeated aim of 'simplifying fashion,' might have
been divinely appointed to be Mrs. Guest's dressmaker."
C.Z.'s other style mentors included the Edwardian beauty
Consuelo Vanderbilt Balsan, Diana Vreeland, the duchess of
Windsor, Mona Bismarck, and Thelma Foy, who was Walter
Chrysler's daughter. Foy, a fine-boned beauty famed for her
lavish Dior wardrobe, a spindle waist, and an exceptional
eighteenth-century decorative-art collection, counseled C.Z.
never to forget her own waist when choosing clothes.

As a young man newly arrived in Manhattan in the early
sixties, Oscar de la Renta was dazzled by C.Z.'s understated
style when he was invited to Old Templeton. "The duchess of
Windsor was staying, and there was Babe [Paley] and all the chic
ladies, and we were having drinks," de la Renta recalls. "Sud-
denly, C.Z. walked into the room—with about 25 dogs—wearing
a dark-dark-gray long satin skirt and a cashmere pullover. And
I had never seen anybody ever dress that way. There was the
duchess all in Dior, all gilded and jeweled, and I don't think
that anybody ever saw the fabulous Babe without an ounce of
makeup, but C.Z. was a total natural, always. That made such
an impression on me. She was always the anti-snob in a lot of
ways—her life was about her dogs, her horses, her children."
—HAMISH BOWLES, *AUGUST 2002*

Amanda Burden

The daughter of Babe Paley and
Stanley Mortimer was nineteen, here, in 1963;
made her debut at Kiluna Farm, the
Paleys' Manhasset, New York, home,
the year before; and in 1964 would marry
Vanderbilt descendant S. Carter Burden, Jr.
By 1966 she was voted to the best-dressed
list, and *Time* magazine would trumpet,
"Goodbye, Jackie! Hello, Amanda!"
Burden is now the highly effective chair
of the New York City Planning Commission
and director of the Department of City
Planning under Mayor Michael Bloomberg.
Photographed by Irving Penn.

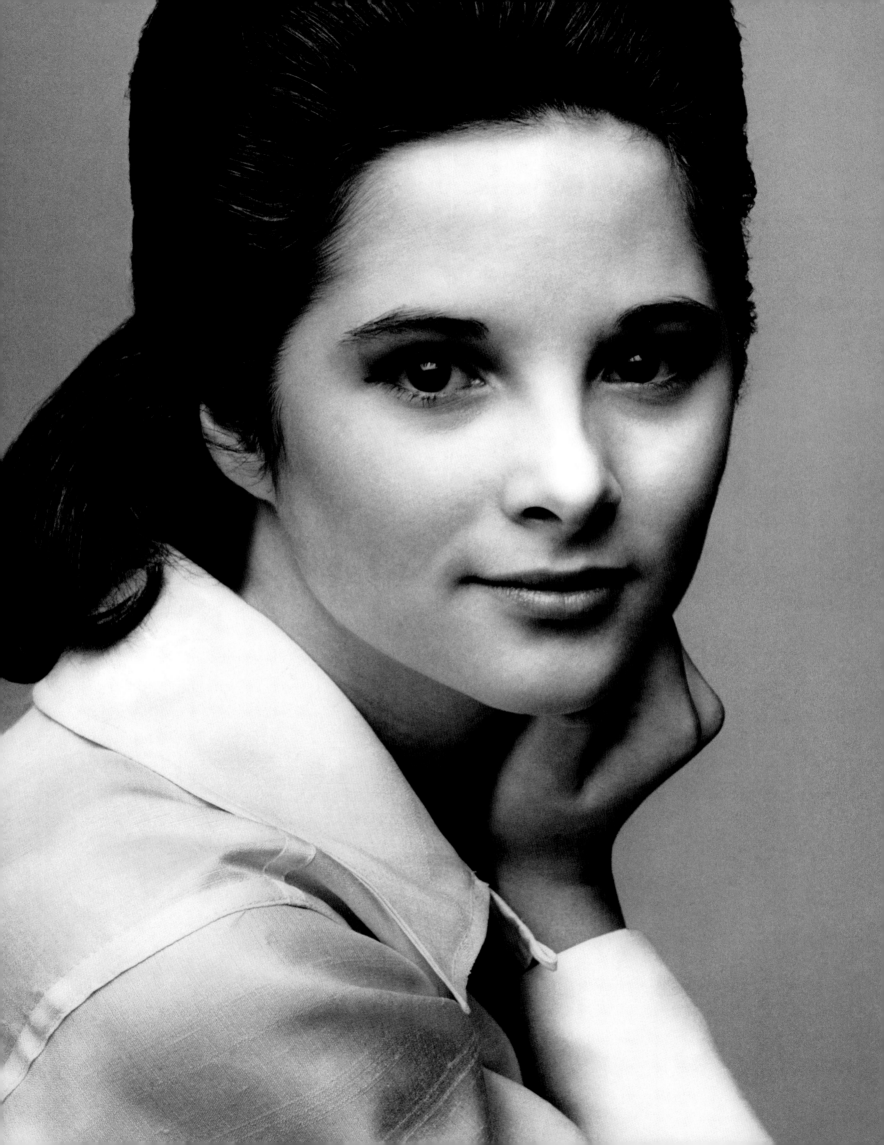

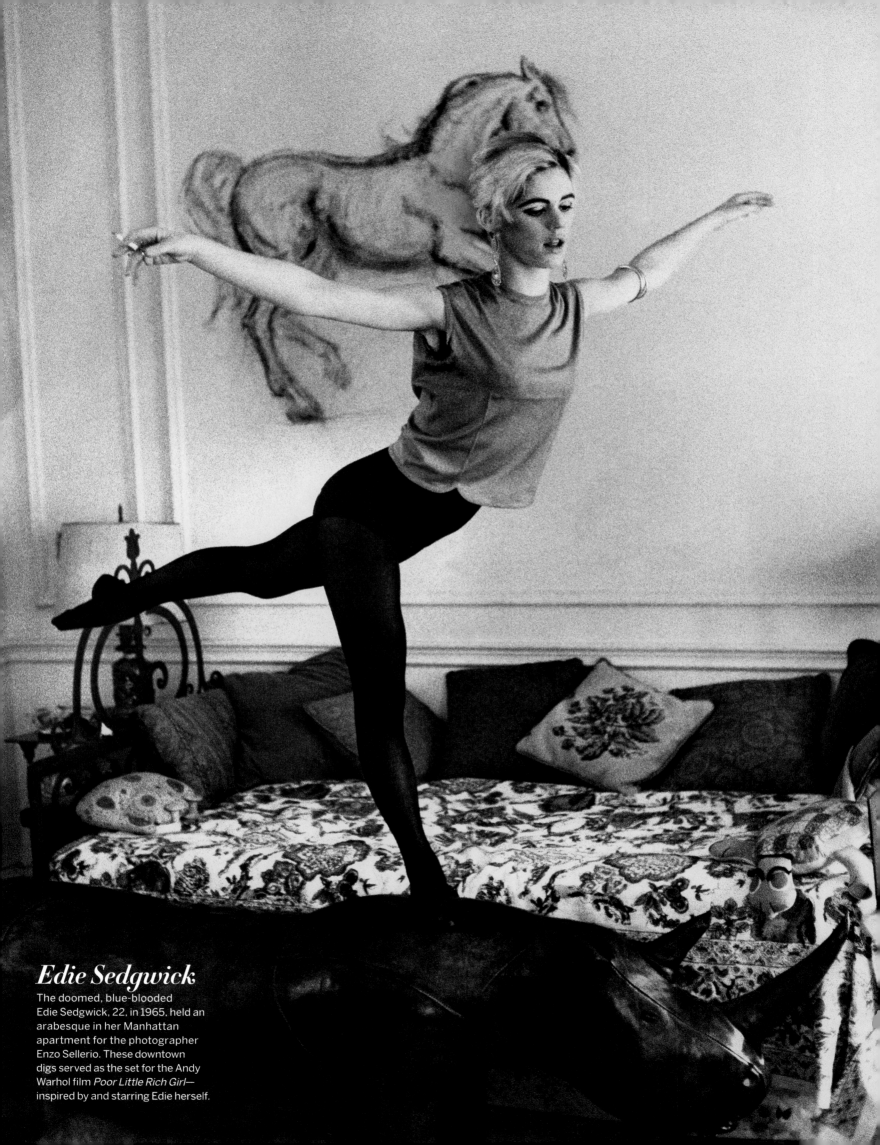

Edie Sedgwick

The doomed, blue-blooded Edie Sedgwick, 22, in 1965, held an arabesque in her Manhattan apartment for the photographer Enzo Sellerio. These downtown digs served as the set for the Andy Warhol film *Poor Little Rich Girl*—inspired by and starring Edie herself.

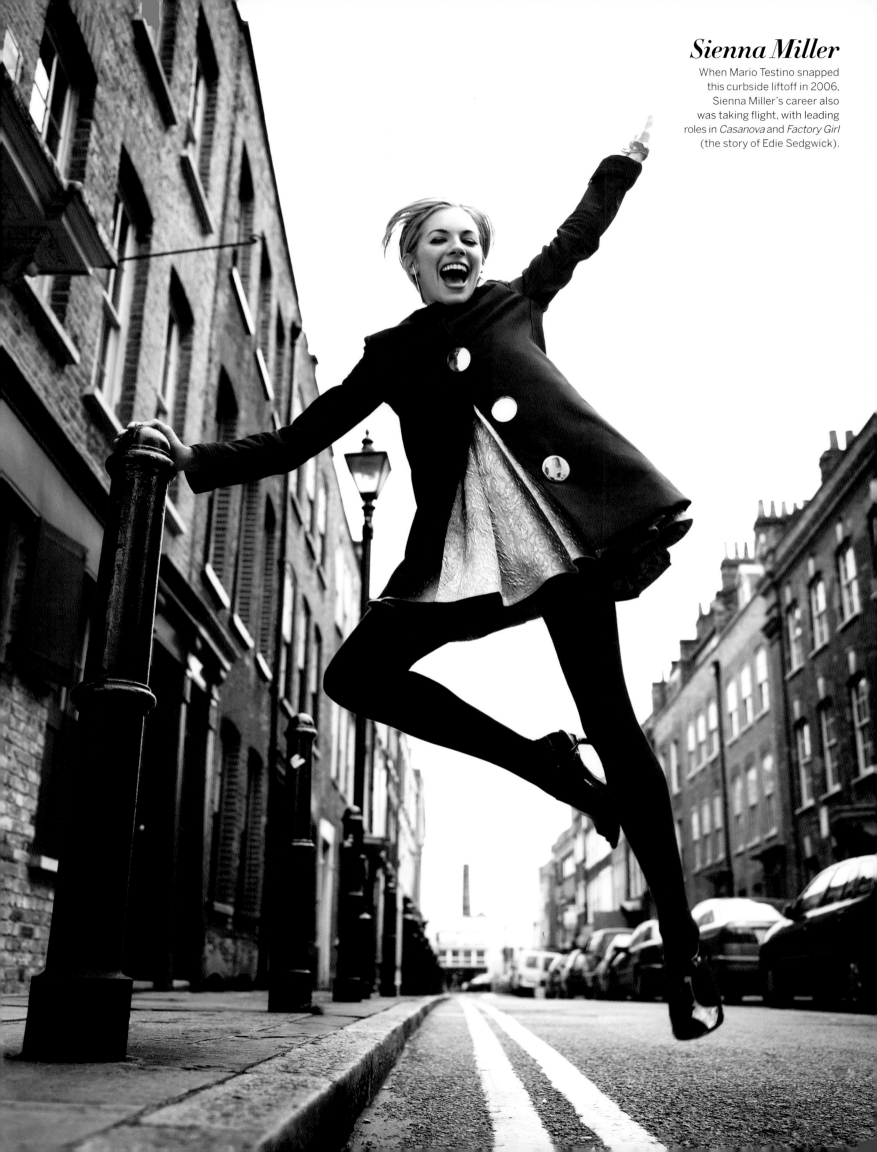

Sienna Miller

When Mario Testino snapped this curbside liftoff in 2006, Sienna Miller's career also was taking flight, with leading roles in *Casanova* and *Factory Girl* (the story of Edie Sedgwick).

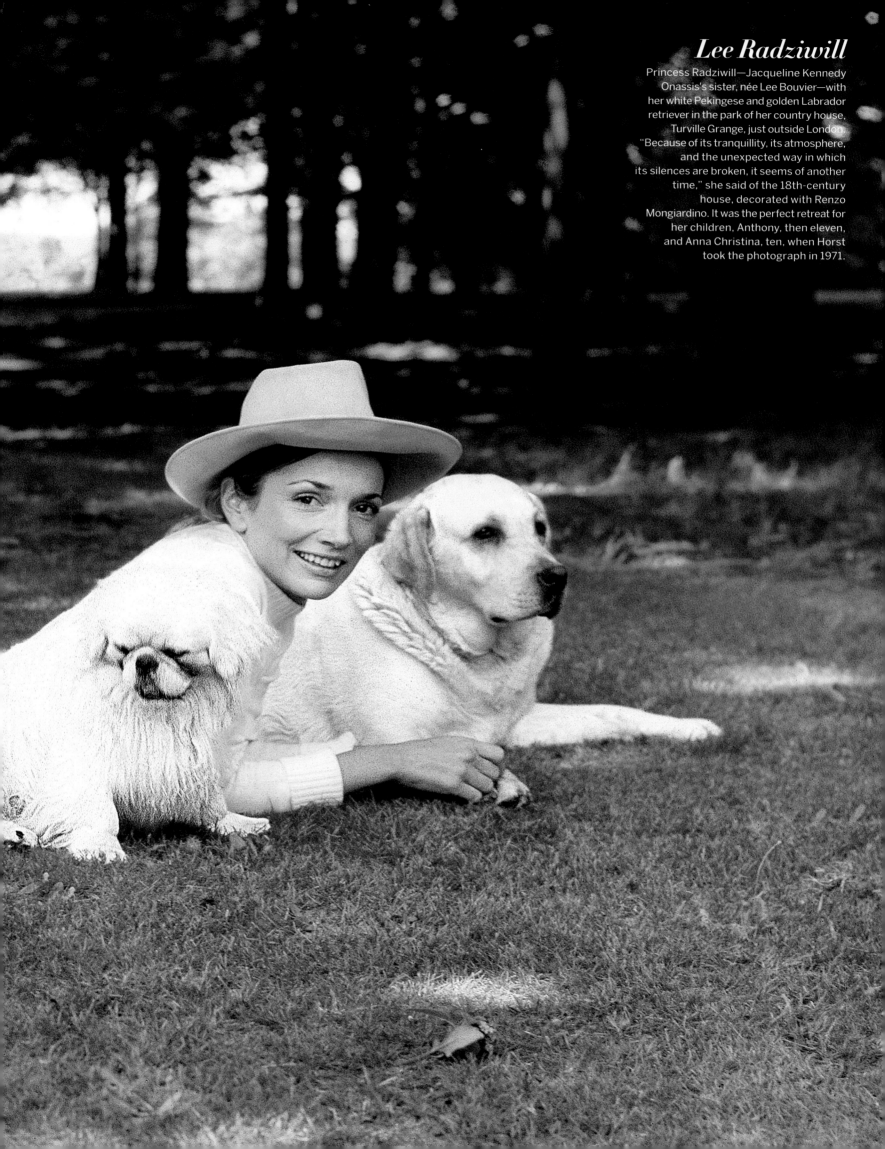

Lee Radziwill

Princess Radziwill—Jacqueline Kennedy Onassis's sister, née Lee Bouvier—with her white Pekingese and golden Labrador retriever in the park of her country house, Turville Grange, just outside London. "Because of its tranquillity, its atmosphere, and the unexpected way in which its silences are broken, it seems of another time," she said of the 18th-century house, decorated with Renzo Mongiardino. It was the perfect retreat for her children, Anthony, then eleven, and Anna Christina, ten, when Horst took the photograph in 1971.

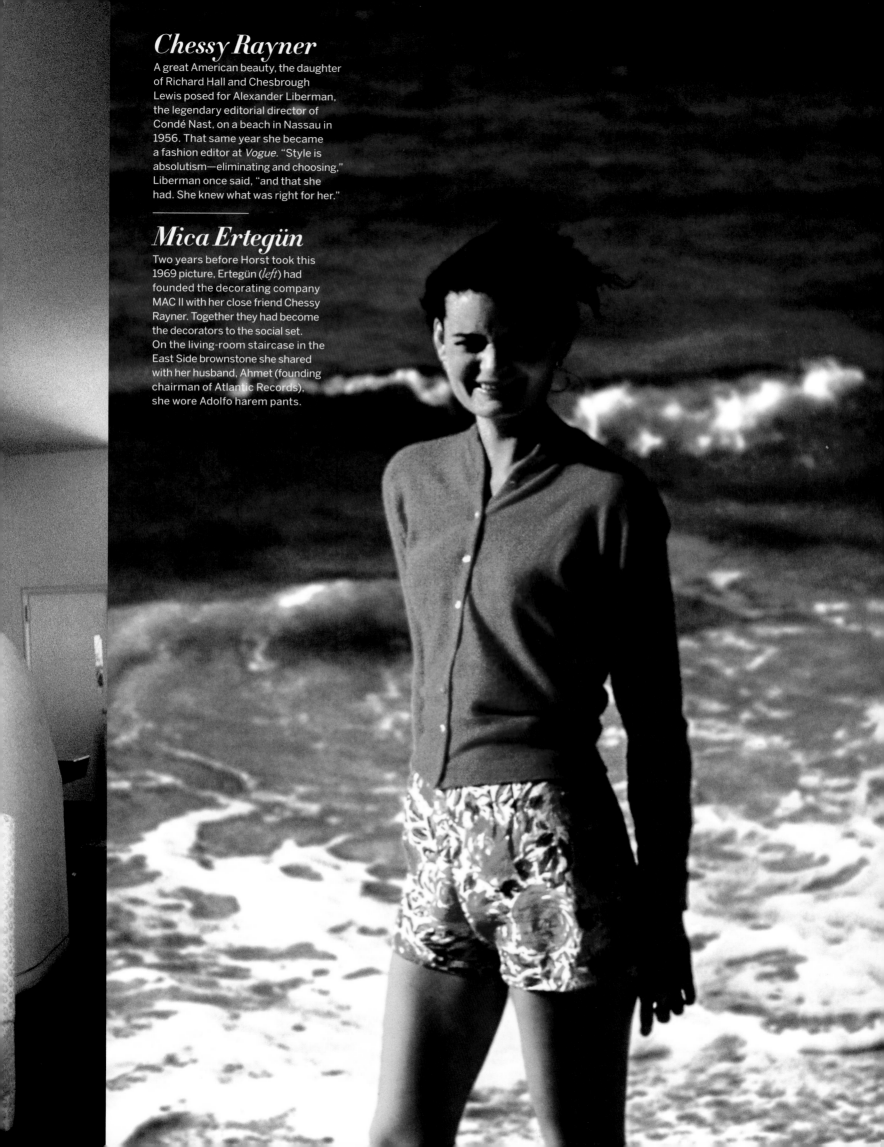

Chessy Rayner

A great American beauty, the daughter of Richard Hall and Chesbrough Lewis posed for Alexander Liberman, the legendary editorial director of Condé Nast, on a beach in Nassau in 1956. That same year she became a fashion editor at *Vogue*. "Style is absolutism—eliminating and choosing," Liberman once said, "and that she had. She knew what was right for her."

Mica Ertegün

Two years before Horst took this 1969 picture, Ertegün (*left*) had founded the decorating company MAC II with her close friend Chessy Rayner. Together they had become the decorators to the social set. On the living-room staircase in the East Side brownstone she shared with her husband, Ahmet (founding chairman of Atlantic Records), she wore Adolfo harem pants.

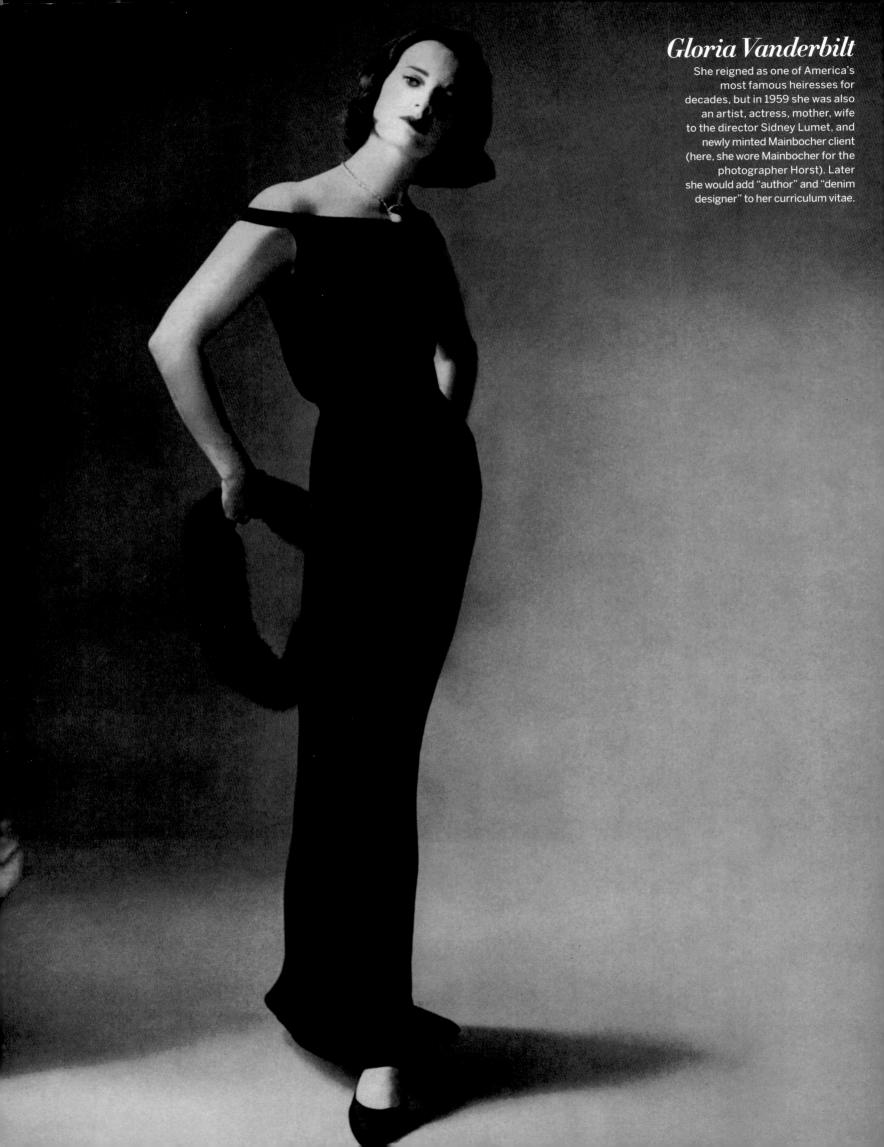

Gloria Vanderbilt

She reigned as one of America's most famous heiresses for decades, but in 1959 she was also an artist, actress, mother, wife to the director Sidney Lumet, and newly minted Mainbocher client (here, she wore Mainbocher for the photographer Horst). Later she would add "author" and "denim designer" to her curriculum vitae.

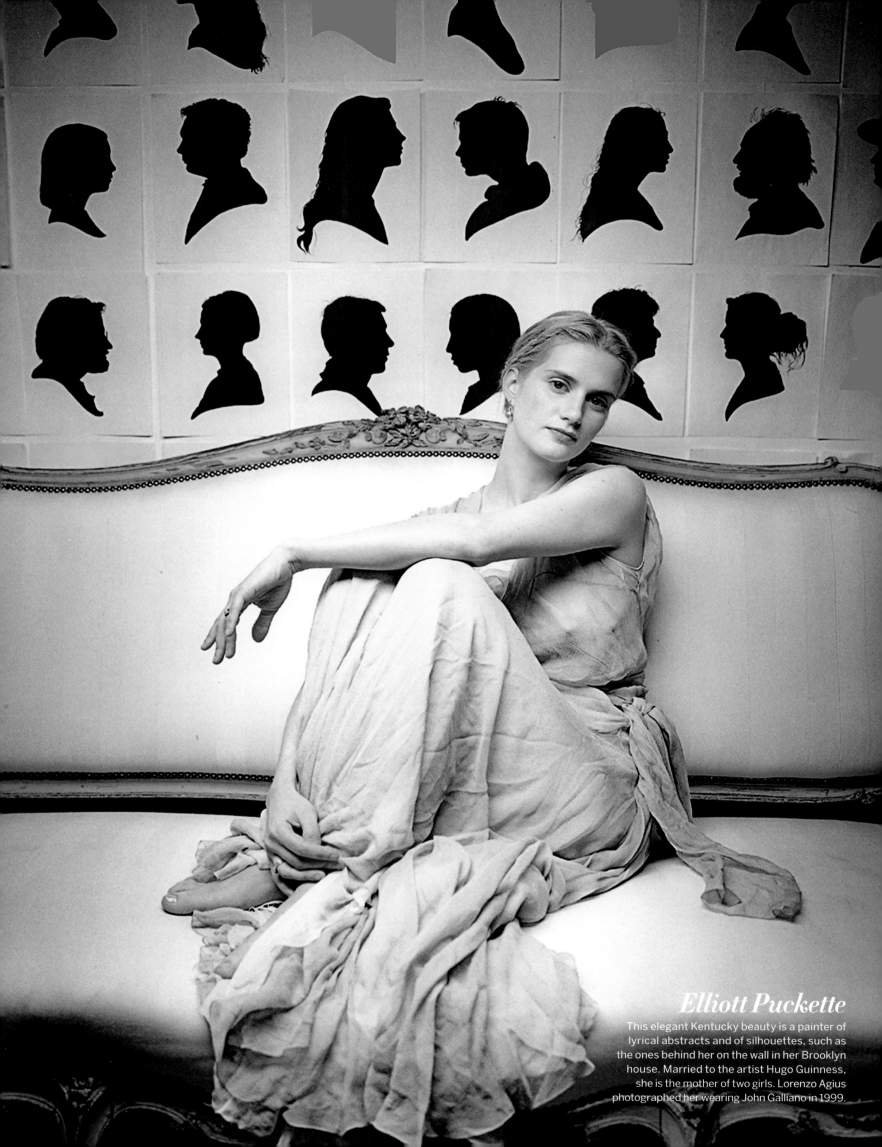

Elliott Puckette

This elegant Kentucky beauty is a painter of
lyrical abstracts and of silhouettes, such as
the ones behind her on the wall in her Brooklyn
house. Married to the artist Hugo Guinness,
she is the mother of two girls. Lorenzo Agius
photographed her wearing John Galliano in 1999.

Carolyne Roehm

Mentored by Oscar de la Renta,
Roehm created her own fashion
line in 1984 and has continued to
be an influential tastemaker.
Here, with Christian Lacroix at the
American Ballet Theatre gala in 1988.
Photographed by Roxanne Lowit.

Aerin Lauder

"The most important thing Estée taught me was to do whatever you do well, and with passion," the cosmetics executive said of her dynasty-founding grandmother Estée Lauder. Jonathan Becker photographed her at the family's summerhouse in Long Island's East End in 2005.

Jayne Wrightsman

The self-taught connoisseur of 18th-century decorative arts was photographed by Horst in 1956 in her Palm Beach library with her collection of Meissen porcelain birds.

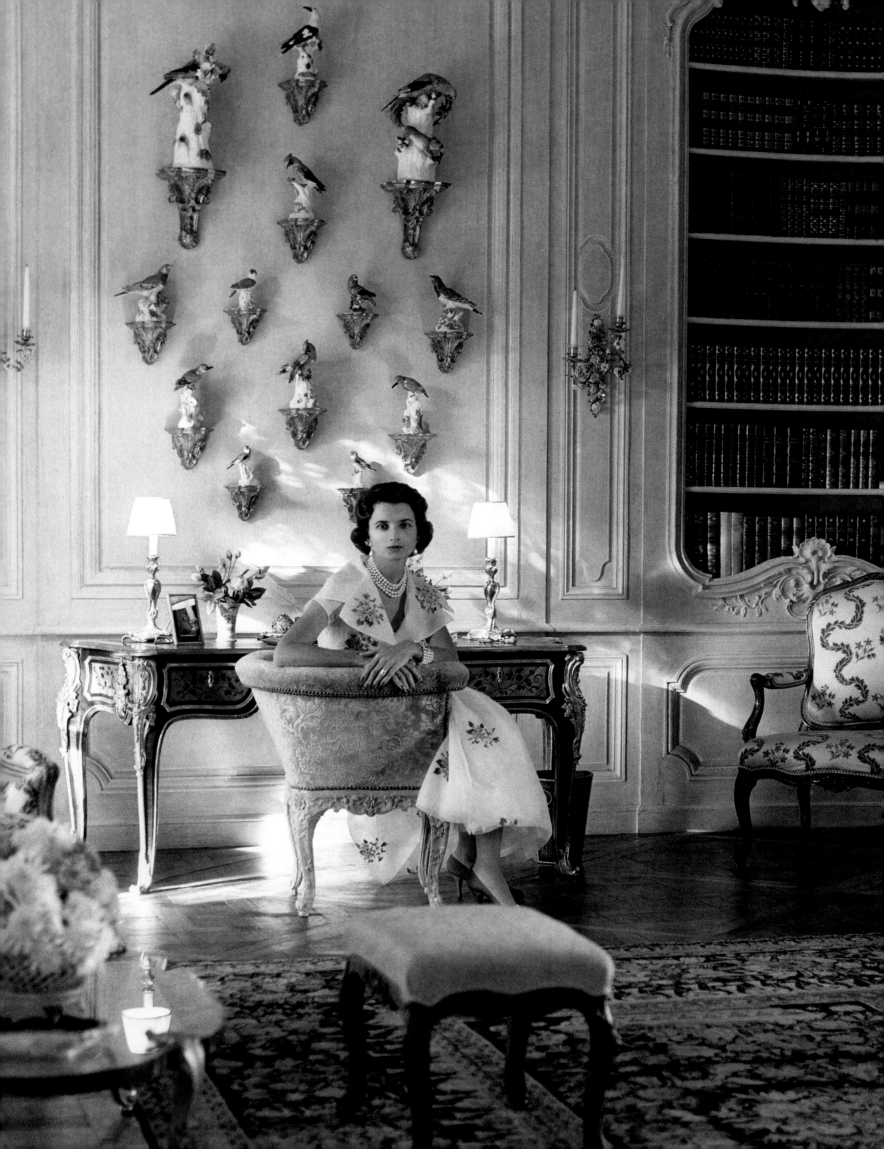

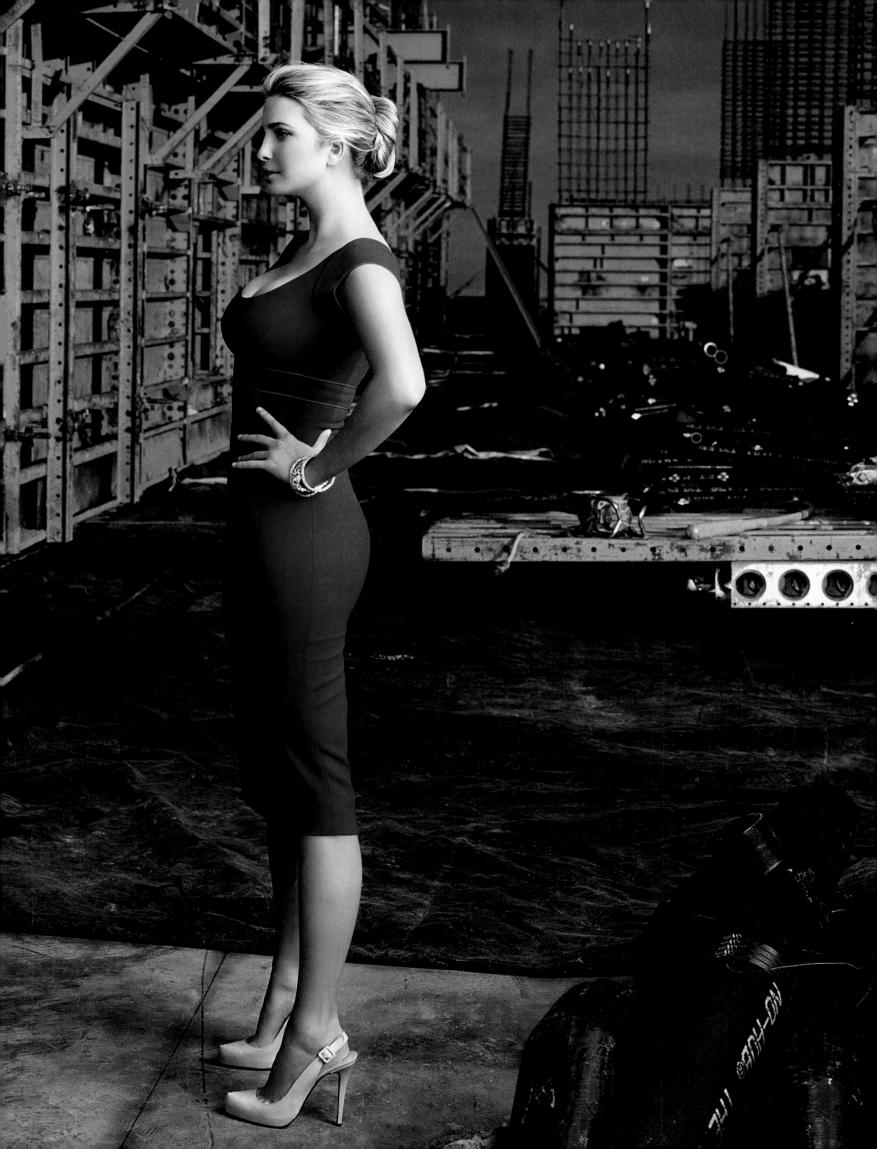

Ivanka Trump was vice-president of development and acquisitions for the Trump Organization in 2007. Norman Jean Roy photographed her on the construction site of the Trump International Hotel and Tower in Las Vegas.

following spread:
Melania Trump, pregnant with her son, Barron, poses on the steps of the Trump Boeing 727-23 in West Palm Beach; her husband, Donald, is in a Mercedes-Benz SLR. Photographed by Annie Leibovitz, 2006.

IVANKA and MELANIA TRUMP

L ike her father, Ivanka Trump is strangely compelling, larger than life—unlike anyone you have ever met. She has, as one person put it, a "killer hand-shake." She regularly indulges in the macho language of exaggeration, gleefully talking about "destroying" the competition. One gets the sense that she could talk a dime out of a nickel.

As for her stepmother, Melania, a Slovenian girl with an accent last heard when the Gabor sisters stormed America in the fifties, she navigates the surreal and competitive and over-the-top and altogether disorienting Trump universe—all that crystal, all that celebrity, all that slippery marble, all that galactic cash—with marvelous aplomb. The key is the same combination of beauty and sweetness and firmness that used to make Cary Grant and Jimmy Stewart fall flat on their faces. When Tom Ford told her to do something about Donald's hair, she answered, "I like him the way he is."

—JONATHAN VAN METER, *March 2007;*
SALLY SINGER, *February 2005*

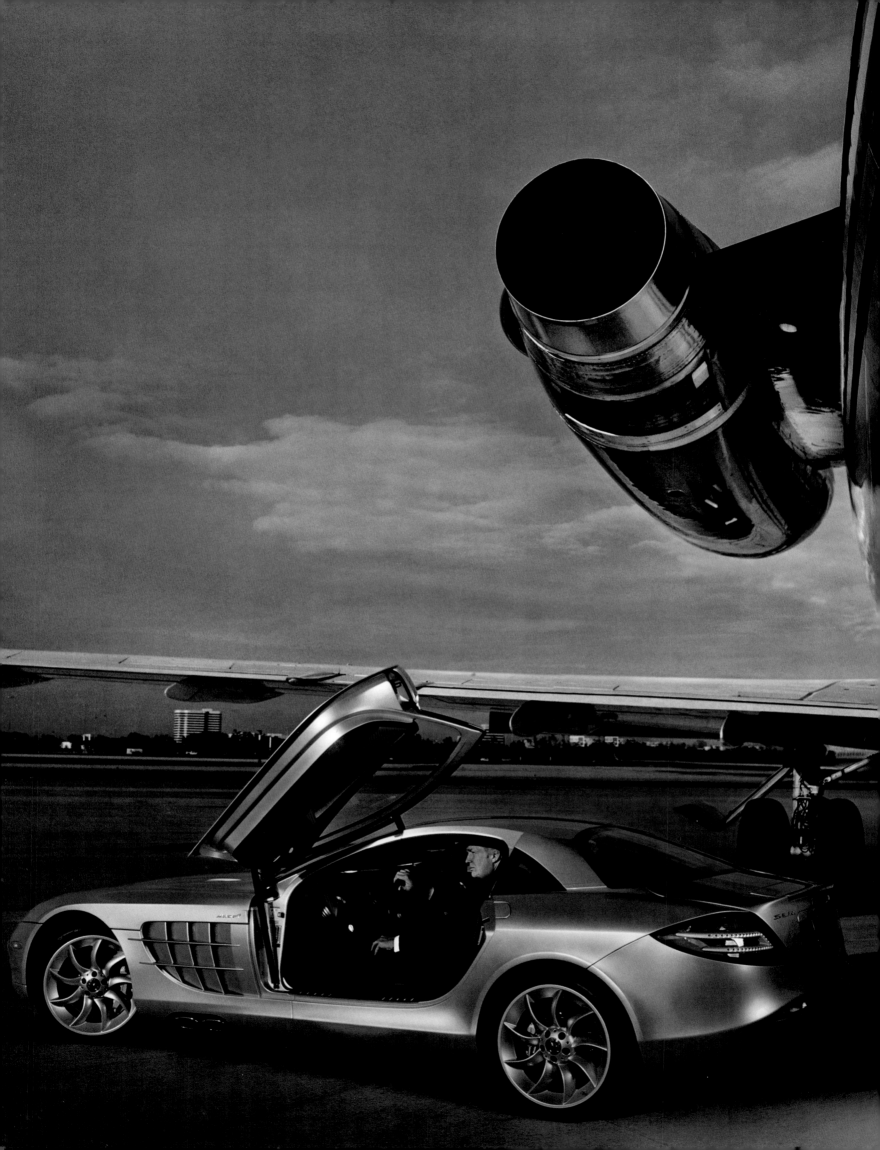

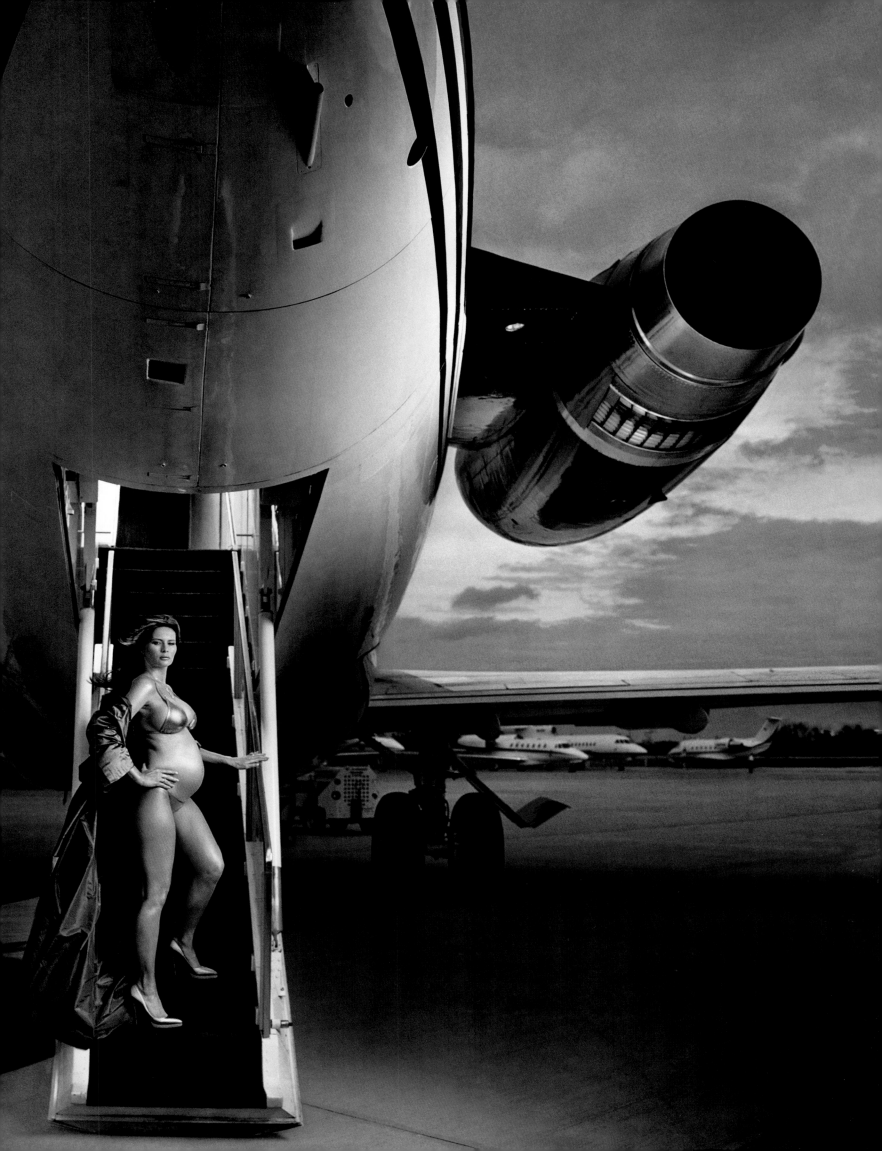

The sisters, raised in Hong Kong and schooled in Switzerland and Paris, were photographed after Pia (*far right*), then 28, married Christopher Getty (grandson of J. Paul Getty), and just before Marie-Chantal, 26 (*middle*), wed Crown Prince Pavlos of Greece and Alexandra, 22, married Alexandre von Furstenberg. Photographed by Herb Ritts, 1995.

THE MILLER SISTERS

it has been said that the Miller sisters followed a great American tradition that inspired novels by Edith Wharton and Henry James and whose most famous real-life example was the marriage of Consuelo Vanderbilt to the duke of Marlborough: the marriage of American heiresses with money (their father, Robert W. Miller, cofounded Duty Free Shoppers, the largest duty-free retailer in the world) to titled foreigners without. But those marriages, real and fictional, were arranged; the Miller sisters struck their matches spontaneously. Marie-Chantal introduced Alexandra to Alexandre von Furstenberg, son of Prince Egon von Furstenberg and designer Diane von Furstenberg, in the elevator of the Carlyle hotel when they were mere teenagers; she met her own prince—Crown Prince Pavlos, the eldest son of Greece's exiled King Constantine II and Queen Anne-Marie—at a party in New Orleans.

If, as everyone says, the Miller sisters have style, they thank their mother, Chantal, an Ecuadoran beauty who, like her daughters, married in her 20s. They describe her taste as conservative with a penchant for Valentino; her grooming is impeccable. "Never bite your nails; don't get fat" is some of the advice Pia remembers their mother giving them at an early age.

For a time one was likely to find Marie-Chantal in a Valentino suit, often borrowed from her mother, since they are exactly the same size, or Alex in something by Donna Karan or Ralph Lauren, one of those slinky, long, Hollywood-siren confections she wore to her engagement party. But the sisters also recall defying the edicts of fashion. "We rebelled against labels," Marie-Chantal says. (She began collecting T-shirts as a teenager and now has several hundred, a kind of souvenir diary.) Pia describes the style of both her sisters as "chic and classic." They in turn say Pia is "Italian sportif; very jacket-and-pants." While Alex finds Marie-Chantal's style tends toward the classics, Marie-Chantal says Alex is the sister most likely "to try a new trend. Like, two years ago she was completely grunge."

"Not the sloppy grunge," clarifies Alex, "but the chic grunge."

"The lovely Marc Jacobs dress with the Birkenstock shoes," Marie-Chantal adds.

"Don't say that! I never wore Birkenstocks," Alex exclaims. "People will get the wrong impression. If I wore grunge, well, you might say I did because I follow *Vogue.*"

When Marie-Chantal and Prince Pavlos became engaged, Mrs. Miller gave her future son-in-law a silver lighter in the shape of a frog. "You see," explains Marie-Chantal, "my inscription in one of my yearbooks said, 'She'll kiss a prince and turn into a frog.'

"So I kissed a prince. But am I turning into a frog? I don't know," Marie-Chantal says and laughs.

—WILLIAM NORWICH, *July 1995*

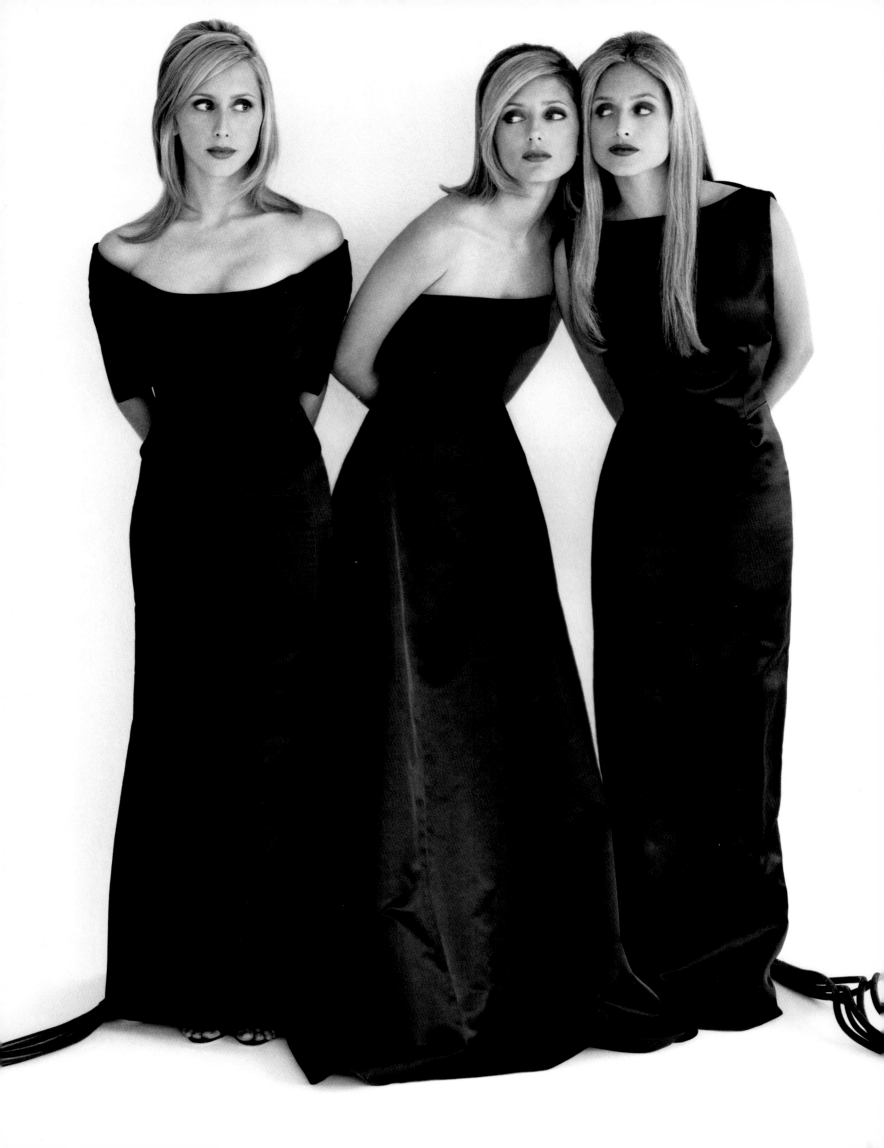

Diana Mellon

This descendant of the industrialist
Andrew Mellon spent the summer of 2007,
between her sophomore and junior
years at Yale, working in the curatorial
department at the Frick Collection.
Jonathan Becker shot her in
Oscar de la Renta in the museum's
Russell Page Garden.

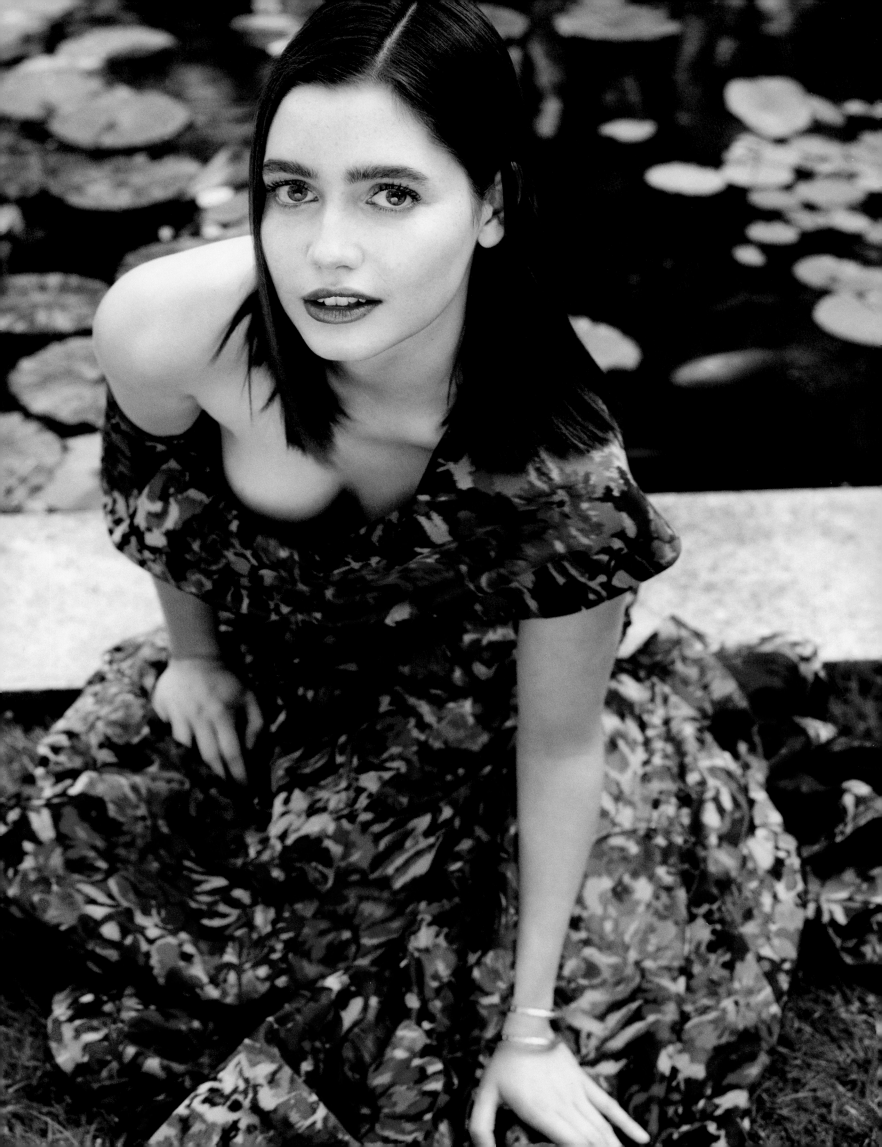

Kelly Wearstler

The founder of House of KWID interiors is known for setting trends, not following them—whether she leads the crowd with her professional choices (reviving quirky seventies styles) or her personal ones. Her Los Angeles house, seen here, was designed in 1956 by the modernist architect Hal Levitt. Photographed by Jonathan Becker, 2005.

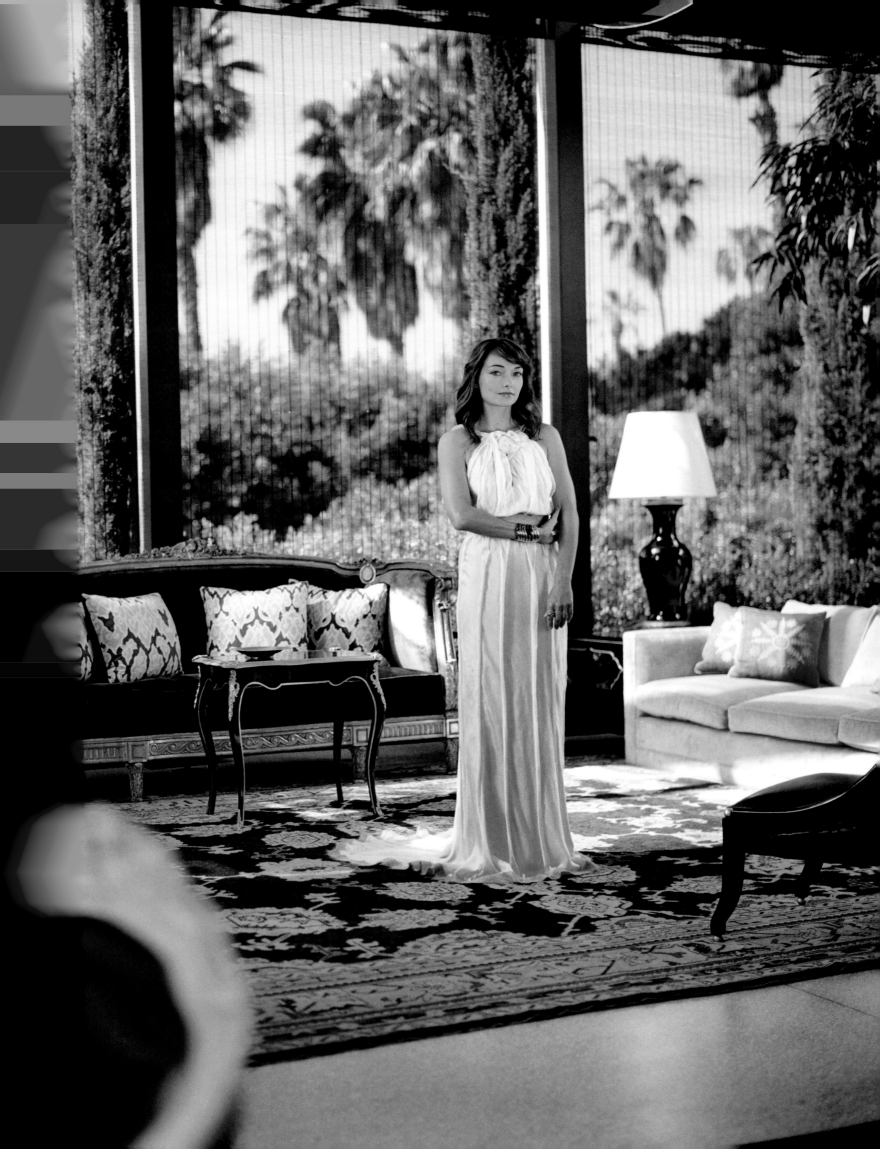

DIANE VON FURSTENBERG

diane has seen the value of age since she was 40, when she announced, "It's time to become a myth." She was already a myth in 1976, at 29, when her little cotton jersey wrap dresses put her on the cover of *Newsweek.* By the time her marriage to Egon von Furstenberg ended, she was a princess and a tycoon. "At 30, I had seventeen licenses and was swimming in gold," she says. She combined public success and private adventure with unique nonchalance, fell in and out of love, and the business followed her heart. Her own attitude to the dresses was laid-back. "They're comfortable, so you're comfortable; you act comfortable, so you get laid."

Her relationship with Barry Diller has been important since Sue Mengers, then known as the first superagent, introduced them in 1975. He was the young head of Paramount Pictures, and not considered a ladies' man. "From the beginning," Diane says, "he opened himself to me unconditionally." Sue Mengers weighs in: "He always wanted to marry her, and Diane didn't want to give up her—perceived—freedom. I used to say to Barry, 'Be patient; let her grow up.' " "The years passed," the designer says—and this is a pure Diane-ism—"and it was his birthday, and I didn't know what to give him, so I gave him myself." They

married at City Hall, with only close family in attendance, on February 2, 2001. Barry gave her 26 rings circled with diamonds, one for every year they were not married.

"The essence of Diane," says Barry Diller, "is that she is so completely OK with herself that every expression is idiosyncratic. It's not processed fifteen times, edited, manipulated, or designed. That's why she's so endlessly interesting, because it's real. She's like great earth; the longer it goes, the richer it gets."

"I am the daughter of a woman who left for the camps with a smile, " says Diane. Her mother, a Greek Jew, was sent from Auschwitz-Birkenau to Ravensbrück to Neustadt. "She came back in June 1945, weighing 64 pounds. Six months later she married, and less than a year after coming out of the camps she was pregnant with me. I was not only a miracle but also her revenge. It explains my character. I never did anything really dumb, because I had a responsibility toward her. I was forced to be serious at the base, be strong for myself, be good to myself. I'm so lucky—that is what has given me the roots of my being. It's important to be a serious person deep down; if you take life seriously, then you can be frivolous."

—JOAN JULIET BUCK, *August 2003*

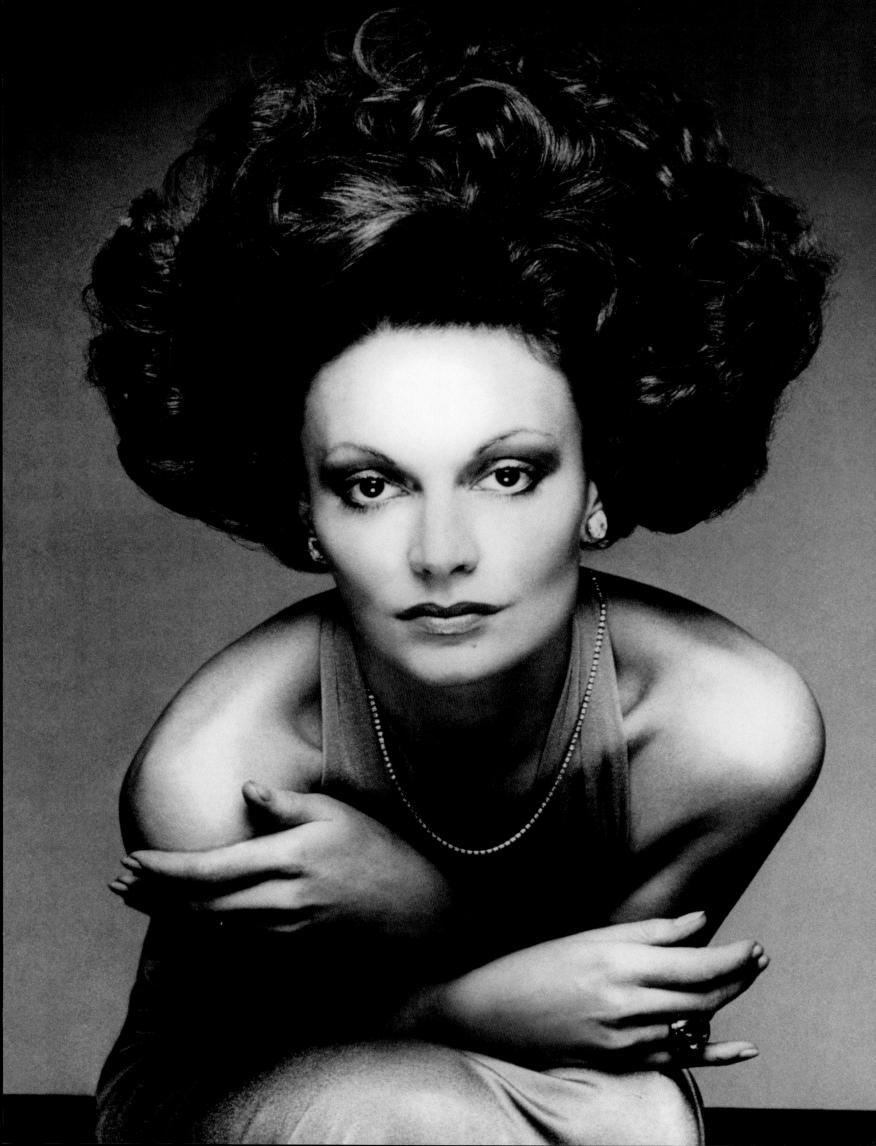

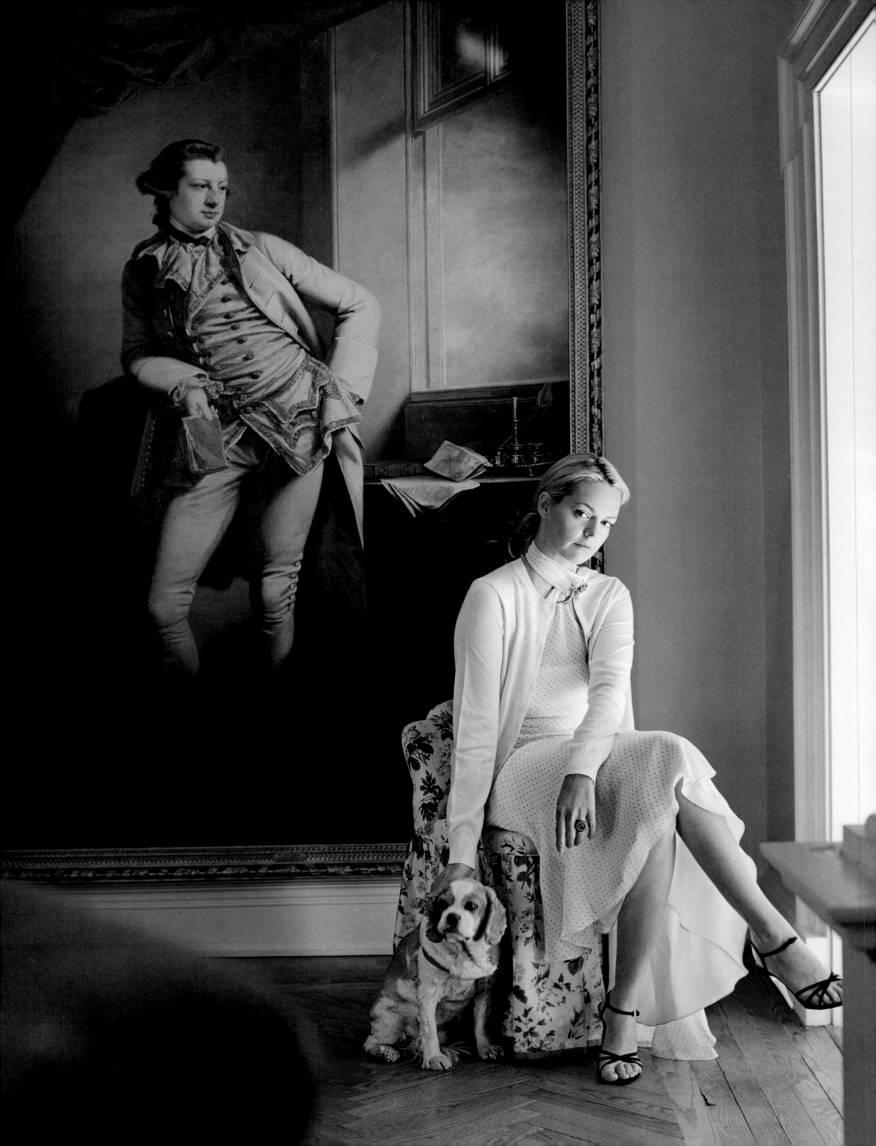

Lauren duPont

Jewelry designer and onetime *Vogue* editor duPont dresses to combine Bohemian flair with unapologetic elegance. Says Isaac Mizrahi, "When I look at Lauren, I just see her, not the outfit—she really takes over." Photographed by Jonathan Becker, 2004.

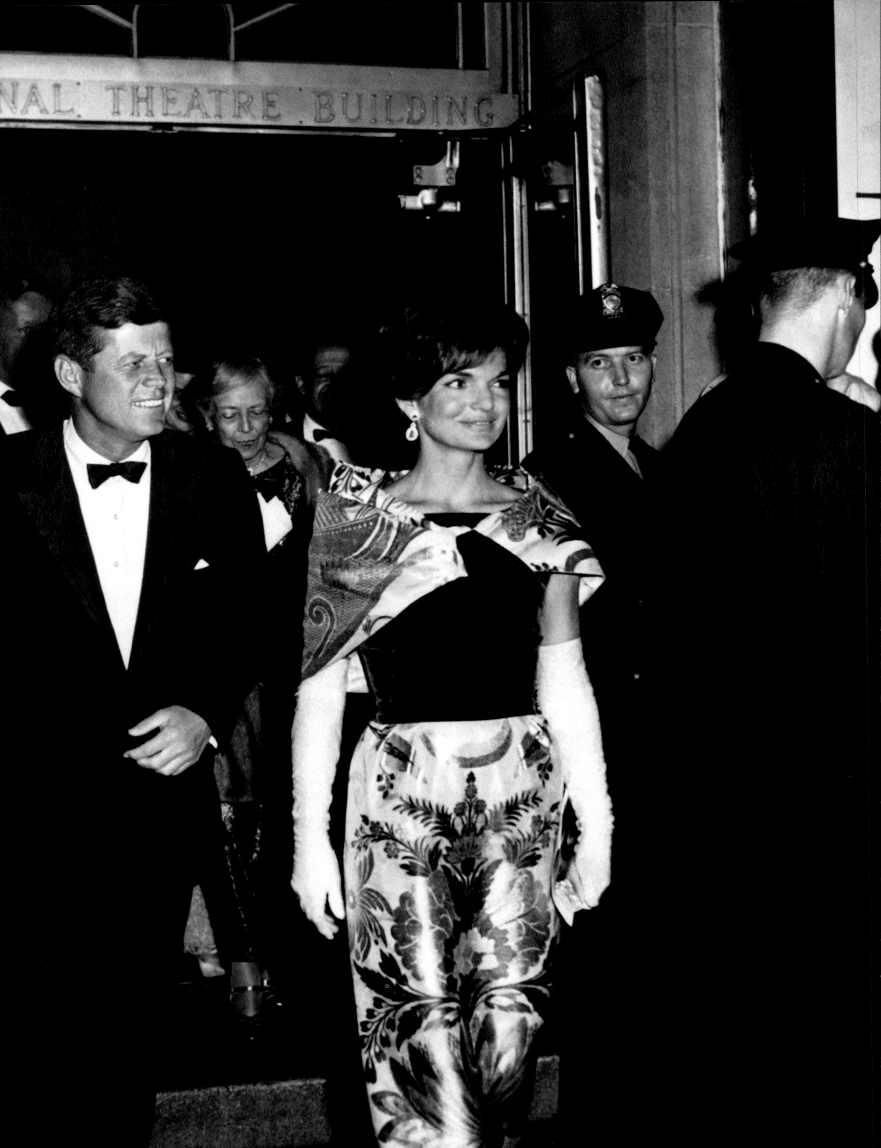

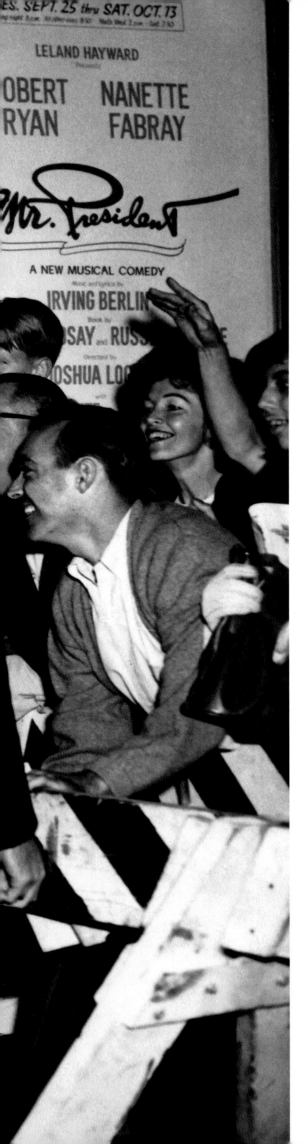

The president and his wife at Irving Berlin's musical *Mr. President* in 1962. The First Lady's dress was designed by Joan Morse for the Manhattan boutique A La Carte; it was made of brocade that had been a gift from the king of Saudi Arabia. Photographed by Abbie Rowe.

JACQUELINE KENNEDY

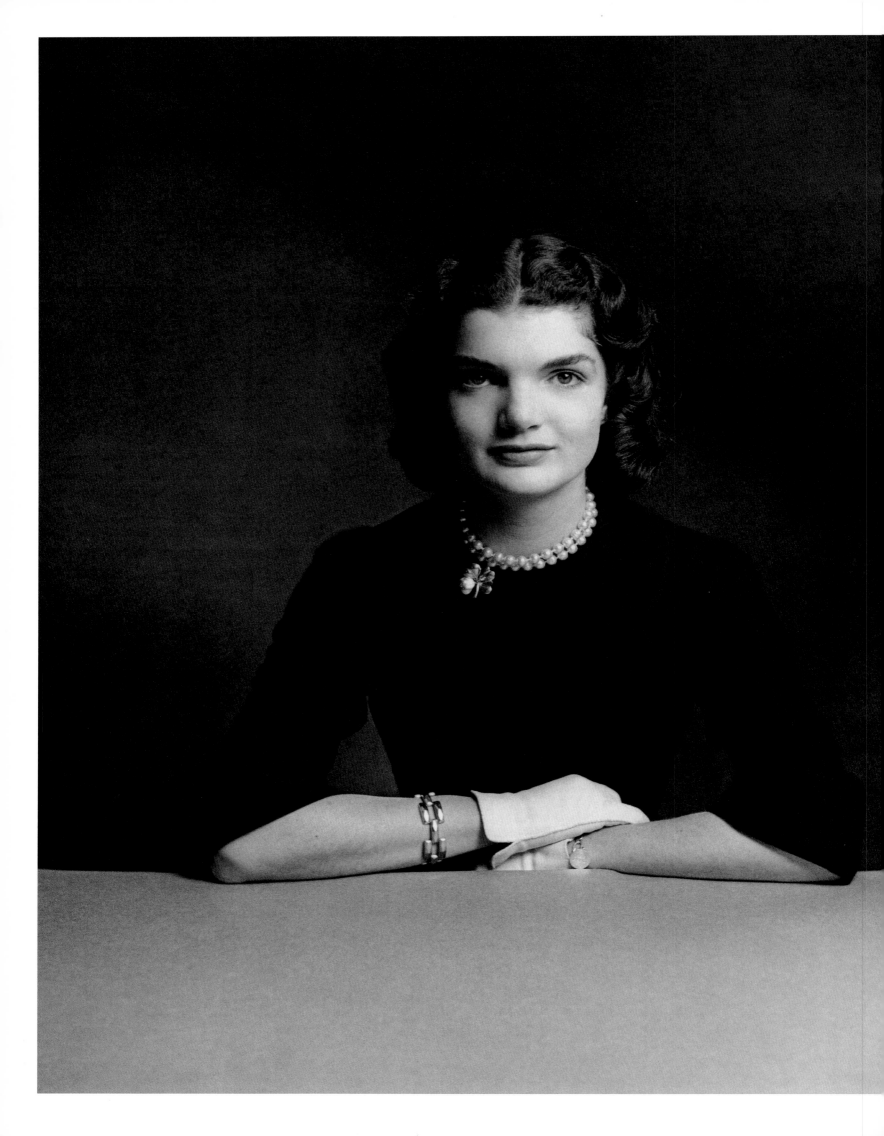

in 1951 Jacqueline Bouvier, then 21 and a senior at George Washington University, made her *Vogue* debut. She was photographed by Cecil Beaton, with her sister, Lee, sitting poised and faintly wistful on a golden ballroom chair, wearing a billowing Elizabeth Arden gown. The same year she also won the magazine's annual Prix de Paris. For an essay titled "People I Wish I Had Known" she wrote of Baudelaire, Oscar Wilde, and Diaghilev. Asked to include a lightly sketched autobiography, she described her appearance with winning detachment: "brown hair, a square face, and eyes so unfortunately far apart that it takes three weeks to have a pair of glasses made with a bridge wide enough to fit over my nose."

Vogue, however, would laud her "almost extravagant beauty" when it celebrated her 1953 wedding to John F. Kennedy, the young senator from Massachusetts, and the Kennedys' glamorous lives and presence would ignite the magazine's society pages. They were caught applauding the opening night of *The Reluctant Debutante* on Broadway, for instance, and Jacqueline was photographed at the Night in Monte Carlo ball—where Prince Rainier and Grace Kelly made their first public appearance after announcing their engagement—and at a gala at the Spanish Embassy for Don Juan Carlos, then Spain's crown prince.

By 1961 she was the First Lady of a transforming America—"a straight-out beauty with three extra qualities: brains, gentleness, and charm." To celebrate her thirty-fourth birthday, in July 1963, the magazine published an image of her smiling through the rain-lashed window of her limousine, dressed en fete in gleaming white. "The time was right for her, no doubt about that," the magazine noted. "We wanted to grow up. She came along, and suddenly we forgot about *the American girl* . . . and fell in love instead with *the American woman,* a creature possessed of thoughtful responsibility, a healthy predilection for the good and the beautiful and the expensive, and a gift for moving through the world aware of its difficulties, its possibilities, its large and small joys."

Jacqueline Kennedy's life, of course, was to change irrevocably. In 1967, *Vogue* wrote that "she put new shine to old wisdoms: that raising children is never ordinary, that privacy is a prize, that discipline gives fame a base and tragedy a bearing."

—HAMISH BOWLES, *2009*

Senator and Mrs. Kennedy at the wedding reception of his sister Patricia to Peter Lawford, April 24, 1954. The ballroom at the Plaza hotel was decorated to suggest a country garden, with snapdragons, dogwood, tulips, and delphinium. Among the 250 guests: actress Greer Garson, Bernard Baruch, and Supreme Court Justice William O. Douglas. Photographed by Nick De Morgoli.

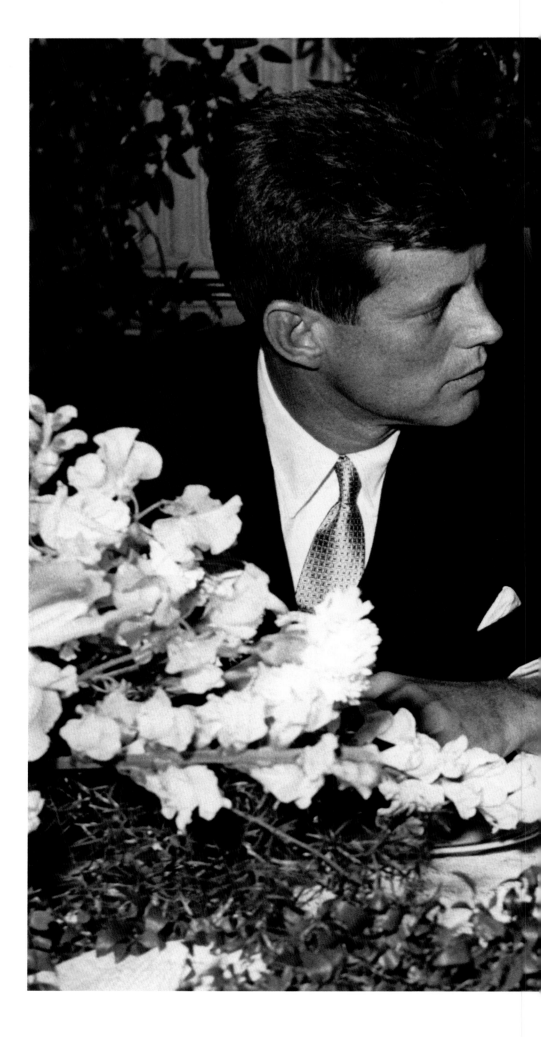

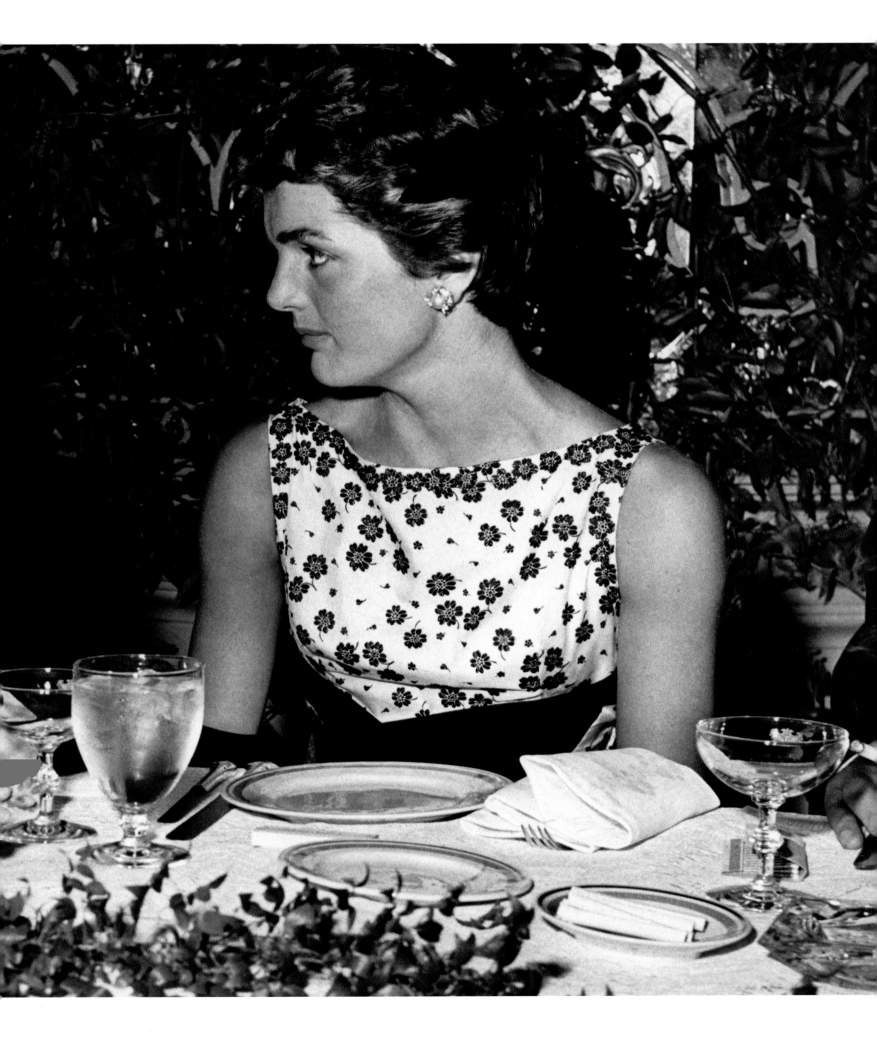

Jacqueline (*below left*) and her sister, Lee
(then Mrs. Michael Canfield), at the April
in Paris Ball at the Waldorf-Astoria in 1954.
Photographed by Nick De Morgoli.

Slim Aarons photographed Mrs. Kennedy in white
satin Givenchy (*right*) at the third annual April in
Paris Ball at the Waldorf-Astoria, New York, 1959.

following spread:
Caroline Kennedy, age three and a half,
with her parents at Hyannis Port, Massachusetts,
in 1959. Photographed by Mark Shaw.

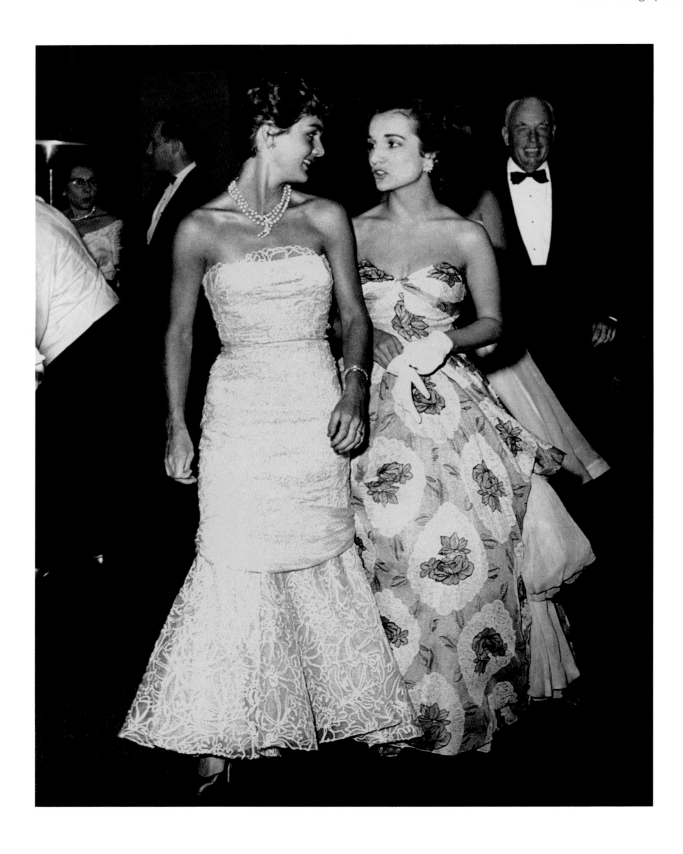

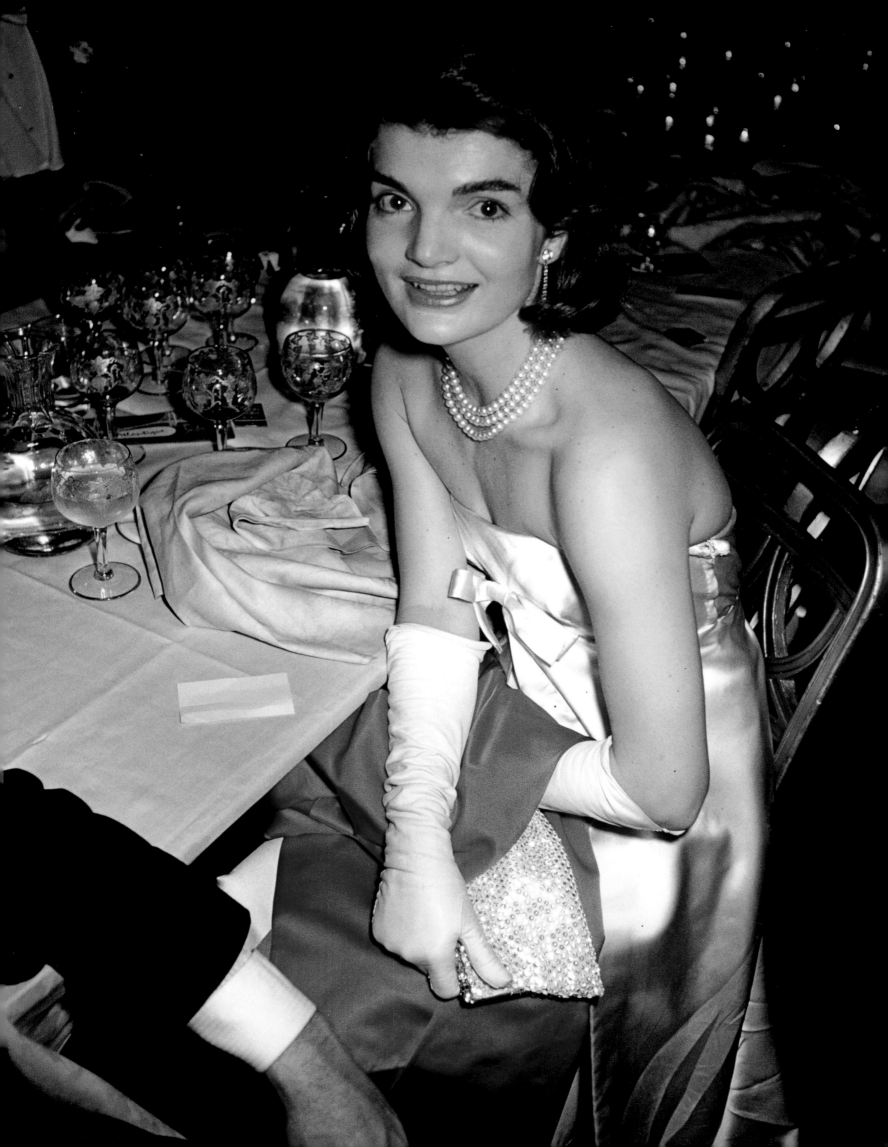

Annie Leibovitz took the future First Lady's portrait in 2007, when Barack Obama's campaign was still in the hope-and-dream stages.

MICHELLE OBAMA

i t's been an awfully long time since strangers off the street could wander right into the presidential mansion, but First Lady Michelle Obama's intention is to open up the White House again in a spirit of diversity and inclusion. She speaks of her future there as almost a collective experience. It's never *me* or *mine* or *some,* but *we* and *our* and *all.*

No doubt this attitude owes a lot to the sense of community she drank in as she grew up in a modest house on the South Side of Chicago. She doesn't come from a culture of exclusivity, and she doesn't appreciate a "members only" attitude. She'll be guided by another lesson of her upbringing: "We learned in our household that there was nothing you couldn't talk about and that you found humor in even some of the toughest times. I want to bring that spirit of warmth, openness, and stability to my task." She also wants "entertaining in the White House to feel like America, that we are reminded of all the many facets of our culture," and sees 1600 Pennsylvania Avenue as a national classroom "to make sure that our young people remember and understand what classical music is, who some of the great American artists are."

Three days before the Inauguration, I boarded the "Obama Express" at Philadelphia's Thirtieth Street Station, a whistle-stop tour headed with unstoppable momentum toward the three-day blowout in the nation's capital. How many among the crowds gathered to watch us pass were like me and turned their eyes to Barack and Michelle Obama not just with hope but with recognition? If the great expectations weigh heavily on her shoulders, it doesn't show; this is her enigma, this is her grace.

—ANDRÉ LEON TALLEY, *March 2009*

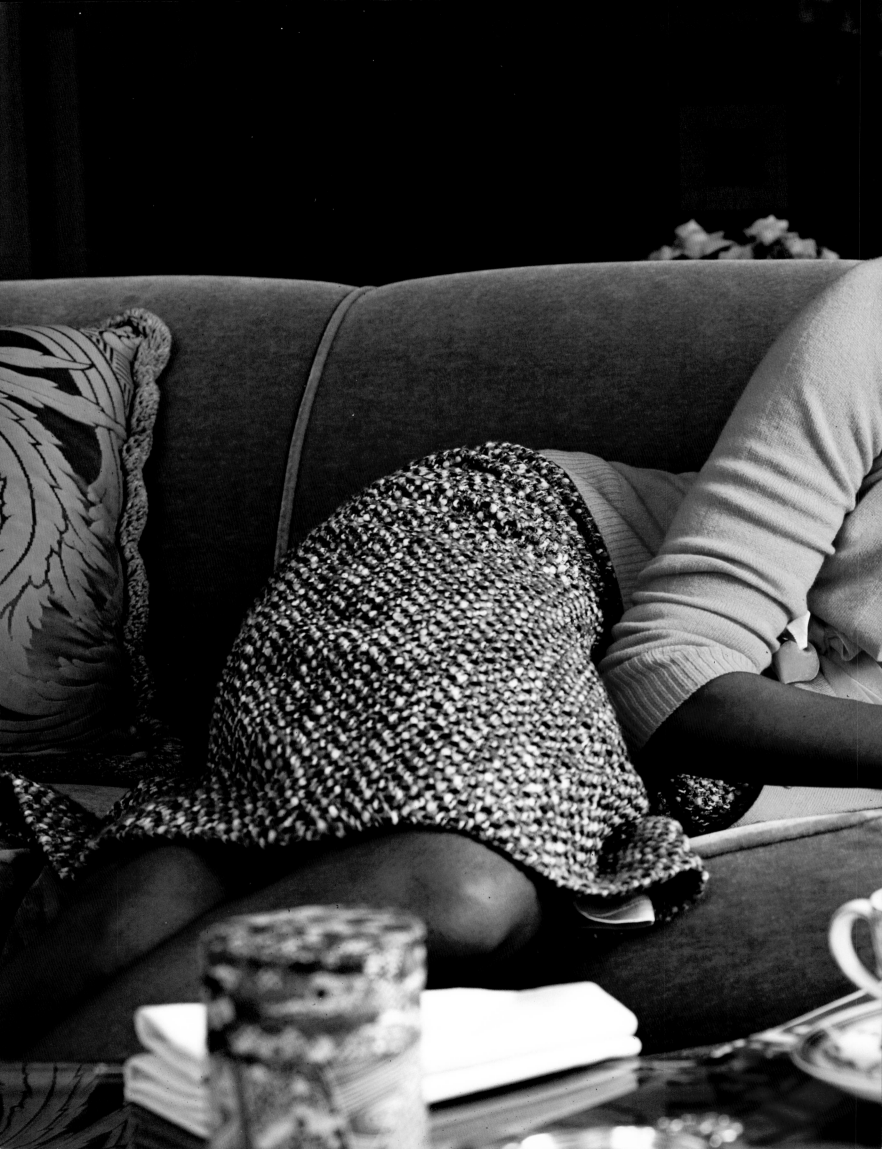

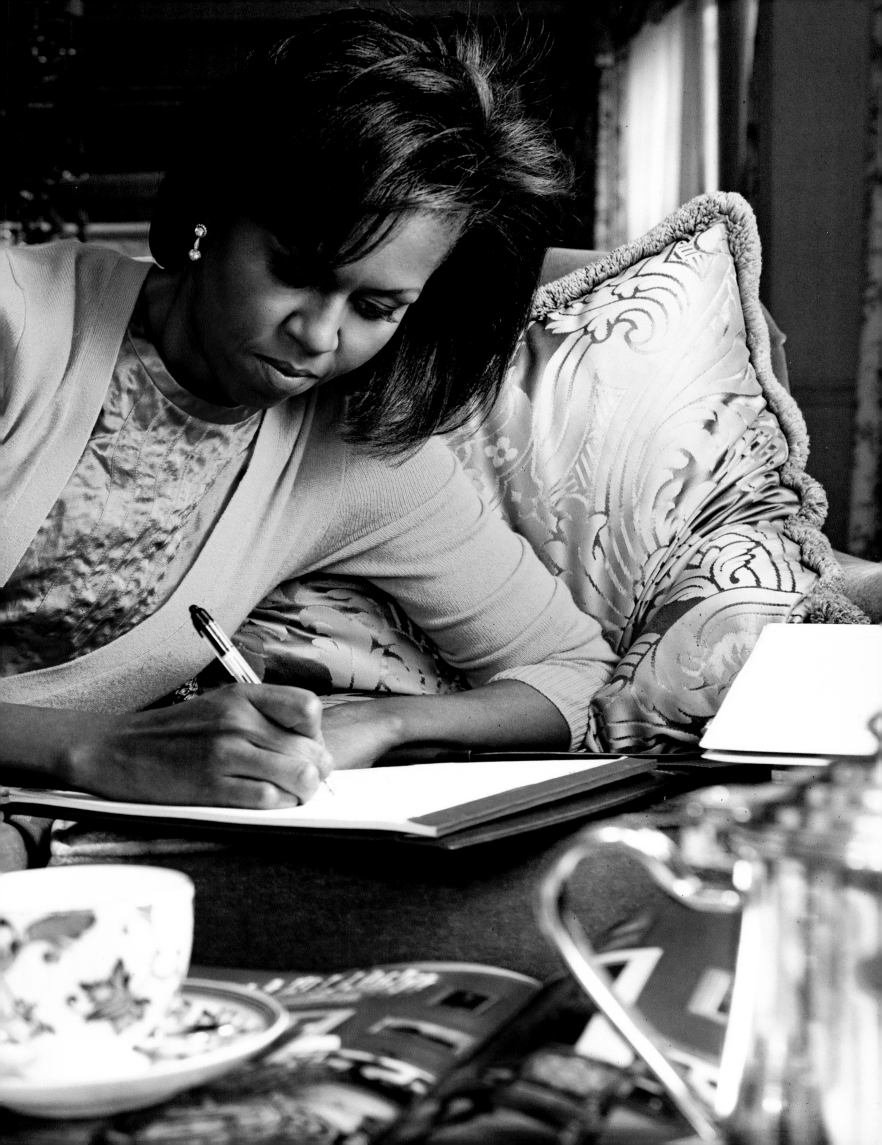

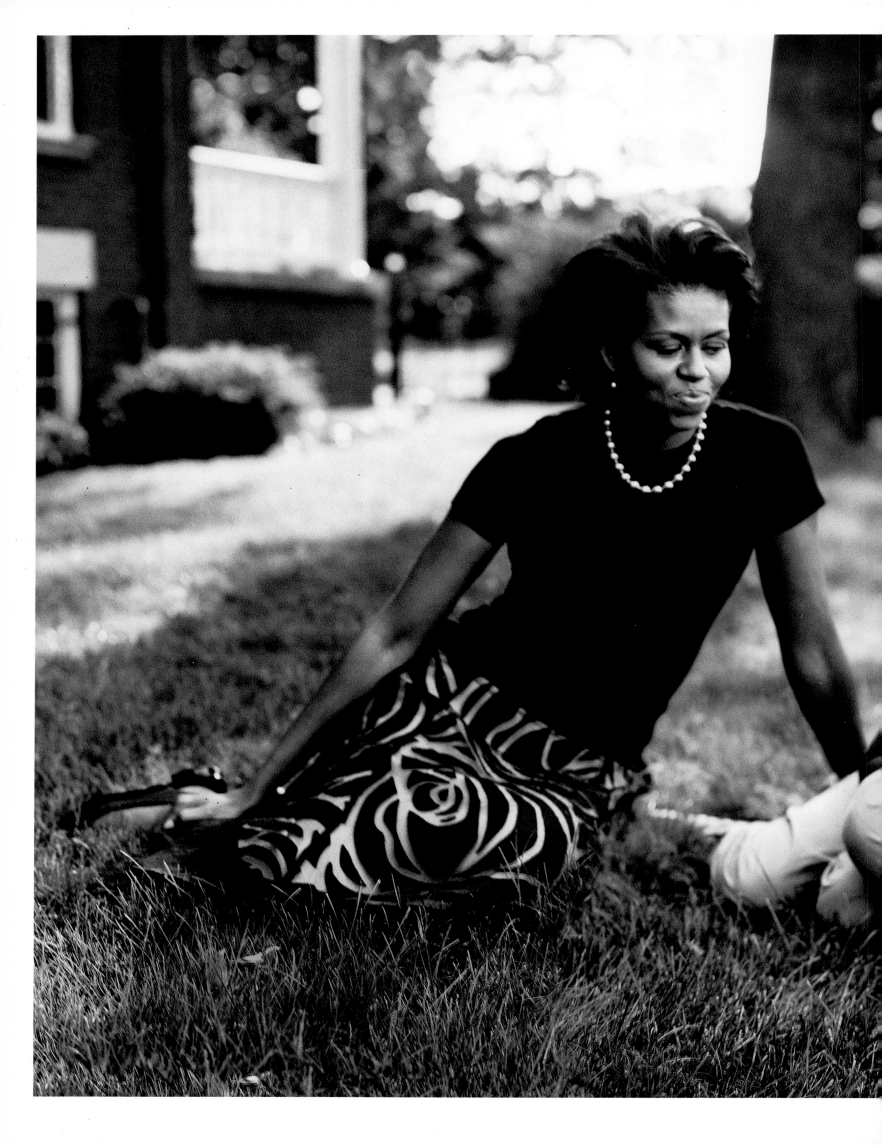

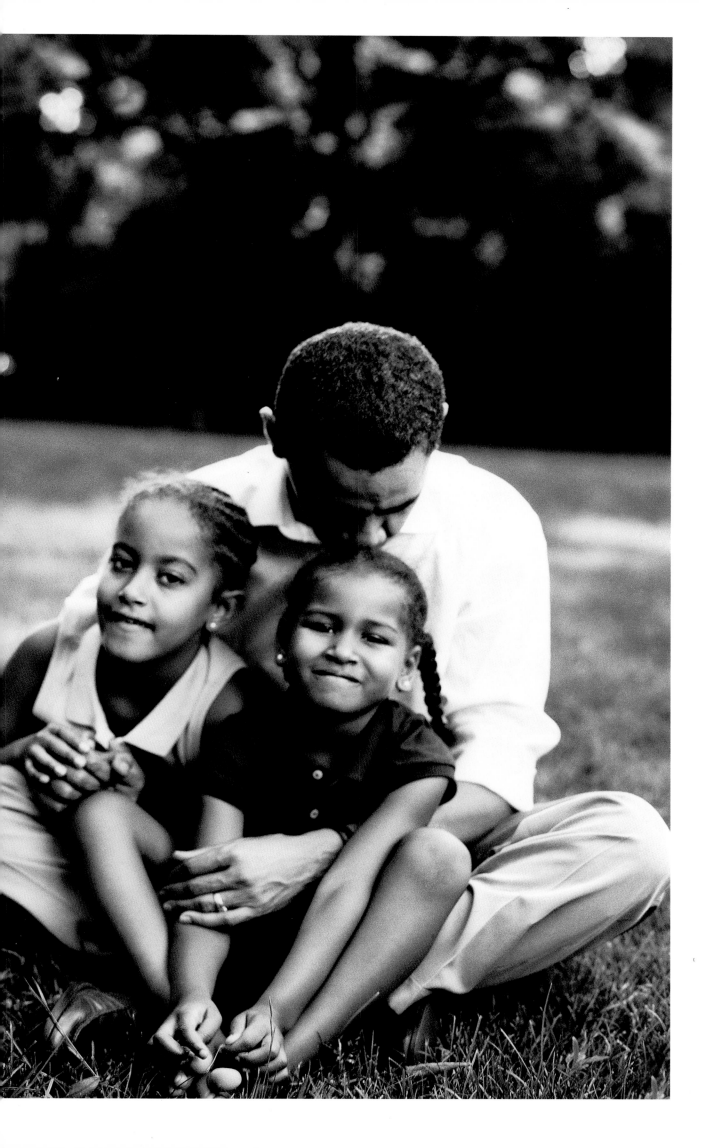

previous spread:
Michelle Obama at the
Hay Adams Hotel in
Washington, D.C.,
one week before the
Inauguration. Photographed
by Annie Leibovitz, 2009.

The senator and his wife
gathered in their Hyde
Park, Chicago, backyard
when Annie Leibovitz visited
them for *Men's Vogue* in
2006. Malia (*center*) was
then eight; Sasha, five.

95

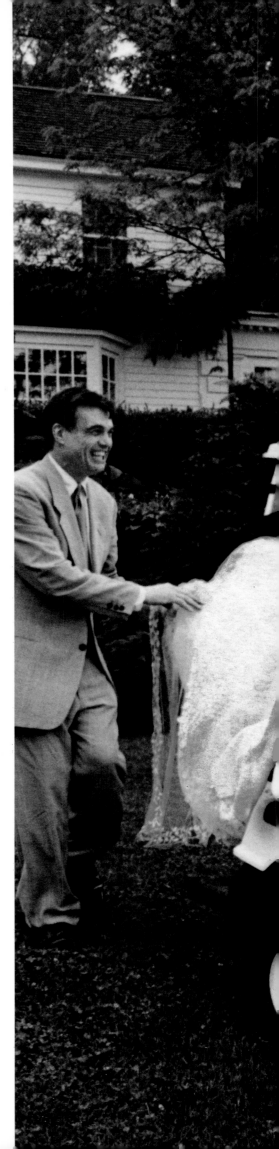

Eliza Reed, with her stepfather, Oscar de la Renta, at the designer's Brook Hill Farm in Kent, Connecticut, on her wedding day. Photographed by Mary Hilliard, 1998.

THE
PARTIES

———

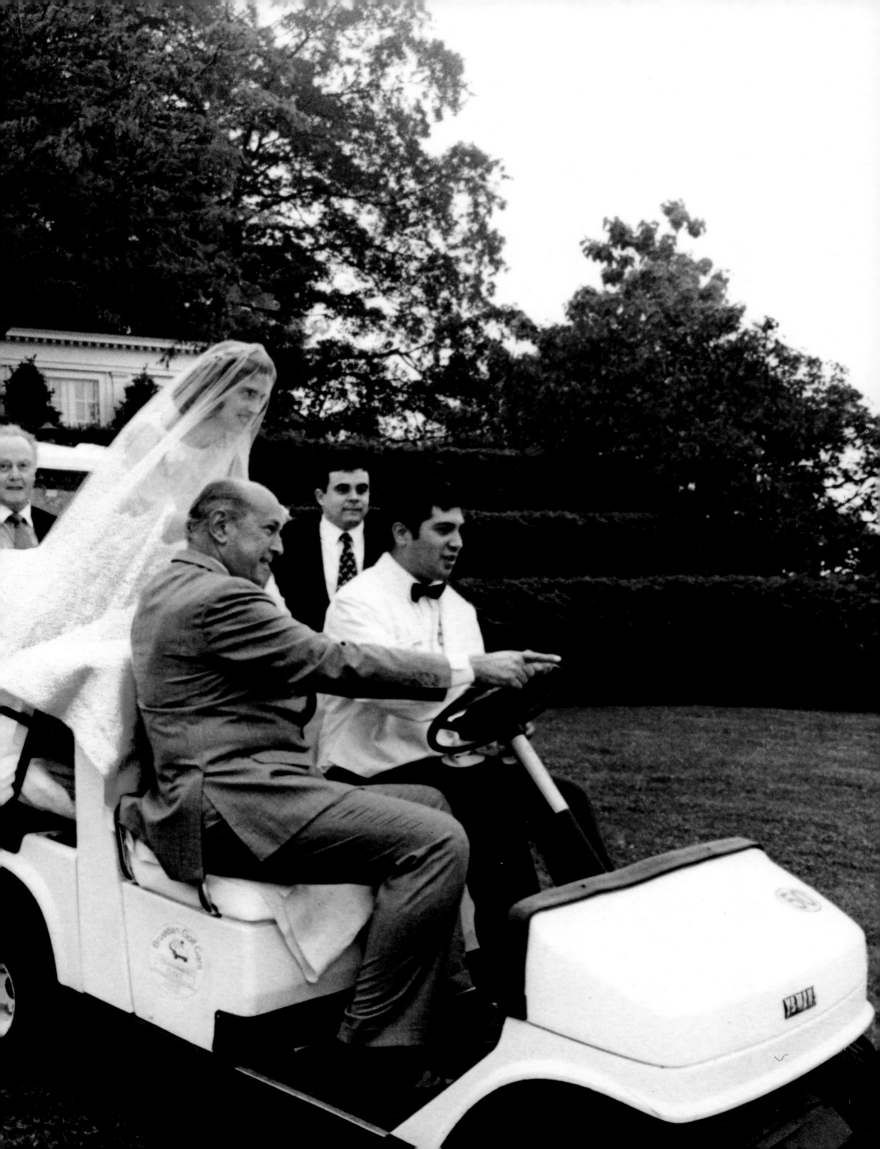

ELIZA REED
and
ALEXANDER BOLEN
WEDDING

f rom the flagstone terraces of Oscar and Annette de la Renta's Connecticut house, the bucolic view is so wide and endless that it snatches the breath away. A roiling ocean of beech, oak, and sugar-maple trees seems to eddy over the hills and into the infinite distance. The trees that Oscar planted three decades ago—disposed in artfully haphazard imitation of nature in the fashion that Humphrey Repton and Capability Brown decreed for the great estates of England's eighteenth-century landed gentry—have now matured to stately magnificence.

It was the view that sold de la Renta and his first wife, the

late Françoise de Langlade, on the property when they discovered it in 1971. She died in 1983, and to celebrate her memory, her widower embellished the gardens that she so loved. To the magnificent allée of flowering Redspire pear trees originally designed by legendary landscape architect Russell Page, François Goffinet now added an eye-catcher: a tall curved wall of juniper embracing a copy of the *Florentine Boar.* (Later, once Annette had moved in, this was mirrored by a statue of Diana rising above a lattice of low box hedges at the opposite end.) It was Page who told a crestfallen de la Renta that he would never have a garden on the property;

In "Caroline's Garden," treilliage obelisks tower above honeysuckle, Alba roses, iris siberica, linaria, artemisia, and thalictrum. Photographed by Eric Boman, 1997.

De la Renta (*below*) dancing with Mercedes Bass at the reception. Photographed by Mary Hilliard, 1998.

Box hedges, topiary trees, and shrubs frame the epic views. Photographed by Eric Boman, 1997.

The bride stands at the door to the terrace (*below*). Photographed by Mary Hilliard, 1998.

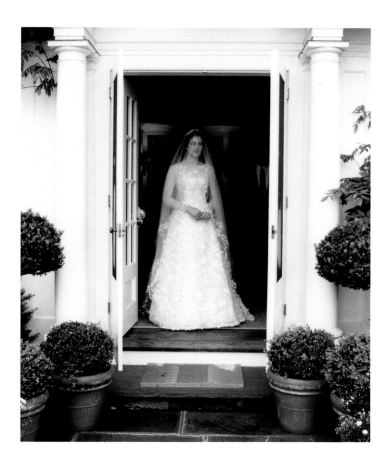

a garden—in the English sense of flower beds and herbaceous borders—needed walls. Undaunted, de la Renta eventually created an enfilade of green rooms, their yew hedges now tall enough to create a genuine sense of revelation and enchantment as one passes from one to the other.

It was against this sylvan backdrop that *Vogue*'s 1998 "wedding of the year" unfolded when Annette's daughter Eliza Reed was married by the Most Reverend Theodore E. McCarrick, the Roman Catholic archbishop of Newark, to Alexander Bolen before an assembled company that included the Henry Kissingers, the Henry Kravises, Brooke Astor, and Alan Greenspan. Oscar de la Renta designed his stepdaughter's "simple reembroidered cotton organdy" dress and his wife's "Whistler mauve-gray" Balmain couture ensemble. The heavens opened, and Mica Ertegün wore galoshes. Annette supervised what guest André Leon Talley dubbed the "*Appalachian Spring* aesthetics." "For all the dramatic splendor of the tents," John Richardson told Talley, "it was essentially a country wedding: rush-seated Van Gogh chairs, children galore, baskets of berries and cherries and figs, and masses of flowers. Annette's loving touch was in evidence everywhere."

—HAMISH BOWLES, *2009*

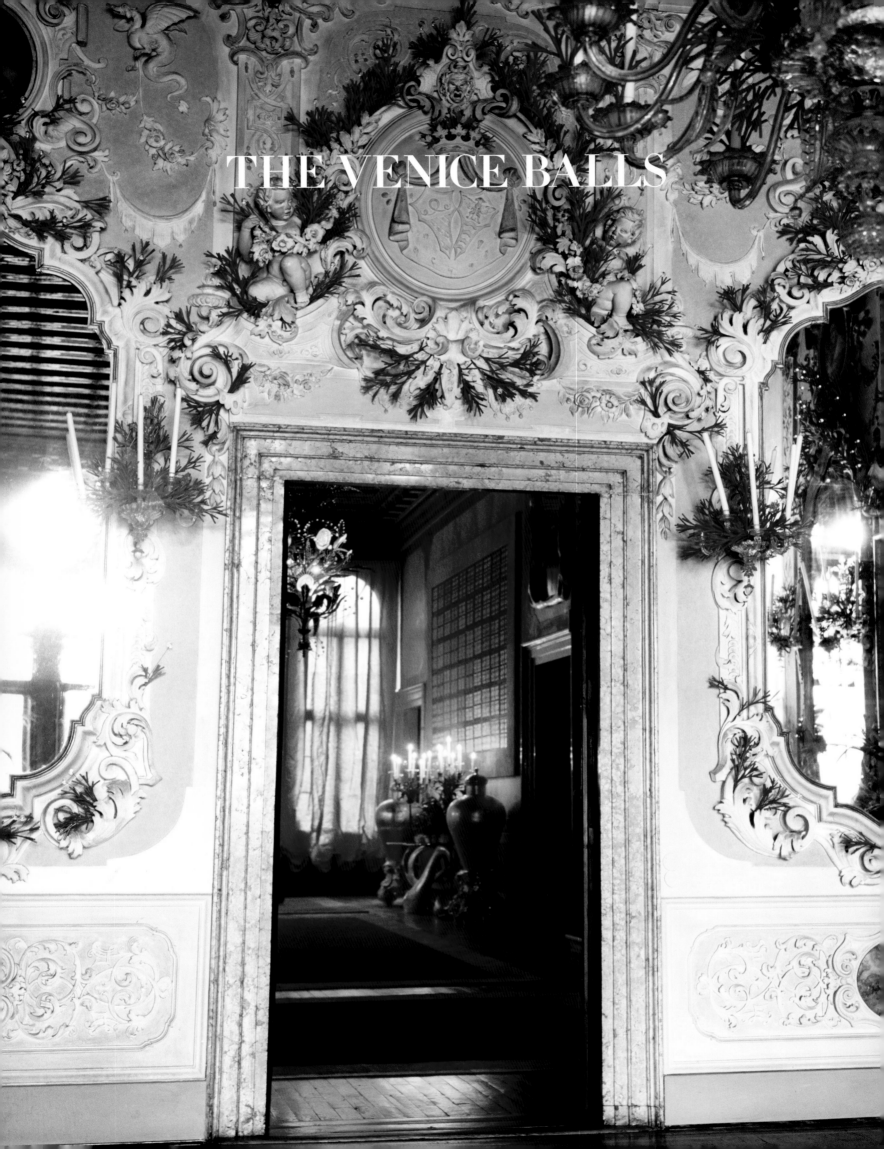

THE VENICE BALLS

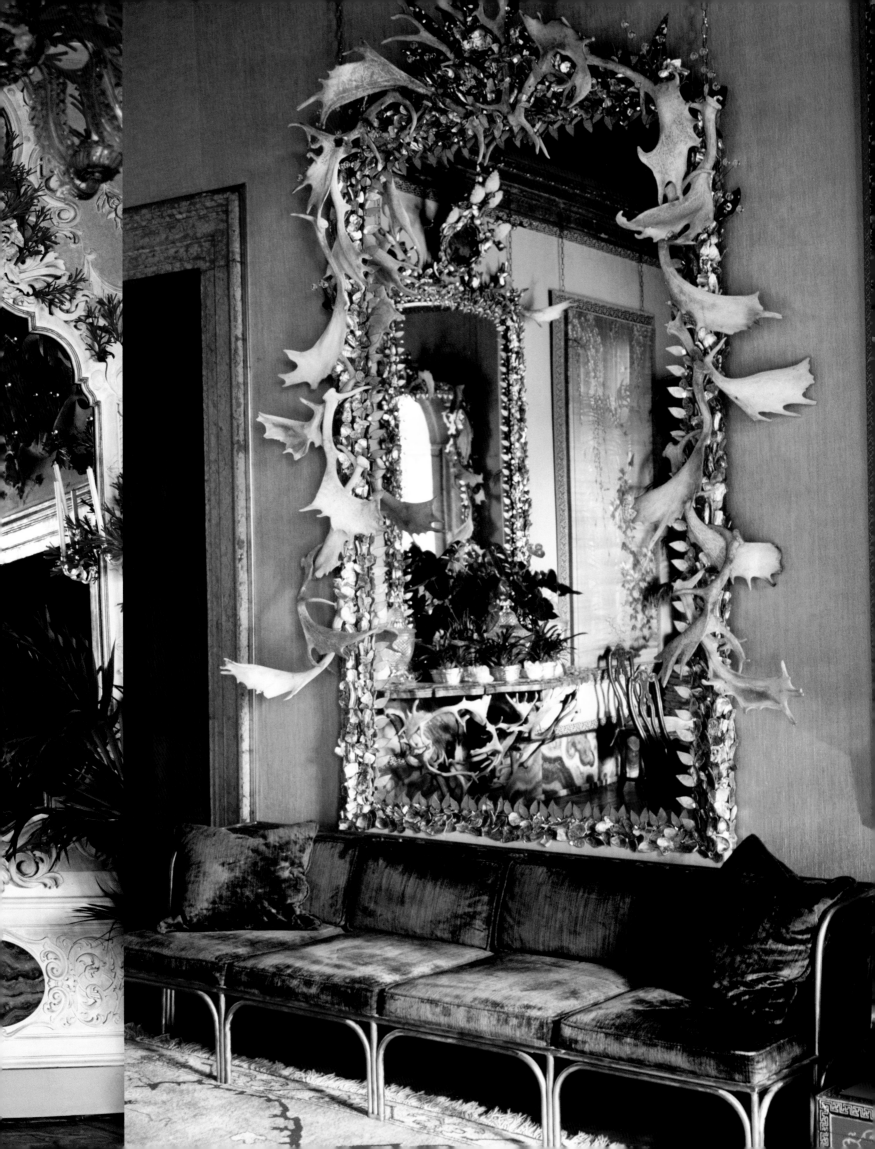

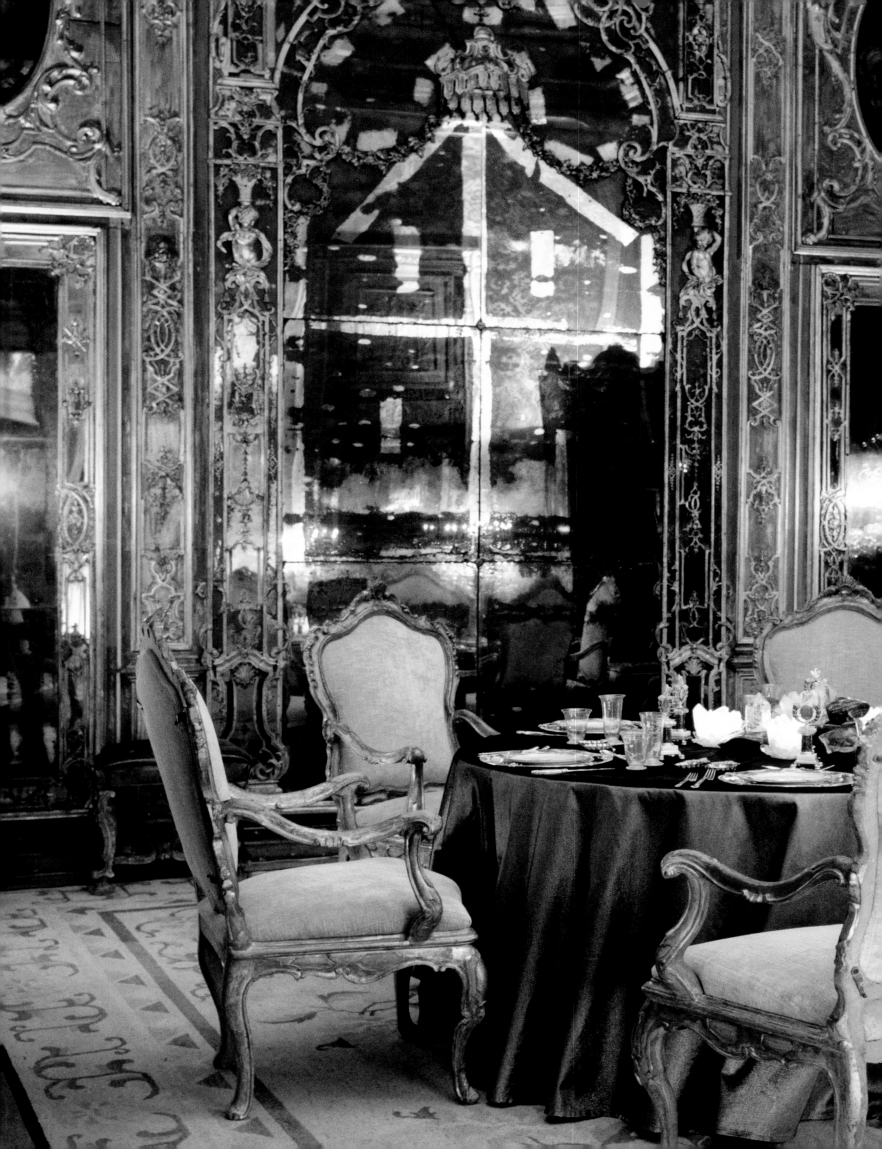

h igh above the Grand Canal, in the *piano nobile* of the Palazzo Brandolini, party preparations are in full swing. All day, boats have been drawing up to the jetties below, disgorging dozens of rococo party chairs, and crates of champagne and sundry intoxicants from Harry's Bar. In the second-floor rooms where Wagner composed act two of *Tristan and Isolde,* golden net and hellfire-red tablecloths are being steamed and dotted with baskets of bromeliads with coral branches and crystal-shard candleholders. And in the magnificent reception halls of the floor above, the legendary designer and professional fantasist Tony Duquette is supervising the placement of thousands of "coral branches" that he has had made (in Thailand, from rattan). These will be spiked into the Venetian-glass chandeliers and bristled behind the lavish curlicues of plasterwork that lap the mirrors and putti on the walls. The original wedding-cake decorations were part of the home improvements initiated by Countess Leopolda d'Adda in the 1870s, in readiness for another party—a ball to honor Kaiser Wilhelm I.

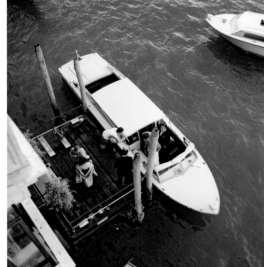

This year's party—which inaugurates a weekend of high-voltage festivities for Venetian Heritage and coincides with the opening of the Venice Biennale—is being hosted by the glamorous new tenants of this palatial apartment, San Francisco philanthropists and art patrons John and Dodie Rosekrans, and by the countess's grandson Count Brandolini d'Adda, and his elegant wife, Cristiana. In 1951 Cecil Beaton photographed this couple on the balcony of another spectacular Venetian residence, the Palazzo Labia, where they were characters in one of the famous tableaux—*Roman Noir,* designed by the whimsical artist Lila di Nobili—at Carlos de Beistegui's legendary ball. Twelve hundred guests were invited to the palazzo, which he had newly and magnificently restored, while 10,000 local Venetians participated in the fête populaire. In the grandest prewar tradition there were eighteen elaborately choreographed entrances. Salvador Dalí and Dior conspired on the fourteen-foot-high costumes for the "Phantoms of Venice." For the Chinese embassy tableau, Patricia Lopez-Willshaw was brought in on a palanquin as the empress of China. The groups proceeded through the palace to greet their host, dressed in crimson silk as the procurator of Venice, and Lady Diana Cooper, representing Cleopatra as portrayed in the palazzo's celebrated Tiepolo mural.

In Dodie Rosekrans the Palazzo Brandolini has found a spirited new chatelaine to carry the torch for the de Beisteguian extravaganza. Dodie is a latter-day Auntie Mame with a flair

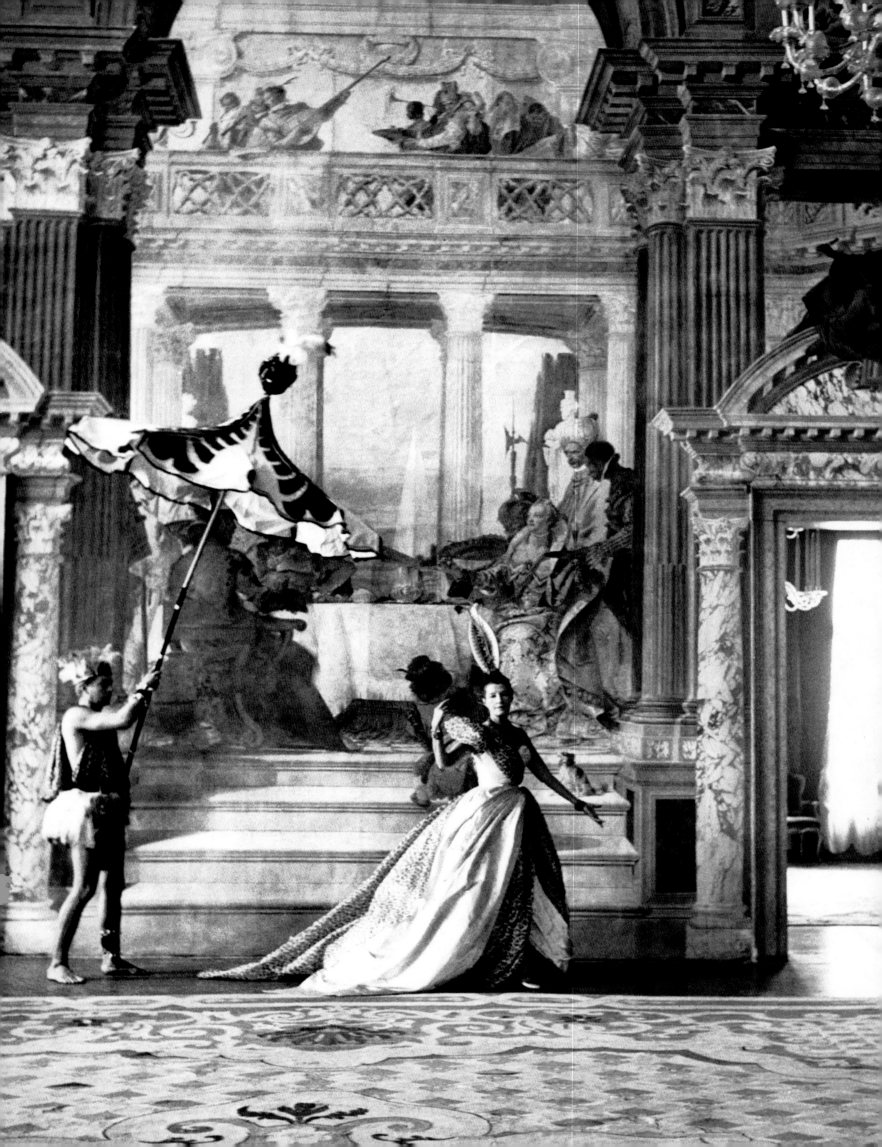

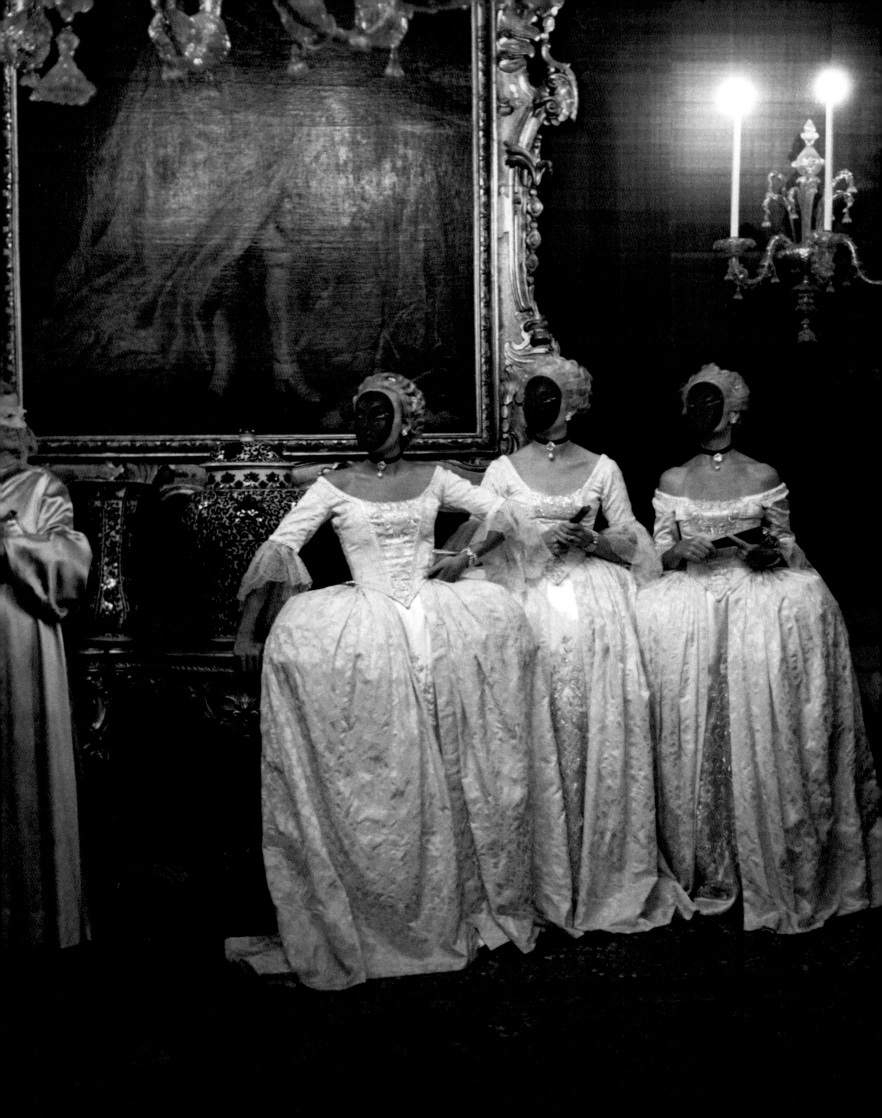

for adventurous sartorial choices (Saint Laurent's African odes in the sixties, the boldest statements of Gaultier and Galliano today), the panache of the Belle Epoque Marchesa Casati, and the passion for art of Peggy Guggenheim. She still remembers the first time she saw the *piano nobile* of the palazzo: "I fell in love with it immediately. It has such a very beautiful view of the Grand Canal from the balconies. And then the terrace with the view over the garden!"

Duquette is an alchemist who can turn base metals into design gold, and in the Palazzo Brandolini, he was given considerably more to work with than standard nickel plate. A palace had originally been constructed on the site for the descendants of the Byzantine emperor Justinian, and when the Brandolini d'Adda family acquired it in the 1850s, the structure was already seven centuries old. For Duquette and his design associate, Hutton Wilkinson, however, more is most emphatically more. "If it looks good, they take it a step further!" says Dodie. "Their creativity is enormous."

A case in point: The Brandolinis stipulated that the walls of the salon, hung with natural-colored cloth, were not to be changed. The designers rose to this challenge with characteristic panache, bordering the fabric and framing the paintings (Tiepolo-esque scenes from the lives of Antony and Cleopatra, installed by Countess Brandolini) in dramatic bands of leop-

ard and tiger silk-velvet, woven on antique Venetian looms. Rosekrans's own playful design spirit is reflected in the cavalier mix of elements in the library, where the magnificent throne came from Houghton and the twenties Knole sofas were found in Venice; the tribal chairs are from Africa, while the bicorne hat cushions were made for her by madcap milliner Mr. John.

"I have a very beautiful, correct house in San Francisco," Dodie explains. "I wanted fantasy in Venice." And fantasy she got. When launches dropped off couture-clad swans for the festivities, the scarlet-and-gold flags of the city fluttered from the Rosekranses' balconies. When Italy's jeunesse dorée arrived after dinner to dance to the Arab disco strains of the Tony Linares Orchestra in the first-floor entrance gallery, the reflected glory of Duquette's decorations—festoons of gold and silver lamé and laughing Venetian masks—made even the beautiful people more radiant. And Dodie stole the scene at her own dinner dance, upstaging the chic understatement of Paloma Picasso, Princess Firyal of Jordan, and Marie-Chantal of Greece by wearing a spectacular ocean-blue Dior couture crinoline, decorated with waves of nylon horsehair, designed by John Galliano. To this, as if in tribute, she added a Duquette necklace from her extensive collection. Of her collaborators, Dodie says, "They're daring and very, very creative. So we're just made for each other!"—HAMISH BOWLES, *September 1999*

LAUREN DAVIS and ANDRÉS SANTO DOMINGO WEDDING

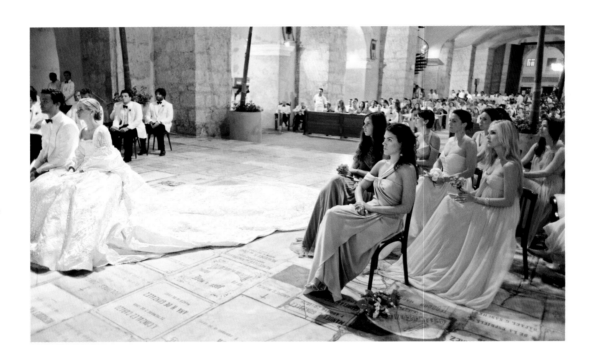

the burning sun is setting over Cartagena, the colonial jewel in Colombia's crown. In a scene worthy of Gabriel García Márquez, the city's favorite son, families have crowded along the narrow Calle de Santa Teresa, leading to the sixteenth-century Iglesia de Santo Domingo, its lime-washed walls pink as a dusky sunset. The *vallenato,* the musicians who ramble day and night playing seductive paseo and merengue, are respectfully silent—at 7:30 P.M., Lauren Davis and Andrés Santo Domingo will be married. The crowd cheers the city's most beloved benefactors, Julio Mario and Beatrice Santo Domingo, the parents of the Brown University–educated groom, as they pass on their way to the church.

Meanwhile, in the entrance hall of the seventeenth-century Casa Conde de Pestagua, Lauren Davis clasps her great-grandmother's rosary—old, borrowed, blue stone—as Olivier Theyskens arranges her wedding dress. Fashioned from 60

meters of silk jacquard woven with peony blooms, its coat embroidered with tinsel paillettes, vintage lace, silver threads, and tufts of clipped white feathers, this is Theyskens's masterpiece. The dress took the workers in Nina Ricci's atelier a mere 1,200 hours to make (with an additional 800 hours from the legendary Lesage embroiderers).

Davis has spent the day sequestered here with her mother, the artist Judy Davis (now in a tulip-stem-green crepe by Carolina Herrera), and her nine bridesmaids. As Theyskens fixes the veil over her chignon—mindful of the pearl-and-diamond Buccellati earrings that belonged to Doña Beatrice (Mrs. Santo Domingo), her wedding gift to the bride—Lauren hears her carriage arrive on the cobblestones. A woman otherwise of many words and enthusiasms, she is now contemplative. With a touch of the rosary and a lift of her train, the heavy wooden doors creak open and the crowd cheers. The bride and her father get into their horse-drawn carriage, she whispers something in his ear, and down the narrow calle they go to arrive at the church on time.

Earlier that afternoon, Lauren's bridesmaids assembled in a hacienda near the church to dress for their portraits by Arthur Elgort and the ceremony to follow. The women are dressed by nine different designers working in a palette dictated by the colors of the church: its harebell-blue ceiling, its soft apricot-pink distempered walls, its gray stone floors. Lauren's gift to each of her bridesmaids is a gold chain necklace inscribed with their initials. She makes thoughtful, specific hair and makeup suggestions, for a balance of hair up and hair down, and then announces, "Don't listen to what I am saying. At the end of the day, we're not 21 anymore and we all have our individual styles, so do what you want to do."

Lazaro Hernandez stops by for a viewing of the wedding dress and coat, which is being held in one of the air-conditioned bedrooms. "Amazing," he says. "Olivier makes the most beautiful evening dresses." Then the groomsmen arrive to escort the bridesmaids to the church, where the groom is waiting.

As requested, all the men are wearing white jackets (the groom's is custom-made by Tom Ford) and black tie, and the women, despite the heat, have not let their fashion slide. "I am looking for the man of my dreams," Jessica Joffe, in purple satin Thakoon, says, laughing.

"How is it going?" asks her friend Justinian Kfoury.

"Well, I've narrowed the search down—to a man in a white dinner jacket."

Every guest is given a fan, a mercy in the suffocating heat that rises up to the vaulted ceiling and through the fronds of the towering palm trees that are the sole floral decoration. The bell tower of the Iglesia de Santo Domingo is picturesquely crooked, according to legend, because the Devil is always knocking.

Swaying in the heat, waiting with great anticipation for the reveal of the bride and her dress, the South American grandees, the New York fashionistas, the Paris aristocrats, and the London bankers sit in the pews talking softly. Many others line the en-

At 2:00 A.M., Theyskens shears the hem of the bride's second dress (*left,* photographed by Hannah Thomson) to create a version (*right,* photographed by Arthur Elgort) for the dance floor.

———

following pages:
Davis poses in her wedding dress and coat in Casa Conde de Pestaqua. The newlywed Santo Domingos lead the procession from the 16th-century chapel to the home of the groom's parents for the reception. Photographs by Arthur Elgort, 2008.

trance of the church, chatting and fanning and gossiping, while pigeons from the piazza fly inside and perch above the altar.

The guests turn to hear the sound of Lauren's carriage approach; the church doors are shut lest the groom see her. Mendelssohn's "Wedding March" begins, ends, and begins again (Theyskens is arranging the train on the church's steps). The crowd in the piazza is cheering, chanting, "Lauren, Lauren, Lauren!" The veiled bride enters on the arm of her beaming father. The guests part as if they were a sea. Fans stop. People stand. Even the most sophisticated sigh over the bride and her heavenly dress: a dress for the ages. In this moment, every other piece of couture could be sackcloth.

The ceremony includes Franz Schubert's Mass in G Major and two sermons. The first, in Spanish, preaches against the pleasures of the flesh. The second, in English, describes for the groom's behalf the pleasures of fidelity. This is followed by Communion, and, as if suddenly "El Jet Set Internacional" has found religion, a great many take it. (Minnie Mortimer explains, "I took Communion just to get a closer look at the embroidery" on the bride's coat.)

Staring at Lauren's dress in wonder, the flower girl, Daniela Pérez, asks, "Is it heavy to wear?"

"No," Lauren answers. "In fact, it is amazingly light. The only thing I feel is the corset, the bustier; the entire dress is constructed from there. It is amazing."

Once the ceremony has finished, the more than 500 guests walk the cobblestone streets to the Santo Domingos' house for cocktails under the mango trees. While Marielle Safra and Mica Ertegün catch up on a few details of the apartment in New York Mica is decorating for Marielle and her husband, the father of the bride and a daughter of the president, George W. Bush, are talking. Mr. Davis says he has given his best advice to the groom, three lines to repeat over and over: "I was wrong, you are right, and I love you." He sighs. He misses Lauren already.

At dinner, on the tennis court transformed by bougainvillea, there is salsa music by the Latin Brothers band from Bogotá, and more exquisite dancing. At 1:30 in the morning, Lauren finds Olivier Theyskens. They leave the dance floor and head upstairs to Lauren's room, where Theyskens brandishes the dressmaking shears he has in his pocket. At approximately 2:00 A.M., with such precision that it could be reattached at a moment's notice, Olivier cuts most of the skirt off Lauren's second dress, leaving her feathery finery in a heap on the bed.

Thus transformed, the new Mrs. Santo Domingo leads the guests up a ramp lined with ceremonial dancers to the seventeenth-century fortress for disco and live-orchestra dancing overlooking the sea. At 5:00 A.M. London's Izzy Winkler exclaims, "I told all my friends, Thank God you're already married. Because I don't know what anyone could do to top Lauren and Andrés's wedding—except, I suppose, get married on the moon."

—WILLIAM NORWICH, *March 2008*

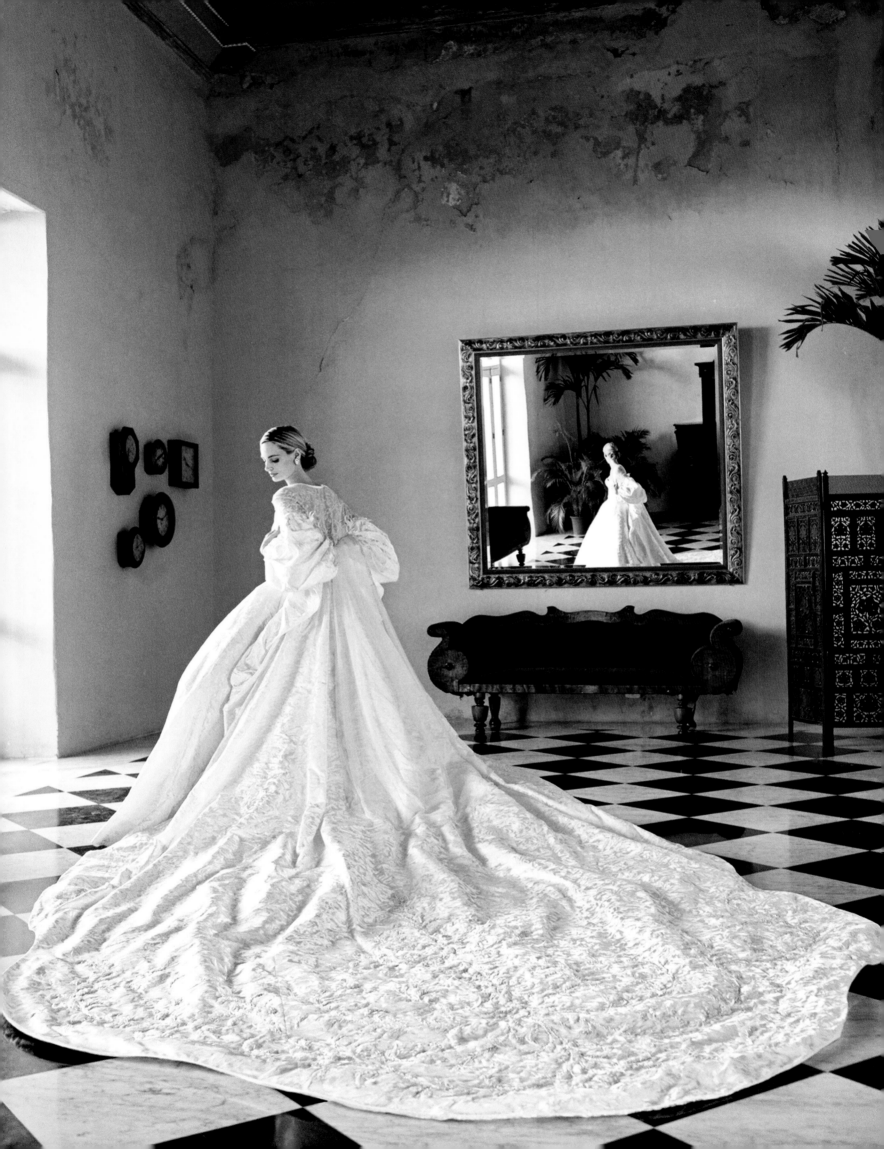

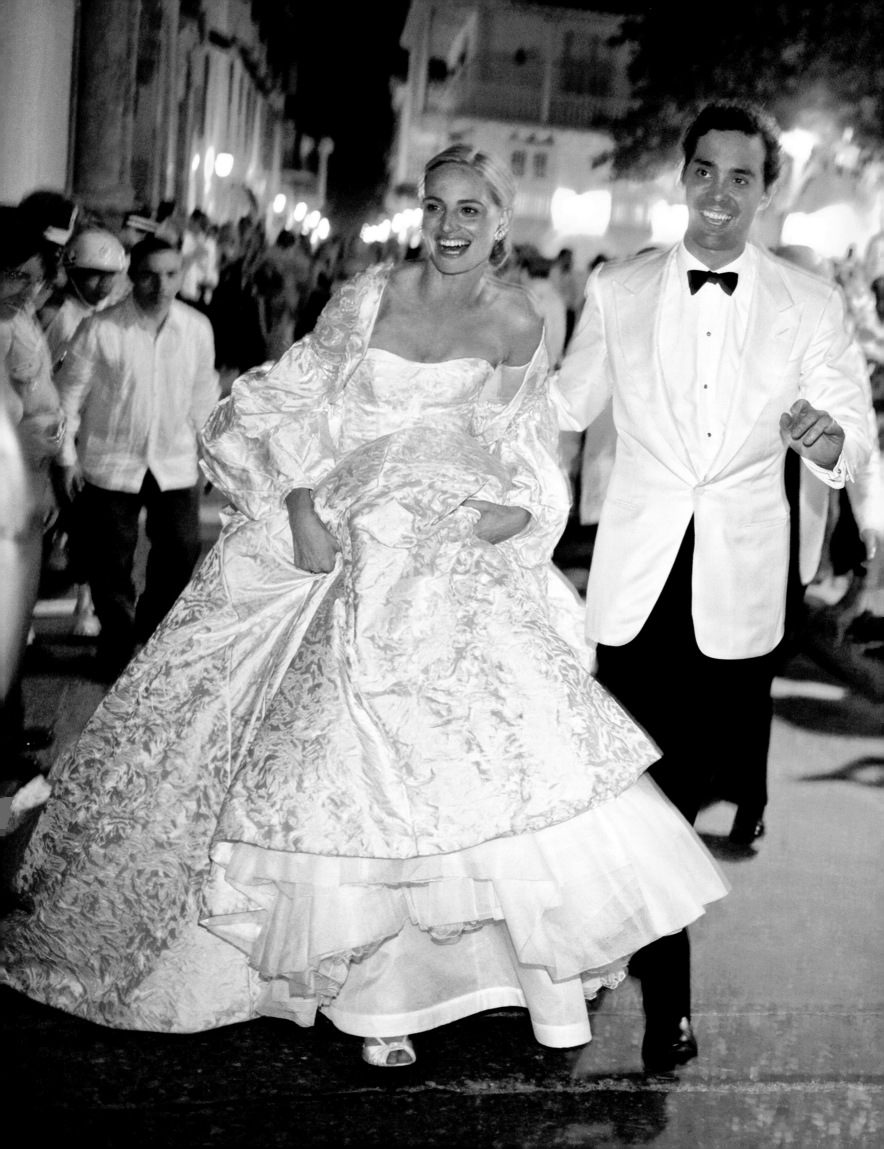

WEDDING CAKES

hy a cake?" I demanded. "Why not a meatloaf?"

Our wedding was only two panic-packed weeks away. The place would be the disintegrating Manhattan loft in which we had lived together for seven years. The music would be two friends, a cellist and a harpsichordist. We had found a judge and procured the marriage license. The bride would wear pale pink and white and spend an absolute fortune on a haircut. The menu was easy: plenty of Russian caviar and French smoked salmon with toast and blinis and bottles of icy vodka. Plus champagne for those who believed either that champagne goes with caviar, which is false, or that champagne goes with weddings, which is obvious. But the dessert was still completely open to question. I was simply not a cake kind of person, and a standard three-tiered, basically white, gummy, and distasteful wedding cake was unthinkable. So we chose what was then, incredibly, a state-of-the-art dessert: gigantic, out-of-season strawberries dipped into dark chocolate the night before by the groom's own trembling hand.

Today at last I understand what I had failed to grasp then: An ornamental cake is absolutely essential to every wedding and to the years of marriage that follow. Even the modern Japanese have adopted the custom. Their cakes are just like the white three-tiered Anglo-American model, except that they are made of white wax (but for a small zone of real cake to allow for the ceremonial cutting) and can be used again and again by the company from which they are rented.

For the Japanese, white is not the color of purity or virginity, as it is for us. White is the color of death and mourning, and this works quite well with other elements of the Japanese wedding, which is full of deathly imagery symbolizing the end of the bride's ties to her family. For both Japanese and Westerners, the cake itself stands for fertility because it, or at least the edible part of it, is made from grain, a nearly universal symbol. That's why we throw rice as the joyous couple leaves the wedding celebration and heads toward the marriage bed. That's one reason a special bread or cake and not a special meatloaf has been central to our wedding rituals at least since the Greeks and Romans.

The bride in ancient Greece spent several days preparing the wedding bread with her own hands and then gave it to the groom. Today's brides are less clever, but their total mania for wedding cakes now grips the land, with the richest families vying for the largest, most ornamental cake that money can buy. The great wedding bakers of America are besieged at least a year in advance for June nuptials, and stories abound of prefabricated cake layers' being flown to the remotest parts of the world, including Nigeria and Oklahoma, along with the artists who will assemble and decorate the cake.

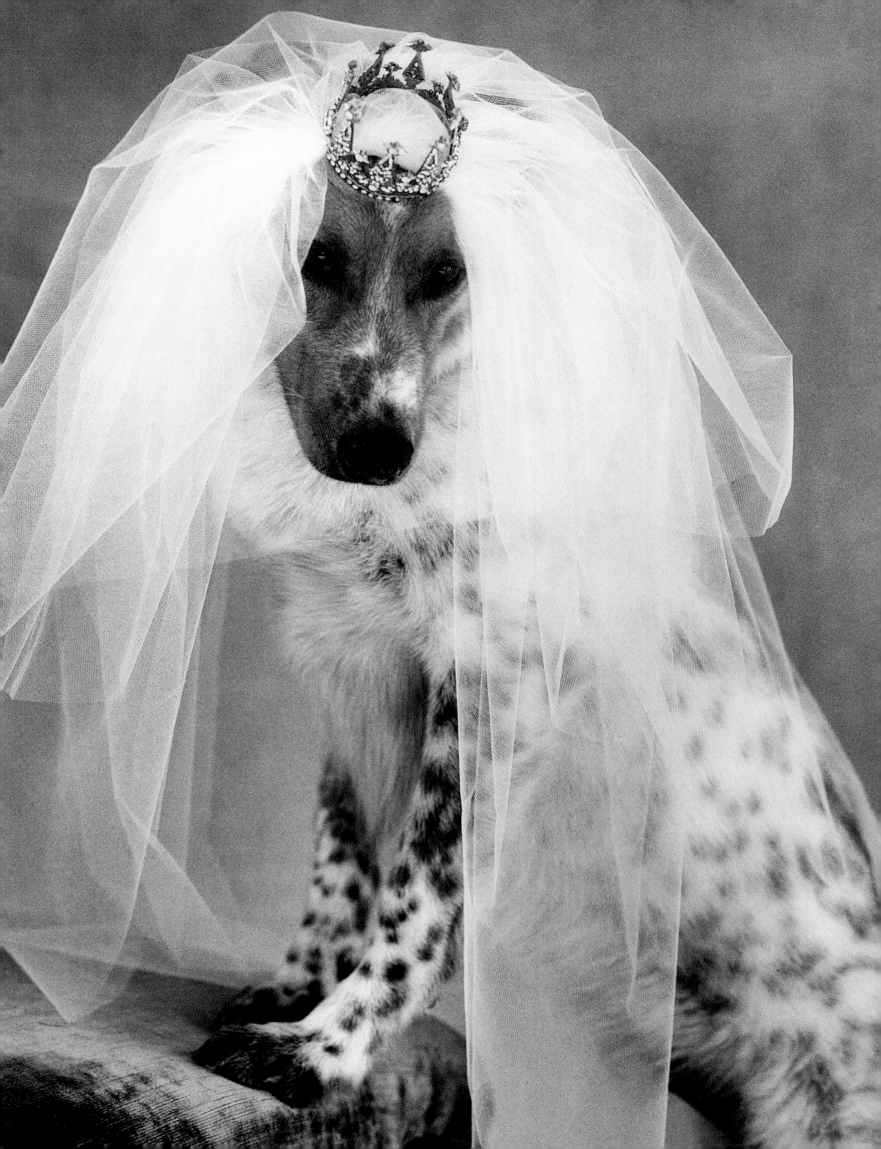

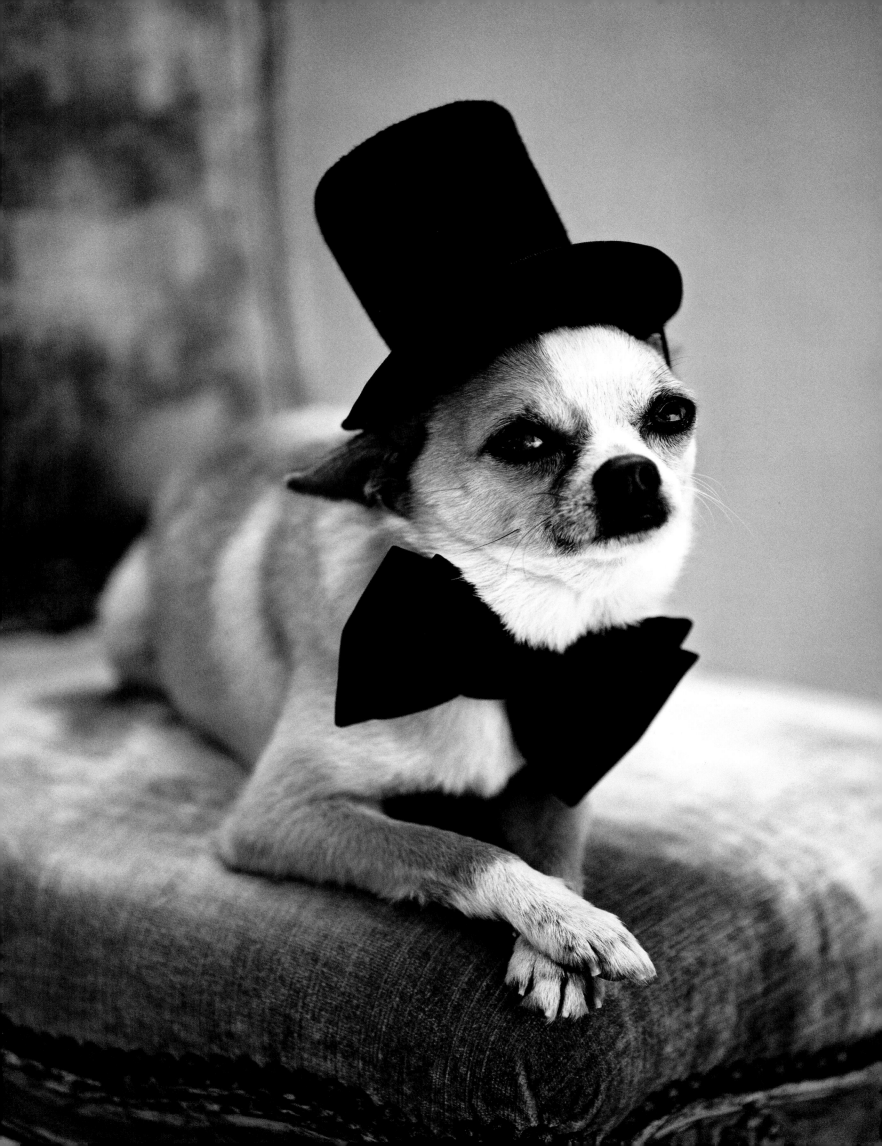

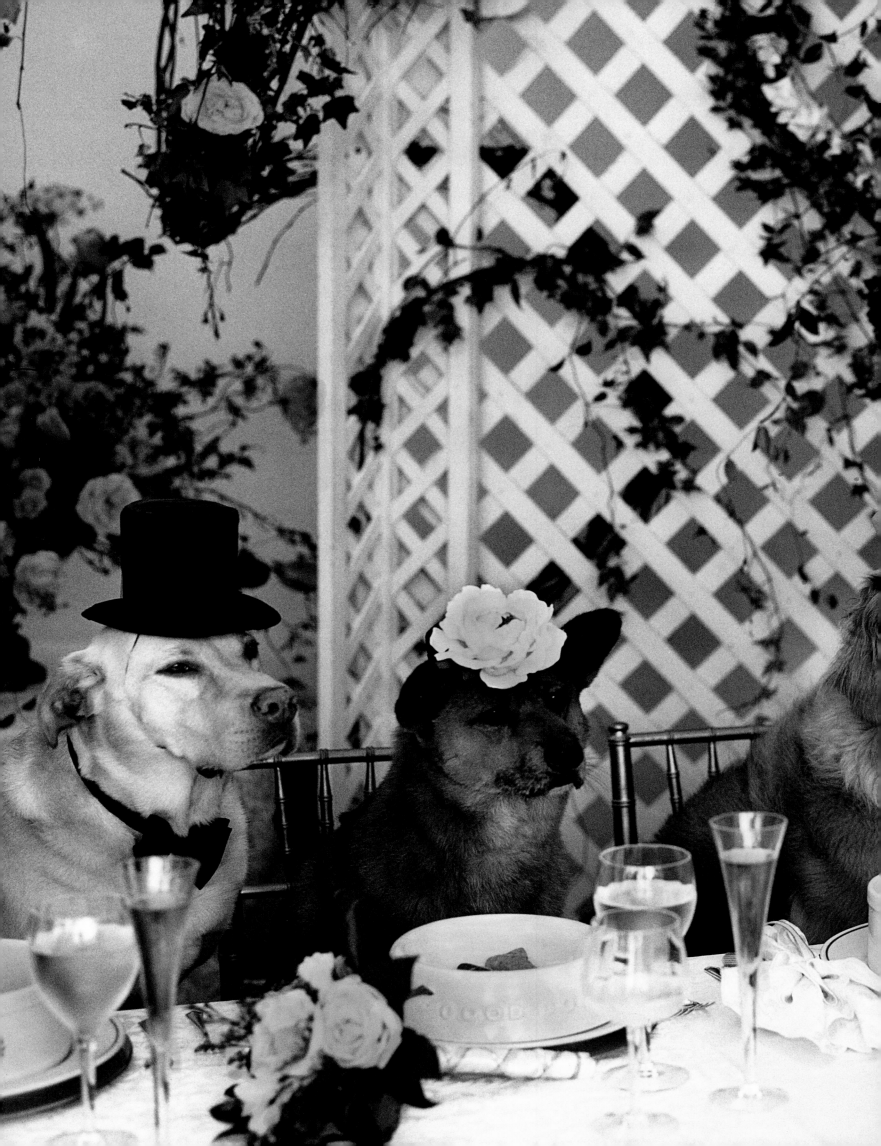

Why should such uncontrollable mania surround a simple
and ancient fertility symbol that could take the form of a large
loaf of good, honest bread? I wondered. To discover the rea-
sons, I bought every wedding magazine at my local newsstand;
took a short course in baking and decorating wedding cakes;
visited one of the most famous practitioners in the country and
interviewed several others; paid a visit to one of the grand wed-
ding palaces in New York's Chinatown; spent several hours lurk-
ing around the nearby New York Cake and Bake Supply, which
carries everything from premade sugar flowers to edible spray
paint; read Simon R. Charsley's *Wedding Cakes and Cultural
History* (the authoritative history of the British wedding cake)
several times; and dipped into a few dozen other anthropological
and historical treatises.

Is a wedding cake made to be actually eaten?
No doubt these newlyweds would always
answer, "Yes!" Photographs by Bruce Weber.

Bridal comes from the Old English "bride-ale," and refers to the drinking of ale at the wedding feast. At Anglo-Saxon weddings, small cakes were distributed, but these were more like flat, grainy breads or oatcakes. The Anglo-Saxons had no sugar. Their cakes and those of the ancient Romans were more like biscuits, which were broken above the bride's head in a shower of crumbs that symbolized fecundity. These were the first "bride cakes." (The great Cavalier poet Robert Herrick coined the expression "wedding cake" in 1648, but nobody followed him until the nineteenth century.) In medieval England, the bridal biscuits were enriched first with spices and then with *plumbs,* a term for dried fruits, which explains why the plumb, or plum, pudding of the English Christmas may contain no plums, either fresh or dried. Then came nuts (another hint at fertility), eggs, and when it became available, sugar. By the seventeenth century, the dark English fruitcake had been born. When the first recipe for this Banbury Cake appeared in 1655, the fruitcake had become the obligatory wedding confection.

British cakes were not covered in icing, white or otherwise, until 100 years later, when Elizabeth Raffald first published her famous cookbook in 1769. It is not that icing was unknown—*glace royale,* or royal icing (at its simplest, a mixture of powdered sugar and egg whites that dries to a rock-hard finish), had been imported from France at least 100 years before. But the British simply did not ice their fruitcakes before Raffald, who added ground almonds to the standard formula. And thus the white wedding cake was born.

Queen Victoria's own daughters were married too early to have true white, ornate Victorian wedding cakes. The technique for piping sugar icing through a paper cone had been invented in Bordeaux but did not reach England until the 1880s. The Victorians added their fondness for height, creating the modern three-tiered cake, often within an elaborate sugar superstructure. Middle-class families with enough money for only one tier satisfied their longing for altitude by placing the cake on a tall stand and planting a vase of flowers on top. Inside there remained the same dark, fruity cake.

Modern American wedding cakes fall into three broad categories. Rarest is the incredibly elaborate, all-white Victorian cake decorated with flowers, urns, arches, vases, and trellises of *glace royale* with an artistry and skill that would have made the queen herself proud. Equally elaborate but more modern are cakes covered with a newer material known as "rolled fondant," apparently pioneered in Australia and England. Rolled fondant has the consistency of stiff Play-Doh and is composed of sugar, gelatin, corn syrup, and glycerin—all cooked together, then kneaded like bread and cooled. It can be rolled into sheets less than a quarter-inch thick, cut with any knife or scissors, and then draped and pressed over any cake, producing, without

any great skill or talent, a porcelainlike surface. You can spot rolled fondant a mile away: Most routine cakes made with it have rounded edges and look a little like tea cozies. But the most extravagant wedding cakes today are first paved with fondant and then modeled, dyed, sprayed, and adorned with delicious buttercream ornaments, barely edible gum-paste flowers, or rock-hard *glace royale.*

Typically more delicate but less elaborate are the cakes of bakers like Sylvia Weinstock. The tiers are made of rich, tender cake, and the fillings can be soft and moist because the overall creation is assembled and decorated quickly. The icing is a smooth and scrumptious buttercream, the gum-paste flowers (always botanically correct) are made in advance but applied at the last minute, and the leaves can be piped on with green buttercream. On an even more ethereal gustatory plane, Markus Färbinger at the Culinary Institute of America fashions his flowers (on his rare floral cakes) only out of pure, pulled sugar—featherlight, translucent, and good to eat or dissolve in your coffee.

Which version you prefer depends on how important you think it is to actually eat the wedding cake. From Anglo-Saxon bridal biscuits and spiced medieval breads to the white Victorian sugar palaces, tasting and swallowing the bride cake was the last thing expected of the guests. Early in this century, in a rite of sexual magic, the bride was expected to pass small pieces of cake through her wedding ring and distribute them among female guests, who would tuck them in their left stocking and, once safely home, put the pieces under their pillows to inspire dreams of prospective husbands. Even today it is not uncommon for the cake to be wheeled out upon the dance floor, cut by bride and groom, and then distributed in little boxes, while another dessert is served. For the Japanese the cake is entirely symbolic—the fecundity of grain, the deathly whiteness, and something else as well.

This something else is crucial to understanding the wedding cake, and yet its meaning eluded me—until I read about an old Scottish custom. It was once the practice to pin a multitude of favors made from fancy ribbons to the bride's skirt; at some point during the wedding banquet these were plucked off by the guests. In the modern and less raucous version, the favors were pinned to the wedding cake. And now it is clear: The wedding cake is a symbol for the bride herself. As the wedding cake throughout the last century grew taller and whiter and more delicately decorated, it actually began to look like the bride. Now we understand wedding-cake mania, the reason why, for many brides, the cake is nearly as momentous as her dress. From a gastronomic point of view, the modern wedding cake is a bride you can put into your mouth.

—JEFFREY STEINGARTEN, *June 1998*

The author of *Bergdorf Blondes* and *The Debutante Divorcée* climbs the grand staircase at Sledmere House in Yorkshire, owned by her cousin Sir Tatton Sykes, in the dress created for her by Alexander McQueen. Photographed by Jonathan Becker, 2005.

The newlyweds drive off after the ceremony on July 2, 2005. Photographed by Christopher Simon Sykes.

PLUM SYKES
and TOBY ROWLAND
WEDDING

two days before her wedding, Plum Sykes is very calm. A shoe crisis has been averted: White satin Manolos have just arrived from New York. We sit amid perfectly aged chintz in Plum's suite at Middlethorpe Hall, a historic-house hotel in North Yorkshire. Sun streams in through giant-paned windows looking across green lawns dotted with bunnies. Around Plum are seating charts sprinkled with Post-its.

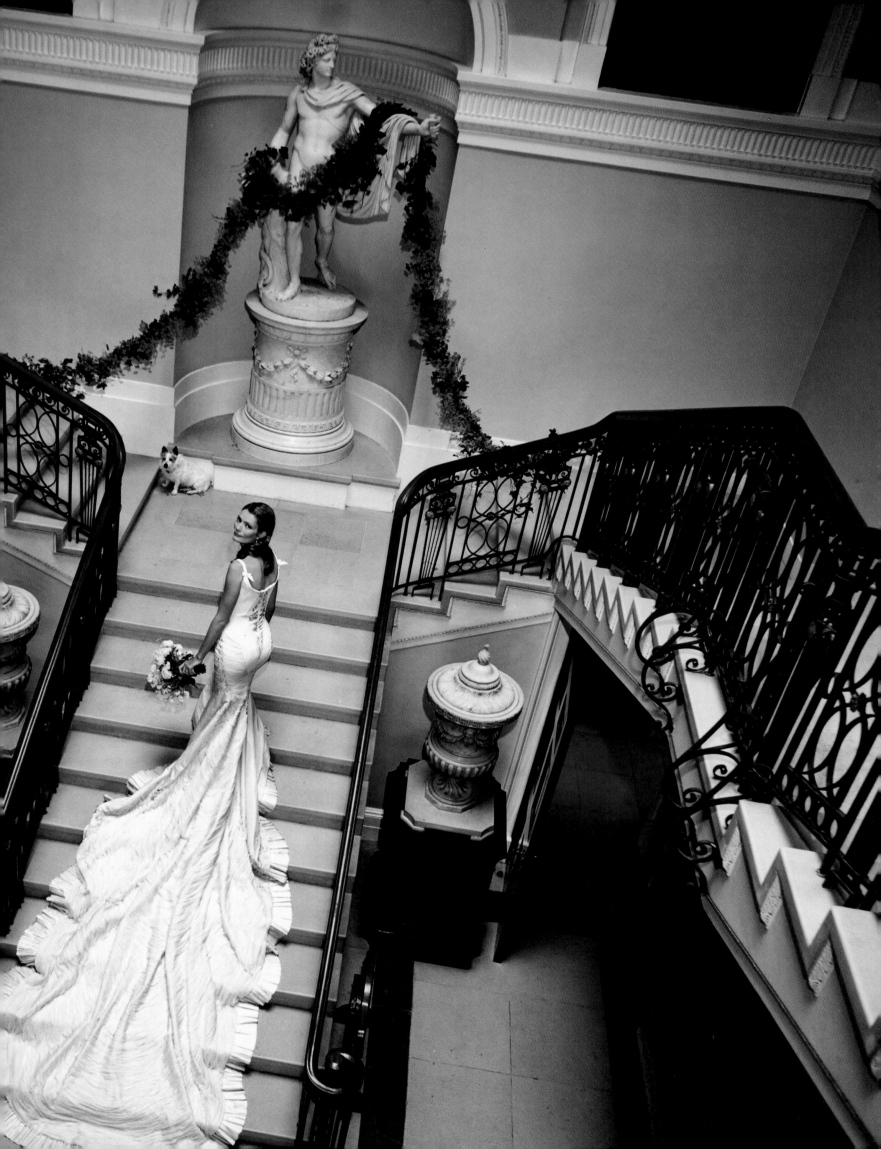

Robert Fairer photographed Sykes and her daughter, Ursula, in the country in Gloucestershire three years after the wedding.

The groomsmen made their way to St. Mary's Sledmere for the ceremony. The aisles were flanked by silver birch, white hydrangeas, and miniature rosebushes (*insets*). Photographed by Christopher Simon Sykes.

We have a broken-toed bride. Five days ago, she stubbed one in the kitchen in an excited bridal moment. The Blahniks are backup, she explains: the low-cut court shoes, made by Alexander McQueen in white paper taffeta embroidered with vintage rhinestones, are still in Italy. Over tea and scones, Plum tells me about her dress. Or dresses.

There had been ten fittings with McQueen. "It started with the idea of an inside-out dress," says Plum. "All the luxury is on the inside," she explains—a pure white satin corset. The lining is paper-silk taffeta with a tiny knife pleat peeping out from underneath an overlay of ruched net. "The net takes the shine of the white taffeta down to a gleam," she says. Sykes first met McQueen in London when she was working at British *Vogue.* "I've known him since I was 23. He is a maverick, but he knows the history of fashion. He is obsessed with silhouette. Early on, I asked if we should do this asymmetric. 'It's not a party dress,' he told me. 'It has to be immaculate.' Look at these." She holds up a beautiful pair of large pearl-and-diamond drop earrings. They are from the same source as her 1954 diamond-and-emerald engagement ring: Peter Edwards, a London dealer specializing in the forties and fifties. "They're my something borrowed."

"The flowers are unbelievable," she says over toast the following morning. It has been a busy night. At 12:30 A.M., she fired the makeup artist, who had raised her fee at the last minute. So Plum's hair person, Adam Reed, will bring a friend. There will be a 10:00 A.M. eye-shadow test tomorrow. She wants Priscilla Presley eyes.

Plum is checking out of the hotel. For the rest of the weekend, she will be on site at Sledmere, the grandly gorgeous family house, built in 1751, owned by Plum's cousin Sir Tatton Sykes. The church where the ceremony will take place,

St. Mary's Sledmere, is one of eighteen churches built by the Sykeses in Yorkshire.

"You look like a Parisian teenager," exclaims Plum's sister Lucy when she sees the bride wearing a vintage pistachio cheesecloth dress and green zebra espadrilles. The rehearsal goes smoothly. Plum and her fiancé, Toby Rowland, are in the front of the church, and I hear her whisper loudly, "Never, ever, leave me, ever." He laughs, squeezing her hand.

The wedding day is glorious. Pots of basil are mixed among white flowers outside St. Mary's, and guinea hens roam the lawns and gardens. The men look peacockish in their colorful vests and ties. Inside, the choir from Clare College, Cambridge, sings. Potted silver birch trees flank the aisles. At their base are white hydrangeas and tiny rosebushes that will be replanted in the garden. "I want everything growing," says Plum.

After the wedding, the guests walk a short way to Sledmere House. Tea is served in the entryway as well as champagne. When I see Plum, she lifts her knife-pleat hem to show me: There they are, the backup shoes. No, she says, the toe does not bother her. Today nothing could bother her.

Dinner is served under the tent: pâté made in a neighboring village, followed by barbecued Yorkshire lamb, then raspberry fool with fruit salad and meringues for dessert. Darkness falls over the ledged lawns as sheep graze in the distance. At eleven, there are spectacular fireworks, a present from Toby's mother. Someone says they've heard Plum's dress will be on permanent display at Sledmere, alongside the Sykes-family christening gowns.

"Fitting," says an Englishwoman.

"I just touched it," says a friend. "It's soft . . . like I was stroking a swan's bottom."

—MARINA RUST,
October 2005

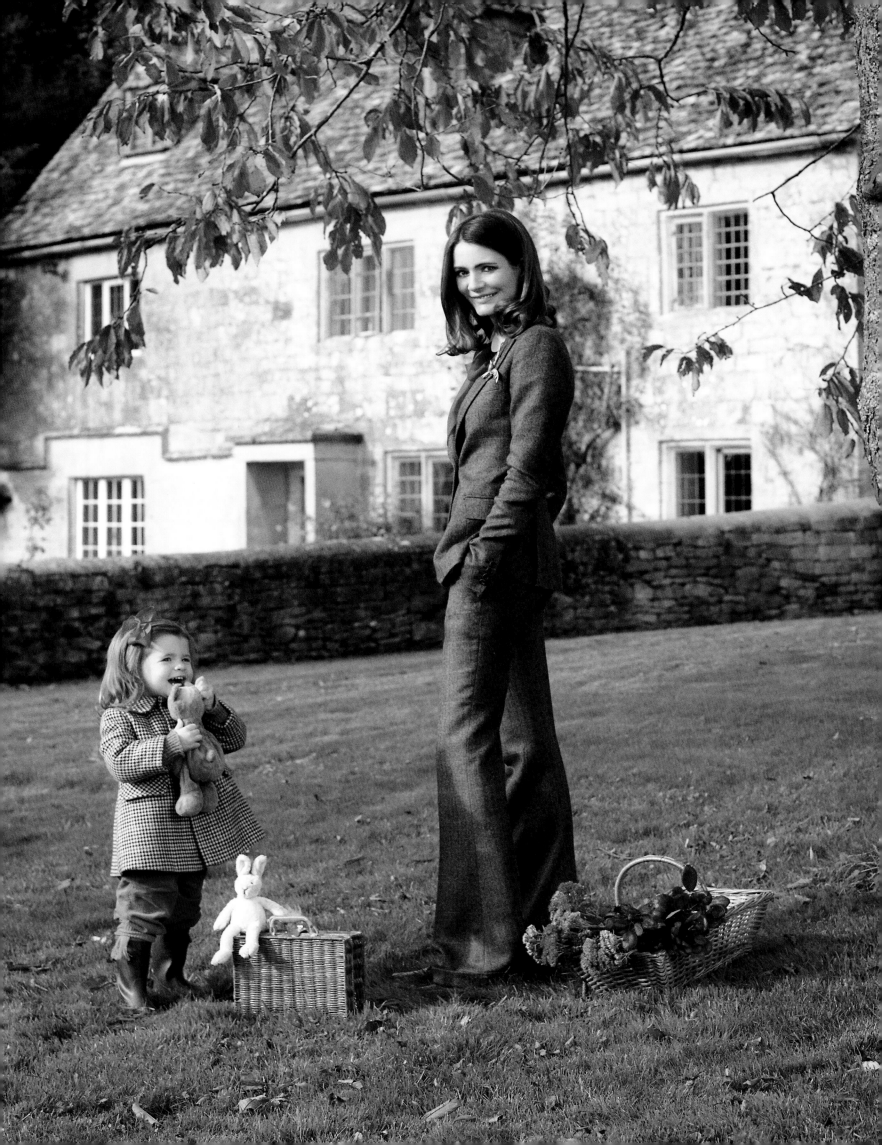

THE BLACK and WHITE BALL

So much beauty, power, talent, and celebrity hasn't been collected in one room since a great Inaugural Ball. And as for luxury of dress and surroundings, this party made most Inaugural Balls seem Spartan. Yet, as Diana Trilling commented the morning after, the evening was a success because it was personal and "basically a very nice dance for friends."

Why? Well, as everyone knew for months before it happened—since last summer, in fact, when guests first began conferring with other guests about what to wear—Truman Capote was giving a party.

And not just any party, but a great masked ball that would bring guests from Europe and Asia, not to mention Kansas, California, and Harlem. No one with an acquaintance one inch less broad than Truman's could announce it as he did: "Just a party for the people I like."

The guest list of 540—inscribed painstakingly by hand, like all his writing, in a ten-cent notebook—reflected the full range of ten years' work and travel: one maharaja, a Kansas detective, half a dozen presidential advisers, businessmen, editors, a lot of writers and performers, some artists, four composers, several heiresses, one country doctor, and a sprinkling of royals, with defunct titles attached to very undefunct people. Thundering publicity, which leaned heavily on the maharaja-heiress side of things, soon made it the Party of the Year—possibly of several years—leaving the host and everyone involved some combination of pleased and stunned.

As the day approached there was growing conviction—false, but intriguing—that the invitation list was not just friends but a new 400 of the World. Pressure from would-be guests became enormous, especially from those who were strangers to the host but felt their social status alone entitled them to go. Truman resisted, but the requests, even threats, finally forced him to cut off the phone and retire to the country.

The week before the party, international guests began arriving in New York like the family of the groom for a wedding, and caused a string of accommodation problems and preparty parties. A whimsical rumor that we were all being called together for some purpose—probably the announcement of the End of the World—spread by magic or telephone. Jerry Robbins wondered if we were the list of those to be shot first by the Red Guard. John Kenneth Galbraith said no, as *he* was on it.

Torrential rains made the End of the World seem possible, but at eight o'clock the Capote master plan began: Hostesses chosen by Truman received ballgoers in groups prearranged by him for dinners at home. By nine, his thoughtful combinations, old and new friends, were launched on a thoroughly unjaded good time. Before the party began, it had already gotten off the ground. Marion Javits, forgetting her painted-on mask and sequined eyebrows, discussed politics earnestly with her dinner partner, Walter Lippmann. At Mr. and Mrs. Leland Hayward's, Mia Sinatra leaned against her husband's shoulder and explained that she was the brains in the family. Alvin Dewey answered

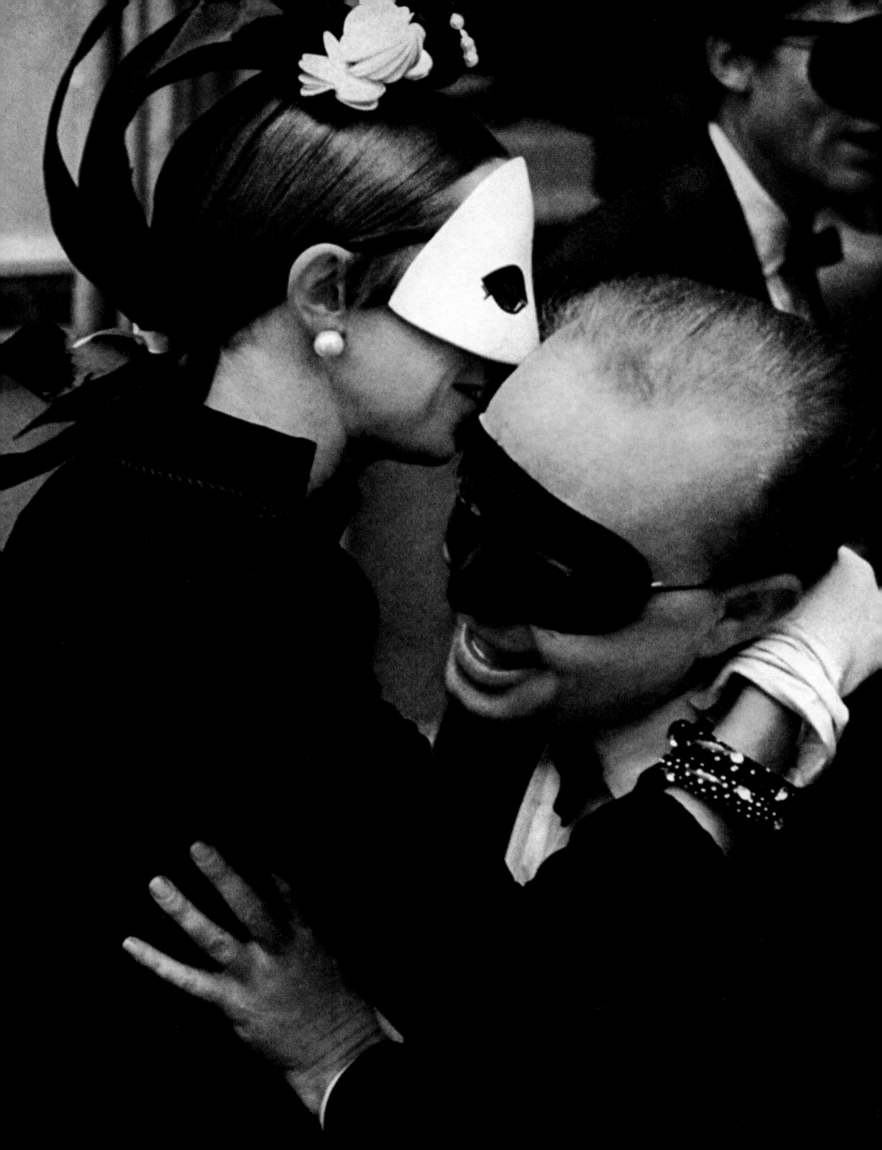

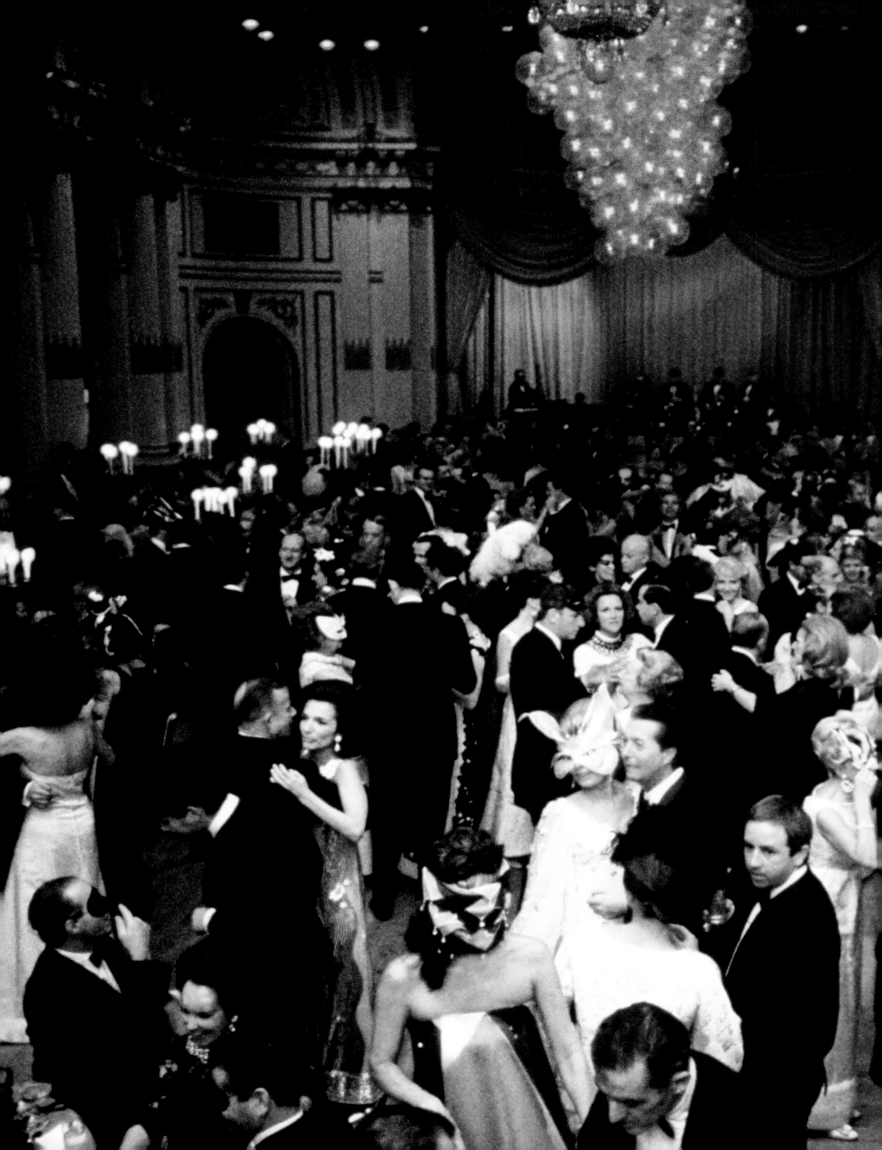

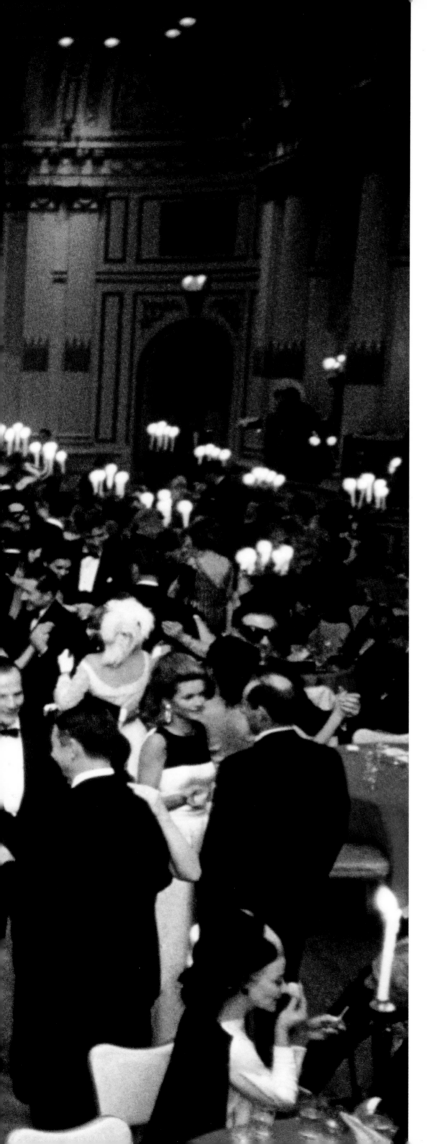

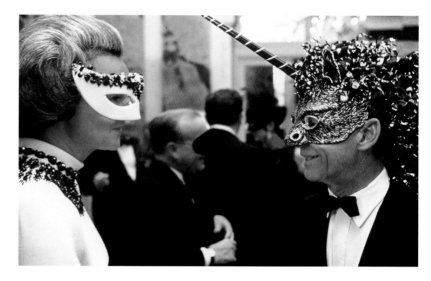

The 540 guests danced to the music
of Peter Duchin and the Soul
Brothers, and unmasked at midnight.
Photographed by Elliott Erwitt.

The guest of honor, Katharine Graham (*below*),
talked to the society decorator William Baldwin,
whose unicorn mask was designed
by the celebrated Tiffany window dresser
Gene Moore. Photographed by Lawrence Fried.

questions about problems of the Clutter case, just as dignified and direct in the Paley dining room as he had been in Kansas during the murder investigation in *In Cold Blood*. Cecil Beaton performed the warm and gentlemanly feat of remembering everyone, even slight acquaintances, and putting them instantly at ease. Mrs. George Backer gave her dinner party as calmly as if she hadn't spent a hectic afternoon at the Plaza supervising the ballroom decoration, which she had designed.

Arriving at the ball, guests were already in high-spirited groups; no solitary couples searching desperately for someone they knew. The host and his guest of honor, Kay Graham, greeted each one before plunging them into the great black-and-white spectacle of the ball, a color scheme inspired by Cecil Beaton's Ascot scene for *My Fair Lady*. Feathers, ball gowns, masks, and jewels all whirled round what Truman chose as "the only truly beautiful ballroom left in New York": The effect was like some blend of Hollywood, the court of Louis XIV, a medieval durbar, and pure Manhattan.

Galbraith turned out to be one of the few men who dance well and talk well at the same time. David Merrick held his partner well away, and appeared to be counting the house. Wyatt Cooper bounced on the balls of his feet, and Philip Roth managed everything but rock 'n' roll. If Ralph Ellison's musicianship wasn't obvious in his novels, it was on the dance floor, and Billy Baldwin, in a unicorn headdress, danced *everything*.

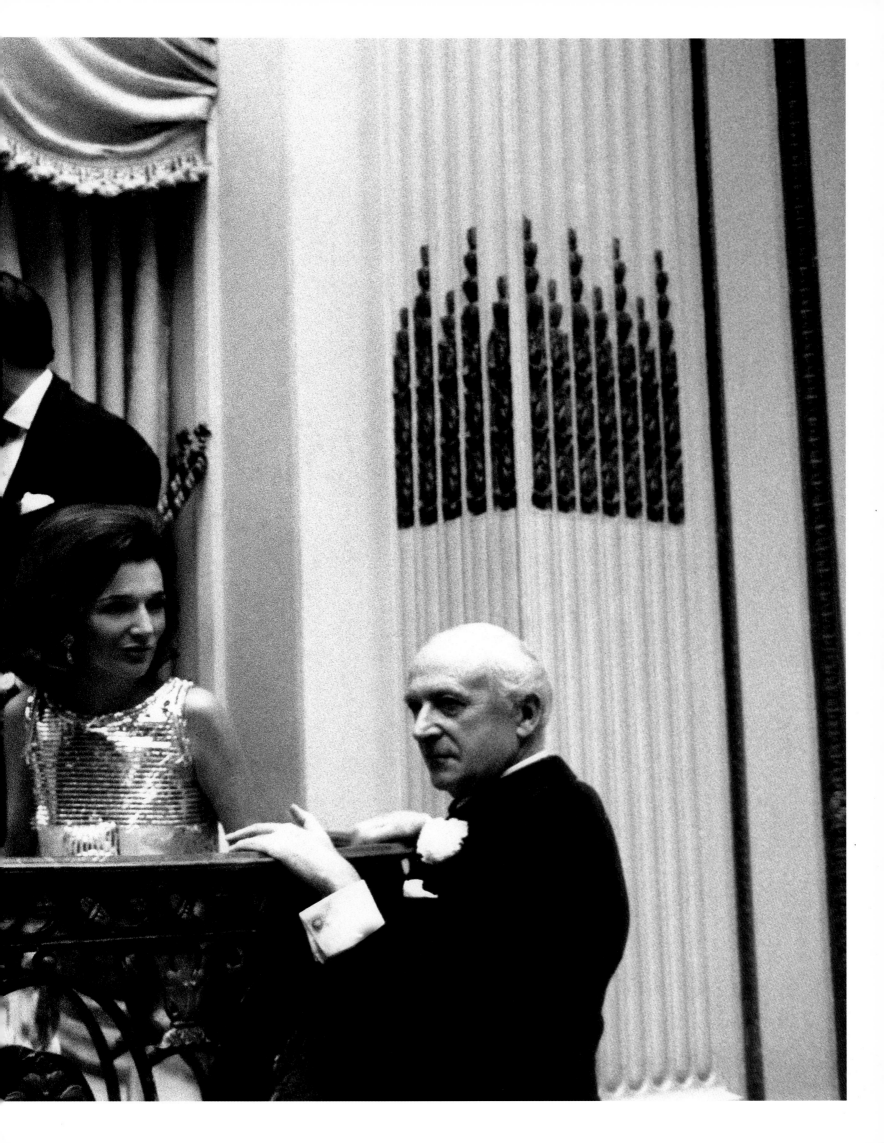

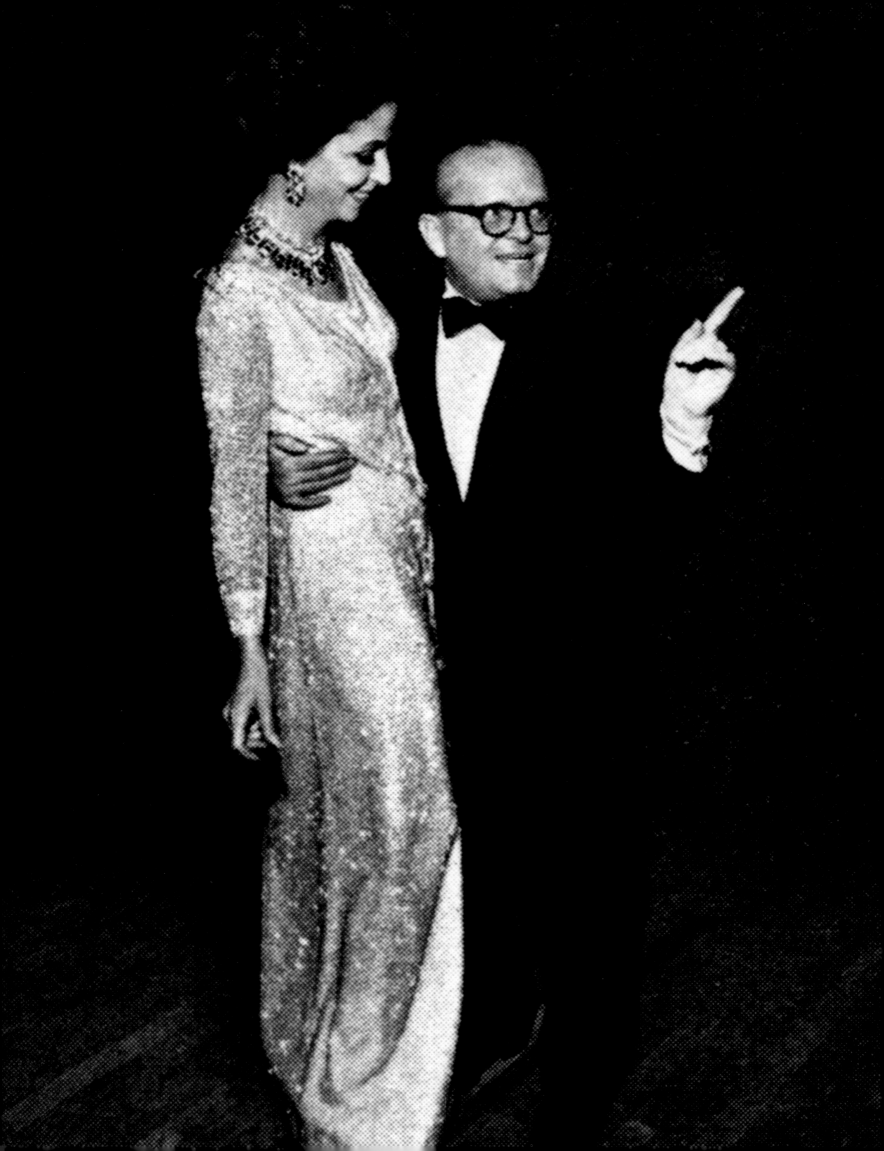

Most guests recorded bits and snatches of mental film as the evening flowed on, scenes that will flash back for some time to come. Sampling my own, I find:

. . . The path to the ballroom lined solid with television cameras, newsmen shouting at each arrival, "Who are *you*?"

. . . A sidewalk spectator, awed by Amanda Burden, saying, "She must be European. *Our* girls don't look that good."

. . . Marianne Moore, without her tricorne hat, surveying an elevator full of ladies in silks and feathers, eyes shining for the party; astonished everyone knows who she is.

. . . Adolph Green, who has just clicked his heels together from sheer high spirits, being told, "You dance just like Fred Astaire," by a pretty passerby who turns out to be Adele Astaire Douglass.

. . . The detective, hired to guard the ladies' jewelry, who falls in love with the ladies, especially Lee Radziwill, and ends by asking her to dance.

. . . Beverly and Norman Mailer making a dance of balancing on an imaginary tightrope.

. . . Lynda Bird Johnson's Secret Service men, who, in black tie and black masks, look more like Secret Service men than ever.

. . . The 60-carat diamond dangling over the bridge of Principessa Pignatelli's nose, and the grab-the-stone-and-run look that comes over everyone who sees it.

. . . John Kenneth Galbraith dancing through the crowd, holding a silver candelabrum.

. . . George Plimpton, taking the candelabrum on the move like a one-handed pass, and carrying it on to . . . whom?

. . . Lauren Bacall Robards and Jerry Robbins dancing so well that no one could resist stopping to watch.

. . . A circle of people dancing around a chair with Norman Podhoretz in it.

. . . Pamela Hayward looking regal and smashing in the only real ball gown in the place.

. . . Harry Kurnitz, totally recognizable with his eyeglasses on over his mask.

. . . Truman Capote in a 39-cent mask from F.A.O. Schwarz, introducing everybody, looking after everybody, having a very good time.

. . . A member of the Soul Brothers rock-'n'-roll group assessing Barbara Paley: "Wow!"

. . . Kay Graham dancing with Capote's apartment-house doorman—who served as official invitation checker in a dinner suit rented by Truman—and thanked by him for "the happiest evening of my life."

. . . Glenway Westcott, surveying the scene from a balcony, remarking with surprise that "there are so many intellectuals."

. . . Frank Sinatra with Mia, the Cerfs, and the Haywards, using his old friends, the Secret Service men, to get his group out the back entrance at 3:00 A.M.

When the music stopped at 3:30, the many remaining guests looked surprised and stayed to talk. Reluctant to leave one another and let the spirit go, some went off to all-night restaurants. Capote thanked each one as if he or she alone had made the party, and wandered off down the hall looking much too boyish and serene to be a major writer, much less the perpetrator of a ball selected by the Museum of the City of New York—along with a party for General Lafayette, a dance given by the city for the Prince of Wales in 1860, and George Washington's Inaugural Ball—to live on in its archives.

A first-rate mind rarely devotes itself to the creation of a social event. But when it does, Watch Out.

—GLORIA STEINEM, *January 1967*

Peter Gimbel, flanked by (*left*) Principessa Luciana Pignatelli, with a 60-carat diamond on her forehead, and (*right*) Contessa Consuelo Crespi.

Mia Farrow (*below*), then 21, had recently married the black-masked Frank Sinatra.

Oscar de la Renta and his future wife, Françoise de Langlade, former editor in chief of French *Vogue* (*bottom*), in cat masks, being greeted by Capote. Photographs by Lawrence Fried.

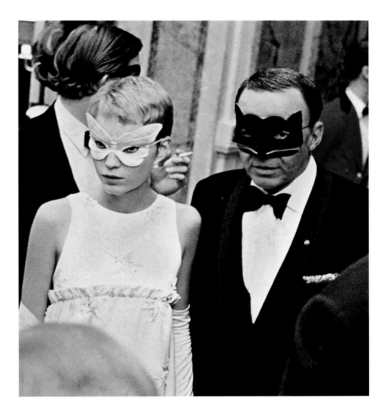

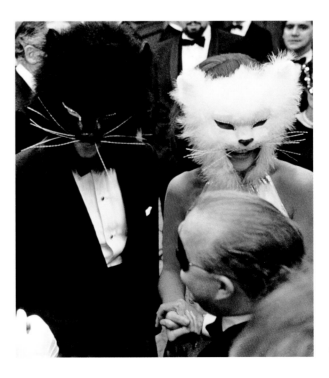

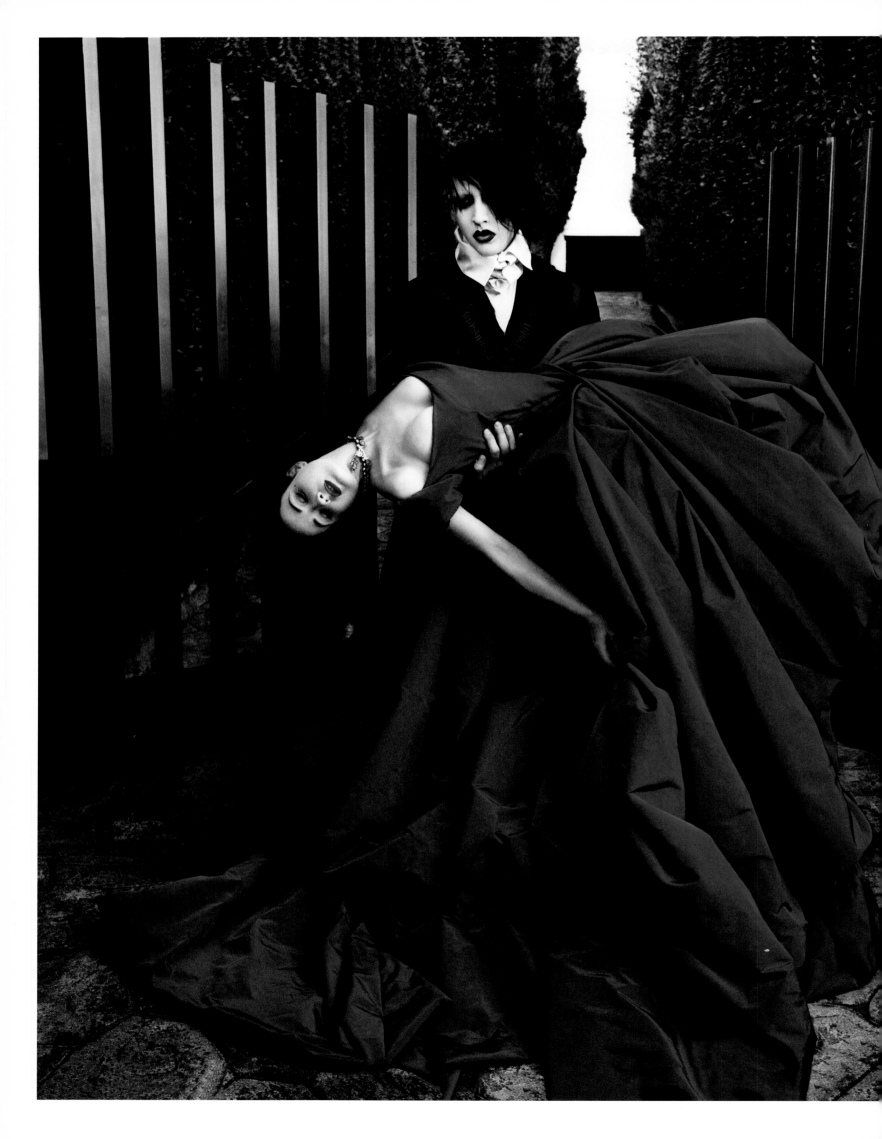

The groom carries his bride across
the threshold of their Los Angeles home.
Her Vivienne Westwood wedding gown was
made of seventeen meters of Swiss silk faille.
Photographed by Steven Klein, 2006.

DITA VON TEESE
and
MARILYN MANSON
WEDDING

born in small-town Rochester, Michigan, Dita Von Teese always hankered after a conventional church wedding. As some considered her husband-to-be something of an Antichrist, however, this proved a challenge. On tour in St. Petersburg, Russia, she finally persuaded Marilyn Manson and his skeptical band to visit a church that she had singled out for its golden magnificence. At the entrance was an old-fashioned sign with the circled silhouette of a shapely stiletto shoe—and a thick red line slashed across it. "Basically, they might just as well have put my picture there!" remembers Dita, who realized, as the band members collapsed in hysteria around her, that a traditional church was not for her, either.

So the couple's civil ceremony took place at their home in Los Angeles. The full-dress wedding—where Dita was able to unleash her Scarlett O'Hara fantasies with the help of Vivienne Westwood, and Manson released his inner Captain Hook courtesy of John Galliano—took place in Ireland the following weekend at the Gothic castle of German artist Gottfried Helnwein, a forbidding Hammer House of Horror edifice

At a Gothic castle in Ireland, the Chilean director Alejandro Jodorowsky presided over the wedding in a white costume from one of his movies. Manson's piratical outfit was designed by John Galliano.

The milliner Stephen Jones created Von Teese's headgear, including this plumed hunting number (*inset*).

following pages:
The Gothic-themed dinner, with Waterford crystal and black Irish linen. The Dior-clad bride and her groom take to the floor for the first dance. Photographs by Robert Fairer.

complete with turrets, crenellations, and a lone bagpiper.

In the double-height Great Hall, a baronial table covered with ruby-colored Swarovski crystals held some of the 4,000 black and crimson roses that florist Hayley Newstead arranged in great volcanic eruptions. In the dining room, the newlyweds sat together between two long banqueting tables, lit by the candlelight from towering candelabras spilling with the garnet fronds of love-lies-bleeding, roses, and clusters of dark-burgundy grapes. The tables glinted with the light of black-and-ruby Waterford crystal goblets and were scattered with porcelain blooms that Wedgwood specially made in black basalt. The tablecloths and napkins were custom woven in crisp black Irish linen; the napkins monogrammed black on black with the couple's elaborate Victorian initials. This motif also decorated the Wedgwood side plates and was woven into the black lace curtains that hung at the high windows of the principal reception rooms and invested them with a disquieting, Edgar Allan Poe air of mystery.

As the first of the 60-something guests arrived—including a smoky-eyed Lisa Marie Presley in Goth black chiffon—in an upstairs gallery Stephen Jones carefully stitched the veiling and mink pom-poms onto the bride's exquisite tricorne hat. "A better hat model there isn't," he said. Moments later, after Dita's maid of honor, Catherine D'Lish, got out of the bath in the dressing room she shared with the bride, there was a deafening crack, and the room's entire ceiling collapsed, turning the space into a shocking bomb site of dusty rubble, buried cosmetics, and alarmingly hefty slabs of plaster. "Some Goth-kid Manson fan is going to say it's successful black magic!" said Dita, sighing. "My kids all say the castle is haunted," added Renata Helnwein.

Dita deftly cross-laced herself into the extraordinary corset that Mr. Pearl had fashioned to create her seventeen-inch waist. Then, with all hands on deck, she was maneuvered into the vast crinoline

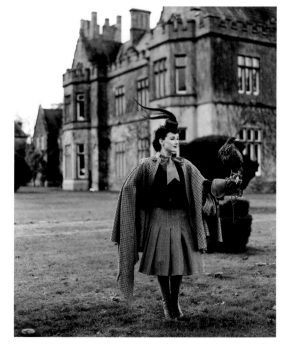

petticoats that supported her gown. "I think the dress weighs probably as much as Dita herself!" said Brigitte Stepputis, Westwood's couture directrice. The breathtaking gown was created from seventeen meters of Swiss silk faille in a dazzling shot violet, draped to swirl and eddy around her hand-span waist and milky bosom, and then spread into eighteenth-century volumes in the skirts. "The dress, which we adore, especially for you, you Princess," read Vivienne Westwood's note to the bride.

The moment arrived. "Wow!" Manson says, seeing Dita in her wedding finery. A piper leads him downstairs. Dita is led by the Berlin big-band-meister Max Raabe, singing a haunting, unaccompanied "Ave Maria." There is a collective gasp as Dita enters the drawing room—an exquisite eighteenth-century Dresden figurine come to life. Alejandro Jodorowsky, who will preside over the ceremony, is an astonishing sight himself in an all-white version of a costume from his cult movie *The Holy Mountain,* complete with towering stovepipe hat and platform shoes.

Dita has to force Manson's too-small ring on, and Jodorowsky announces, in English, that he may kiss the bride, as a chorale version of the Beatles' "Across the Universe" fills the room and the guests drift next door to take glasses from a champagne pyramid. Christian Louboutin sweeps Dita up for an impromptu waltz, and suddenly it's *The King and I,* the bride's vast purple crinoline swinging about her as Deborah Kerr's did when she asked Yul Brynner, "Shall we dance?"

Guests seated at the two long tables feasted on Dublin Bay prawns, wild Irish lobster, and Angus beef, and cleansed their palates with blackberry-and-"absinthe" sorbet. Dita had changed into Gaultier's black velvet for dinner, where her beloved stepfather, Dan Lindsey, allowed reality to peek through the black lace curtains when he toasted the happy newlyweds—Heather and Brian.
—HAMISH BOWLES,
March 2006

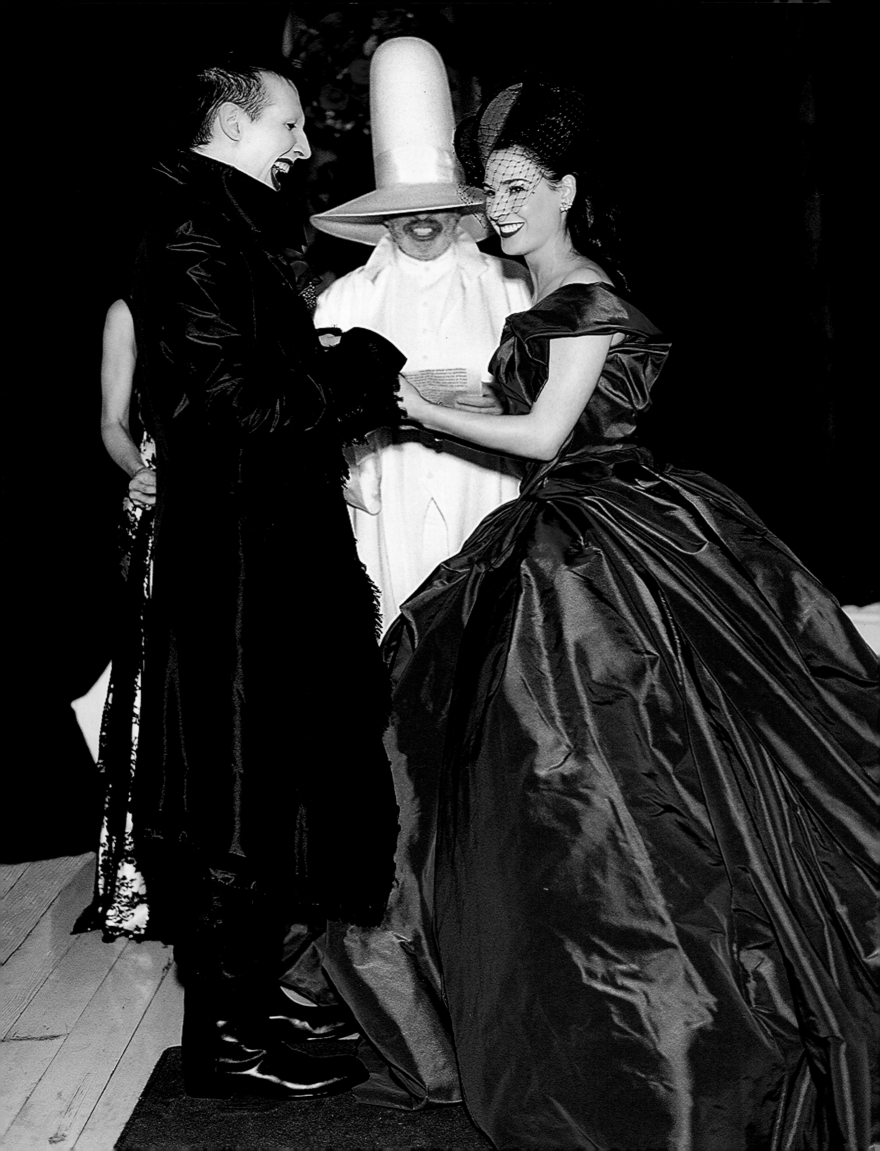

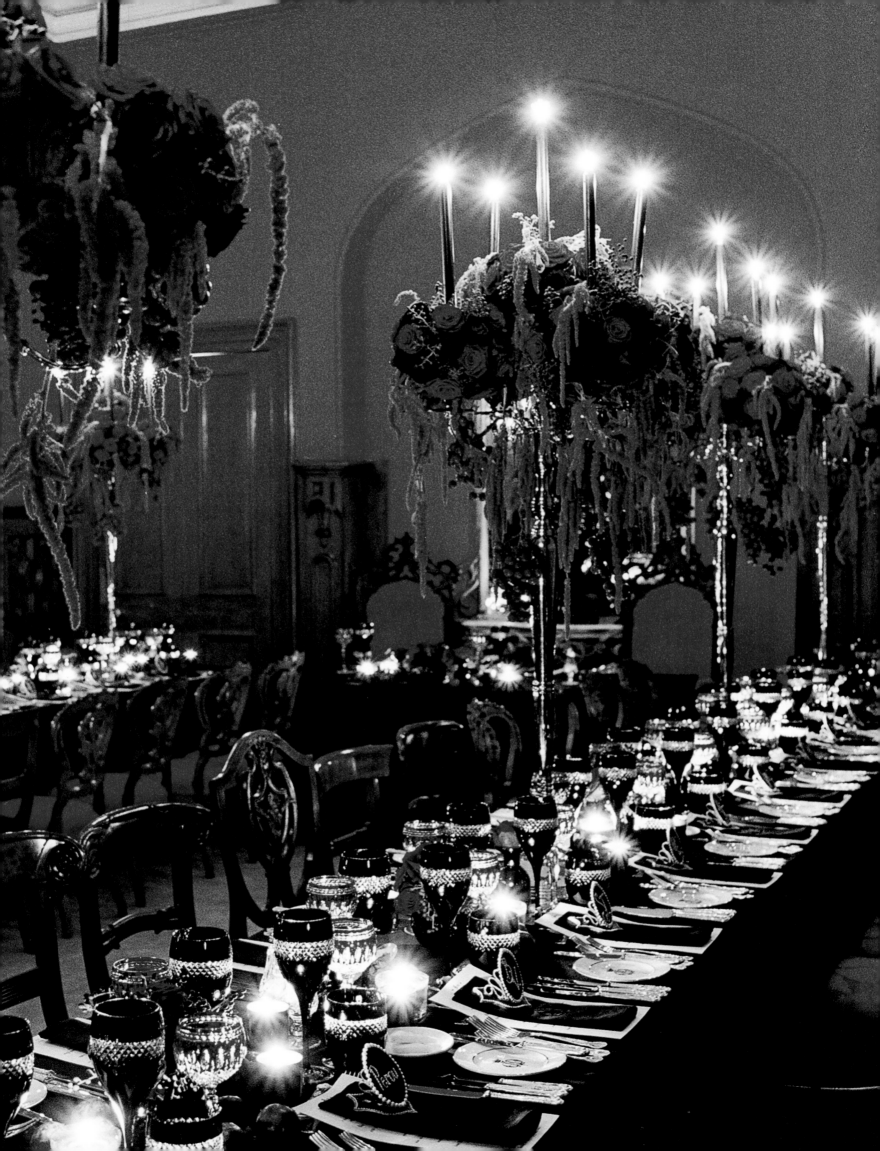

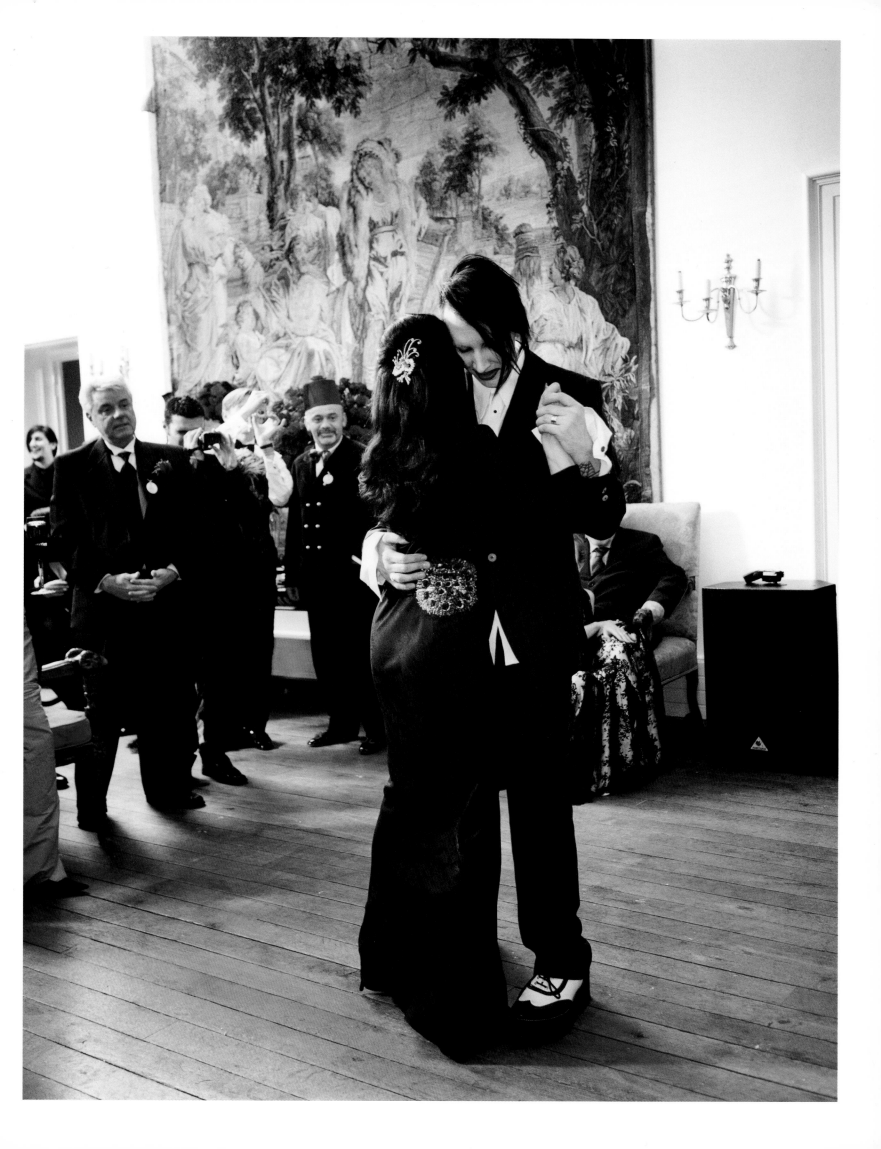

MINNIE CUSHING
and
PETER BEARD WEDDING

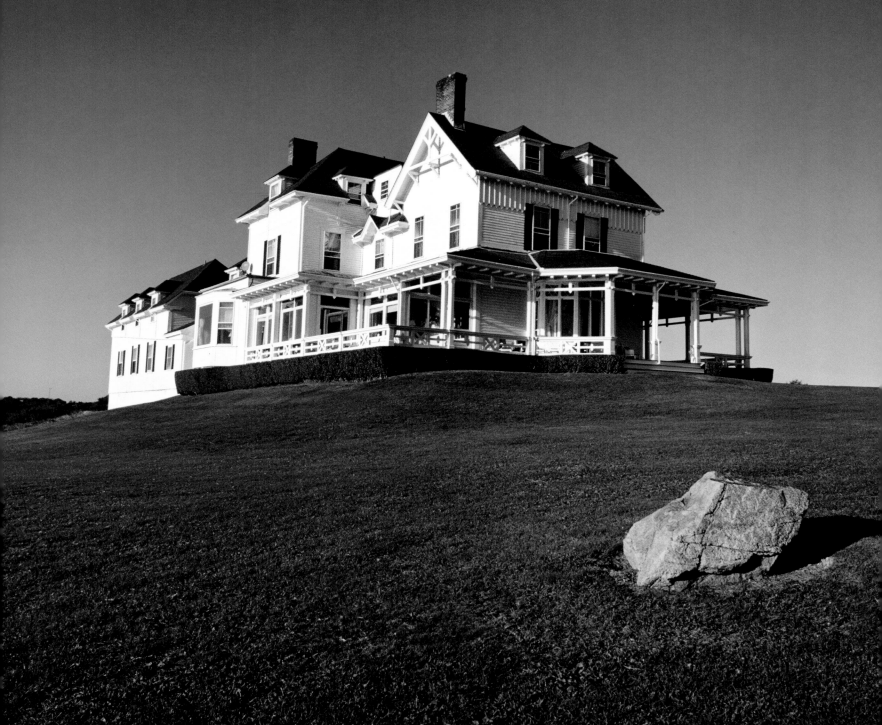

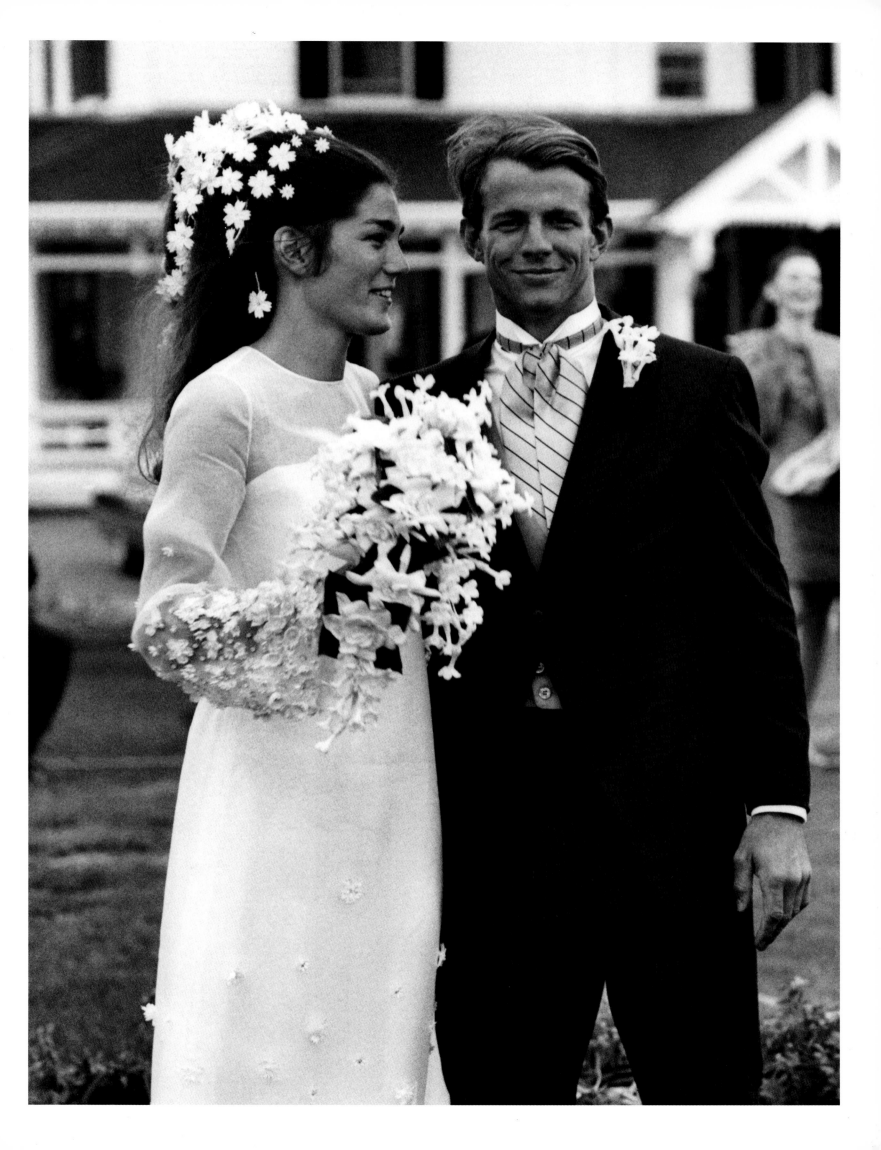

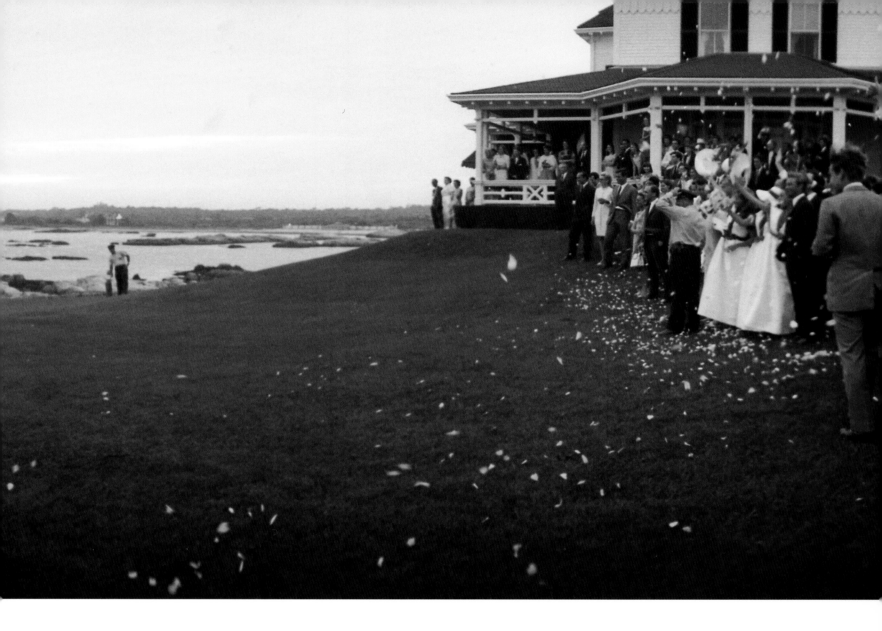

previous pages:
Minnie Cushing met Peter Beard in Kenya, where he had gone to photograph Masai warriors and wildlife after graduating from Yale. Photographed by Toni Frissell. They were married in 1967—she in Oscar de la Renta with petal-strewn hair—at the Ledges, her family's Newport summer cottage, built in 1867. Photographed by Jonathan Becker.

———————————

The newlyweds leave for their honeymoon by helicopter (*above*), as guests look on and flowers are blown across the vast lawn.

———————————

Cushing on a Honda motorcycle (*left*) in Newport, 1965. Photographs by Toni Frissell.

———————————

Frissell—who had worked for *Vogue* in the thirties and for the Women's Army Corps during World War II—captures Beard drinking tea before the ceremony (*right*).

———————————

following pages:
In the entrance hall of the Ledges (*left*) is a Chinese-motif mural painted by Howard Gardiner Cushing, the bride's grandfather. Howard Cushing's studio (*right*) was transformed into a book-lined party room by his children. Photographs by Jonathan Becker, 1999.

The groom records their helicopter departure. They honeymooned in the Bahamas, Europe, and Nairobi, where they would eventually settle.

The couple (*below*) arrive at the rehearsal dinner dance. Photographs by Toni Frissell.

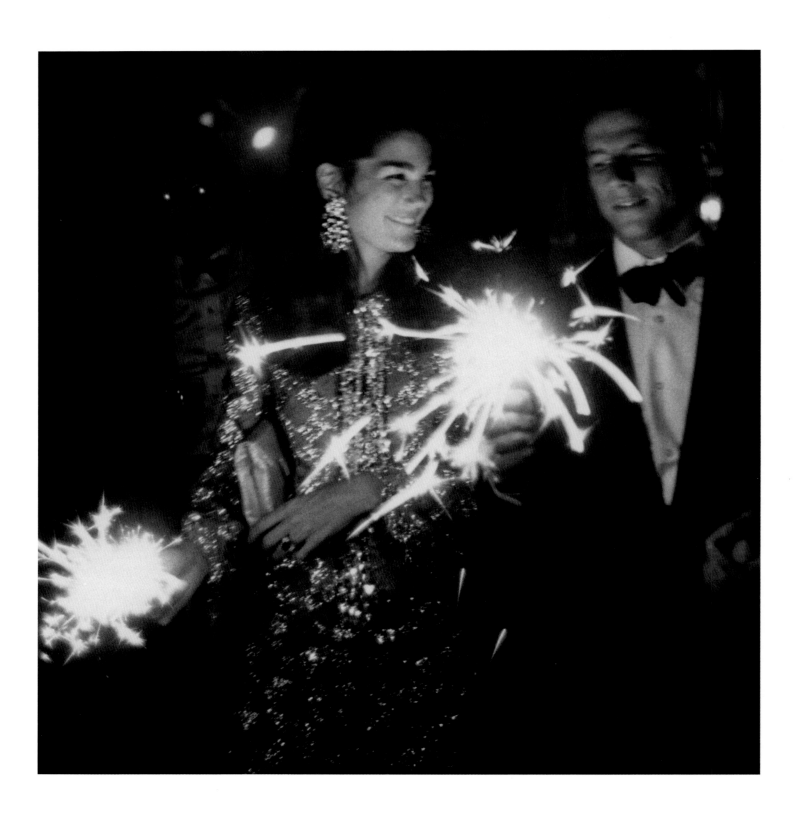

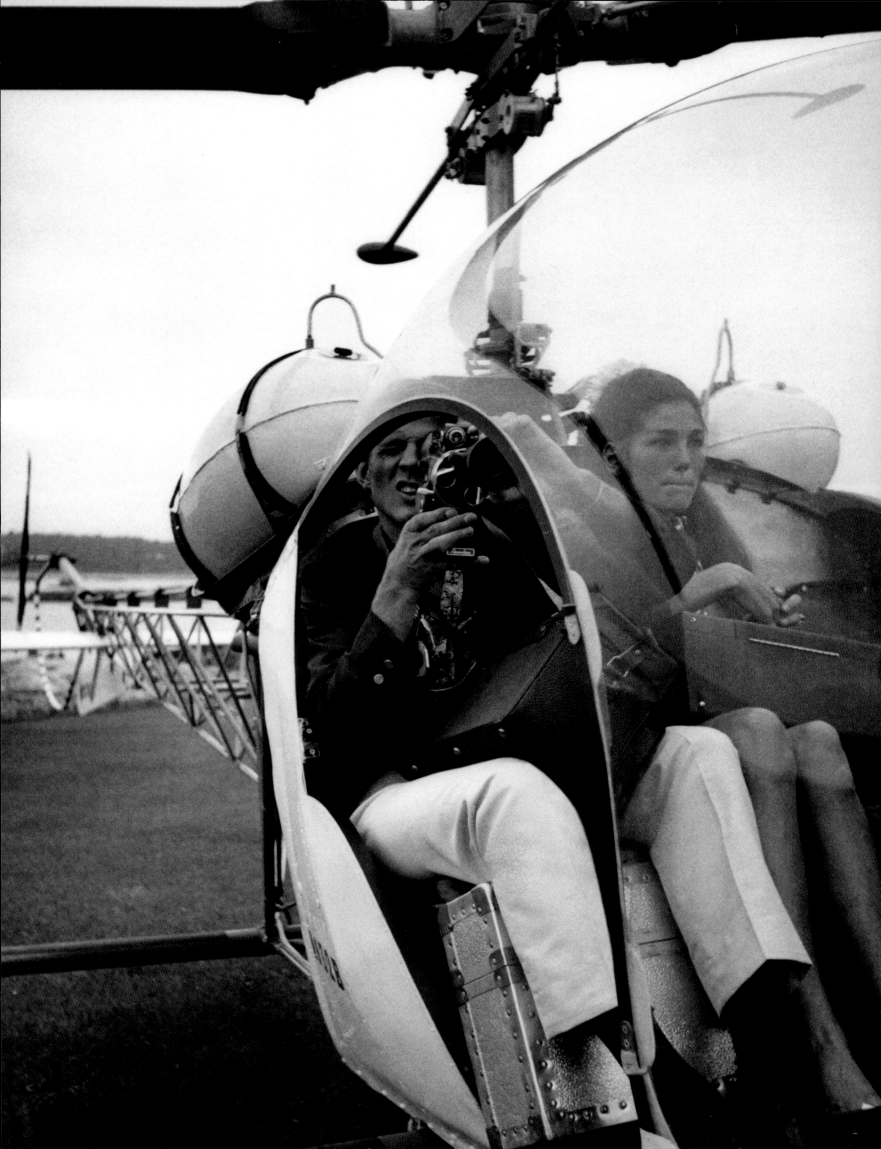

THE COSTUME INSTITUTE GALAS

after her retirement from the magazine in 1971, *Vogue*'s fabled editor Diana Vreeland became special consultant to the Costume Institute of the Metropolitan Museum of Art, and in 1972 she assumed the running of the annual Costume Institute gala, a fund-raising initiative that became an ever-more-glamorous arena for high fashion.

In the mid-nineties, the guest list opened up further to reflect the magazine's embrace of Hollywood, the music scene, politics, the arts, and international uptown and downtown society, and the galas came to establish and confirm fashion trends, both through the exhibitions themselves and through the bravura sartorial choices of the guests. "It made you feel that the epicenter of fashion was not Europe at all but actually New York," said Simon Doonan, "because this is where all the sewing, all the couture, all the runway becomes

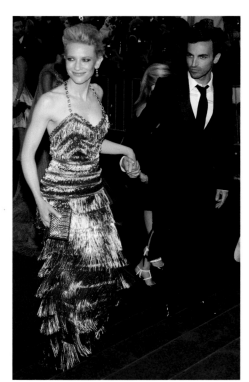

reality." In 2005 Lauren Davis told *Vogue*'s William Norwich, "It is amazing how much effort people put into how they look tonight. It reminds me of my senior prom. Someone said this is like a wedding, but at a wedding you cannot wear your most exquisite gown for fear of committing the ultimate faux pas, upstaging the bride. That isn't a problem here. At the Met, it is a faux pas *not* to wear your most elaborate dress."

Through the eyes of the curators, primarily Harold Koda, Andrew Bolton, and the late Richard Martin, the Costume Institute's own extraordinary holdings (often complemented by loans from international private and public collections) have suggested themes that run the gamut from individual design innovators (Poiret, Chanel, Gianni Versace) to more abstract notions such as "Goddess," as well as historical periods (including the eighteenth century of *Dangerous Liaisons*) and genres ("AngloMania," "Rock Style," and "Superheroes"). In

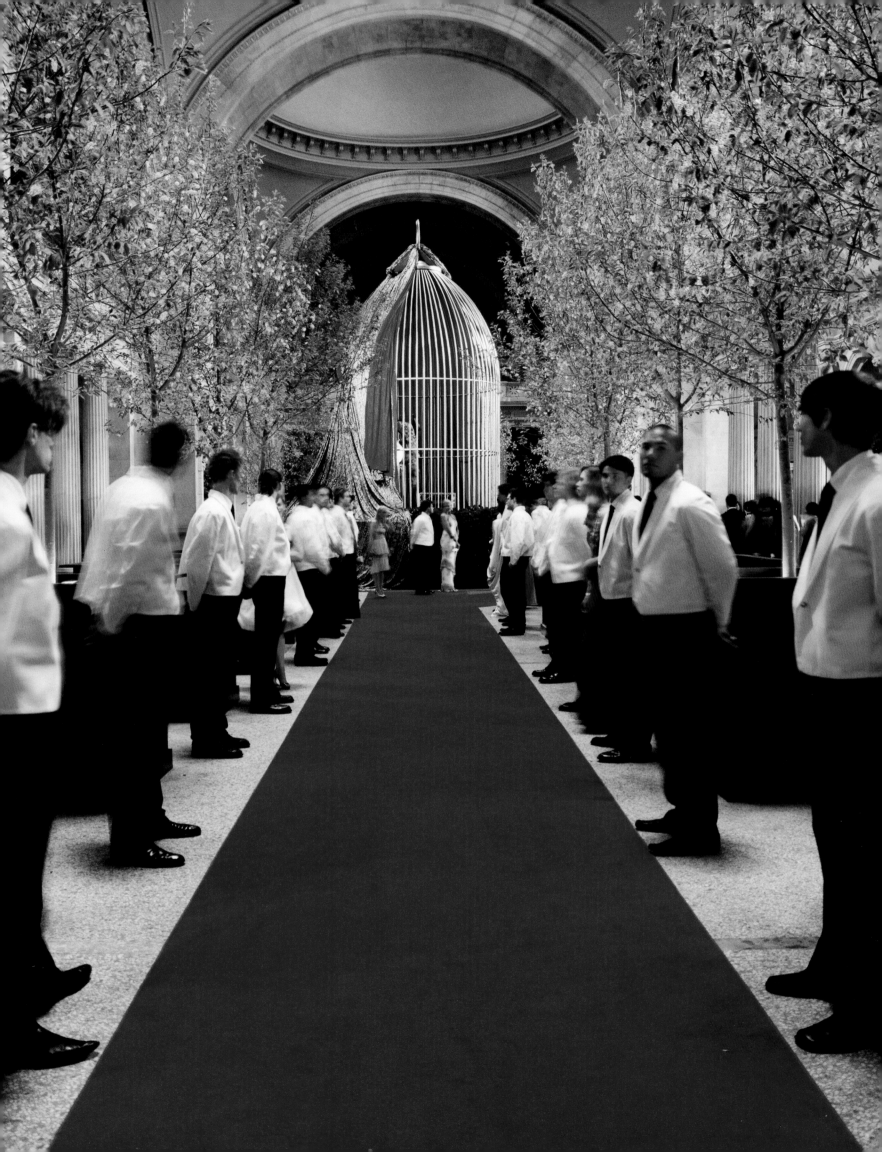

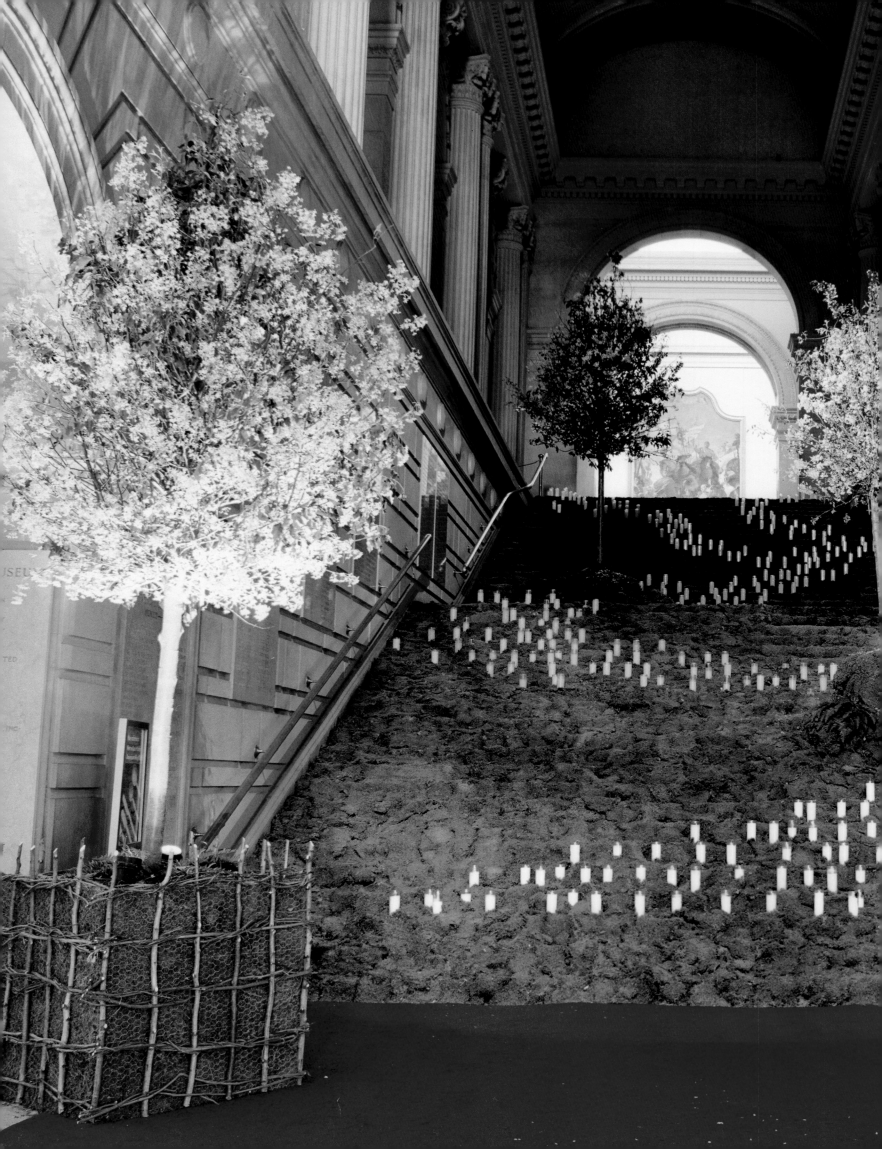

For the 2006 gala "AngloMania," the main staircase was transformed into an enchanted garden path, dotted with twinkling tea lights. Photographed by Michael Lisnet.

turn, each of these themes has inspired idiosyncratic interpretations from the guests, and subtly or overtly suggested future fashion developments.

In 1997, the Costume Institute celebrated Gianni Versace, the great Italian showman of fashion, following his tragic and untimely death earlier in the year. The theme brought the designer's eclectic world into the hallowed halls of the museum, and for the first time Hollywood and the worlds of art and music collided with Manhattan society's Old Guard and a flotilla of young pretenders, changing the face and energy of the gala forever. The following year's "Rock Style" exhibit continued the trend, with Puff Daddy entertaining guests who included Whitney Houston, coruscating in Dolce & Gabbana crystals, and Jennifer Lopez, "backless in Versace."

The tenor changed dramatically for 2001's "Jacqueline Kennedy: The White House Years," where Senator Hillary Clinton, in leopard-print taffeta, upstaged stately First Lady Laura Bush. After the events of 9/11, the gala went on hiatus for a year, but for 2003's "Goddess," an exhibition that addressed the classical ideal seen by designers from Madame Grès to Tom Ford, "a thousand fashion dreams [became] shining reality." "Everybody feels they are a goddess!" says C. Z. Guest, "scintillating in Oscar de la Renta's gold brocade," *Vogue* reported. "The girls really rose to the challenge! They made a knockout, and I think it's fabulous!" "Even in a museum full of goddesses," noted *Vogue,* "the arrival of cochair Nicole Kidman, heralded by the blinding light of a thousand flashbulbs, sets the bar for glamour. With her complexion like sugar-glazed marzipan, a galaxy of sparkles on her nude Tom Ford gown, a waterfall of Bulgari diamonds at her ears—and with fellow Oscar winner Adrien Brody on her arm—Kidman is indubitably the evening's Aphrodite."

At "Dangerous Liaisons: Fashion and Furniture in the 18th Century," in 2004, Amanda Brooks wore panniers, Amber Valletta's hair was molded into the form of a powdered wig ("I am the evening's dangerous liaison"), Blaine Trump "had a beehive high enough to warrant warning signs for low doorways," and Stella Schnabel's antique tiara from Fred Leighton was "perilously crooked."

Climbing the steps to the 2005 Chanel gala, William Norwich, escorting Selma Blair, "could smell the scent of some 7,000 gardenias flourishing inside." The menu was inspired by Coco Chanel's favorite Ritz recipes, and Renée Fleming, accompanied by Dmitri Hvorostovsky, sang Mahler. "Every lady here was wearing *the* dress," noted Norwich. "The dress of her dreams . . . from Jessica Simpson to Mercedes Bass, from L'il Kim to Marina Rust, full gallop, full stop."

For 2006's "AngloMania: Tradition and Transgression in

Christian Dior Haute Couture's crinoline gown from 1998 was featured in Patrick Kinmonth and Antonio Monfreda's designed installation for "AngloMania."

Philip Treacy, Kate Moss, and John Galliano at "AngloMania" (*below*). Photographs by Robert Fairer.

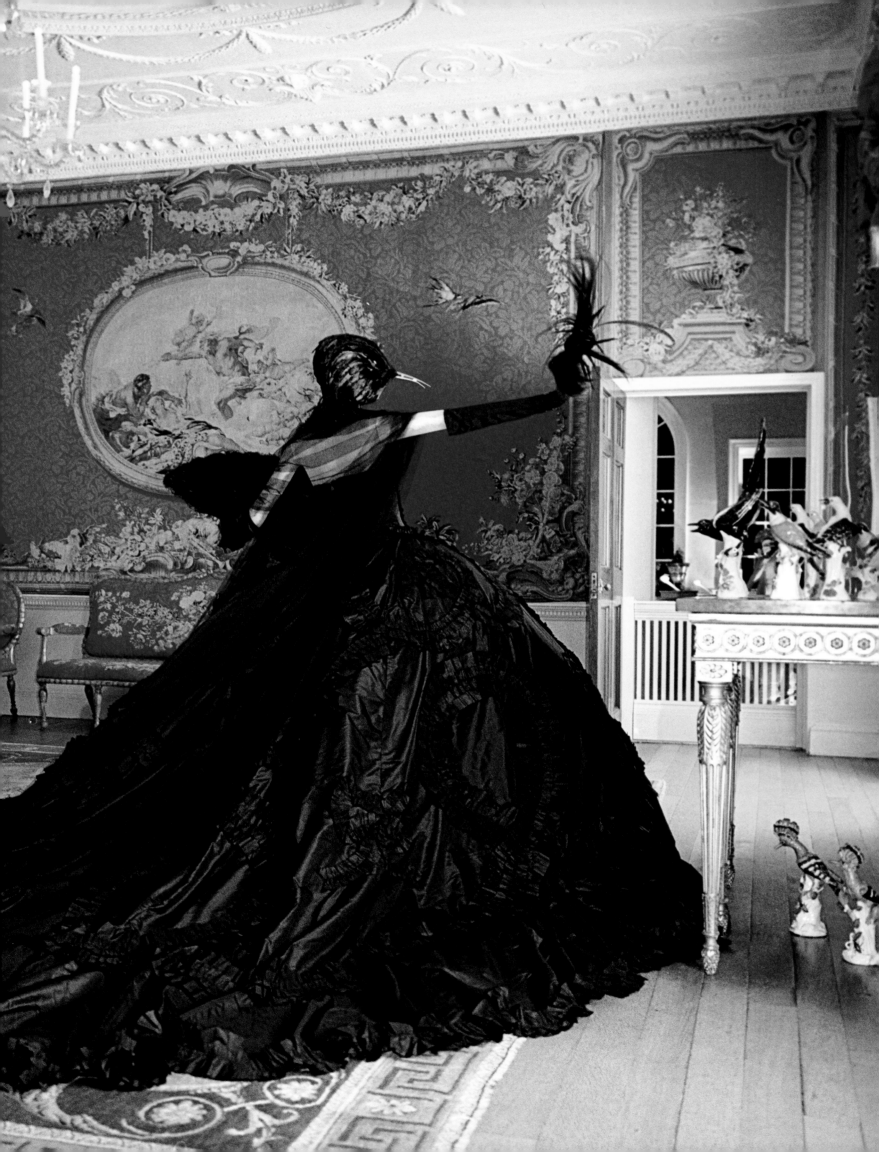

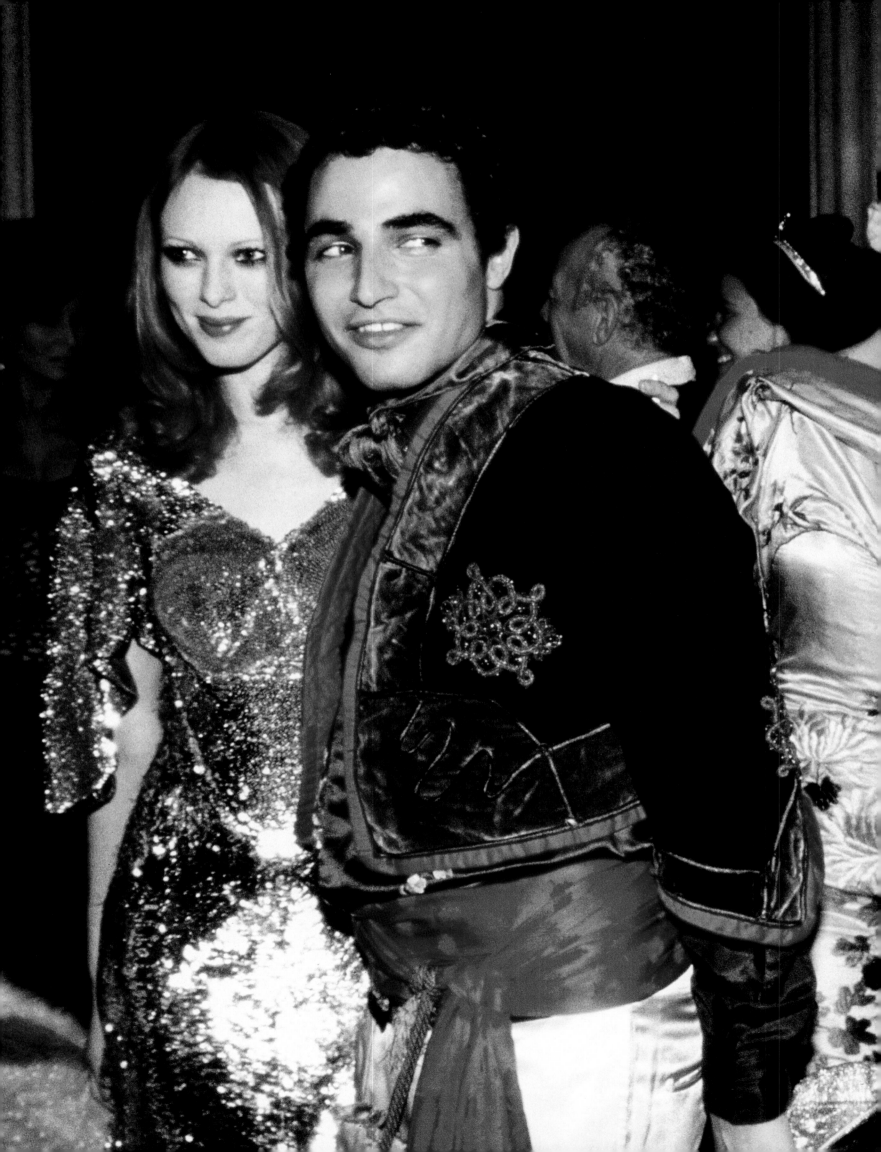

At the "Dangerous Liaisons" party in 2004, designer Zac Posen is surrounded by models (*from left*) Karen Elson, Linda Evangelista, and Karolina Kurkova. Photographed by Hannah Thomson.

Tatiana Santo Domingo (*below*) ascends the museum's steps with her beau, Andrea Casiraghi, in 2006. Photographed by Evan Agostini.

British Fashion," the Engelhard Court was transformed by event designer David E. Monn into an English garden "with 400 running feet of espalier apple trees, wisteria on every marble pillar, green-sisal carpet, and 35,000 daffodils and 12,000 hyacinths." Dame Vivienne Westwood, Juicy Couture's Gela Nash-Taylor, and Diane von Furstenberg each draped themselves in the Union Jack. Stella McCartney wore a white smoking jacket and Kate Moss a black one, and "there was a punk romance to Sienna Miller," who channeled Twiggy in her golden Burberry minidress and black tights.

In 2007, "Poiret: King of Fashion" evoked the fantasy and extravagance of the Belle Epoque couturier's celebrated costume balls. Designers Jean-Hugues de Chatillon and Raúl Àvila conceived "a 20-foot-high birdcage filled with four exquisite

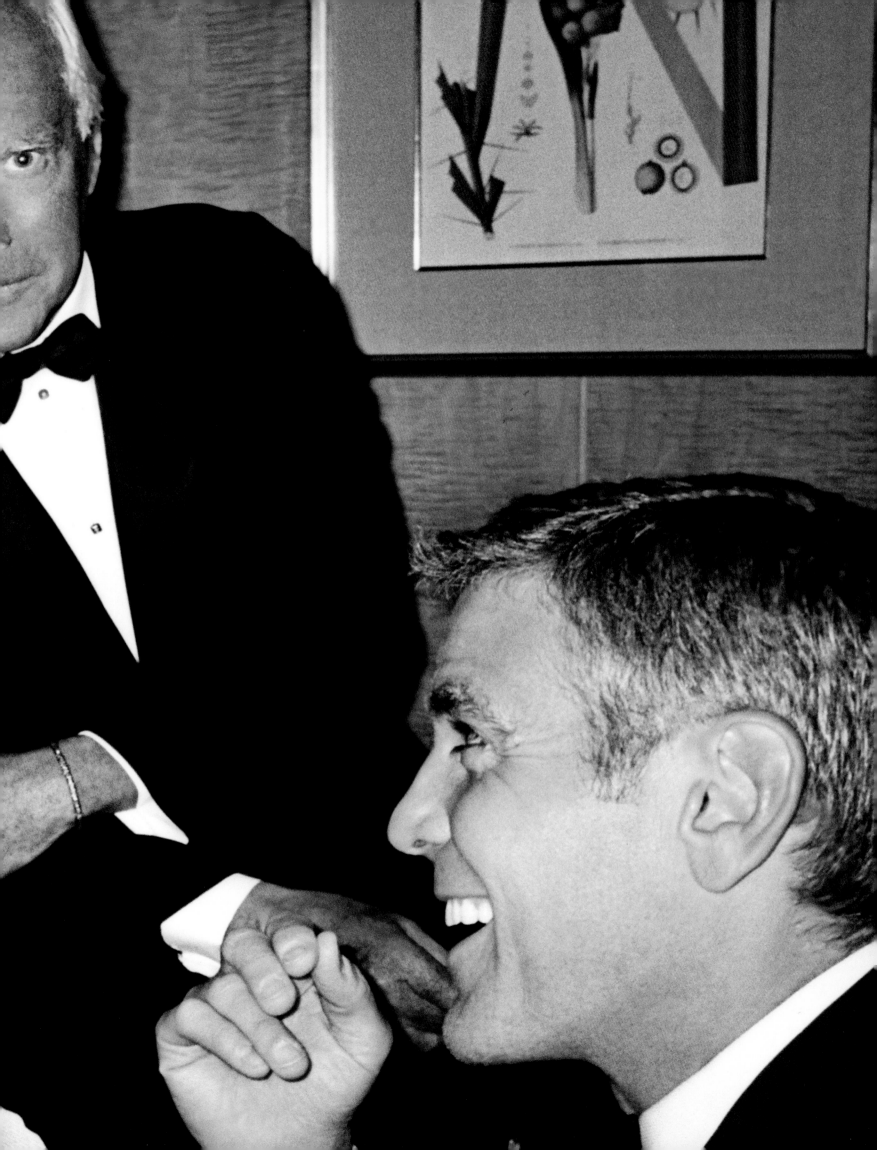

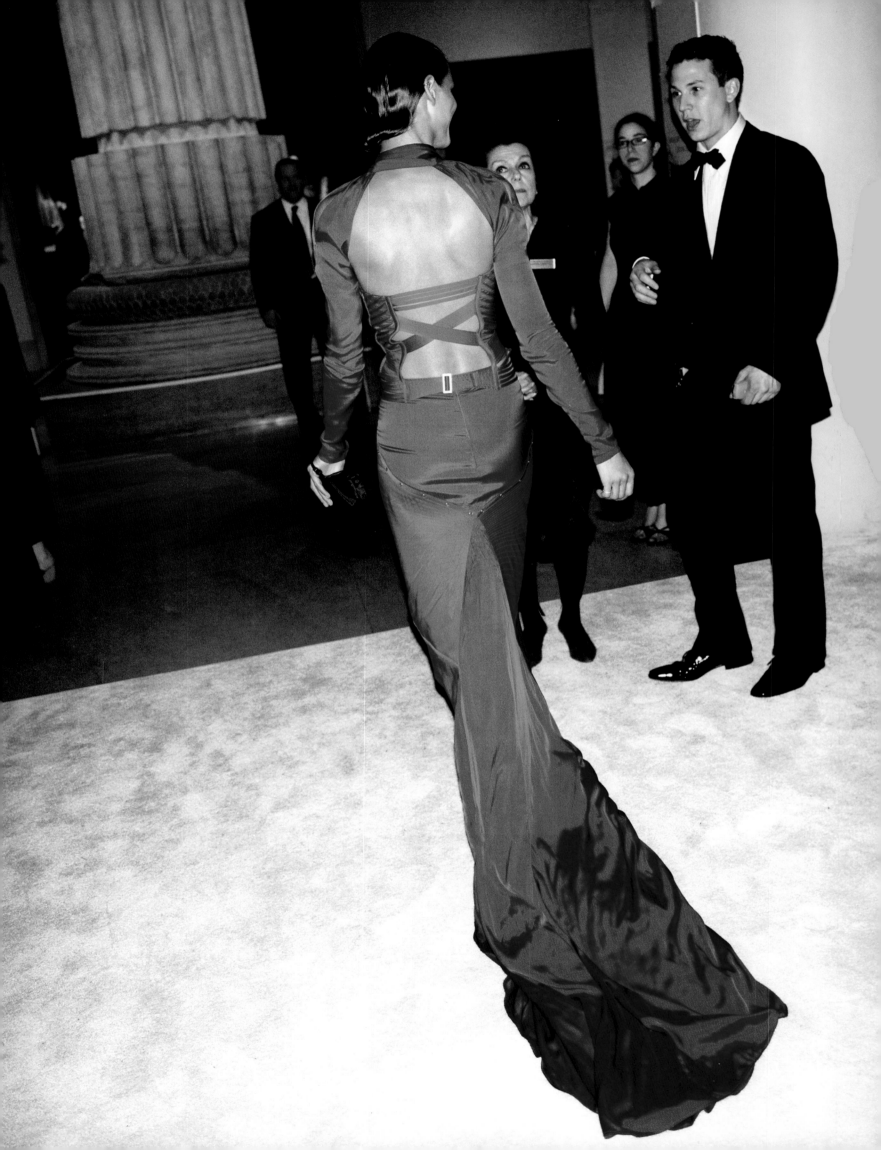

previous spread:
Julia Roberts, Giorgio
Armani, and George
Clooney in a suite at
the Carlyle hotel
before heading to
the museum to host
"Superheroes: Fashion
and Fantasy" in
2008. Photographed
by Mario Testino.

Model Carmen Kass in
Tom Ford's Gucci dress
for the "Goddess"
gala, 2003. Photographed
by Robert Fairer.

At the Chanel party
in 2005, dinner was
served in a French
garden of gardenias,
boxwood, and juniper
(*right*). Photographed
by Michael Lisnet.

peacocks and surrounded by more than 12,000 long-stemmed red roses and a cascade of fabric designed by the artist Raoul Dufy for Poiret." Cate Blanchett wore Nicolas Ghesquière's golden shimmy fringe for Balenciaga, and Jennifer Hudson sang "La Vie en Rose."

At 2008's "Superheroes: Fashion and Fantasy," movie art director Nathan Crowley worked with event designer Àvila "to transform the Temple of Dendur—a structure of mythic power itself—into the planet Krypton." Diane von Furstenberg dressed Ashley and Mary-Kate Olsen as Wonder Women, and Lisa Airan channeled Storm from *X-Men* in a Rodarte dress "like the froth of an ocean wave crashing." André Leon Talley, escorting Venus Williams, wore the most dramatic cape of the night: "acres of scarlet faille designed for him by Lagerfeld for Chanel Haute Couture." Zac Posen went as Clark Kent, and the Couple of the Evening were "incontestably Tom Brady and Gisele Bündchen," who exuded "such megawatt glamour, disquieting bodily perfection, and powerful animal magnetism that they seemed to have dropped in from another galaxy."

In 2009, "The Model as Muse: Embodying Fashion" attracted a pan-generational pantheon of models whose looks exemplified their eras. From Carmen Dell'Orefice (who was fifteen when she posed for her first *Vogue* cover in 1945) to a Versace-clad Bündchen (newly married to Brady), from Lauren Hutton and Marisa Berenson to Agyness Deyn and Natalia Vodianova (wearing an original Fortuny Delphos dress), the model count was 102, including *Vogue*'s fashion editors Grace Coddington and Tonne Goodman.

Movie designer John Myhre (working with Àvila) transformed the Temple of Dendur into the El Morocco nightclub, complete with palms and zebra banquettes, and the evening's honorary chair Marc Jacobs dressed cochair Kate Moss in glamorous homage to the era in a gold lamé turban and abbreviated sari draperies.

"At the Oscars, guests wait anxiously to see who wins the gold," wrote William Norwich after 2007's "Poiret: King of Fashion." "At the Met gala, the gold is the invitation."
—HAMISH BOWLES, *2009*

At the Poiret party, Kate Bosworth greets Kirsten Dunst. Giancarlo Giammetti is directly behind. Photographed by Hannah Thomson.

———————————

Elle Macpherson (*below*) wore Calvin Klein and sandals for the Chanel gala in 2005. Photographed by Evan Agostini.

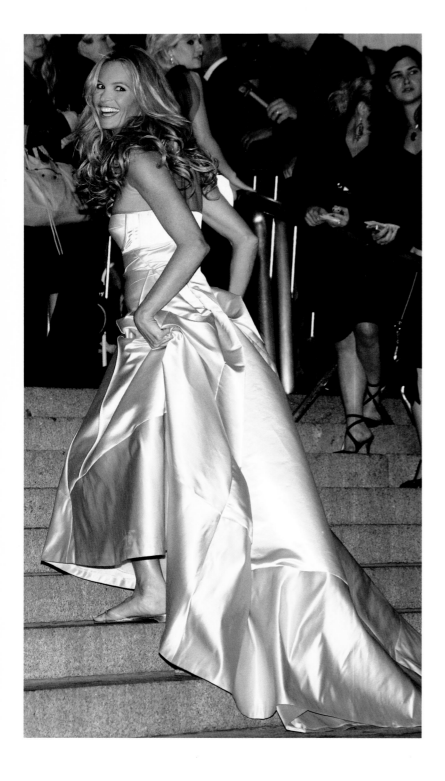

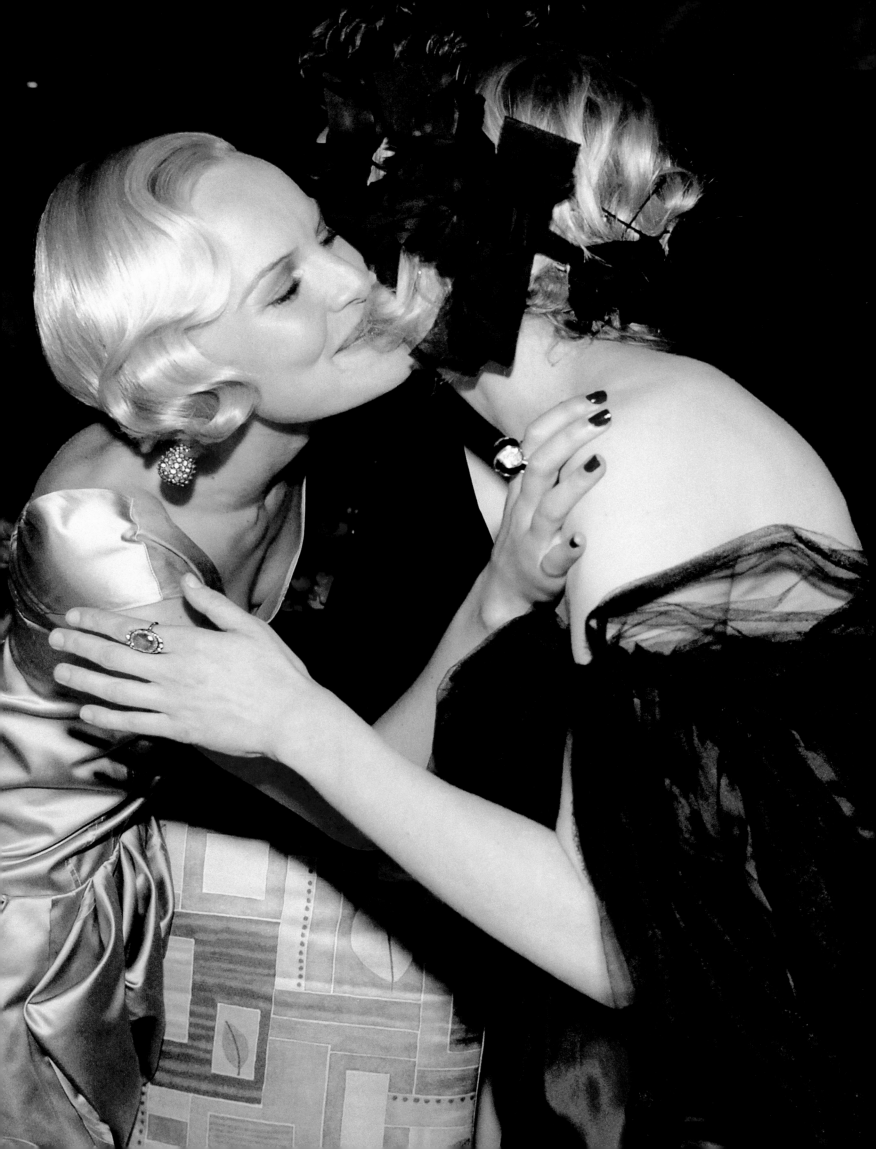

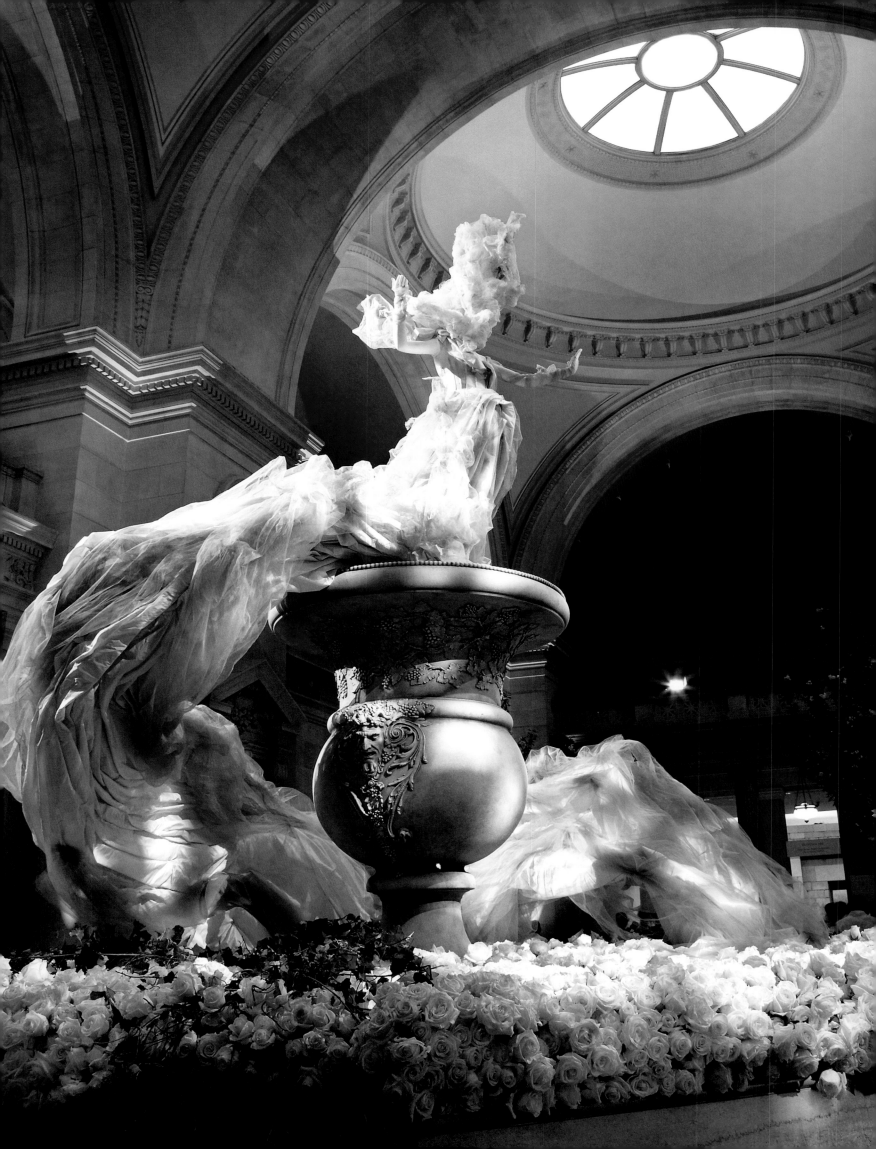

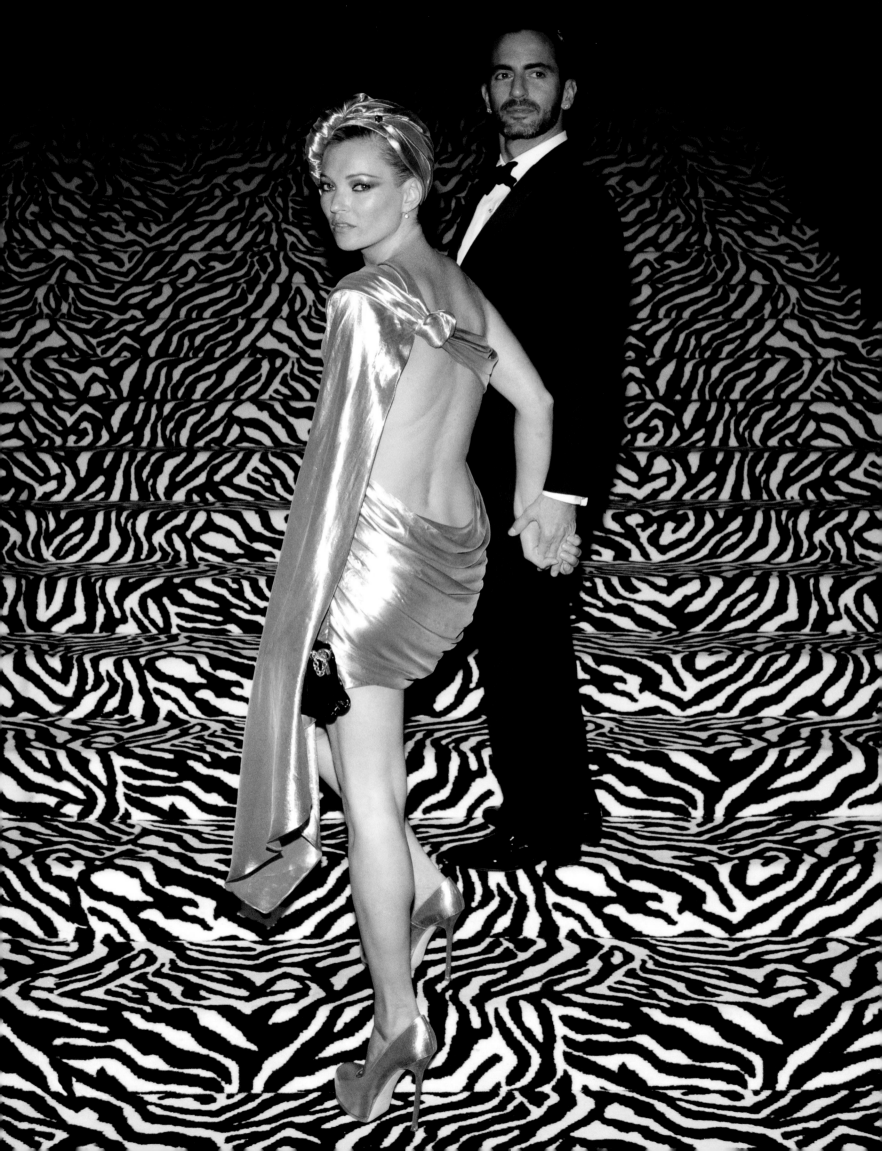

Kanye West and Rihanna (wearing Dolce & Gabbana) performed in the Temple of Dendur. Photographed by Hannah Thomson.

On the red carpet (*below*), gala cochair Justin Timberlake drew attention to girlfriend Jessica Biel's Atelier Versace dress. Photographed by Larry Busacca. Gisele Bündchen wore Versace (*bottom*). Photographed by Arthur Elgort.

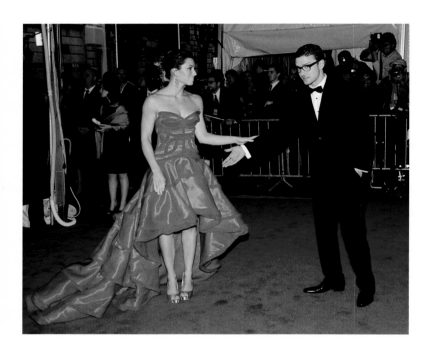

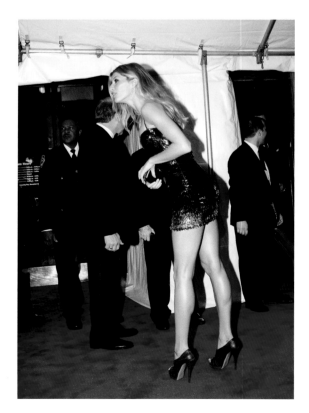

THE
ACTRESSES

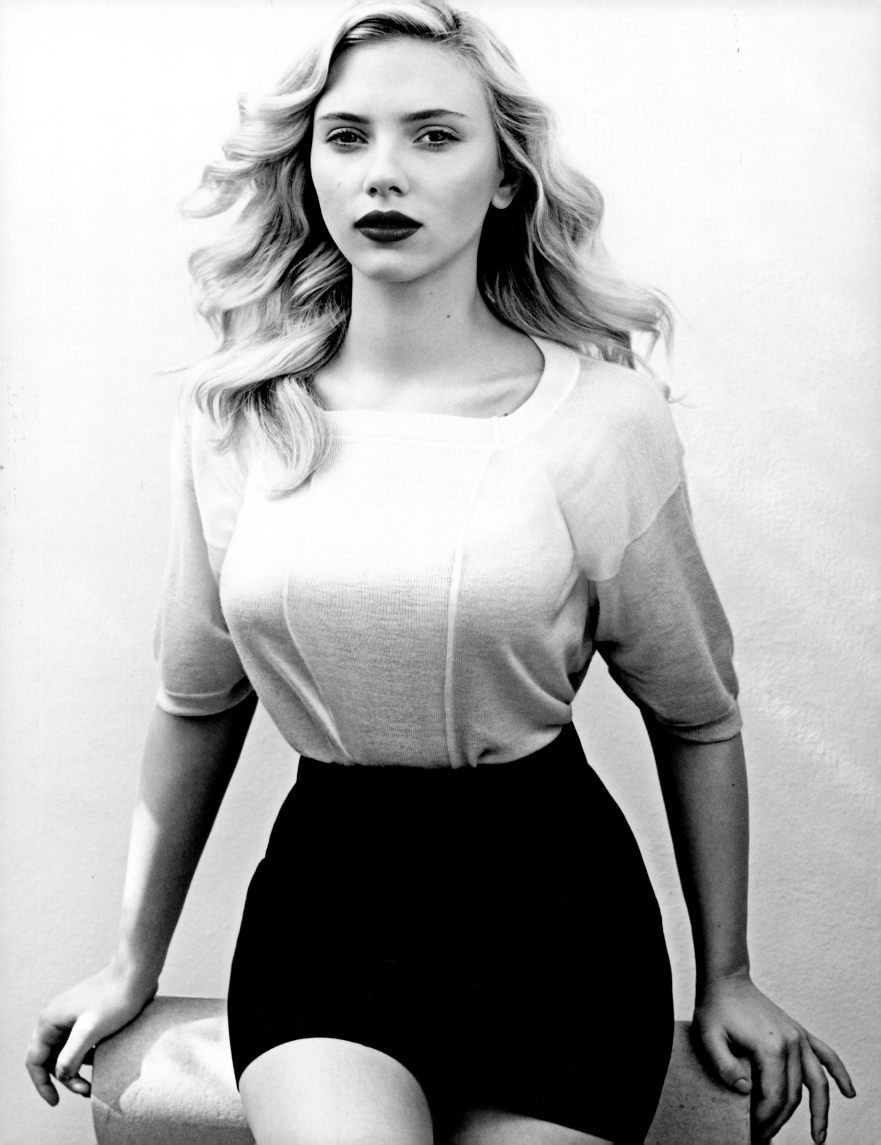

CATE BLANCHETT

i like the trapeze aspect of my profession," she says. "But I never make those decisions on a conscious level. I don't say, Hey, I want to do something shocking. Perhaps it is the need to be exposed and found out." Cate Blanchett's beauty is undeniable, yet it is also difficult to deconstruct: She has an angular face and a broad nose. Her teeth don't always line up, and her pale skin makes her eyes seem almost shockingly blue. "I guess I have some sort of theatrical death wish," she says, slowly working her way through her complex motivations. "On some level, when I do these things, maybe it's the need to fail. It's a bit pathological, I know, but when I am working I like to drive right up to the edge of the cliff. I mean, if you are going to commit to something, you should do it all the way. That is what I believe. Why would you even bother to embark on the journey if you know in the end it's going to bore you?"

—MICHAEL SPECTER, *November 2006*

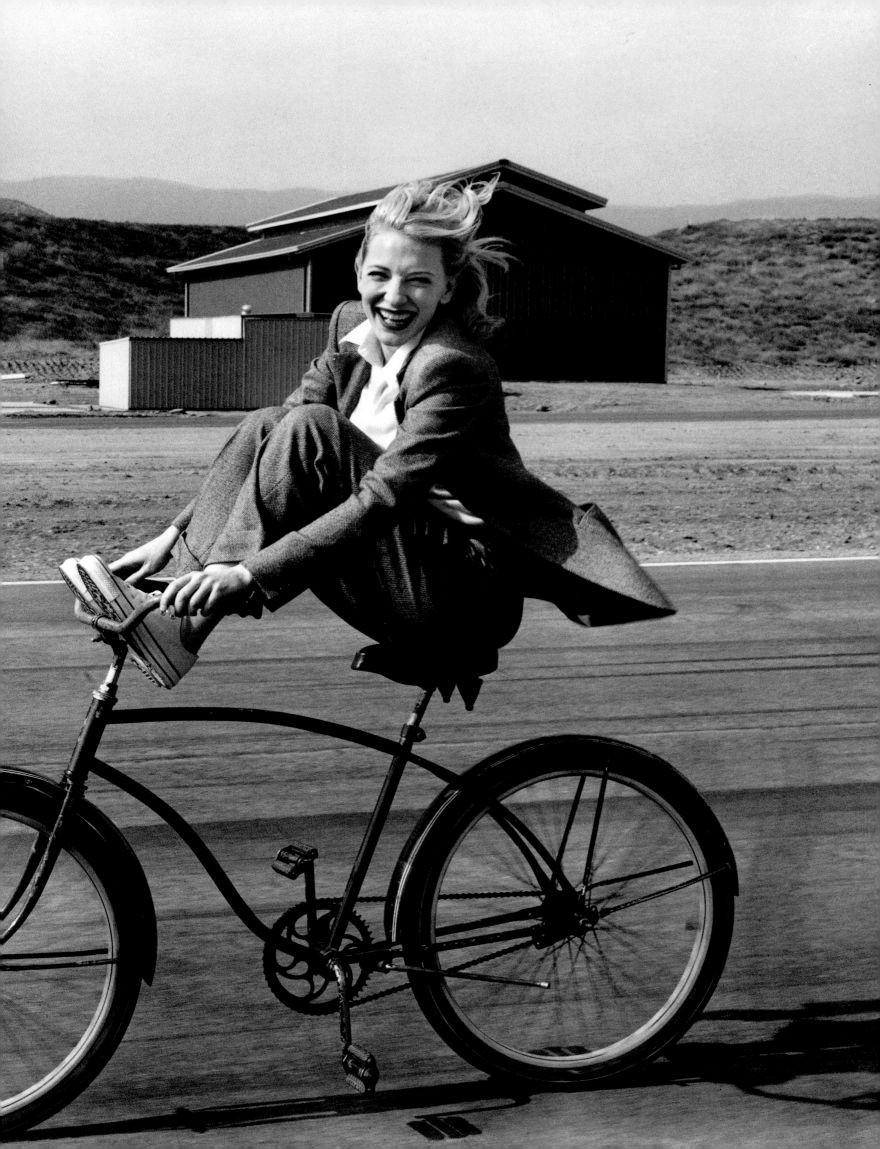

Blanchett, in a Behnaz Sarafpour dress.
Photographed by Annie Leibovitz, 2004.

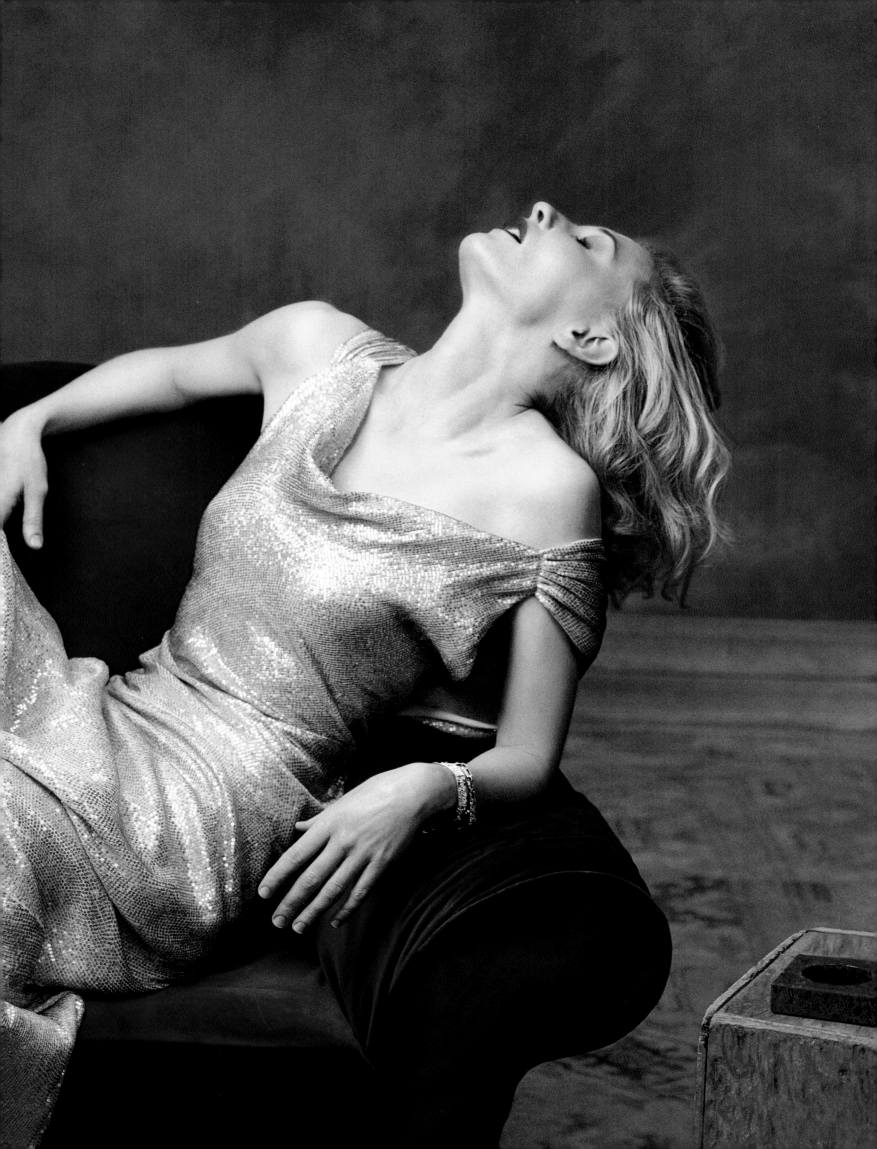

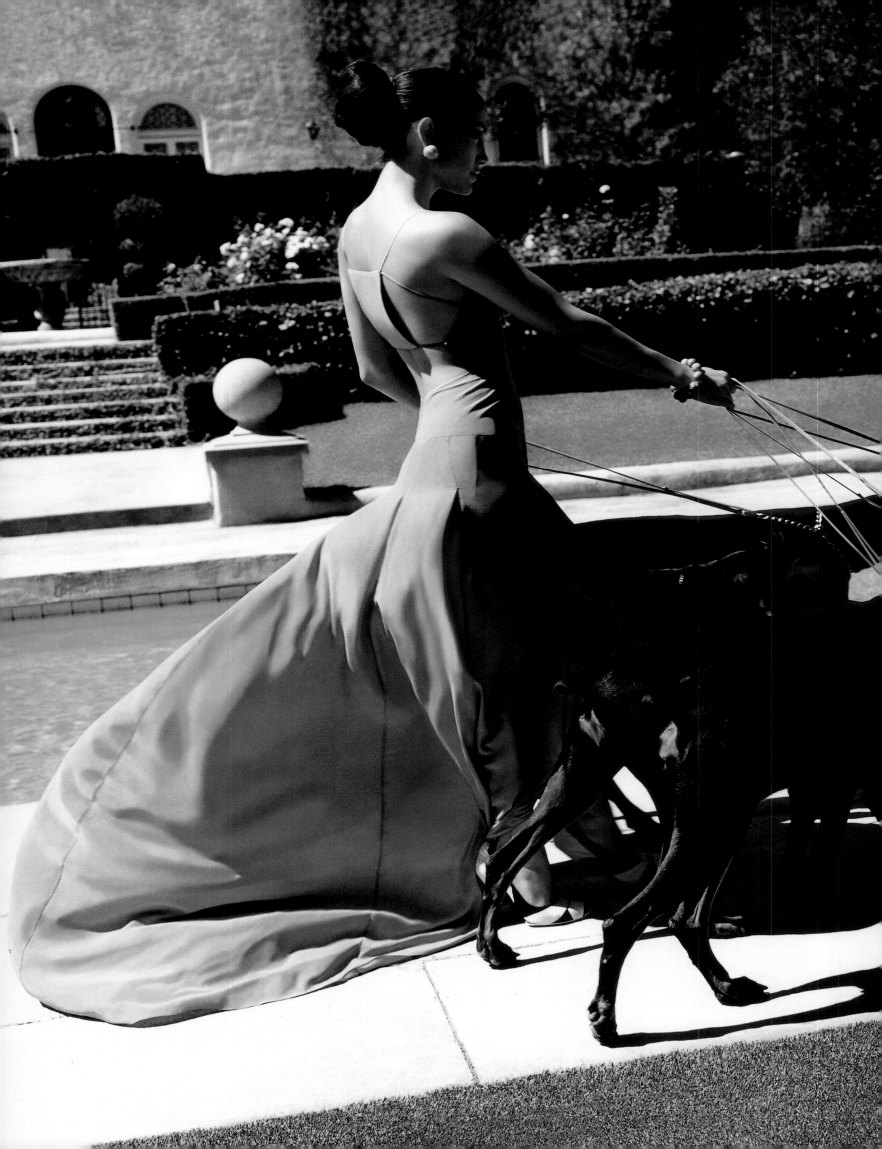

Jennifer Lopez

Newly married to the salsa vocalist
Marc Anthony, the singer
and actress from the Bronx wore
an azure dress by Narciso Rodriguez,
posed ferociously with
Doberman pinschers, and laughed
about her diva reputation. "Sometimes
I think it's just because I have a nice car
and I'm not afraid to wear a big fur,"
she said. "It might be as simple as that."
Photographed by Mario Testino, 2005.

ISABELLA ROSSELLINI

isabella Rossellini, known to anyone who's ever opened a magazine as the face of Lancôme, and to anyone who's ever seen *Blue Velvet* as the battered, naked Dorothy Vallens, is the daughter of two antithetical dramatic genres and two mutually exclusive temperaments. Ingrid Bergman was Hollywood's biggest star when, enthralled by the stark realism of his films, she took off with Roberto Rossellini, leaving behind husband and child. Bergman was half-German, half-Swedish; Rossellini, one of the greatest charmers of all time, was all Italian. The easy paradoxes go thus: North/South, Fantasy/Realism, Cold Blood/Hot Blood, Reason/Passion, Order/Chaos. Isabella has a twin named Ingrid, whose existence presumably helps to dilute the conflicts. Isabella, however, is known to enjoy serving at dinner the peculiar combination of lasagna and herring. Her parents are getting fainter in people's minds. Roberto Rossellini's work was paramount to Isabella's first husband, Martin Scorsese (whom she married in 1979). On the other hand, David Lynch, with whom she lived for five years, has never seen her father's films.

"I am," says Isabella, "a lieutenant of famous people. Encouraged by a certain feeling that I'll never be as good as them. How many times I felt confronted with the passion that Marty had for films, or that my mother had for making films. I wish I had that passion, but I don't. For them it was always 'First film, then family.' I can't say that about me. So I felt that if I didn't have that consuming passion, I might not be as good. Am I an impostor, or should I do it? Is it honest to do something that you like, or is it only honest to do something you care about so much that if you don't do it, you'll die?"

—JOAN JULIET BUCK, *January 1993*

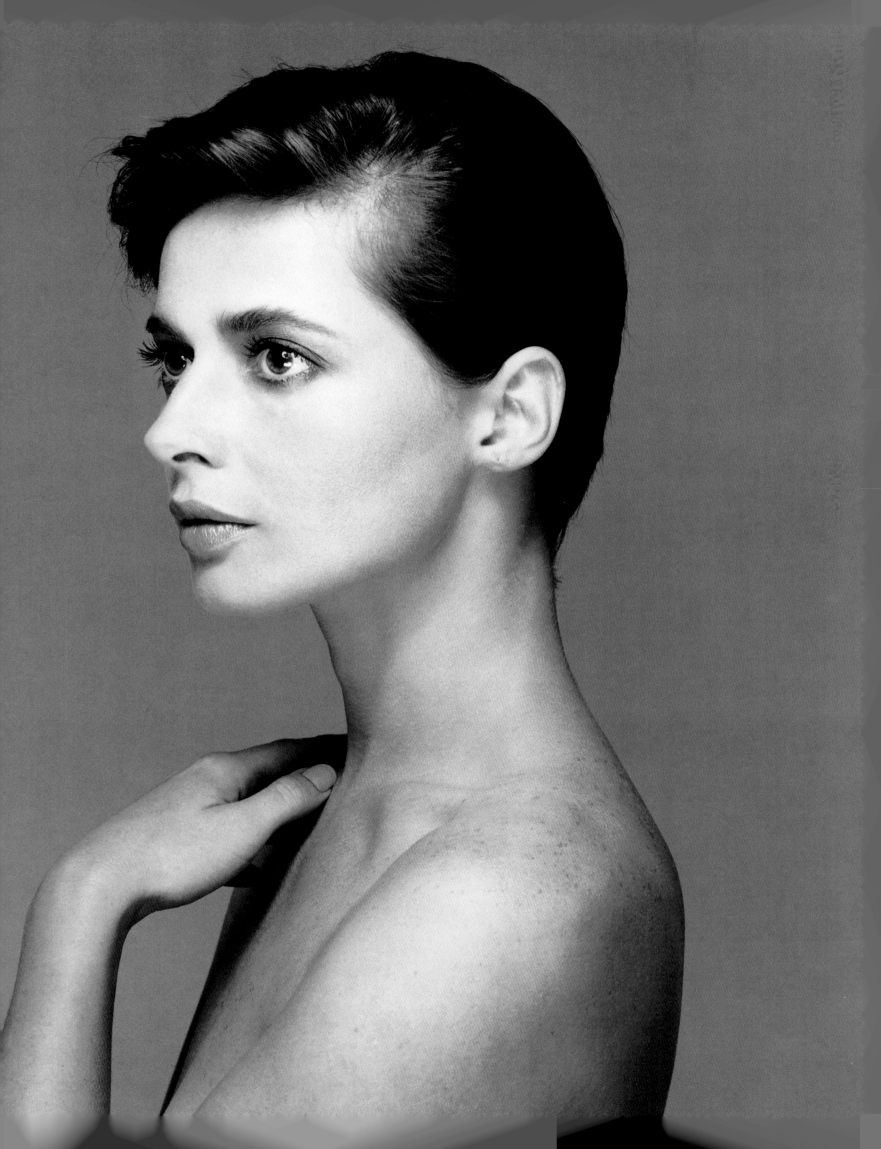

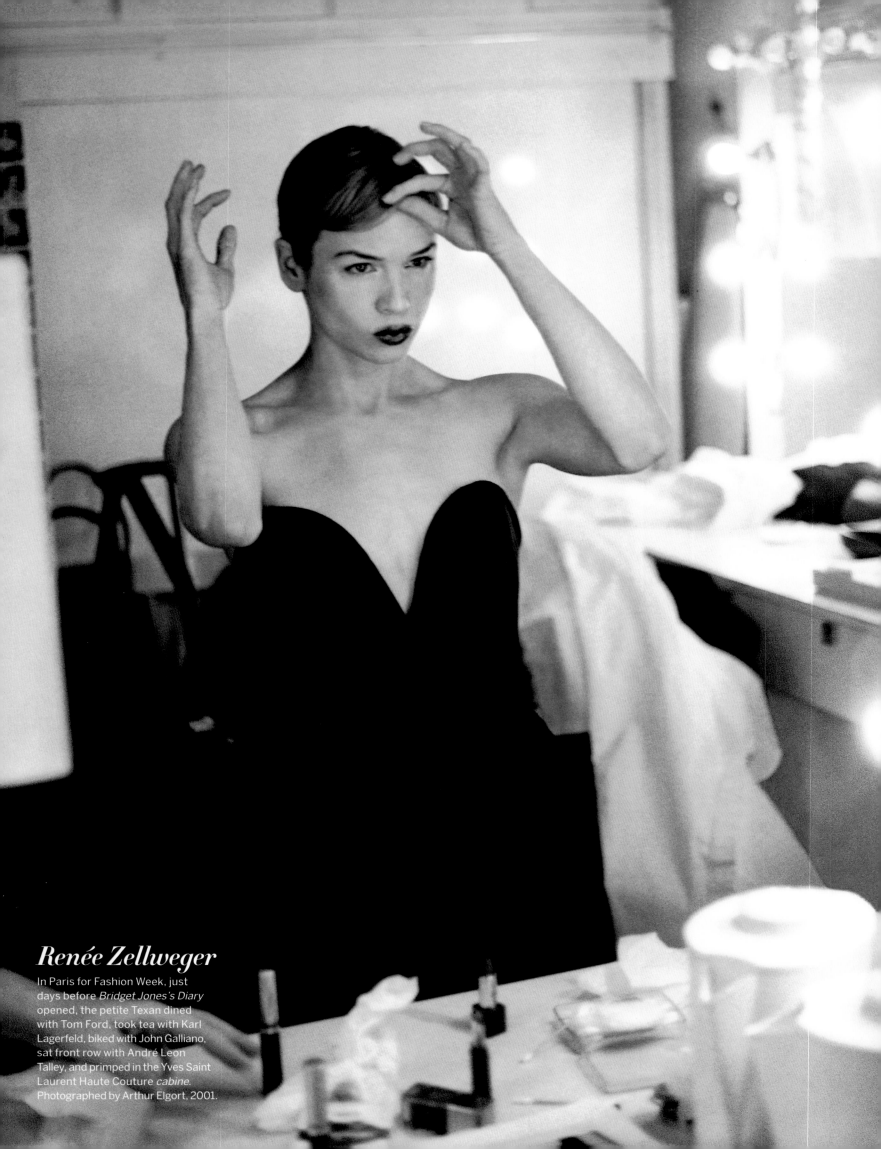

Renée Zellweger

In Paris for Fashion Week, just days before *Bridget Jones's Diary* opened, the petite Texan dined with Tom Ford, took tea with Karl Lagerfeld, biked with John Galliano, sat front row with André Leon Talley, and primped in the Yves Saint Laurent Haute Couture *cabine*. Photographed by Arthur Elgort, 2001.

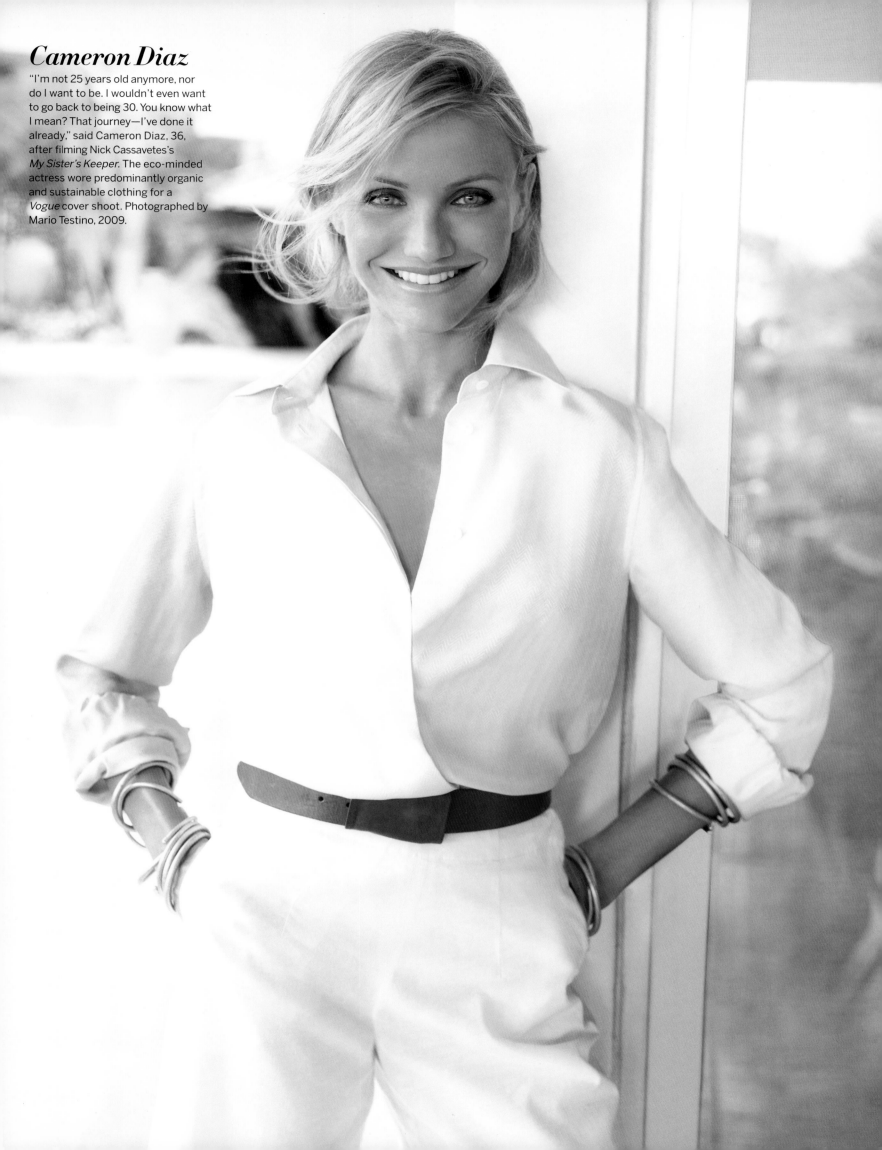

Cameron Diaz

"I'm not 25 years old anymore, nor do I want to be. I wouldn't even want to go back to being 30. You know what I mean? That journey—I've done it already," said Cameron Diaz, 36, after filming Nick Cassavetes's *My Sister's Keeper*. The eco-minded actress wore predominantly organic and sustainable clothing for a *Vogue* cover shoot. Photographed by Mario Testino, 2009.

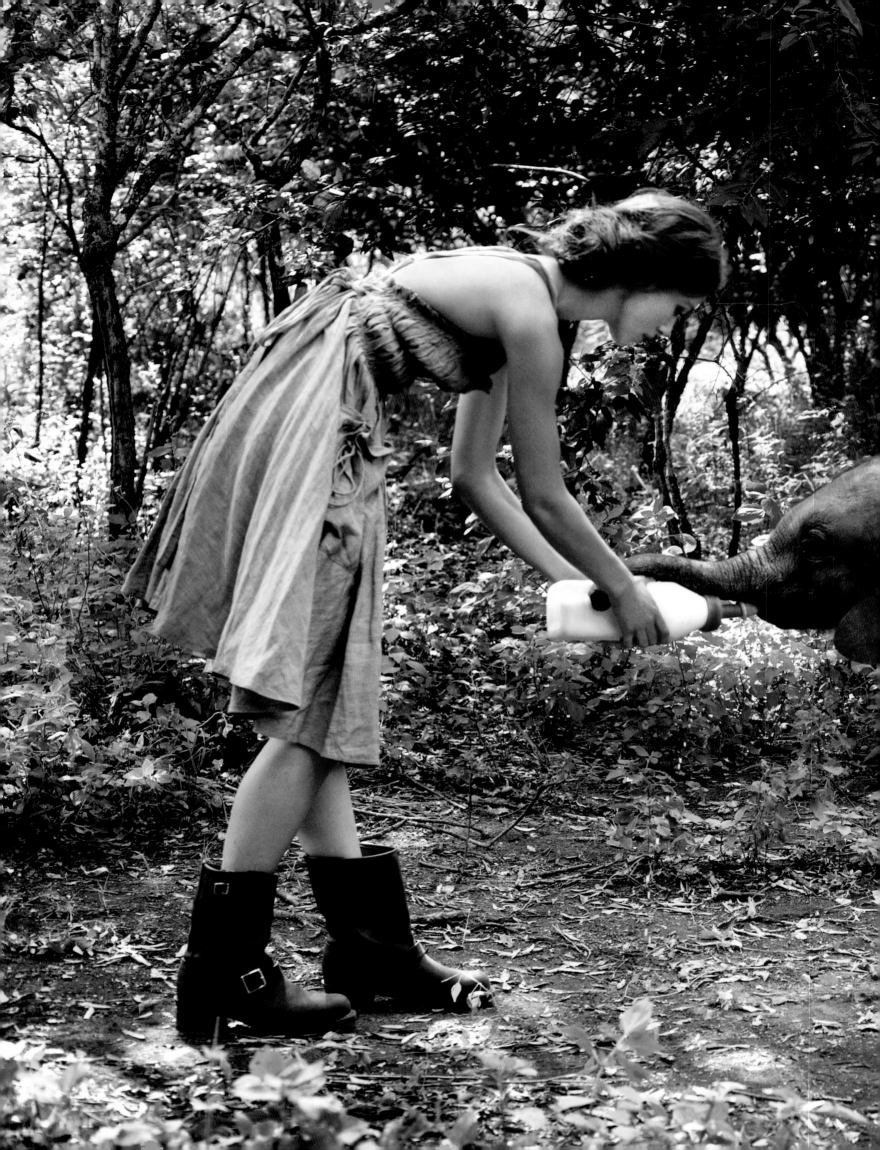

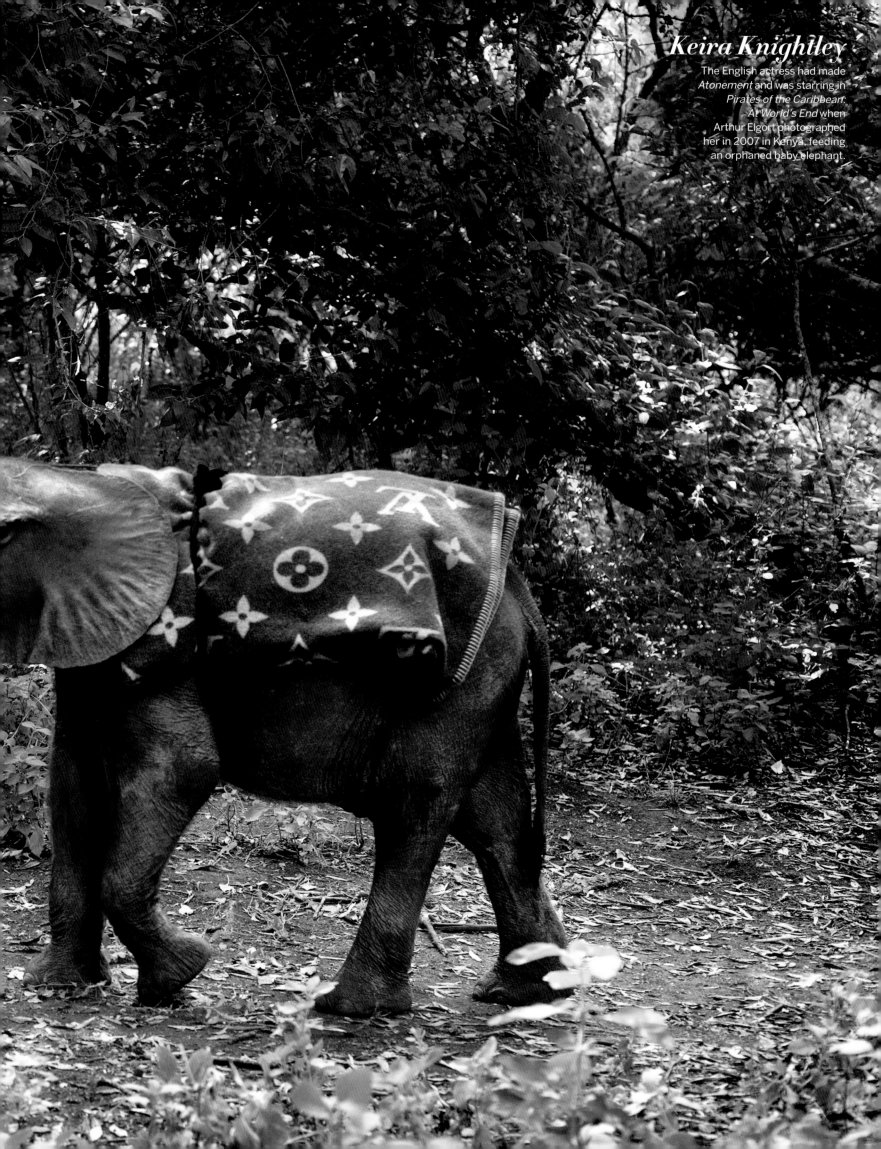

ALI MacGRAW

Very, very together, with her racy, swing-limbed architecture and her made-in-America grit, grin, and gleam, Ali MacGraw ignited a short fuse to fame playing a Philip Roth heroine in her first film, *Goodbye, Columbus*. "I don't see myself as one of Portnoy's women," said Ali MacGraw, who, to one critic, seems to be cast more in the Fitzgerald mold, "playing some endless version of Gatsby's Daisy, whose voice had 'a singing compulsion, a whispered "Listen," a promise that she had done gay, exciting things. . . .' " For Ali MacGraw, excitement spansuled. Born in Pound Ridge, New York, she went to Wellesley College before working in New York as a fashion model and a photographer's assistant, taking acting lessons, and finally, at 30, making it. "It's the whole charade . . . but I'm not a different person. I live on the West Side, and I live quietly," she said. "I do weird things with embroidery and collages of junk while listening to Mozart and Donovan. I love books and would like to read everything Dostoyevsky ever wrote. I'm not ready for the theater yet, but I want to stay in New York and make more films." Her next role: that of a Radcliffe girl (again), the daughter of a baker, in *Love Story*, to be filmed next month in Cambridge and New York. Now stormed by instant stardom, Ali MacGraw, anti-star, said, "I don't want my life to change . . . the movie business could blow your mind."

—August 15, 1969

Paltrow, photographed by Mario Testino for *Vogue*'s October 2005 cover in John Galliano's raffia floral hat for Dior Haute Couture. It was the eve of the release of *Proof*, in which she reprised a role she had originally played on the London stage.

GWYNETH PALTROW

there's nothing quite like getting married and having a baby to shift a woman's priorities. For the past ten years, no other Hollywood actress, except perhaps Nicole Kidman, has seemed more at ease in the front row than Gwyneth Paltrow. Often compared to Grace Kelly, Paltrow has an effortless, modern classicism that turned her into a major style icon—a role she seemed to relish. But these days, she appears to be almost entirely focused on her husband, Chris Martin, and their little girl, Apple, who turned one on May 14.

When Paltrow started to become famous in her own right, it made her parents—producer-director Bruce Paltrow, who died three years ago, and actress Blythe Danner—nervous. "My father once said to me, 'Your mother and I have always thought of you as a racehorse. We never put the reins on you; we've just kind of tried to guide you in the right direction. You never responded well to "You can't . . . " or "I forbid. . . ." ' And it's kind of funny because I see those characteristics in my daughter."

I ask Paltrow about her relationship to acting these days. "I used to do it not only because of the creative buzz that I got out of it, but because it kind of gave me a sense of my place in the world," she says. "But now I don't look to it to define anything about myself. If I'm going to do it, it's got to be something that makes me feel really alive and enriched, so that the time that I'm spending away from my daughter—at least I'll be a more interesting woman so I can give that back to her."

—JONATHAN VAN METER, *October 2005*

196

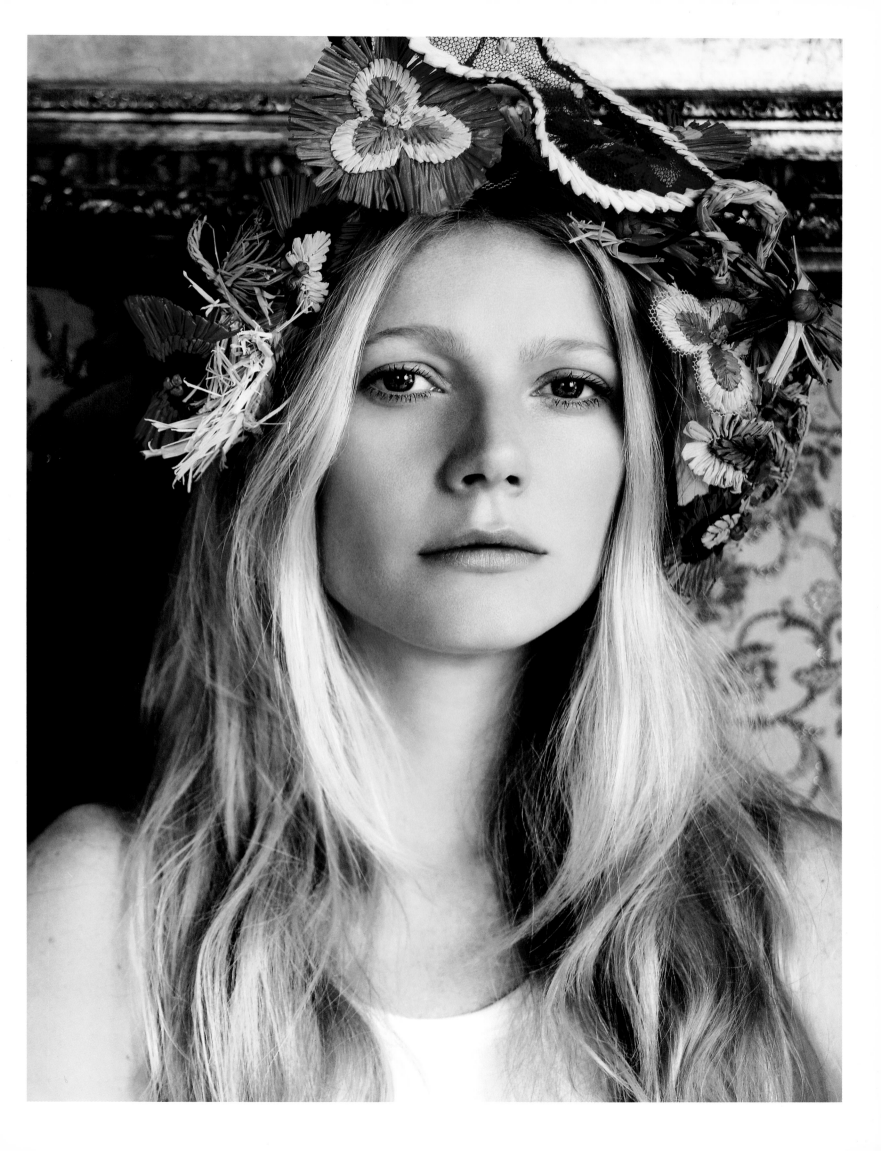

"I have something that's so real. It's not fleeting. It has nothing to do with success or popularity. Life is complicated and you never know what's going to happen, but my family has given me real contentedness." Photographed here, in Giorgio Armani Privé, at the Imperial Suite at the Ritz in Paris by Mario Testino, 2005.

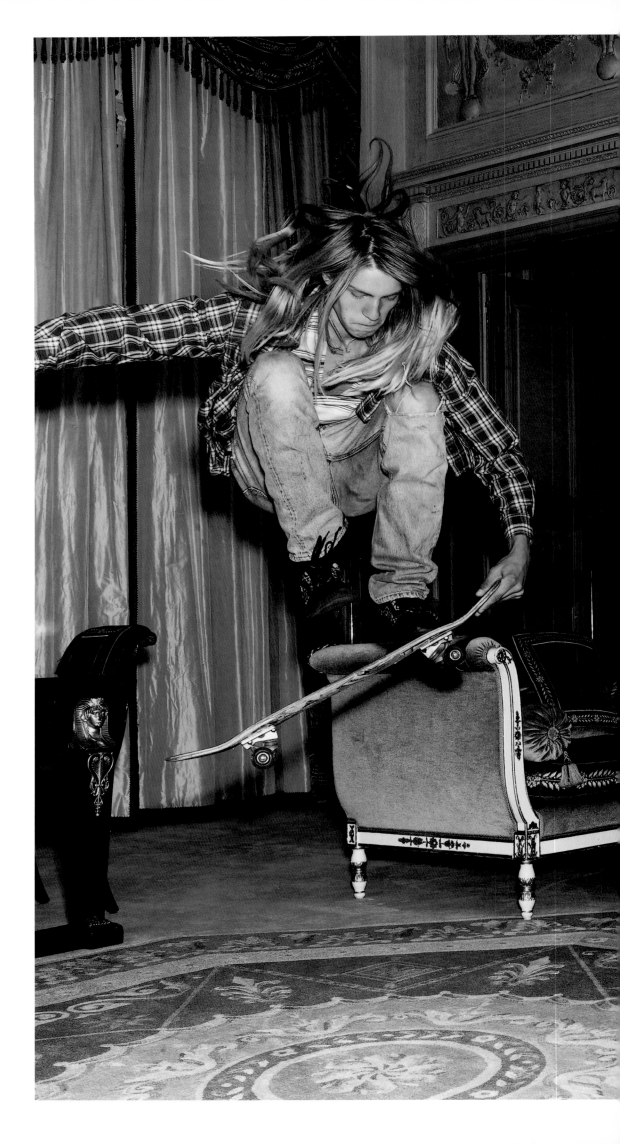

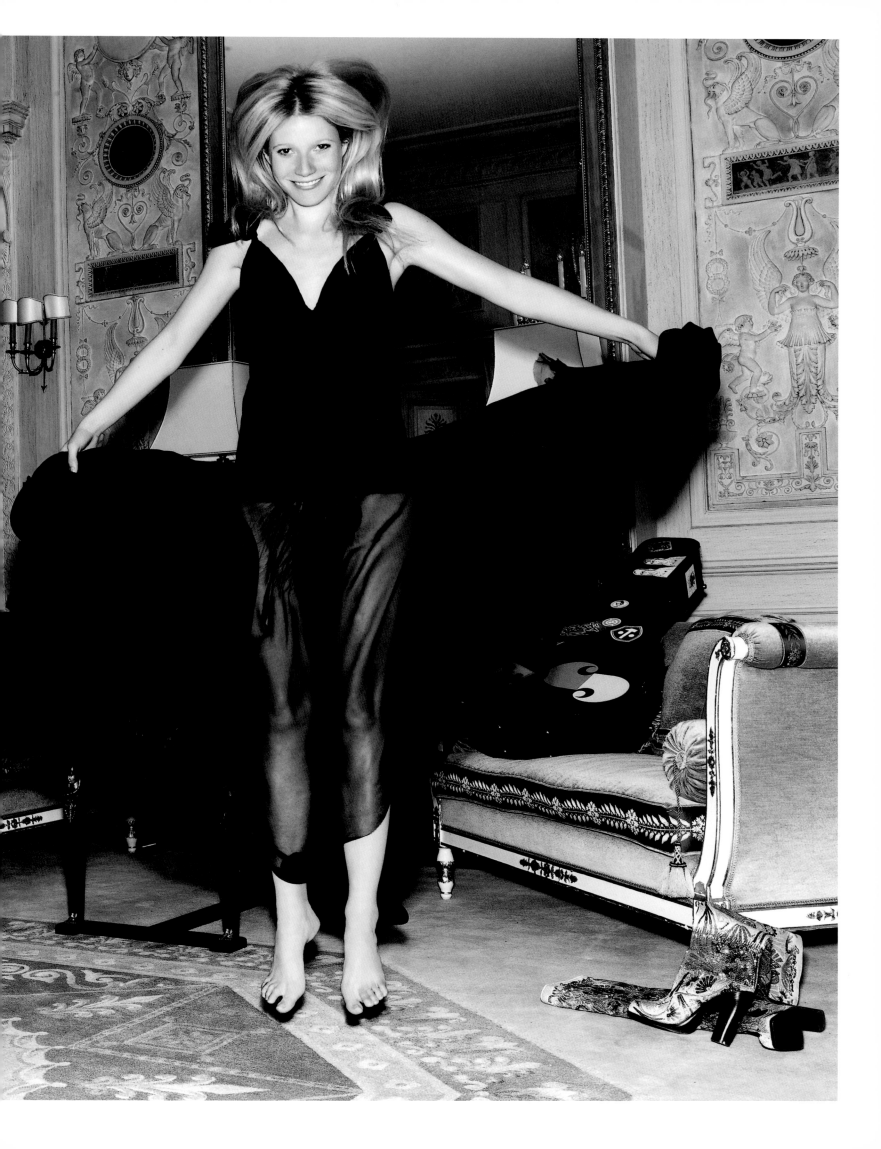

Charlize Theron

In 2004, she won an Academy Award for Best Actress as the notorious Aileen Wuornos in *Monster,* and when Mario Testino shot her in 2007, her film *In the Valley of Elah* had just been released. Wrangling a calf is not so foreign to this South African—she grew up on a farm near Johannesburg.

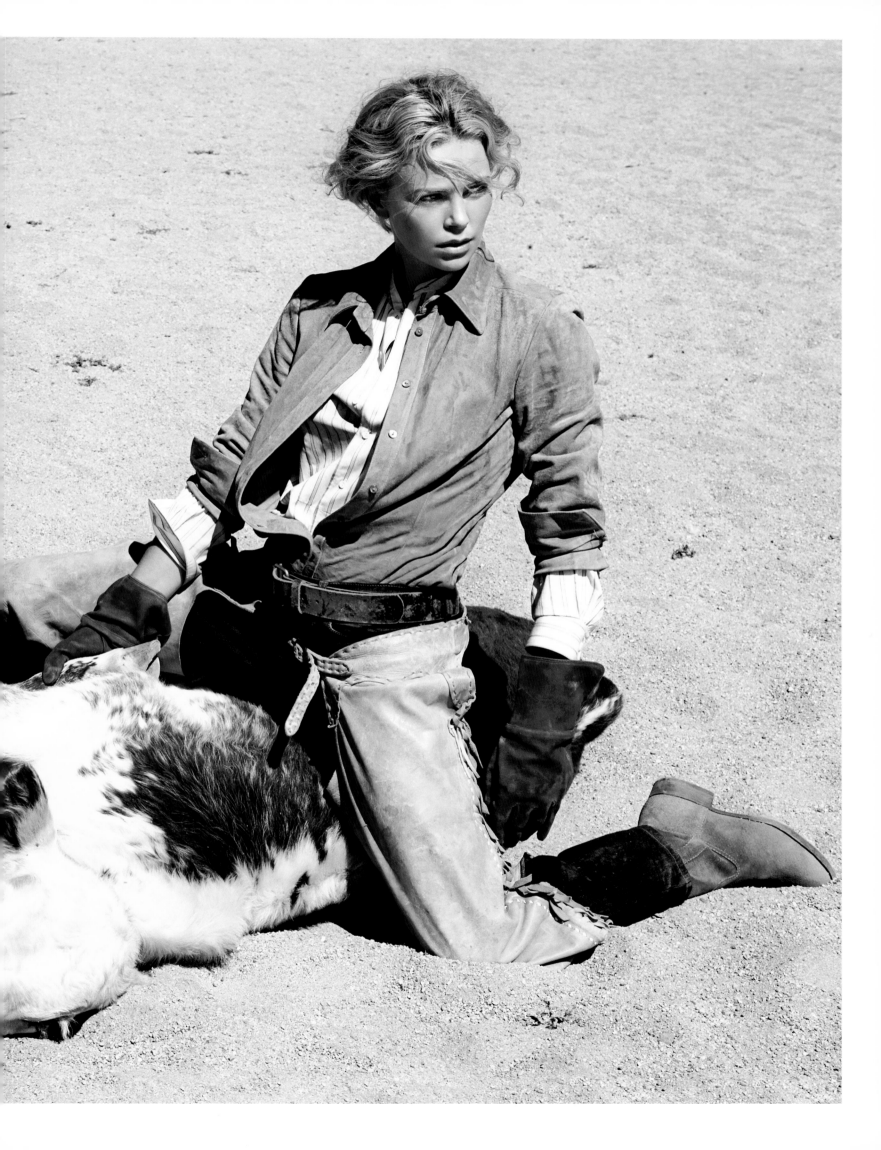

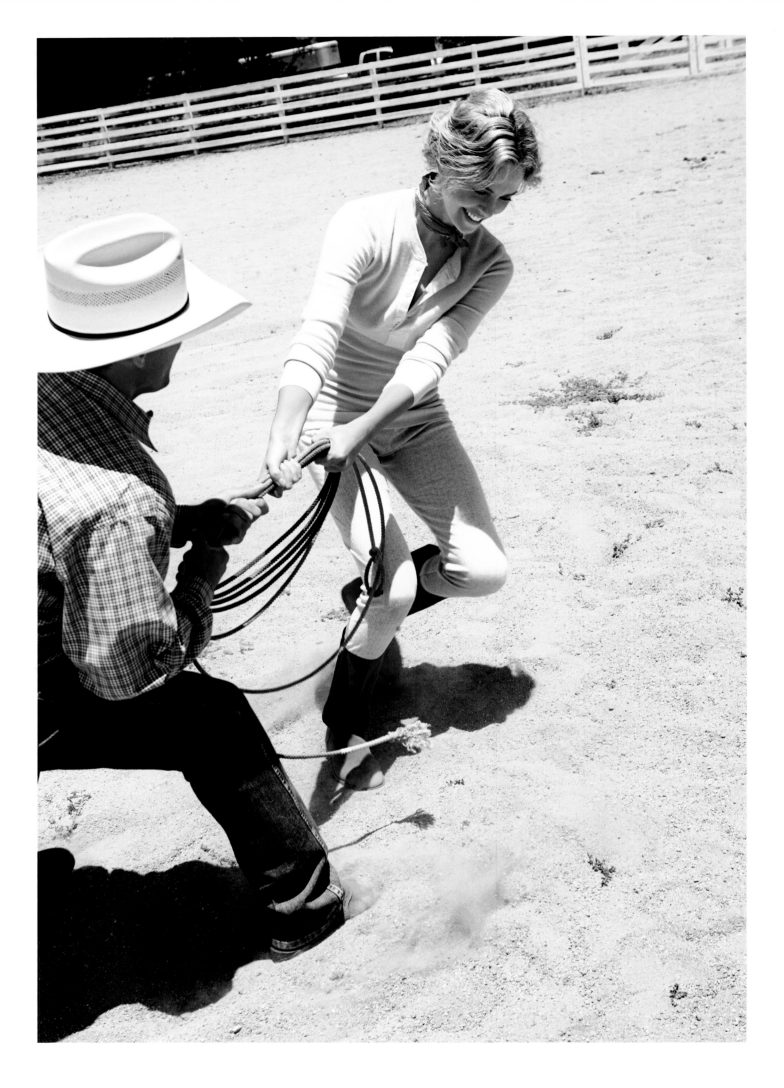

Theron "gamely reenacting a scene from *The Misfits* with a cowboy named Olin."

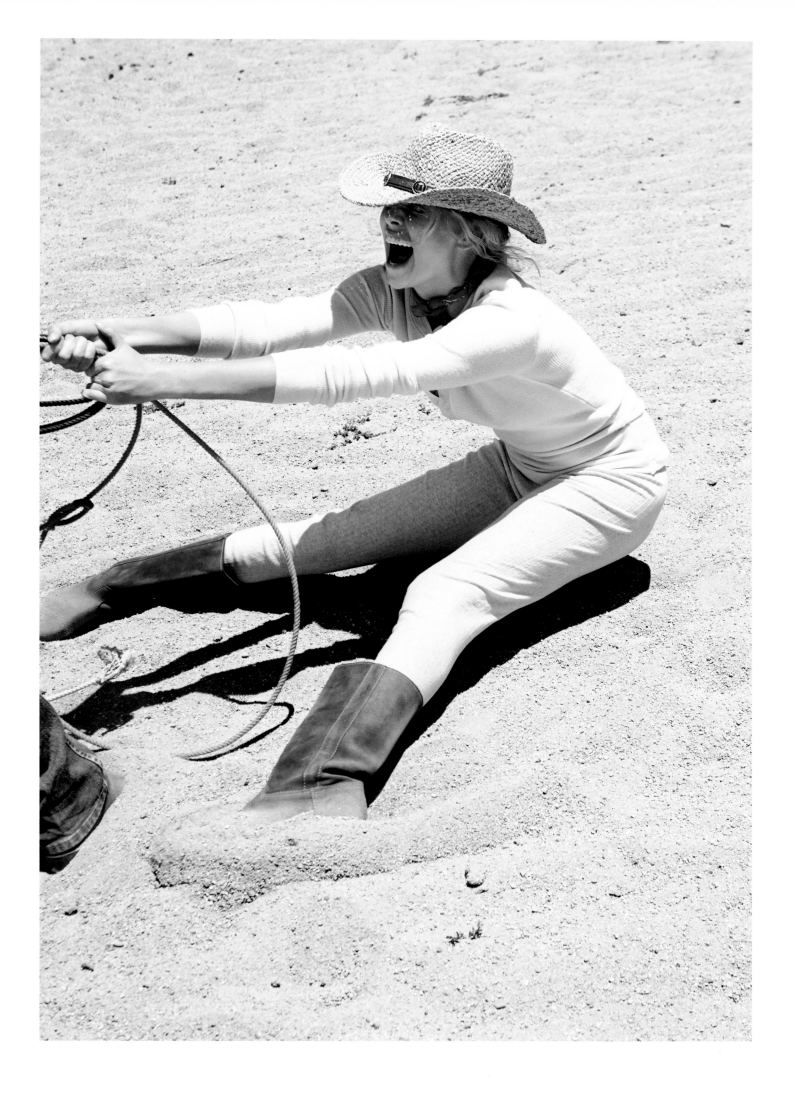

Theron holds her own as Olin pulls on the rope at the Greenfield Ranch in Thousand Oaks, California.

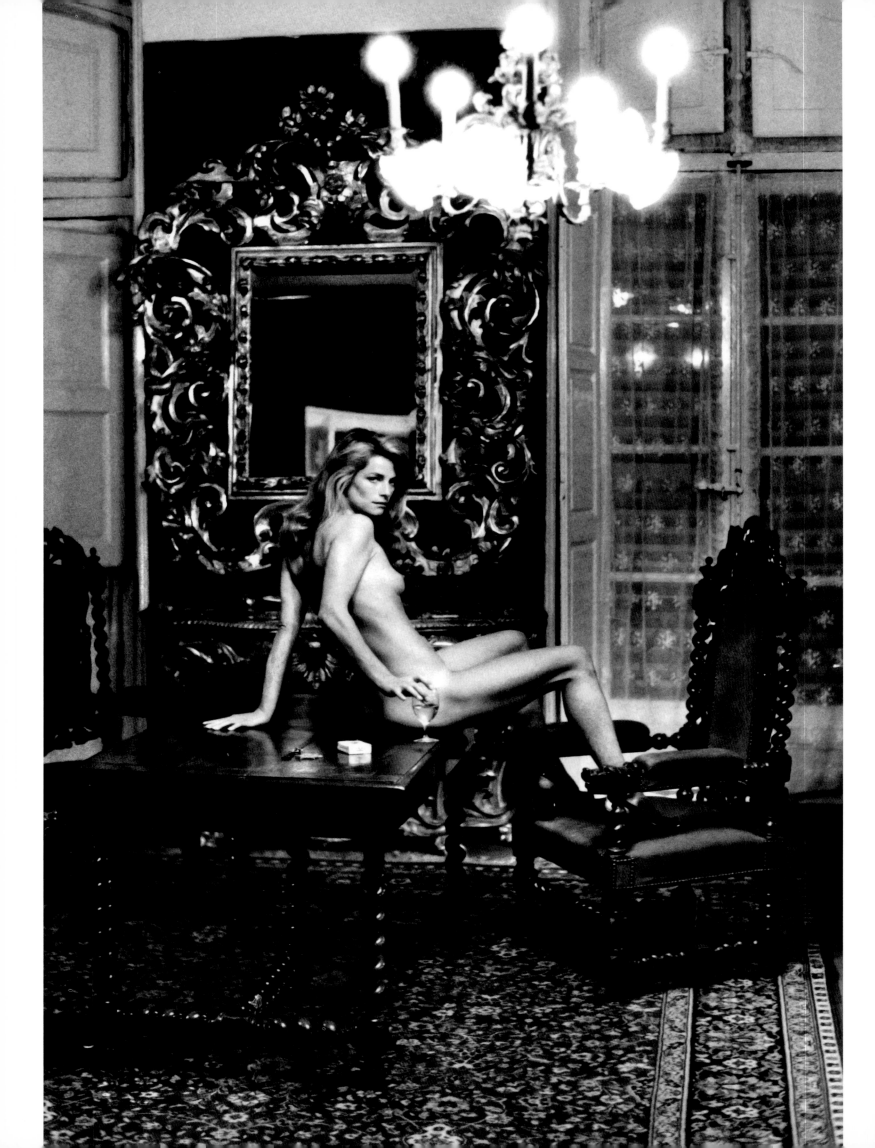

CHARLOTTE RAMPLING

Charlotte Rampling is tall, almost lanky, a cool-to-coldly gray-eyed, intensely self-searching, fine-boned, banked-fires English beauty. In the seventies, she zoomed to sex-slave, sex-symbol global notoriety with a single plangent, sadomasochistic movie, *The Night Porter.* What makes Charlotte the sexiest woman in the world? Her high-bred looks. Her don't-touch-me availability. Her great, hard stare. Her indefinable quality of being of the moment. She says, "Whatever I am giving out, people seem to want more."

What *she* wants is not so much to be a movie star but a marvelous movie actress. And motherhood is most important to her. Says a Rampling colleague, "She's very, very into bringing up Barnaby, her young son. She wants him not only to be a free spirit but to be free in his body. She thinks dance, yoga are very important to everyone but especially to children. She feels that today people aren't physically free, that they don't show affection enough, don't touch enough, don't hug each other enough."

"I am beginning to understand where all the pieces fit," Rampling says. "My life, work, being a mother, love, friends, beauty, seduction, generosity—how to fit it all in."

As for her own looks, everything depends, says Charlotte, on "what is going on inside my head. My looks change as my mental outlook changes."

—LEO LERMAN, *December 1974; July 1976*

Brooke Shields

The actress was expecting her first child, a daughter named Rowan, when she posed for Annie Leibovitz in Los Angeles in 2003. As a fourteen-year-old model in 1980, she was photographed for the *Vogue* cover by Richard Avedon (who also shot her notorious ad campaign for Calvin Klein jeans).

Anjelica
Huston

Herb Ritts photographed
the Oscar-winning actress
and former model at
her ranch in Three Rivers,
California, in 1990.

209

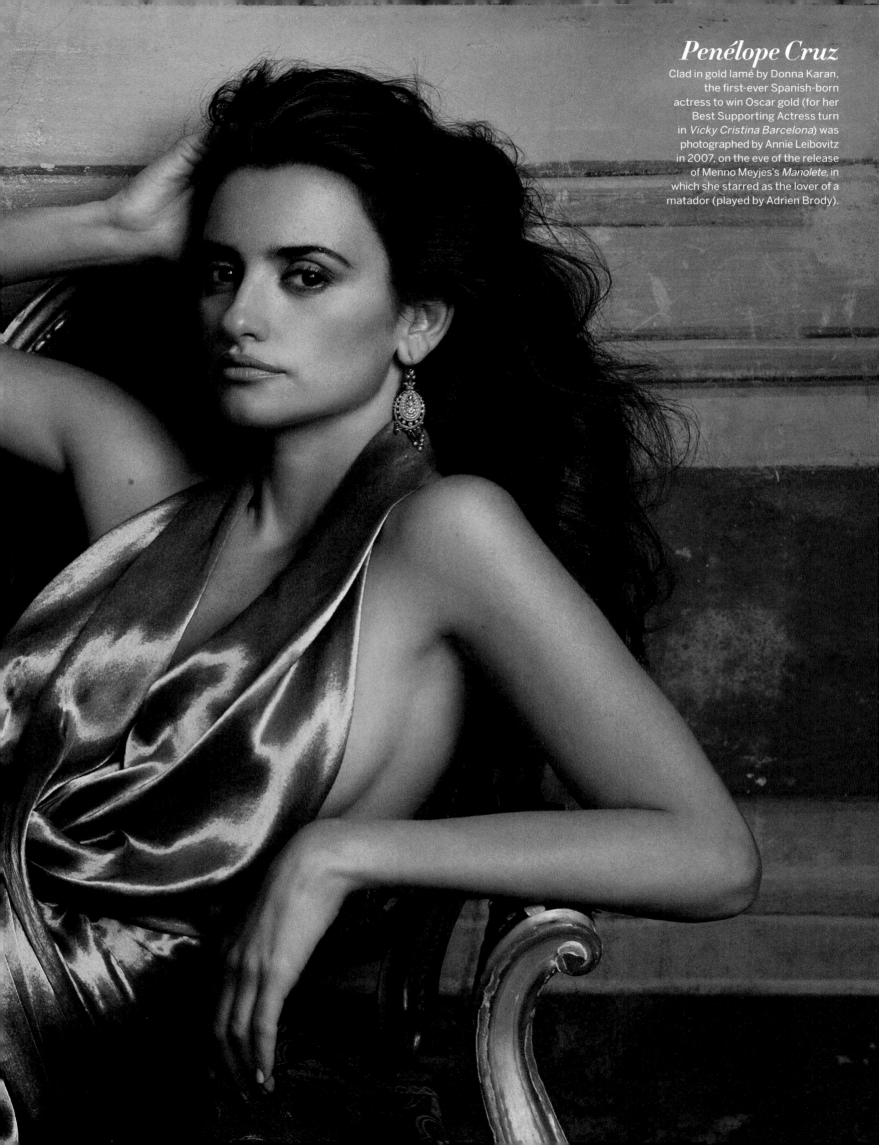

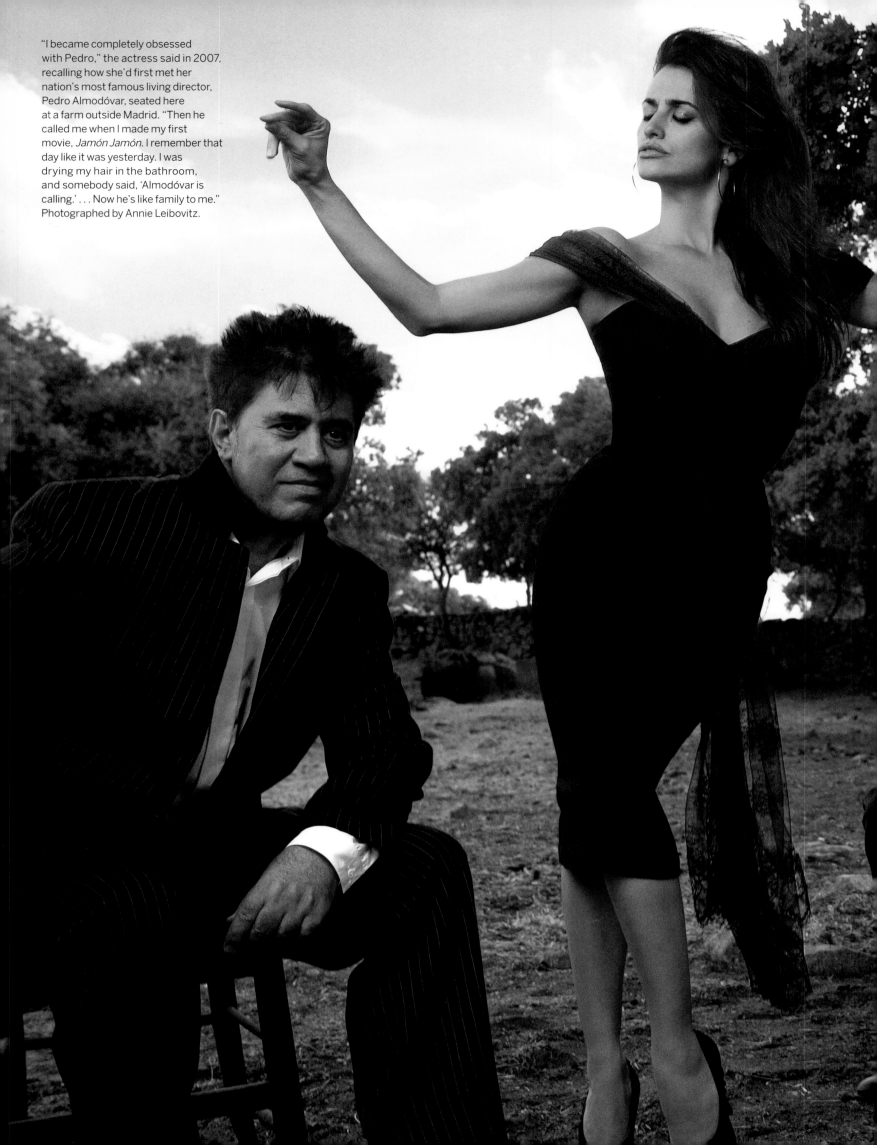

"I became completely obsessed with Pedro," the actress said in 2007, recalling how she'd first met her nation's most famous living director, Pedro Almodóvar, seated here at a farm outside Madrid. "Then he called me when I made my first movie, *Jamón Jamón*. I remember that day like it was yesterday. I was drying my hair in the bathroom, and somebody said, 'Almodóvar is calling.' . . . Now he's like family to me." Photographed by Annie Leibovitz.

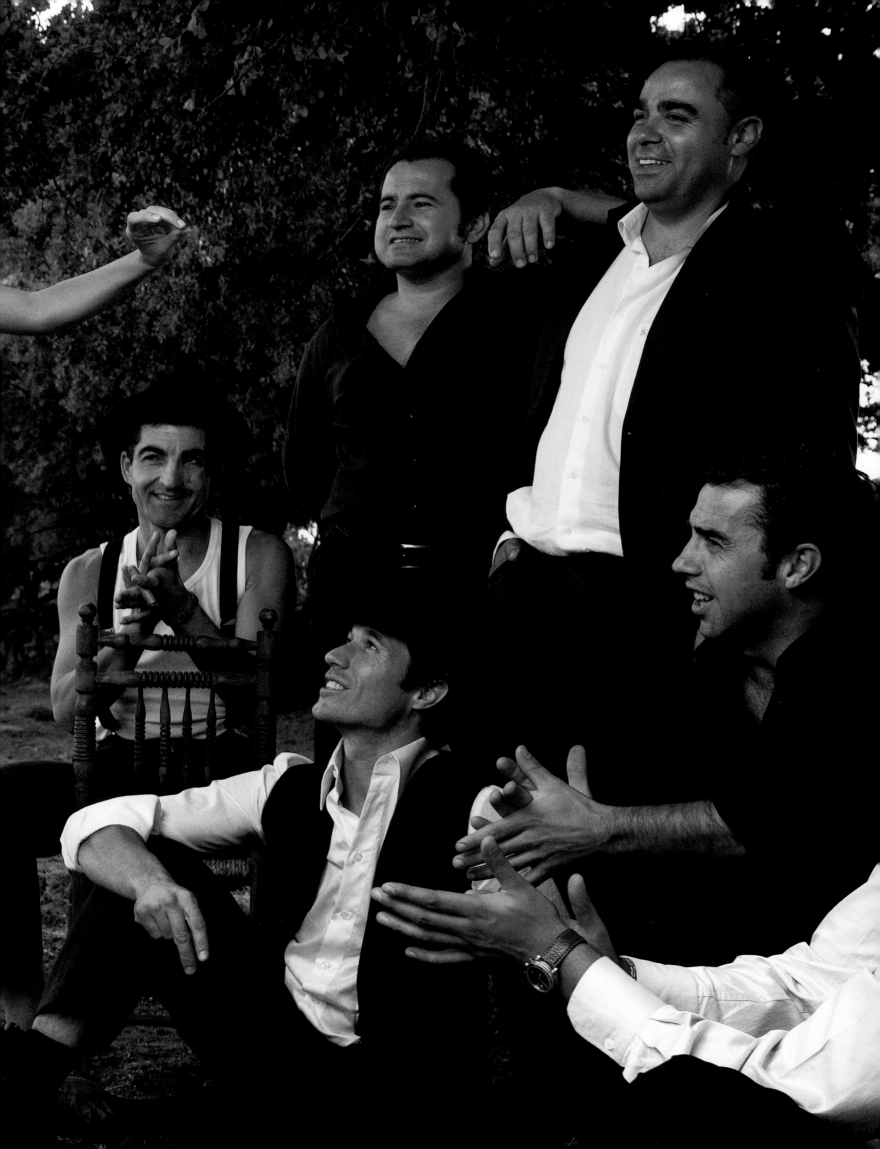

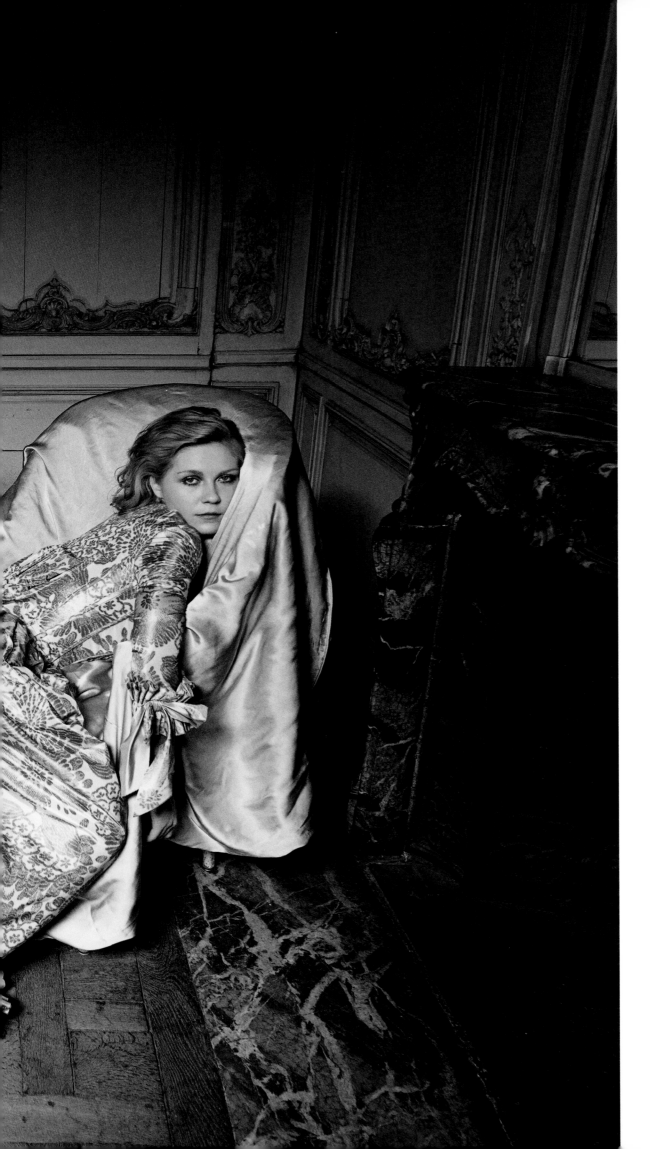

The title-role star of Sofia Coppola's *Marie Antoinette* was photographed by Annie Leibovitz at Versailles in 2006, wearing Oscar de la Renta's chine-taffeta gown.

215

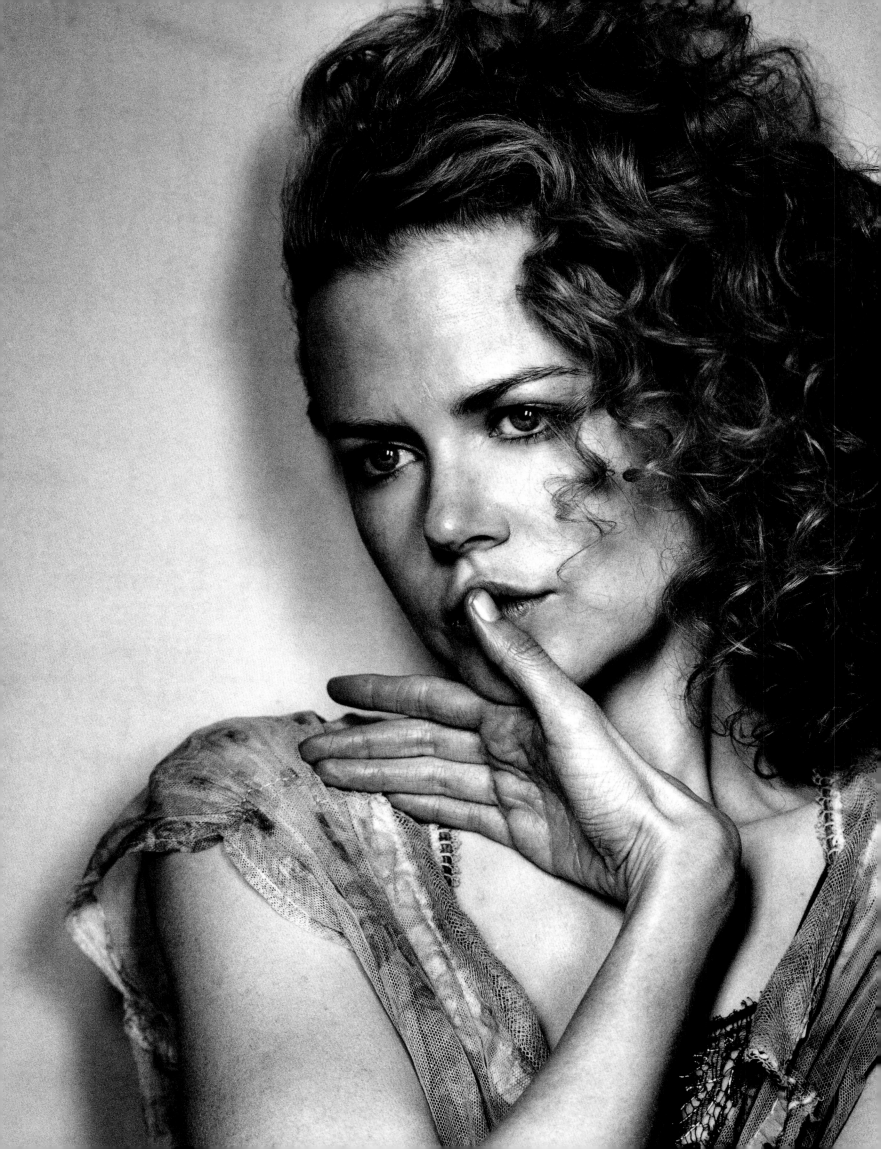

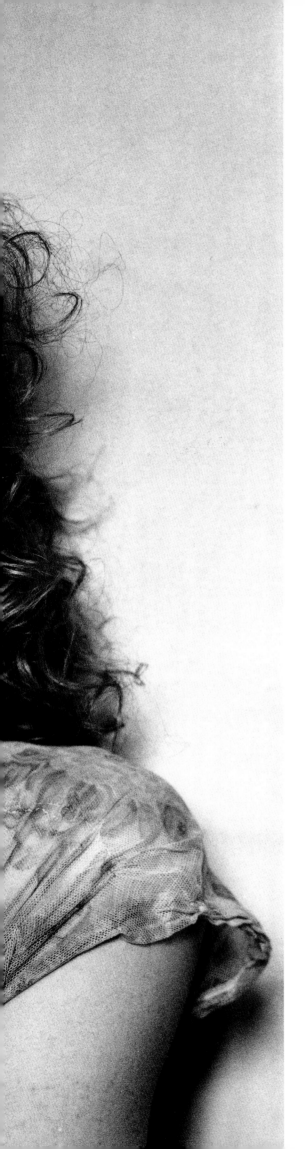

The Oscar-winning actress
in 2003, the year she
starred in Robert Benton's film
The Human Stain.
Photographed by Irving Penn.

NICOLE KIDMAN

Kidman in Christian Lacroix Haute
Couture, photographed by Irving Penn
for the May 2004 cover of *Vogue*.

t o consider the phe-
nomenon of Nicole Kidman is, from one point of view, to
consider the variety of masks and looks this extraordinary
actress has worn with relish and that have transformed her into
an icon of glamour and a certain fabulous appropriateness.
It's not by chance that she has just been appointed the face of
Chanel No 5, the most classically chic perfume on the planet.
As Tom Ford puts it, "She's developed a character for the red
carpet, a public persona that is very groomed, very sleek, very
controlled, very smooth, very much the star, very gracious,
very elegant, very thoroughbred."

Although stylish from the start, Kidman upped the stakes
in 1997 when she wore a chartreuse Christian Dior sheath that
was, observers felt on the night, the first time anybody had
worn haute couture to the Oscars with real conviction. "If you
look at designers as visionaries," says the actress, "and there are
a select number who are visionaries, they can inspire, let you
dream. That's a lovely thing to support and to act as a conduit
for." Says John Galliano, the man responsible for the dress,
"Nic is flawless—a true and believable beauty who completely
resuscitated the red-carpet moment."

That Dior number is still her all-time favorite: "I love the
simplicity of the design, the intricacy of the detail, the boldness
of the color. It shouldn't have worked, you know." But it did, of
course. Just as Christian Lacroix's swirly halter-neck for Pucci
magically stole the show at Cannes, and Gaultier's black toga
looked very good with a gold statuette. "All I know," she says,
"is that this was a dress that I loved."

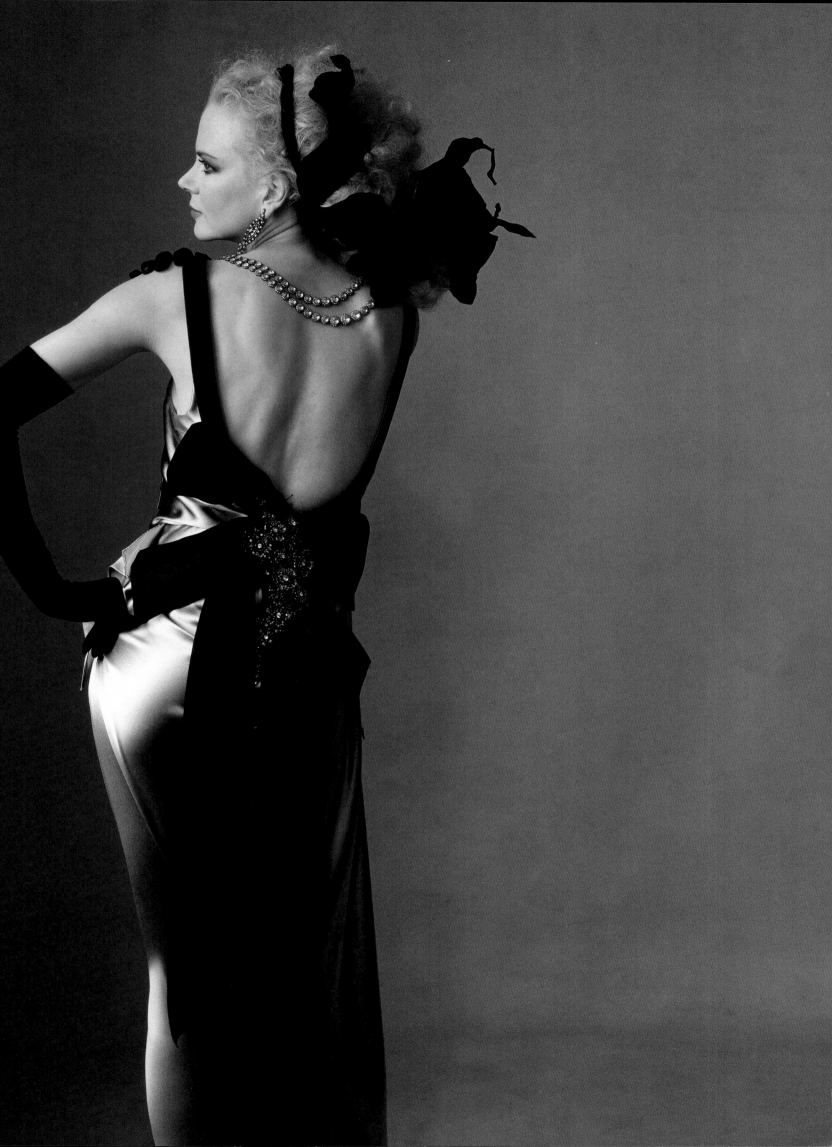

Kidman at Waddesdon Manor,
Buckinghamshire, England, photographed
by Mario Testino in December 2006.

Nicole Kidman knows a little bit more than she admits about red-carpet rules. Better than any of her contemporaries, she knows how to put them in a personal context—"Enjoy these moments. Appreciate them; embrace them for what they are. And know that they exist in a bubble"—and, more significant, in a professional context. She understands, says director Baz Luhrmann, that "the red carpet is a job, and, boy, is it a lot of work!"

Nicole never allows her poise to falter in public—not even, reveals Luhrmann, in the "moments after her life fell apart" during the publicity tour for *Moulin Rouge!* At all times she's discretion personified. There is no irony nor any detectable self-disclosure. This lofty bearing, coupled with her model's frame, is why designers love her so. (Valentino: "She has the most perfect figure." Ford: "She's amazing, she's wonderful, she's skinny, she's tall.") Nicole's status rests on her authority and grandeur. Even though her private life has long been fodder for the tabloids, her dressed persona is mysteriously exempt from the blemishes of an ordinary existence. This makes her, in the eyes of anyone dressing for an occasion, the most instructive role model around.

The paradox is that this seemingly invulnerable fashion icon is famous for playing women who, if they're not on the edge of a nervous breakdown, have actually fallen over the precipice.

"On the red carpet, it is always Nicole, no matter who made the dress," says Olivier Theyskens. "But then, in film, she really becomes something else. She really takes risks." Kidman is, arguably, the most versatile and consistently surprising actress of her generation—singing courtesan one year (*Moulin Rouge!*), suicidal writer the next (*The Hours*)—and she is fearless in pursuit of her craft. "I am going to make failures," she says, "and I'm going to make successes. And I'm going to live my life."

It's an unusual statement of intent coming from a woman who, off-screen, has worked so hard to embody perfection. "She could kick back, use the body, use the red-carpet persona," says Luhrmann, "but she has incredible balls. When it comes to risks, she is team leader." For Kidman sees her tortured on-screen characters as revealing of her inner life: "It's not like I'm hiding my heart or my soul. That train station in *The Hours*—I understood it. The truth of it was important to me." The spirited Ada in Anthony Minghella's *Cold Mountain* and the demented widow in Jonathan Glazer's *Birth* are both roles she claims are "so exposing in terms of my psychology." The actress teeters between self-revelation and its opposite, between fragility and strength, without ever falling down. This is why we can't take our eyes off her, whoever she may be.

—SALLY SINGER, *September 2003*

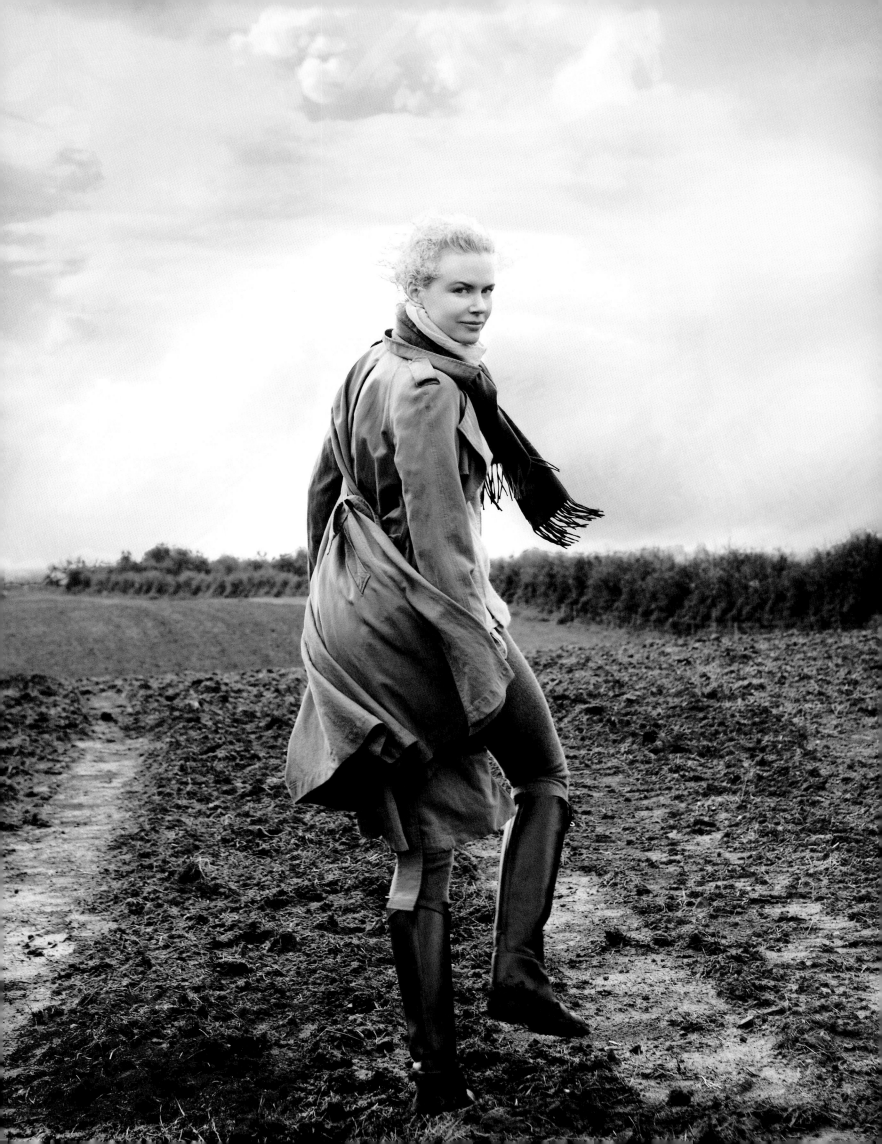

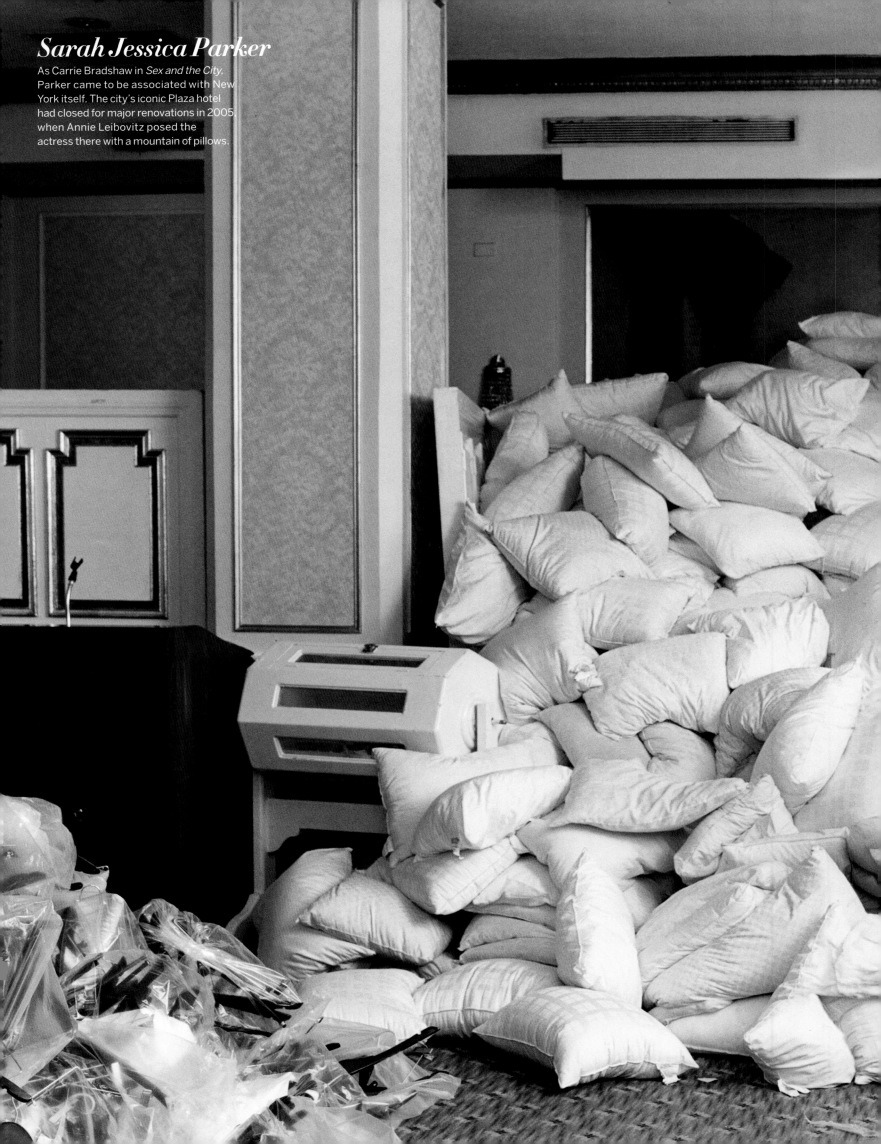

Sarah Jessica Parker

As Carrie Bradshaw in *Sex and the City*, Parker came to be associated with New York itself. The city's iconic Plaza hotel had closed for major renovations in 2005, when Annie Leibovitz posed the actress there with a mountain of pillows.

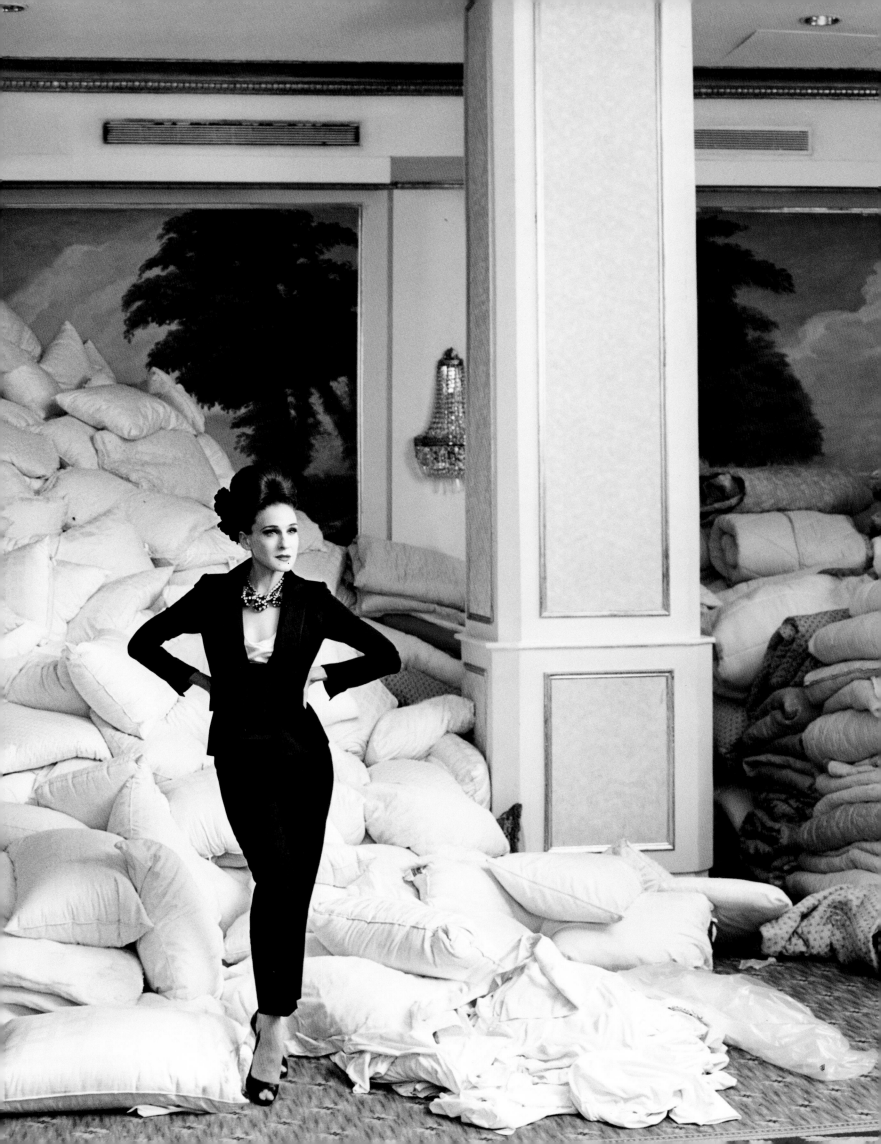

ANGELINA JOLIE

Starring in movies is not always a priority in Angelina Jolie's life. What film role could possibly be more exciting—or more sweepingly romantic, for that matter—than her own epic life story? The daredevil adventuress mother of three seems to have an unquenchable thirst for the uncharted and off the grid. Traveling to some of the most dangerous regions in the world (often piloting her own plane), she has visited refugees, given millions of dollars for schools, hospitals, and shelters, and been honored by the U.N. This is a woman who thinks nothing of helicoptering onto the top of a mountain in post-earthquake Pakistan or of moving to Namibia to give birth in a tiny hospital in a one-doctor town. "I personally can't afford regret, or else I would be more careful about my life," she says. "I really don't have a time where I've thought, Oh, I wish I could go back and turn it around." If anything, she says, "I've actually gotten bolder."

Her partner in all this, of course, is Brad Pitt, who, she says, "is a great challenge to me. We push each other to be better. Even if it's just a better bike rider or a better pilot. We're constantly in competition with each other. He's somebody I admire based on the way he lives his life. And that's why I'm with him."

Unlike her less rebellious, more established A-list peers, Jolie does not seem interested in cultivating a particular look. Clothes for her are a costume, chosen to suit whatever role—activist, red-carpet denizen, globe-trotting mom—she happens to be playing at the moment. She is famously difficult to photograph, perhaps because it forces her to wrestle with the two sides of her public image: tattooed tough girl and insanely feminine sex bomb. "I am still at heart—and always will be—just a punk kid with tattoos," she says.

Many of the things Jolie has said over the years have been misconstrued. One only has to see the raised eyebrow to know she's often half-kidding—being arch or perverse—an aspect of her personality that seems to get lost in translation. "The biggest misperception about me is that I'm not a conscious person or a smart person," she says. "I've been reckless, certainly, but I'm not a rebel without a cause."

Like a modern-day Jane Fonda, Jolie has a propensity for passionate self-reinvention, but she sees her choices as being all of a piece. "I think I'm exactly the opposite of unpredictable," she says. "I'm extremely focused. When I have a feeling to do something, I just do it."

—JONATHAN VAN METER,
April 2002; March 2004; January 2007

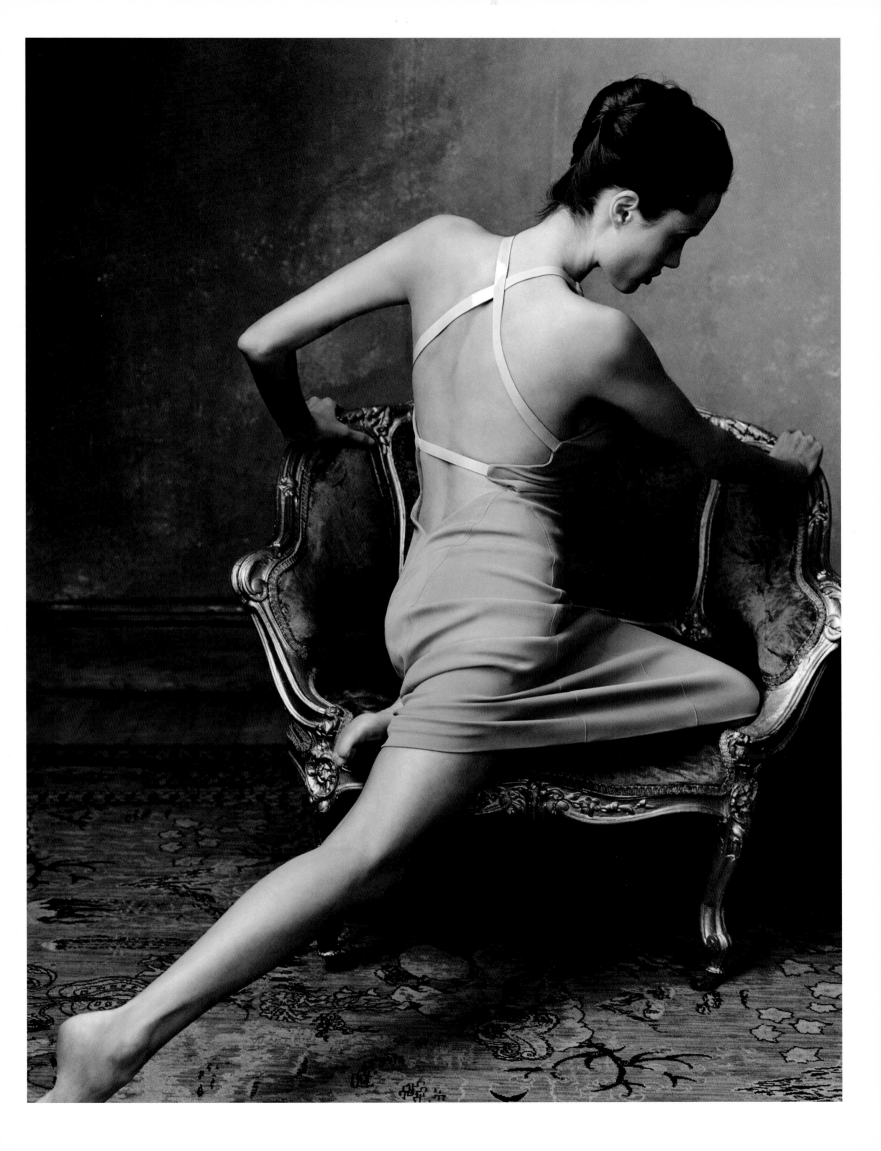

Jolie was married to Billy Bob Thornton when Leibovitz took this picture in 2002.

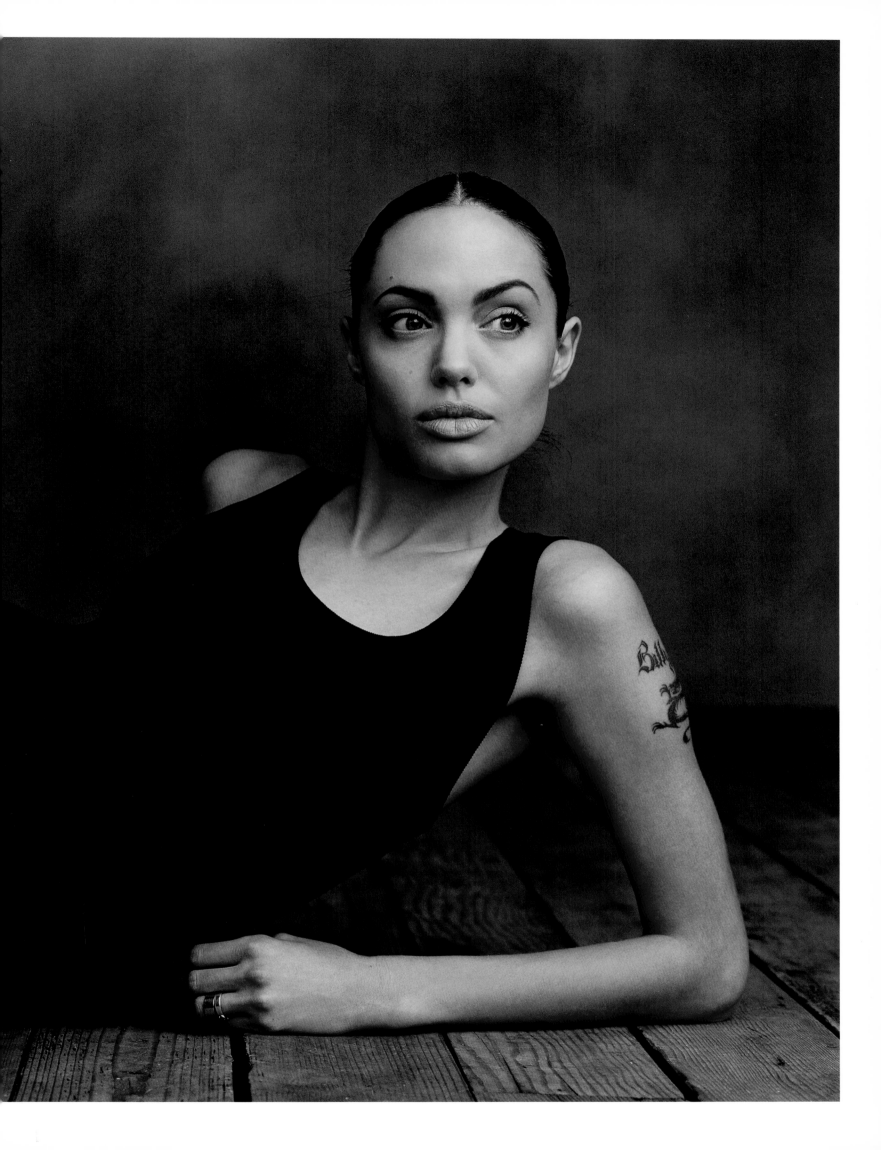

Marella Agnelli on the *Tritona,*
a wide-bottomed caïque,
during a 20-day cruise in 1966
that began in Brindisi,
on the Italian Adriatic, and
headed for the islands
and coast of Yugoslavia.

THE
PLACES

"Village lamps light the distance; but only Gianni, ever the questing spirit, wants to go ashore. The rest of us have more sense," wrote Truman Capote of Gianni Agnelli (*left*), describing their approach to the Montenegrin coast after a rough day at sea.

AGNELLI CRUISE
YUGOSLAVIAN COAST

august 1966—aboard the *Tritona*. Others aboard: Gianni and Marella Agnelli (hosts), Stash and Lee Radziwill, Luciana Pignatelli, Eric Nielsen, Sandro D'Urso, Adolfo Caracciolo, his daughter Allegra, and his nephew Carlo. Seven Italians, one Dane, one Pole, and two of us (Lee *et moi*). Hmmm.

Point of departure: Brindisi, a rather sexy seaport on the Italian Adriatic. Destination: the islands and coast of Yugoslavia, a 20-day cruise ending in Venice.

It is now 11:00 P.M., and we had hoped to sail at midnight, but the captain, a no-nonsense gentleman from Germany, complains of a rising wind and thinks it unsafe to risk the sea before sunrise. Never mind!—the quay alongside the yacht is awash with café lights and piano sounds and sailors browsing among brigades of pretty little purse-swinging tarts.

MAL DE MER NIGHTMARE
Groan. Moan. Oh, oh, oh, hold on to the wall. And crawl, please, Jesus. Slowly, slowly, one at a time: Yes, I am crawling up the stairs from my cabin (where green waves are smashing against the portholes), crawling toward the presumed safety of the salon.

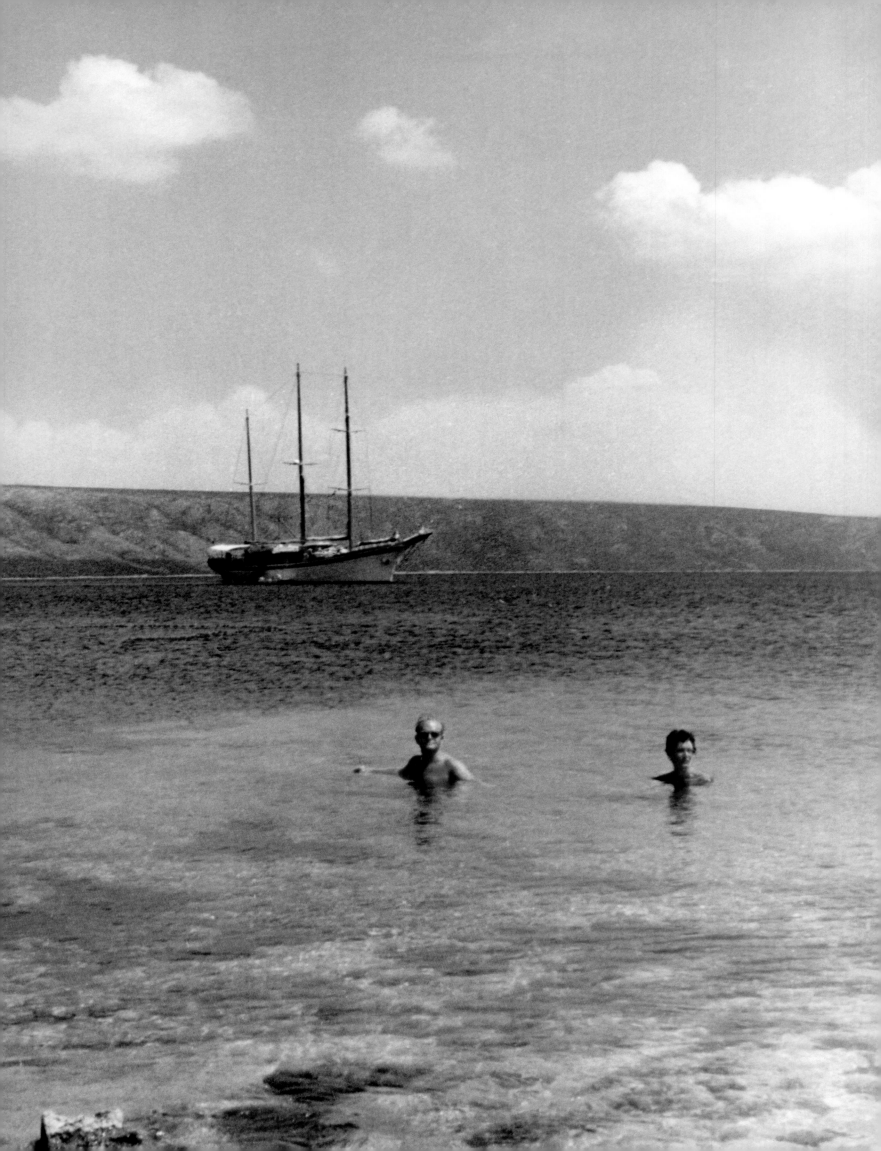

The *Tritona* is a luxurious craft constructed on a wide-bottomed principle of a Grecian caïque. The property of Conte Theo Rossi, who lent it to the Agnellis for their cruise, it is furnished throughout like the apartment of an elegantly humorous art collector: The salon is a greenhouse of flowering plants—a huge Rubens dominates the wall above an arrangement of brown velvet couches.

But on this particular morning, the first day of the voyage, as we cross the swelling seas between Italy and Yugoslavia, the salon, when at last I've crawled my way to it, is a rocking wreck. A television set is overturned. Bottles from the bar are rolling on the floor. Bodies are strewn all over like the aftermath of an Indian massacre. One of the choicest belongs to Lee (Radziwill). As I crawl past her, she opens a seasick eye and, in a hospital whisper, says, "Oh, it's *you*. What time is it?"

"Nine. Thereabouts."

Moan. "Only *nine*? And this is going to last the *whole* day."

A steward had arranged a buffet breakfast, but no one has gone near it—until presently Luciana (Pignatelli) appears. Luciana looking impossibly serene and lovely—her slacks immaculate, every strand of golden hair just so, and her face, the eyes particularly, a triumph of precise maquillage.

"Oh, *Luciana,*" says Lee in a grieving, drowning tone, "how ever did you do it?"

And Luciana, buttering a slice of toast and spreading it with apricot jam, says, "Do what, darling?"

"Put on your face. I'm trembling so—I can't hold a lipstick."

"Trembling?" says Luciana, crunching her toast. "Oh, I *see*. You are troubled by the motion of the boat. But really it is not so bad, no?" Then she calls for the steward, who arrives careening to and fro. "May I have an egg, please?"

Lee says, "Oh, Luciana. How *can* you?"

WASPS

It's my policy to leave heavy sightseeing to others—I've never cared to burden myself with churches and such relics. I like people, cafés, and the stuff in window shops.

As usual in these countries, the store shelves are crammed with merchandise, but none of it is anything you would care to buy, not even as a gift for a cruel stepmother. Occasionally one encounters a street peddler selling pretty-enough native rugs.

Nor can we praise the restaurants. The queer thing is the quality of produce available in the marketplace is excellent. In the larger coastal cities, say Split, the markets sprawl like immense crazy quilts, a pattern composed of tomatoes and peaches and roses and soap and pickles and pigs' feet and severed carcasses strung upside down. And over it all, over everything, hovers a buzzy, prickly cloud of wasps. These wasps are like a political emblem, a subtly evoked threat—they seldom sting, but one cannot escape them, for they are a constant factor in Yugoslavian landscape: a part of the air, unavoidable even aboard the *Tritona;* where we lunch on deck, the wasps dance in a yellow haze above the wines and melon.

AN UNPLEASANT FISHERMAN

"A week is enough. Ten days is the absolute maximum." So remarked Stash (Radziwill), referring to the amount of time he considered it possible to spend within the confines of a yacht cruise; and apparently most people in a position to judge second his opinion—that ten days is the limit, regardless of the charm of the company or the fascination of the scenery. But I do not

agree with this. To my mind, the longer a cruise lasts the more intoxicating it becomes—a strange drifting awake dream, a drug compounded of sun and motion and floating-by views that both lifts and lowers the spirit into a condition of alert slumber.

Also, I like the boat routine. *Tritona* mornings are spent ashore in city ports or island villages; around noon the cast, separated in twos and threes, wanders back aboard, then departs again by various speedboats to isolated coves and beaches for an hour's swim. When everyone has once more reassembled, we gather on the sun-exposed upper deck for drinks and, for the athletes, a session of exercises conducted by Luciana ("my figure has improved 70 percent since I started weight lifting").

Then lunch (Italian chef, lots of great pasta concoctions, am gaining about a half-pound a day, oh, what the hell). And as we start lunch, the yacht sets sail; we cruise all afternoon to our next destination, usually arriving at sunset.

Yesterday, abandoning the languors of a Norwegian-like fjord, we went all together in two speedboats to explore the beautiful waters surrounding a rocky little island. That was where we encountered the unpleasant fisherman.

He was a husky, handsome man, brown and naked except for denim trousers rolled up to his knees; not young—but a youthful 50. His sturdy little boat was anchored in the cove where we had stopped to swim. He and his crew, three men much smaller than their captain, were ashore building a fire under a big iron kettle. The captain, a cleaver in his hand, was chopping up great hunks of fish and tossing them into the pot.

It was Eric who said why not buy fish from them, so we all swam to the beach, and Eric and I went over to discuss the matter with the fishermen. None of them acknowledged our approach. They just, in a rather eerie way, pretended we weren't there. Finally Eric, speaking Italian, which most Yugoslavian seamen speak or understand, complimented them on their fine haul and, pointing out a particular *loup,* asked its price. The sullen captain, with a mirthless grunt, replied, "Three hundred dollars." And he said it in English!

At this juncture Marella arrived, and she said to us, "He thinks we are all Americans. That's why he is being so rude." Then, turning to the captain, still unconcernedly preparing his stew, she announced, "*I* am an Italian."

And in Italian the captain said, "Italians are no good either. Why," he shouted, pointing at the delicious-looking mess simmering in his kettle, "why do you people come here and stare at our food? Do *we* stare at your food?"

"Well," said Marella, as we walked away, "the old boy has a point, you know."

"Personally," said Eric, "I think he ought to be reported to the tourist bureau."

SEX AND SIN IN OLD DUBROVNIK

What new can one say about Dubrovnik anyway? It is like some section of Venice drained of its canals and stripped of color: gray, medieval, and Italian without Italian brio. In autumn and winter it must, in its emptiness, be most impressive; but in summer it

is so crowded with excursion-fare vacationers one can scarcely keep to the pavement. And for those holidaymakers the government has arranged a quite startling nightlife, altogether unlike any this diarist has seen in other so-called Communist countries (which, excepting Albania and China, includes the lot).

Above the city, nightclubs with sea-panorama vistas throb through the night; one in particular, an alfresco affair attached to a full-scale gambling casino, puts on a floor show reminiscent of those erotic hoedowns in pre-Castro Havana. And in fact the star of the show turned out to be that old-time Cuban legend: Superman!

All those who remember Superman from Havana will be interested to hear that his act, which formerly consisted of vigorous sexual intercourse on a brightly lighted stage, has changed: He is now the male section of a dance team. He and his partner writhe around to the banging bongo drums, gradually removing one another's attire until such nakedness appears that Superman seems ready to go into the routine that once made him so famous: But there it stops. The whole thing is fairly humorous, though God knows the audience doesn't think so: Their response is a kind of stupor.

TO THE NORTH

Now, leaving the warm moist southern climate, we steam steadily northward into spheres where the air, though it is only late August, trembles already with a beyond-September chill. It is as if a cold crystal ball had descended, enclosing and stilling the green sea, sky, the growing-greener coast bobbing by: Gone is the harsh and stony Montenegrin grayness, the subtropic pallor, for now each northward-going day the scene is more fruitful, there are trees and fields of wildflowers and grape vineyards and shepherds munching close to the Adriatic's edge.

I feel touched by some extreme magic, an expectant happiness—as I always do when that sense of autumn arrives, for autumn never seems to me an end but a start, the true beginning of all our new years.

VENICE DESERVED

And so our voyage stopped in the mists of a Venetian evening. With sea mists blurring the lights of San Marco, and sea buoys mournfully tolling watery warnings, the *Tritona* entered the saddest and loveliest of cities and anchored *alla* Salute.

The mood aboard is not all sad: The sailors, many of them Venetians, whistle and amiably shout as they swing ropes and lower launches. In the salon, Eric and Allegra are dancing to the phonograph. And I, huddled in the dark, on the upper deck, am very pleased myself—pleased with the air's promising chill, and the oily flickering lights, and the thought of an imminent visit to Harry's Bar.

I've starved myself all day because—Oh, what joy to step out of the night into the chattering warmth of Harry's Bar and wash down those little shrimp sandwiches with an icy martini or three!

—TRUMAN CAPOTE, *April 15, 1967*

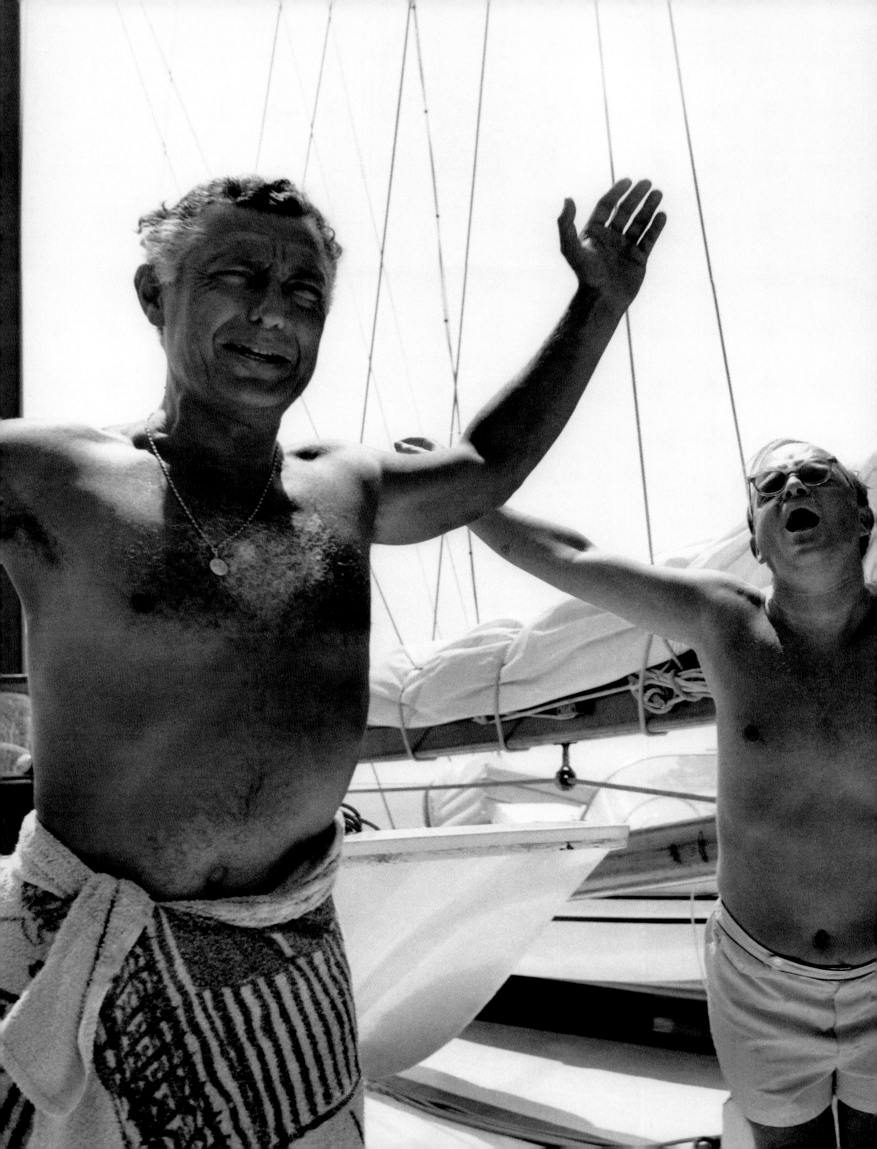

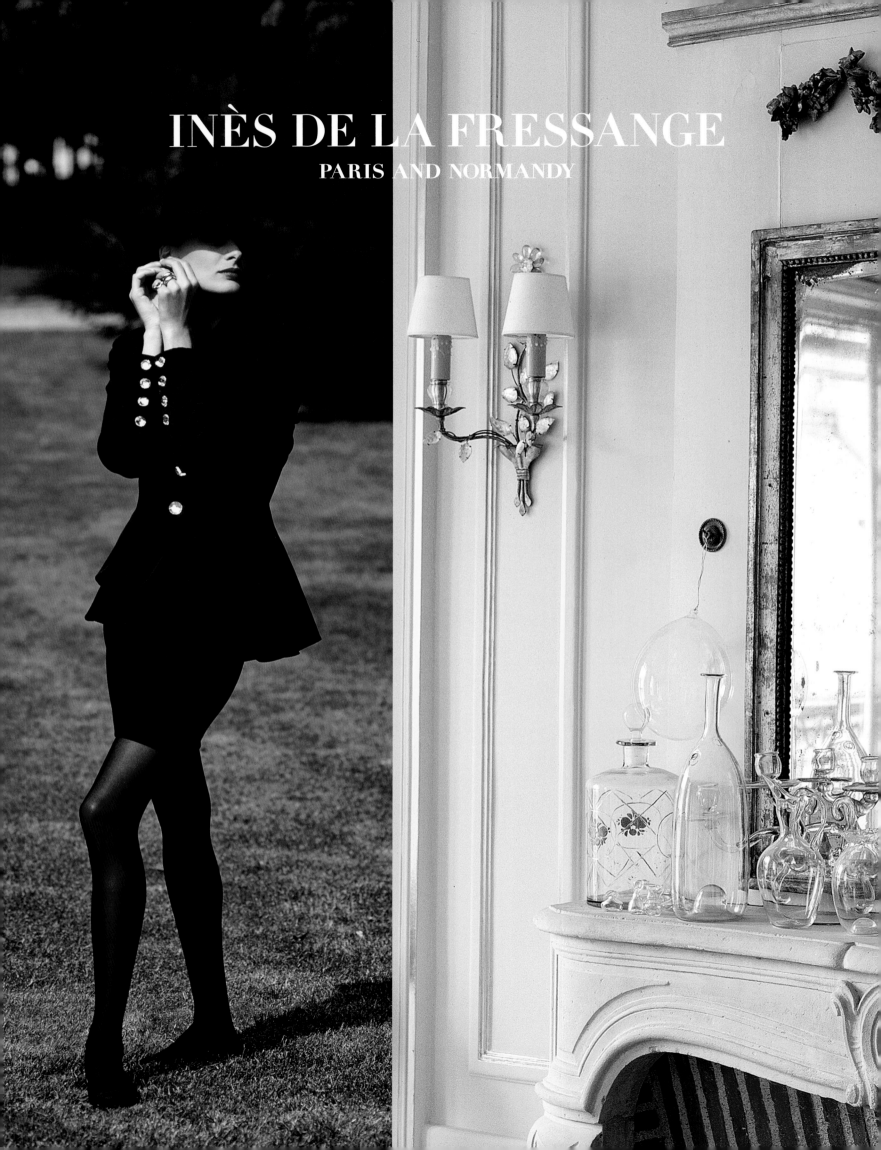

INÈS DE LA FRESSANGE

PARIS AND NORMANDY

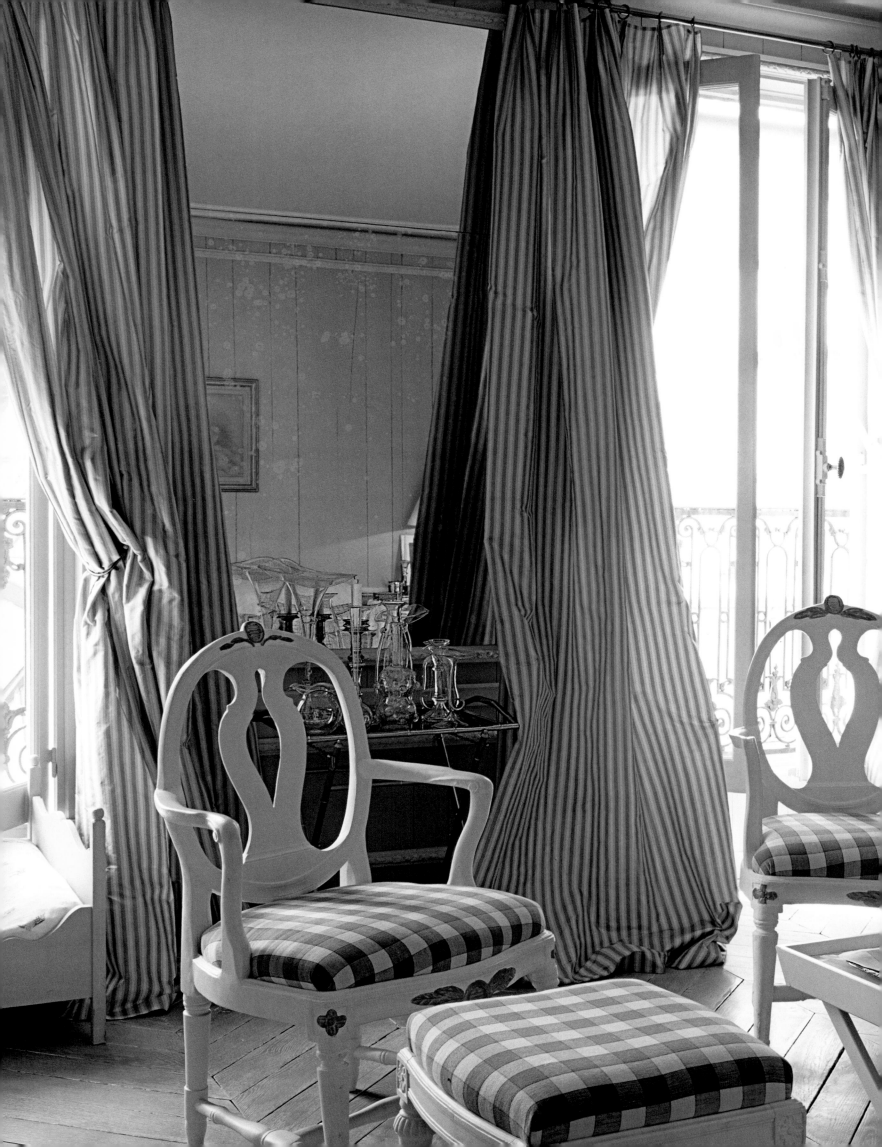

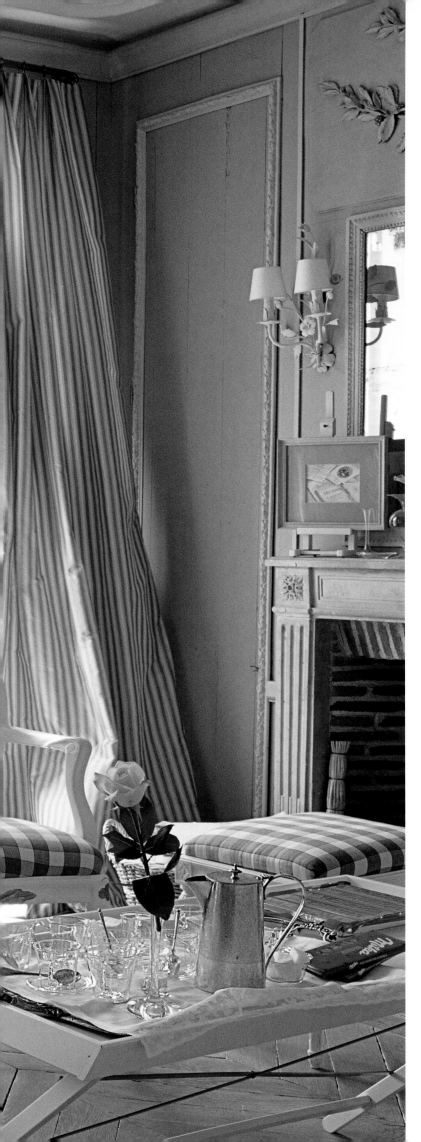

Chicer than Inès you cannot be," said Karl Lagerfeld, and it remains true—after the split between the emperor of couture and his queen of the runway. With her ragged black hair, sparkling black eyes, and vivacious demeanor, the half-Argentine, wholly aristocratic Inès de La Fressange was adopted by Lagerfeld as the irreverent image of Chanel for the eighties. Her seven-year, one-million-franc contract to become the house muse was the best deal ever offered to a French model.

A top model generally embarks on an afterlife with a prince or a billionaire, and her career is swiftly forgotten. Jacques Fath's Bettina teamed up with Aly Khan; Fiona Campbell-Walter married Baron von Thyssen-Bornemisza; and Hattie Carnegie's favorite model, Pauline, married Baron de Rothschild.

Inès married the gentle and charming Luigi d'Urso, a friend she has known since she was seventeen and with whom she has created the prettiest apartment in Paris, in the mansard roof of a classic eighteenth-century house on the rue Montalivet, which we reach in a tiny creaking elevator. Inside, Inès and Luigi have revived a period look all but forgotten by fashion: chandeliers and bare floors, no gilt, a cool northern look refined in the epoch of King Gustav III of Sweden. At its most rural it is illustrated by Inès's favorite painter, the Swedish Carl Larsson, whose series of watercolors, *Our Home,* charmingly illustrates the summer and winter family life of a small wooden house with tiled stoves, paneled walls, and chairs with striped cotton "aprons" tied at the back.

Le style Inès is now the basis of a new career, with her own clothing label and store on the Avenue Montaigne, where she will sell virtually anything she adores, from Alexis de La Falaise furniture to linens to dog leashes. "I always used to feel there was a question mark over me," she muses huskily. "What was I? Not exactly a model. Certainly not a designer. Now I have a real job. I know who I am and what I have to do."

—GEORGINA HOWELL, *October 1991*

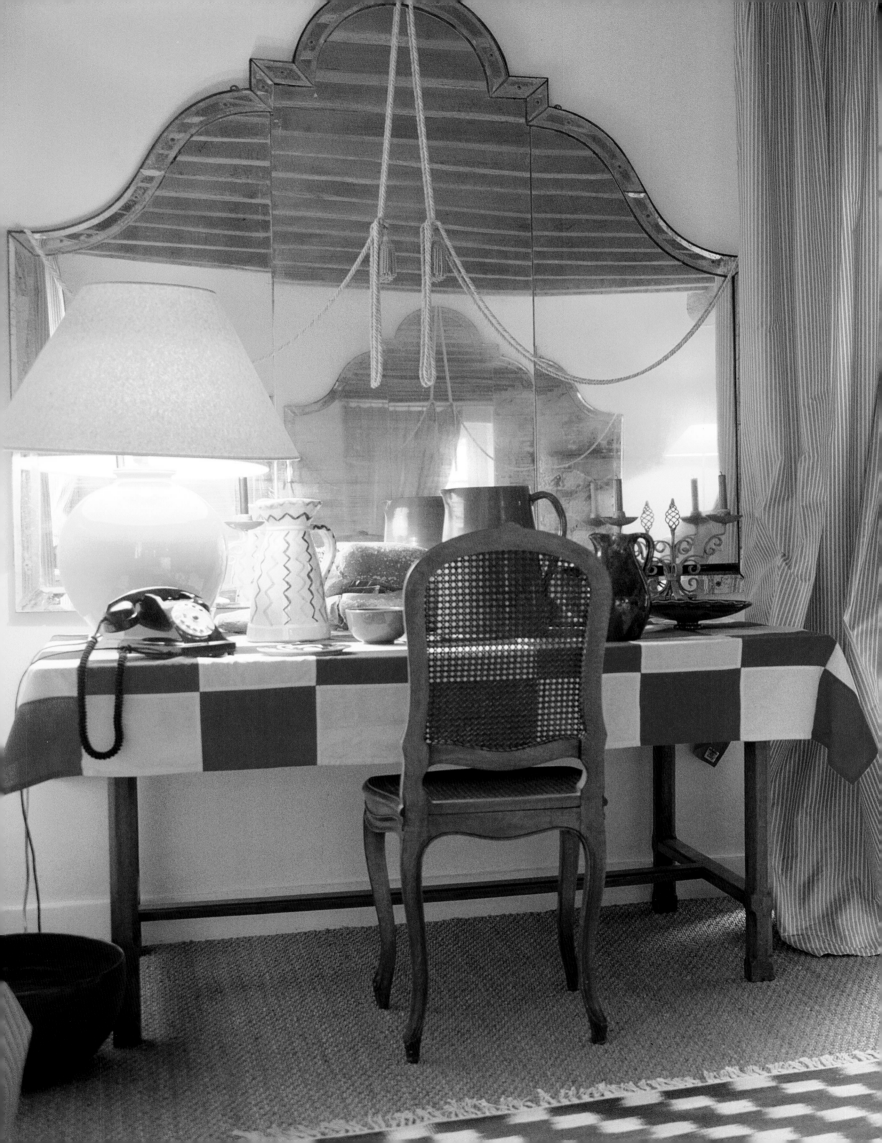

The living room of Inès's
19th-century country
house. Photographed
by Eric Boman, 1991.

THE GARDENS
OF MIRANDA BROOKS
CORFU, MONTAUK, EAST HAMPTON

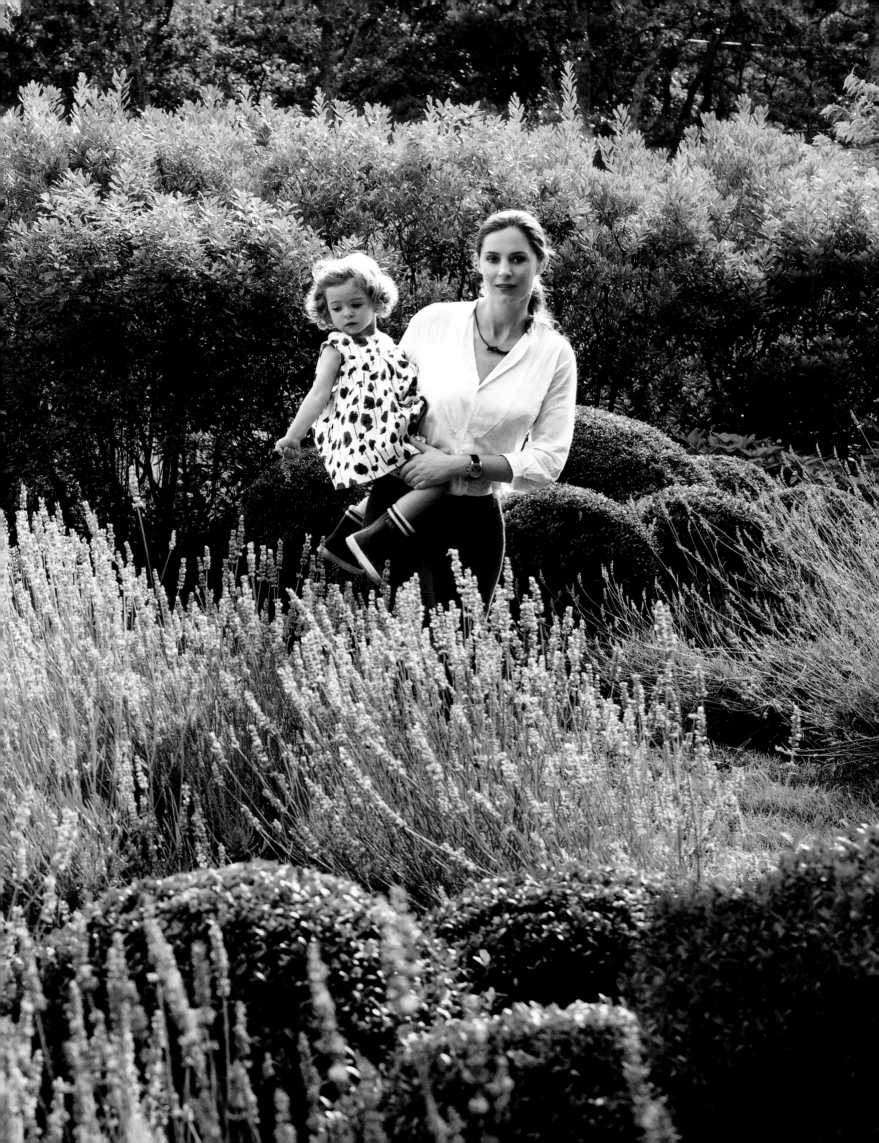

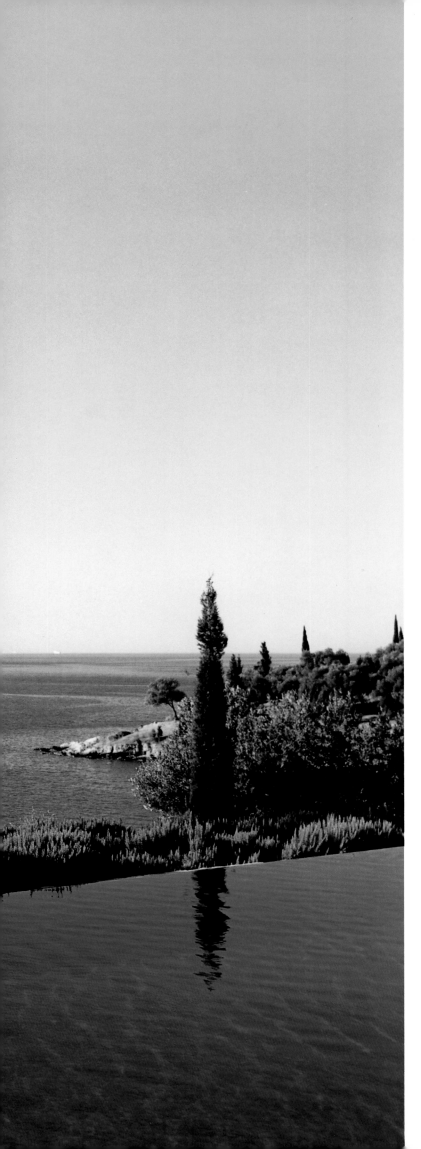

Y

ou can tell that landscape archi-
tect Miranda Brooks is a visionary by the way she paces a
garden she is working on, long legs striding, long hair flowing,
a faraway look in her eye. Grasping the big picture and then
executing it with lavish attention to detail is a skill that has
earned her an impressive list of international clients, includ-
ing assorted Rothschilds and Guinnesses, Ron Perelman, and
numerous others too grand to be named. Annette de la Renta
advises people "to do whatever Miranda recommends because
she has great taste and really knows what she is doing."

The discipline of Brooks's college training in landscape
architecture is as evident as her affection for the unfettered
naturalness of the English countryside in her approach to
landscaping, which incorporates both the satisfactions of
geometry and the free-spiritedness of tumbling areas of wild-
ness. "While her work has clear structure and knowledge, it
is never academic," remarks the New York–based architect
Annabelle Selldorf, who frequently proposes Brooks for her
projects. "Her use of texture and color supports the spatial
clarity, and it seems to me there is always a narrative—a fan-
tasy, almost—that goes with her designs."

Although she recalls spending "two very lonely winters
working on Capri, Formentera, and Majorca, summer islands
that are really bleak, freezing, and empty out of season,"
Brooks also enjoys the adventure of her job. "There's part
of me that loves having these little secret lives. I need to fall
in love, really, with the land in order to understand how to
make a beautiful garden. In a way it's a kind of love affair,
and nobody in your normal life knows about the intense
relationship you're having."

—EVE MacSWEENEY, *September 2008*

247

A view from under the grapevine-covered pergola of a butterfly garden on Long Island, where Brooks created herbaceous borders of phlox, fennel, echinacea, eupatorium, lychnis, perovskia, *Knautia macedonica,* and buddleia leading to a Chatsworth bench against an ilex hedge. Photographed by Eric Boman, 2006.

Brooks planted *Molinia, Eryngium,* fennel, veronicastrum, echinacea, and grasses (*below*) at Adam Lindemann and Amalia Dayan's house in Montauk. Photographed by François Halard, 2009.

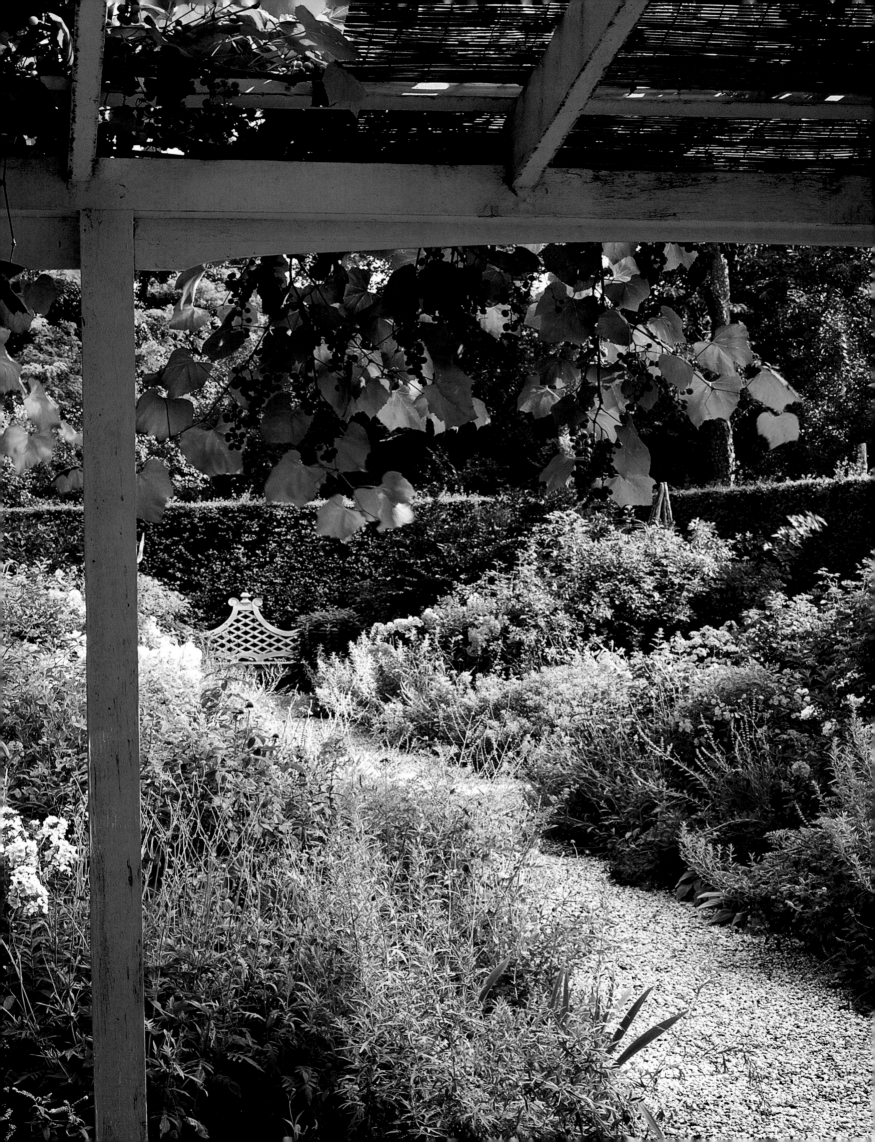

Oak trees border a pool on Long Island.

Ilex and hornbeam (*below*) create an allée called the Long Walk to Love, leading to a Robert Indiana sculpture on a Long Island estate. Photographs by Eric Boman, 2008.

A view of some of the herbaceous borders at the Château de Wideville, 30 minutes outside Paris, the setting for a party Valentino threw to celebrate the end of the Paris couture shows in 2002. Photographed by Robert Fairer.

———————————

The model Linda Evangelista (*below*), one of the designer's frequent guests, in vivid Valentino at his party in Rome, 1991. Photographed by Roxanne Lowit.

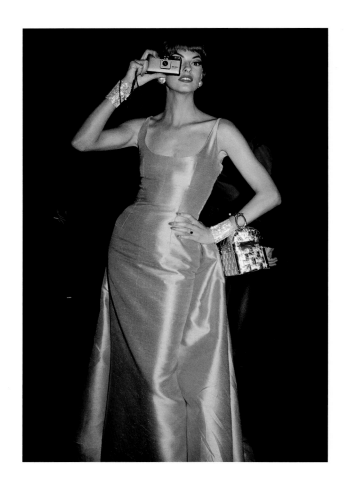

a ravishing jewel box of rose brick and ivory stone, Valentino's Château de Wideville was acquired by Louis XIV, the Sun King, who installed his voluptuous mistress Louise de la Vallière there while nearby Versailles was being built.

At a fete to celebrate the designer's Paris haute couture showing, guests enter at dusk. Wicker chairs and low tables are set under canvas parasols suggesting a perpetual Edwardian summer. Courtly footmen move about lighting candles. Prince and Princess Guillaume of Luxembourg and the former Empress Farah Diba Pahlavi of Iran show up with the disarming

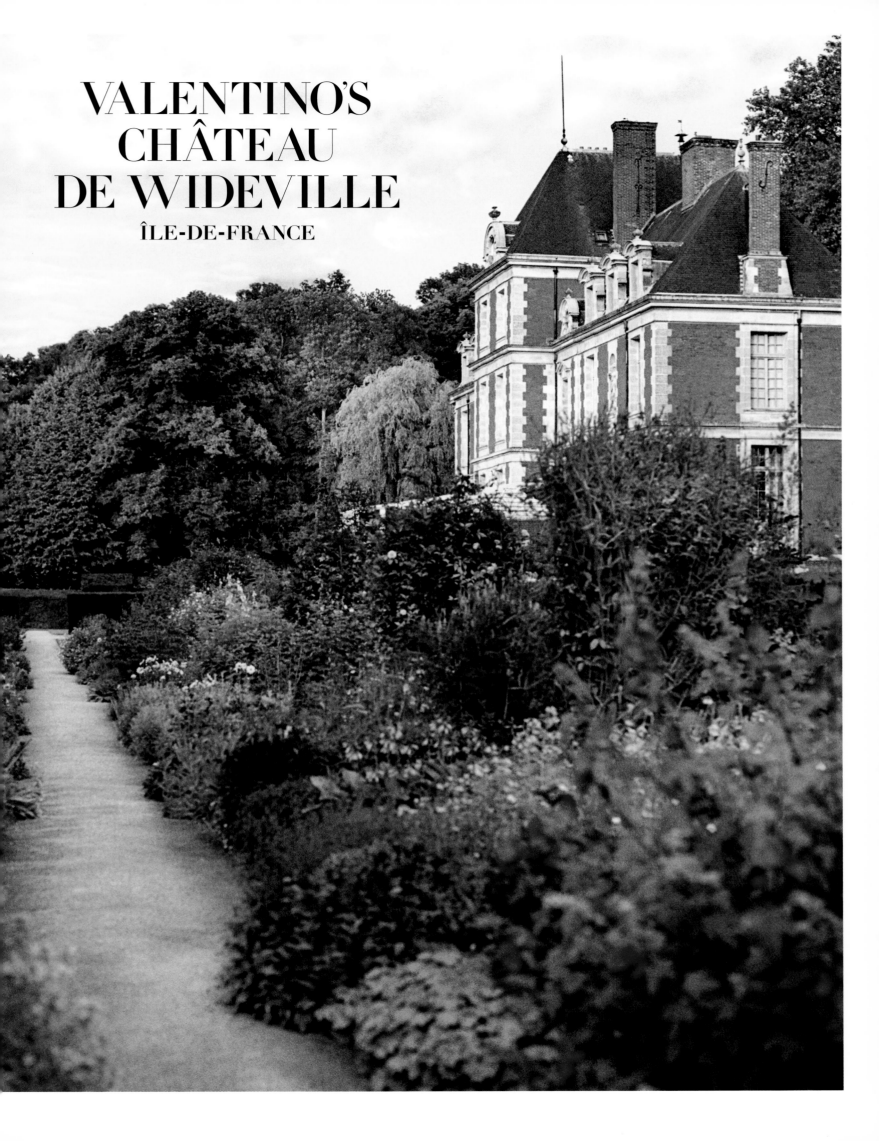

VALENTINO'S CHÂTEAU DE WIDEVILLE

ÎLE-DE-FRANCE

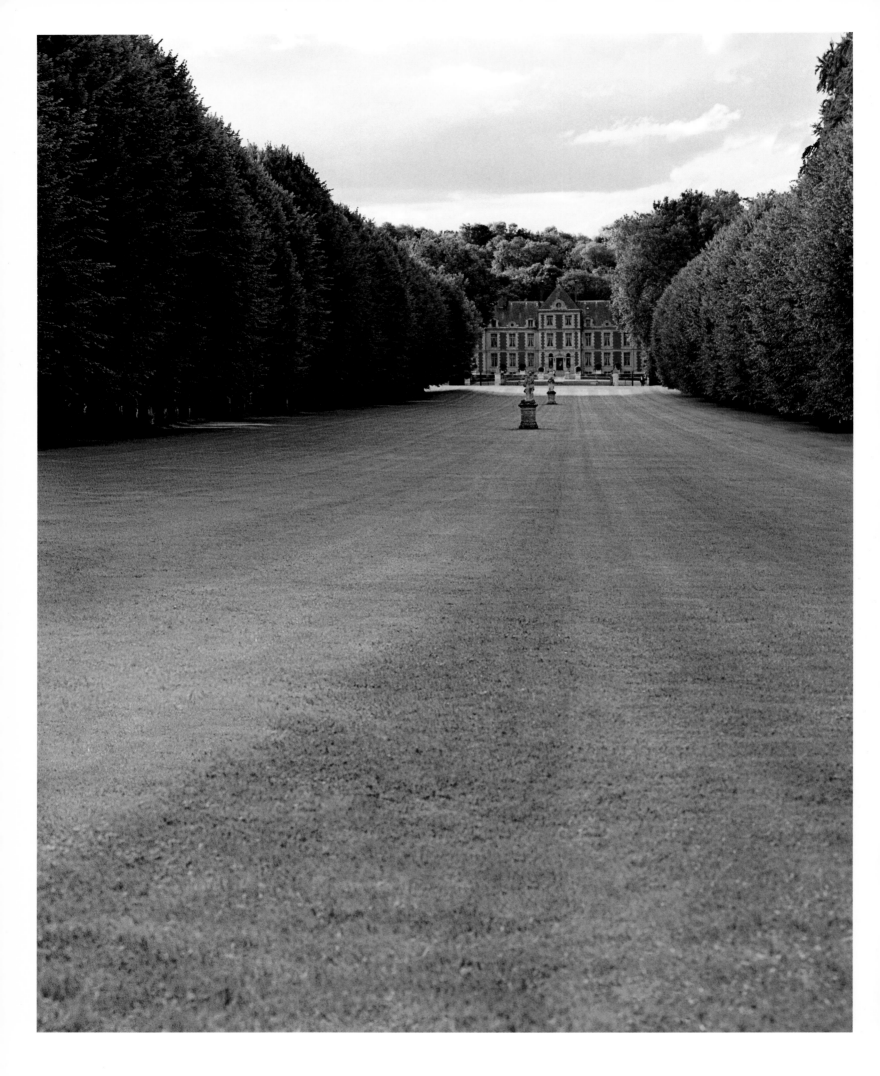

Louis XIV installed his mistress Louise de la Vallière at the 17th-century château while Versailles was being built nearby.

The gardens, including this *potagère*, were designed by the Belgian landscape architect Jacques Wirtz. Photographs by Robert Fairer, 2002. 255

Giancarlo Giammetti, Valentino's longtime partner, at the window of his apartments on the estate.

Molly, Milton, Maude, Margot, and Monty (*below*), five of Valentino's six beloved pugs, caper among the party guests. Photographs by Robert Fairer.

punctuality that is the preserve of royalty. Princess Rosario of Saxe-Coburg and Gotha arrives in a dither, unable to tie the voluminous sash on her strapless dress. The consummately gallant Valentino, who has just come out to greet his guests, reties it for her just so. The appearance of Tory Burch, Jennifer Creel, and Normandie Keith in their enchanting couture Valentino confections enhances the Edith Wharton ambience. Gwyneth Paltrow makes her own dramatic entrance in one of his sleek black satin cheongsams. Last to arrive are Philip Treacy and Daphne Guinness, a New Age Jean Harlow in a slither of tarnished gold sequins and ostrich plumes.

Valentino regrets that intemperate rains have "bashed the flowers about," but bashed or not, his gardens are breathtaking. He is rumored to have dispensed an eight-figure sum on them, working with the Belgian landscape architect Jacques Wirtz, and they match the splendor of the château's interior, the last great project of the decorator Henri Samuel. Whorls of box hedge drift across manicured lawns like borders of Venetian lace. The English rose gardens are as romantic as the couturier's signature flowered ball gowns. Even the vegetable garden is dazzling.

Dinner is served in a specially constructed marquee between house and moat: The designer's favorite mozzarella was flown in from Rome this morning. Over coffee, magician David Jarre, the dashing son of Charlotte Rampling and Jean-Michel Jarre, enthralls with a few card tricks. The arrival of Valentino's beloved pugs Maggie, Molly, Milton, Maude, Margot, and Monty heralds a change of mood as a honey-voiced singer woos guests onto the dance floor. Outside, in the pale glow of candles, a gleaming blonde beauty is walking barefoot through the dewy lawns, hand in hand with a new beau. Anyone for romance? Valentino wrote the book.

—HAMISH BOWLES, *September 2002*

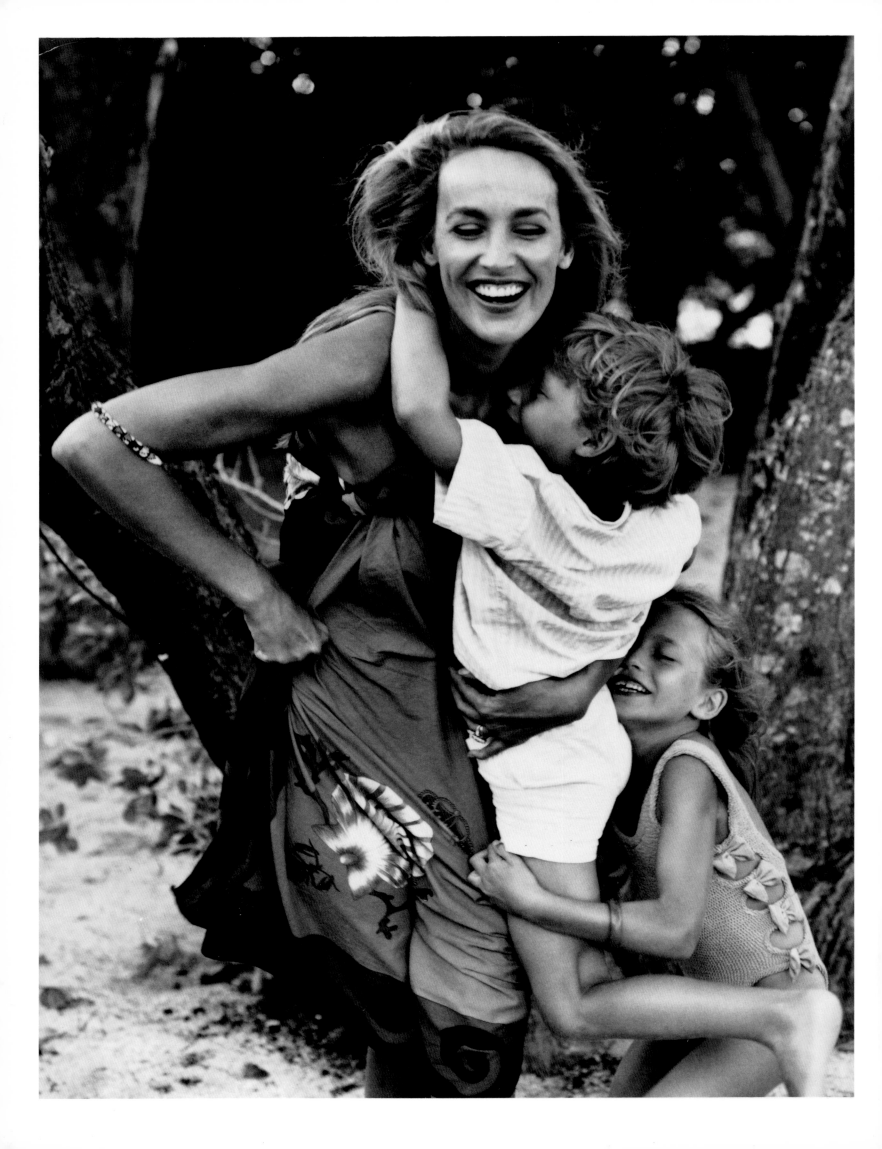

MICK JAGGER and JERRY HALL

t here's a full moon
over Macaroni Beach, a bonfire is blazing, and Mick Jagger is
serenading his dinner guests as Jerry Hall, in black velvet and
pearls, rolls her eyes like the spouse of a slightly tipsy Moose
Lodge president.

"*A Syrian man need a Syrian woman. . . .*" Jagger stands up
and reels down the long picnic table, ricocheting with cheeky
abandon off the back of every young woman. ("My father
warned me about Mick Jagger," says a blonde who was born
the year "Let's Spend the Night Together" came out.) "*A Mus-
tiquan man need a Mustiquan woman,*" he sings. The candles
burn down, the midnight hour approaches, and Jagger is at
full tilt. ("Good thing Jerry's not the jealous type," he says the
next day at lunch.)

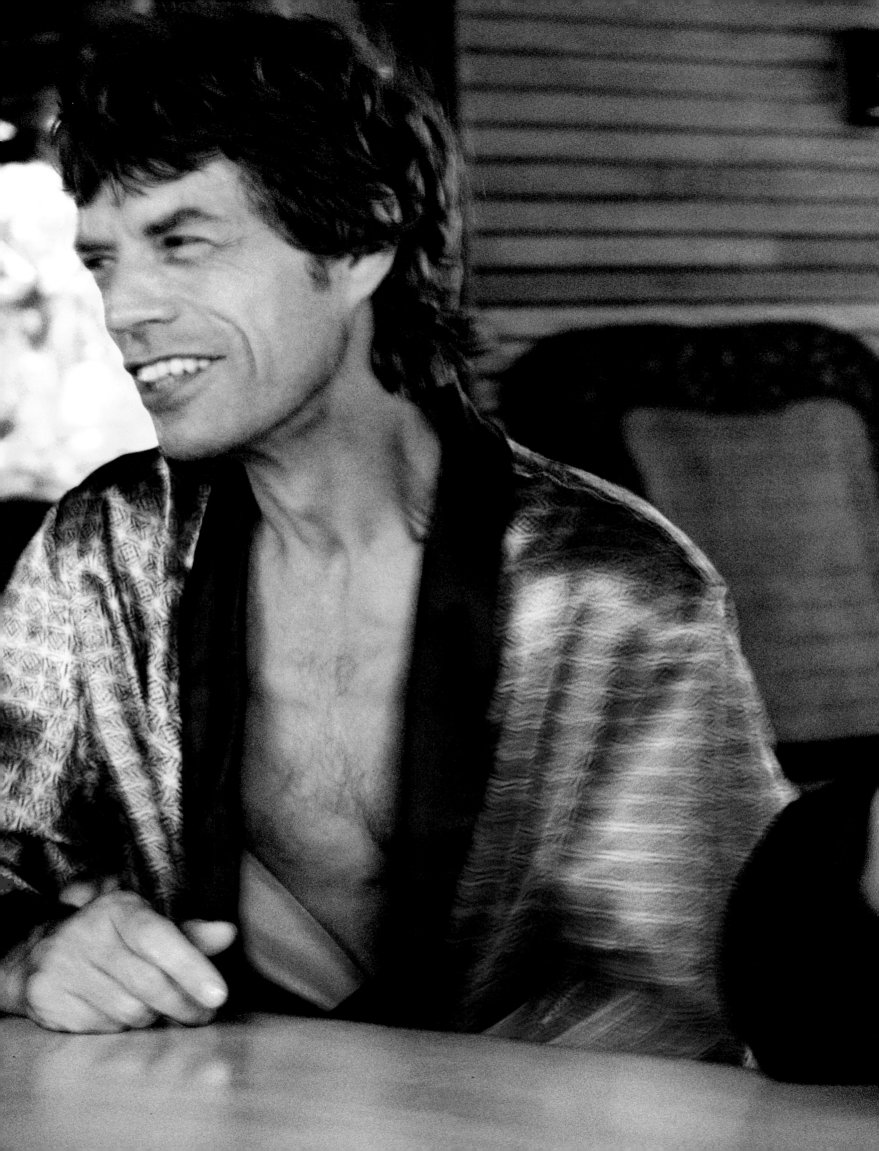

James, age five, snaps a family
portrait. Open-air walkways
link the compound's living spaces.

Sushi furniture (*below left*)
complements the Japanese mood
of the compound; a view (*below right*)
showing the openness of
the pavilion layout. Photographs
by Isabel Snyder, 1991.

This is the Jaggers' regular Saturday-night barbecue on the tiny island of Mustique, far down the Caribbean chain, where the airstrip is the size of a suburban driveway and the only hotel has a clock with one hand that, befitting the tropical malaise, hasn't moved in years.

It is here that the Jaggers have found a sort of buggy Eden: a Robinson Crusoe hideaway on L'Ansecoy Beach, where their two flaxen-haired children, Elizabeth and James, make tepees out of palm fronds and the only decision seems to be whether to go Boogie-boarding before or after lunch.

He calls her darling. She calls him Mick, although it comes out more like *Mee-yick,* owing to her thick Texas accent, which occasionally gives way to a sort of Eliza Doolittle, pseudo-British one. But it's hard not to like her. She's so earthy. And patient. And after all, she waited thirteen years, thirteen *years,* for Mick to marry her.

Their house, Stargroves, took about five years to complete, with supplies coming by boat via St. Vincent. Now the compound includes the original cottage; a series of adjoining Japanese pavilions; a bathhouse with a hot tub; guest rooms;

a children's cottage; and a game room, all linked by polished-hardwood walkways and thick bamboo railings. The staff includes a butler, a maid, a cook, and a tutor and nanny for the children, as well as gardeners, but the island dogs are still likely to stroll uninhibited through the kitchen.

The house's charm is in its details: artifacts from New Guinea brought back by Jagger from an Australian tour; an inlaid-wood screen designed by their friend David Linley, Princess Margaret's son; the long wooden table for open-air dining; the Japanese room with its stark white simplicity; and the dozens of family portraits and inscribed books. Decorator Jed Johnson, who with his partner, architect Alan Wanzenberg, oversaw the design and construction, says, "The idea was to create a very serene and uncomplicated environment. Mick's concept was East meets West. He liked the Japanese influence, but he didn't want to be a purist.

"The house is a place for them to spend time with the children and each other. I think it's very rejuvenating for them. It's the one place Mick can totally be himself."

—STEPHANIE MANSFIELD, *May 1991*

262

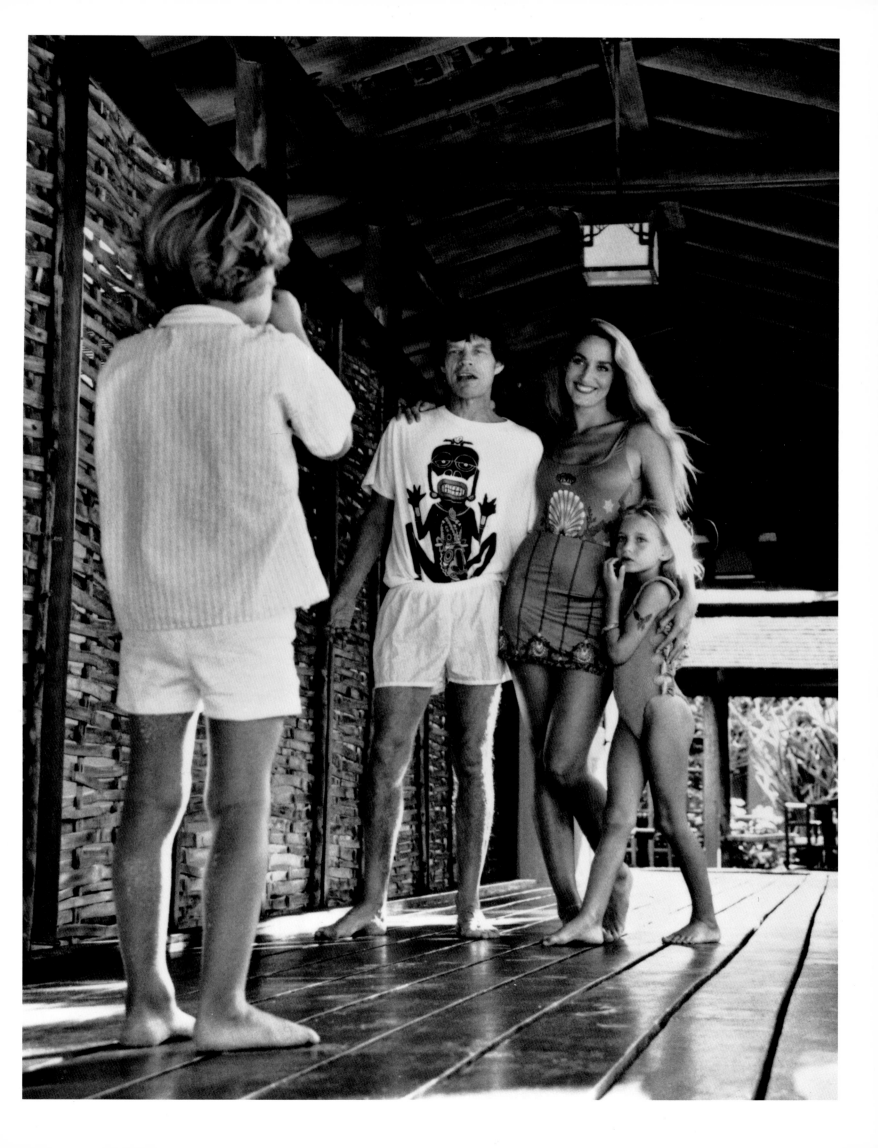

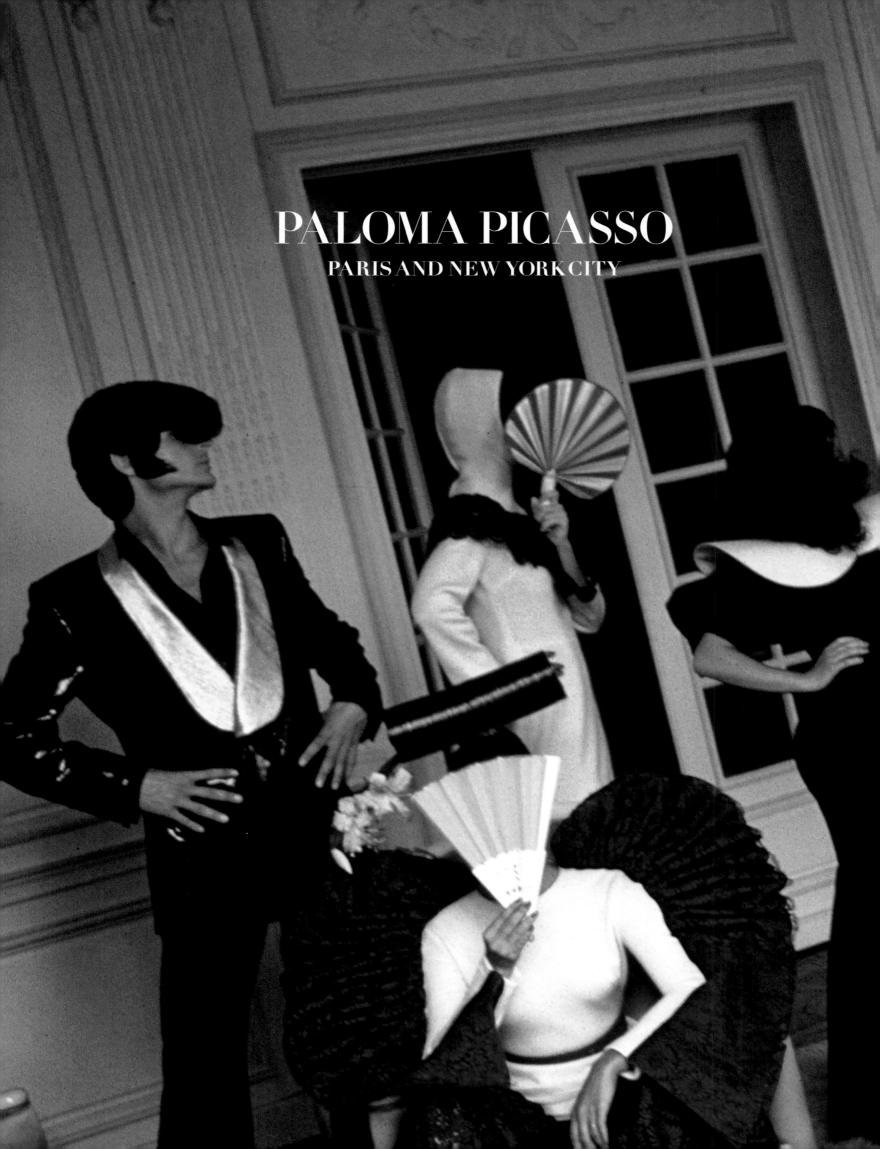

PALOMA PICASSO

PARIS AND NEW YORK CITY

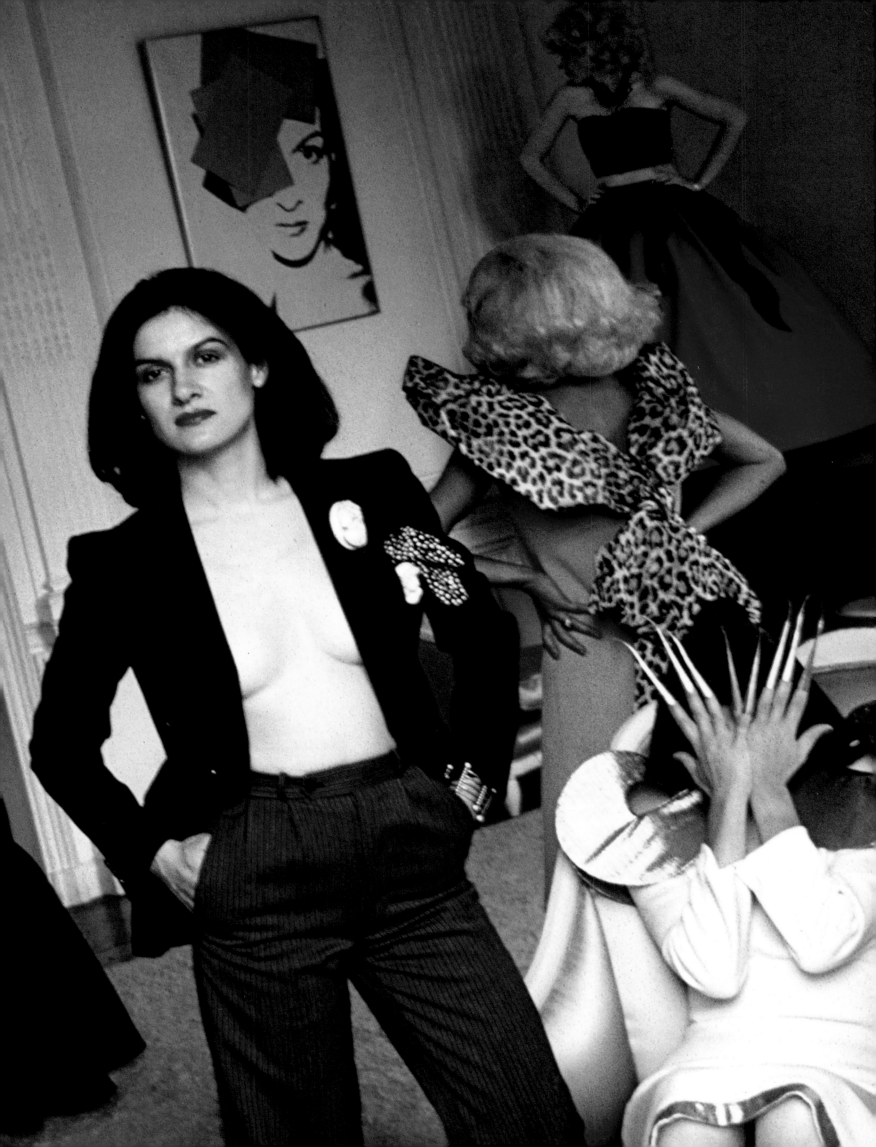

a s a child,
Paloma Picasso didn't speak French, but Provençal. She lived with her brother Claude and their parents, Pablo Picasso and Françoise Gilot, "in a house called La Galloise, an awful little shack with a nice garden that had lemon trees, orange trees, clementines, potatoes. It wasn't at all luxurious, which struck everyone else as strange because it was the beginning of the fifties and Picasso had become a world-famous *monstre sacré* after the war. The housekeeper, Mme Michel, wasn't at all proud of us; she thought we were very badly dressed in our jeans and old sweaters with holes in them. She was ashamed of her boss and thought we made a bad show in the village.

"There were paintings everywhere. We knew we shouldn't walk on them, that it was forbidden to go play on Daddy's paintings. But we were allowed to stay next to him to watch, so long as we didn't start playing or being noisy. He never made

us pose for him, he just painted us anyway. But I posed for my mother. On the first floor, there was a huge room, my father's studio; and my mother built an upper story because there was so little space. She worked downstairs in a little room that was heated by coal and was next to the laundry room.

"We went to school in Vallauris, where they showed the same film about a little red chicken every Saturday for a year. The celluloid was sepia, and I thought that was why it was called *The Little Red Hen.* My father thought one should never teach children how to do anything; kids had to draw what they wanted, so he never showed us how. At one point, he was annoyed with me because I made copies of American comics, then of his own paintings and the Matisses he had: He kept telling me copying was wrong, but the paintings bothered him less than the comics. We had our own paper and pencils; we weren't allowed to touch his. I used to spend hours drawing next to him, but my mother

thought it would traumatize me and Claude to watch them both paint. We used to stare at her while she worked, which drove her crazy; she'd lock us out, and we'd climb round the balcony and stare through the window. I didn't want to be a painter. I was fascinated by hair and wanted to be a hairdresser!

"I don't really remember my parents' separation. I think Claude felt it more, which brought him more problems with our father. Only now do I begin to realize how long it took, because it did not happen in one day. In my memory, there's the Vallauris house, and a place in Paris on the rue Gay-Lussac. . . ."

The move to Paris did not cause any rift between Picasso and his children: They spent every summer with him in the South of France. By then, Picasso was living with Jacqueline Roque, who tolerated the young Paloma and Claude but not his elder daughter, Maya. Once Paloma and Claude began to grow up, they became nuisances; Jacqueline felt uneasy in their presence,

saw them as rivals, and did her best to get them out of the way. Without there being any overt fight, Paloma and Claude suddenly found, in the mid-sixties, that the door of their father's home, Notre-Dame-de-Vie, was closed to them. Paloma says, "I was always sure of my father's love, even when I stopped seeing him."

In April 1973, when Picasso died, his children and grandchildren rushed to the deathbed of the man from whose life they had been exiled. The only one allowed in was Picasso's elder son, Paulo, but his children Marina and Pablito were turned away from Notre-Dame-de-Vie. Paloma and Claude flew down from Paris and spent a day on a hill overlooking Château de Vauvenargues, where Picasso's body had been taken. With them was Maya, Picasso's daughter by Marie-Thérèse Walter.

"We all thought how peculiar we must look, standing all day on that hilltop, in the snow, like three jerks," Paloma says. "The snow made it even stranger: It never snows in the South of

France, especially not in the spring. We couldn't get anywhere nearer, because the place was milling with photographers, and all three of us look so much like our father that we would have been recognized. Then we went to Maya's house in Marseille; and there, on the radio, we heard that Pablito had tried to commit suicide by drinking liquid ammonia. It took three months for him to die."

Shaken as much by Pablito's ordeal as by her father's death, Paloma returned to Paris. She was no longer making funny accessories for Yves Saint Laurent; she had gone on to 22K-gold bracelets in the shape of sliced Doric columns, for the Greek firm of Zolotas. But she could not continue working. "I couldn't even pick up a pencil. My father's death had brought home to me what it meant to draw, to paint. . . ."

Last summer, in a ceremony attended only by their closest friends but besieged by the press, she married Rafael Lopez-Sanchez. On her wedding day, Paloma wore a suit that Yves Saint Laurent had given her. Over lunch, Rafael said, "You have to fight against legends." "No," said Paloma. "You have to fight for them."

—JOAN JULIET BUCK, *December 1978*

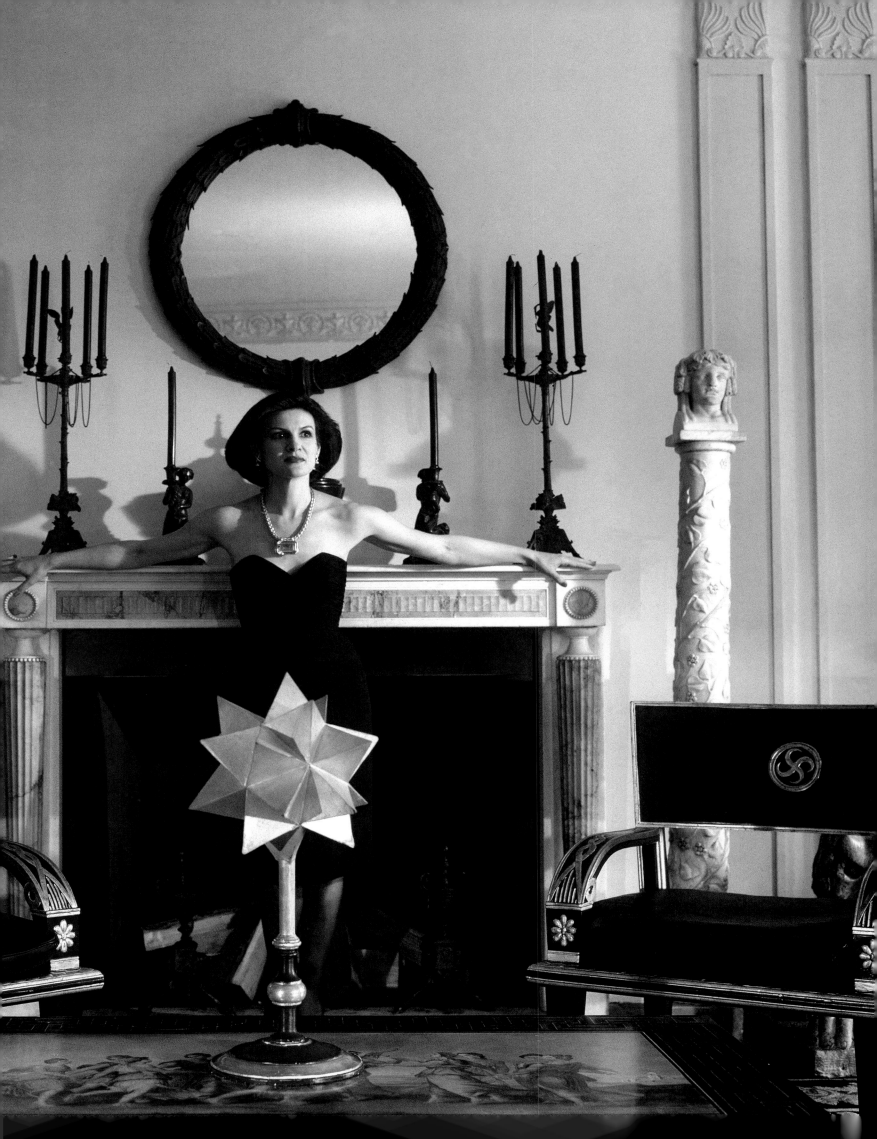

The Yves Saint Laurent muse at a Paris café.
Photographed by Pascal Chevallier, March 1992.

———

An arrangement of wheat sheaves
(*inset*) rests on a reproduction 18th-century
chair in the jewelry designer's master
bedroom in her cottage outside Paris.

LOULOU DE LA FALAISE
PICARDY

W e're self-invented creatures," says Loulou de La Falaise. "You start by creating yourself. You have to be quite brave about it. You've got no choice, unless you bind yourself to rules you don't like."

Loulou has rusty hair like a good fire, scornful green eyes, and a pointed, feline face. A source of inspiration for Yves Saint Laurent's designs and jewelry and hats, she has invented her own brand of chic. Asked to define Loulou's style, an old friend, fashion designer Fernando Sanchez, was at a rare loss for words. Pressed, he produced at last, "She is an artist of the safety pin. Three pins and two pieces of cloth, and she has four ravishing evening dresses."

"She dresses from the cutting-room floor," said Manolo Blahnik, international creator of perfect shoes, "but she puts her stamp on whatever she wears."

She met Yves Saint Laurent in 1968 at a tea party given by Sanchez. "I'll introduce you to Betty Catroux, Clara Saint, Yves, and Pierre," said Sanchez, eyeing her elegantly bizarre appearance with admiration.

"Pierre who?" questioned Loulou, a foreigner in Paris. "Pierre Cardin?"

"I had never seen such *French* people in my life," she growls, on the edge of laughter, remembering the occasion. "My

own French was a bit dodgy, but Yves's childish sense of humor simply vaulted over the language gap. There was a pop star. Yves did a little imitation. We giggled. We dressed up. Then I went back to New York, and he sent me an enormous crate of clothes from his 1940s-inspired ready-to-wear collection."

Wonderful gifts kept arriving in the famous white-and-black boxes. Every time Loulou went to Paris, she would drop in on Yves. And one day he called her and asked her to come to Paris and work for him.

"All I had done were a few prints for Halston. But Yves has an instinct for the people who can help him."

She inhabits a half world between the designer's dreams and the first snip of the scissors. Something more than an ideal, she appears to spark off the inspiration not only for Saint Laurent but for all the top creative talents of her métier, who unanimously regard her with awe. Blahnik gives just one example. Spotting her wearing a turban, poppies, and thick cork-soled espadrilles on King's Road in the summer of 1972, he went on to design a collection of raffia platform shoes.

Five Avenue Marceau is, for Loulou, not the intimidating edifice of the most famous couture house in Paris but a resplendent

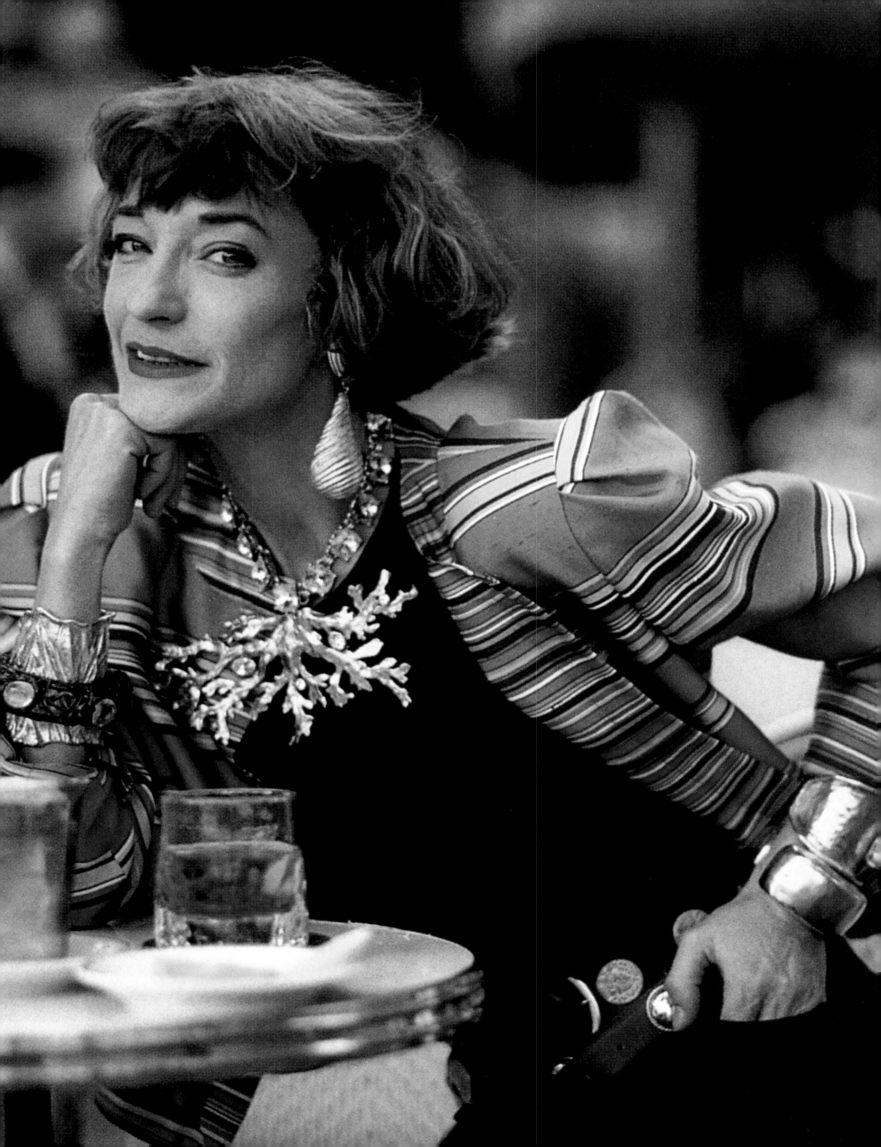

Loulou's vividly colored living room is decorated with furniture left by her father, Alain de La Falaise, and a landscape by her grandfather Sir Oswald Birley, a celebrated portrait painter.

A 19th-century folly (*below*) sits in the garden. Photographs by Eric Boman.

dressing-up box, her superlative of the fabulous trunks of unworn clothes that her grandmother Lady Birley left her mother, Maxime, to distribute around the family, or another version of "Loulou's cupboard" at the house of her friend Eric de Rothschild, whose weekend house parties at Château Lafite she came to dominate in the seventies. Fancy dress was compulsory for the Rothschild weekends, but no one but Loulou was allowed to bring anything. She would arrive loaded with the pickings of the atelier floor—feathers, gold lace, petticoats, hats, and artificial flowers—and fit out the guests: Anthony Palliser as a Berlin cabaret star with half his face painted; David Sulzberger as a robot in silver foil; Rothschild as a billiard cue in a cape with a wastepaper basket on his head. There is an Alice Springs photograph of Loulou in a costume everyone remembers, as a walking tree with branch and frond limbs.

"Agony, but fun," Loulou remembers. "I carried secateurs and asked people to prune me where it scratched.

"Life has its stages and epochs," she muses. "I seem to have hit places at the right moment, when they needed new blood. There was London in the sixties—Ossie Clark, Mick Jagger—and then there was New York: Tanguy and the first Metropolitan opening of the Warhol show, Andy and Marisol turning up in jeans all splattered with paint. The Halston girls—all of us foreigners, all equally at home in three cities."

—GEORGINA HOWELL, *March 1992*

The Matisse-inspired master bedroom, filled with finds from local antiques shops. Photographed by Eric Boman.

Loulou de La Falaise (*below*) photographed by Mary Russell for *Vogue* in 1972, when she worked as creative assistant to Yves Saint Laurent.

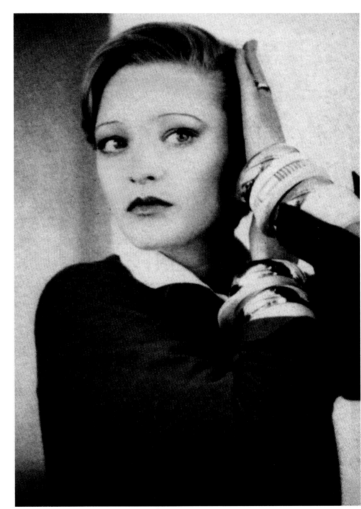

The Italian screen goddess in a fountain
with her son Chipi on the grounds of Villa Ponti,
the restored 16th-century villa
outside Rome that was a wedding present
from her husband, film producer Carlo Ponti.
Photographed by Snowdon, 1970.

SOPHIA LOREN
and
CARLO PONTI
OUTSIDE ROME

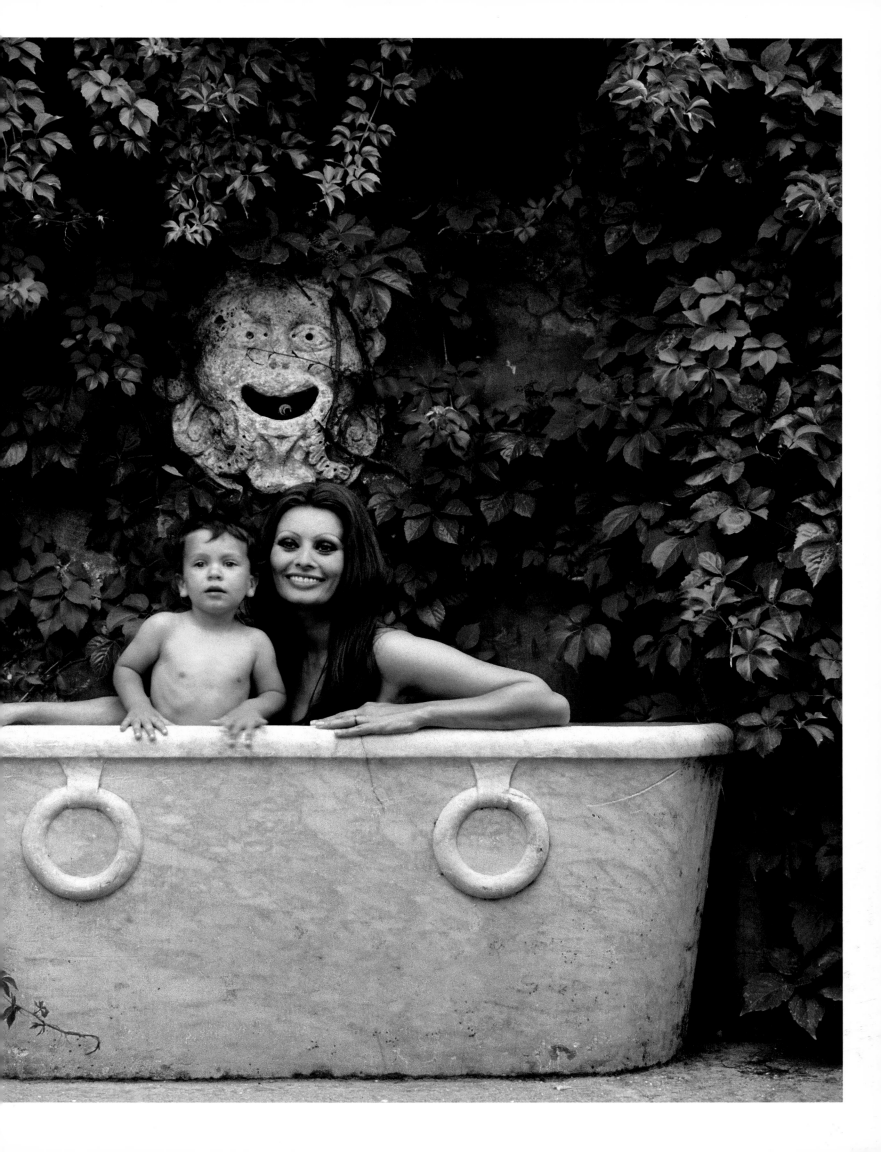

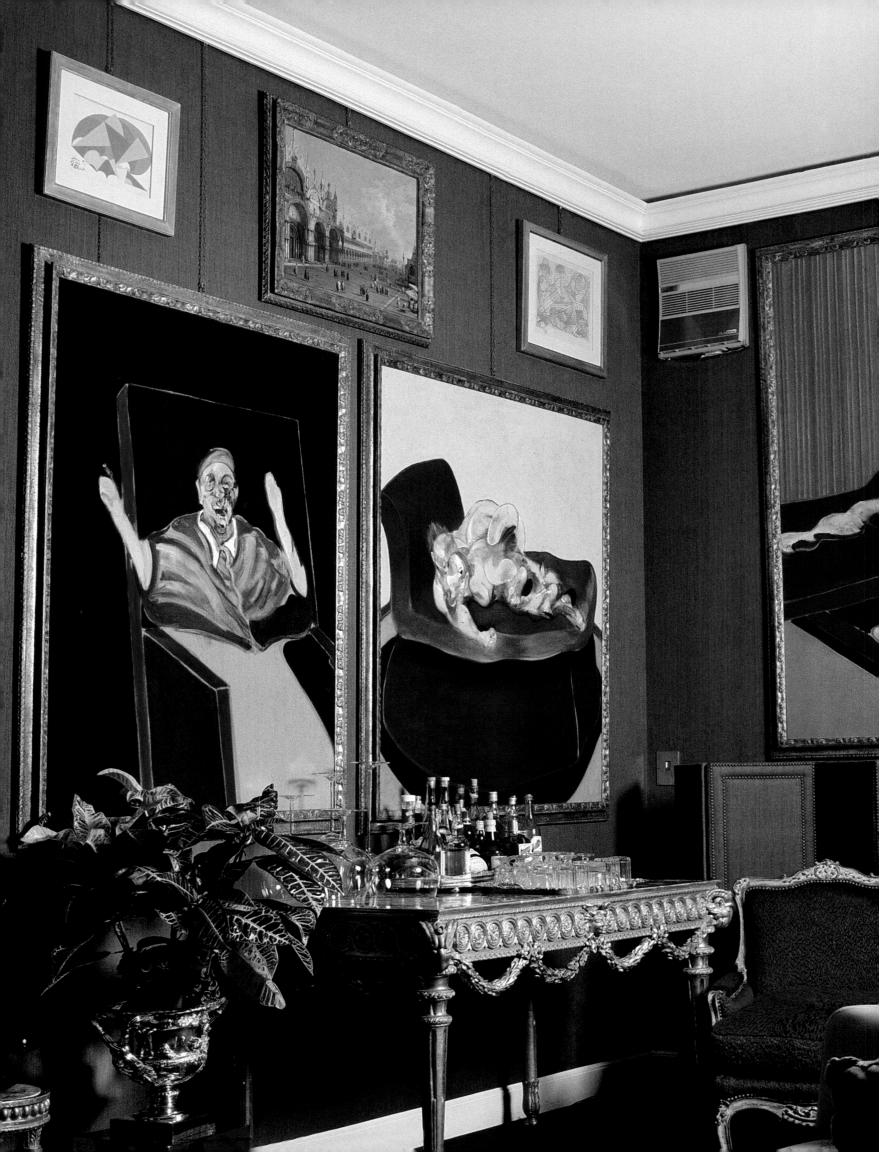

The couple's living room (*left*), called the Brown Room, is hung with Ponti's collection of works by Francis Bacon.

The villa contains some 500 paintings and sculptures. "Carlo buys paintings," said the actress. "I buy jewelry." Photographs by Snowdon, 1970.

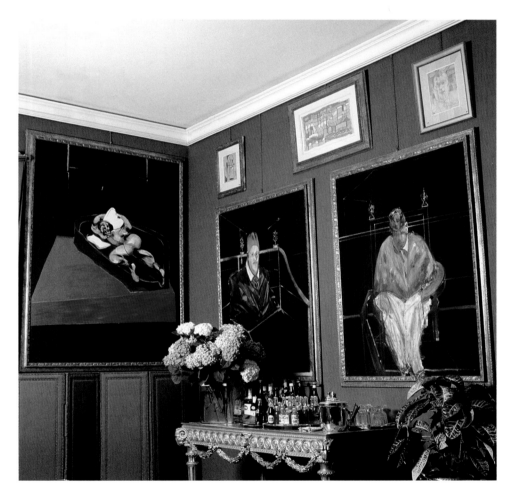

although everything about her expresses an unusual vitality, Sophia Loren in real life has little in common with the fiery, hip-swinging Neapolitan peasant girl she often plays on the screen. The first thing one notices about her (even when she is wearing a dull brown dress with untidy hair for a movie scene) is her elegance; the second thing (even while she is laughing, grinning, rolling her great eyes) is a trace of wistfulness, of mystery, hinting at tragedy. It is this double paradox—the earthiness crossed with elegance, the ebullience tinged with sadness—that establishes her irresistible appeal. Of all the actresses I have interviewed, she has the easiest and least affected manner; in fact, she is so straightforward that one finds oneself forgetting the interview relationship and doing too much of the talking. She is also the most beautiful; every second her features seem to form new, unexpected, yet always harmonious patterns, and one dare not look away for fear of missing a momentary image of Sophia Loren that may never be repeated.

I asked her about acting in epics and in modern parts. Which did she prefer?

"I prefer both. No, that is not true; perhaps epics are not my favorites—though I like to do them every now and again. They are so completely different from realistic films—the emotions are on such an exalted level, it is like Greek tragedy, and that is good for one to do every so often, for a change. But modern films are more interesting to act in because they are about real life, and real life is more interesting to me. How could one talk in an epic in the way that I am talking to you now?"

"Do you find your work prevents you from making friends?"

"It is only possible anyway to have four or five friends who really count—and they, of course, would understand if you cannot see them, or can only see them in the evening. They remain friends."

"Are there any directors you would like to work with?"

"Elia Kazan. And Billy Wilder in a comedy."

"Did you enjoy your years in Hollywood?"

"Of course it was an interesting experience, but I didn't enjoy the kind of stories they tried to make me do."

"Which actors do you admire?"

"Geraldine Page. And Katharine Hepburn. Of the men, Spencer Tracy and Marlon Brando. I think actors should see the work of others. I have always been to a lot of films. But I don't think I have been inspired or influenced by any particular actor."

"What is the most important thing to you in the world?"

"The thing I most love is acting. I so love everything to do with it that I enjoy the things other actresses complain of. I don't mind being photographed, and I don't mind being interviewed—I'm not saying this because you are interviewing me; it is true! I'm like a sponge; I soak it all in. When I am in front of a movie camera, I come alive; I feel that I am free to do anything! I do things I could never do in life, because I am very shy. It is like a visit to the psychiatrist—all my inhibitions disappear."

"Does this feeling depend on the director?"

"No, it is in me. With De Sica—who found me—just a gesture is enough, and I know what is in his mind. Other directors may have to explain more, but my feeling is the same. I sometimes dream of a long vacation. But at the end of a week I'm so bored, I long to work again."

"When you were a child, did you ever think that one day you would be famous?"

"No, never. And I don't now. I don't think of myself as famous. Sometimes my friends say, 'You can't do so and so because you are famous,' and it always surprises me. If I am famous, it has made no real difference to me."

—FRANCIS WYNDHAM, *October 1, 1963*

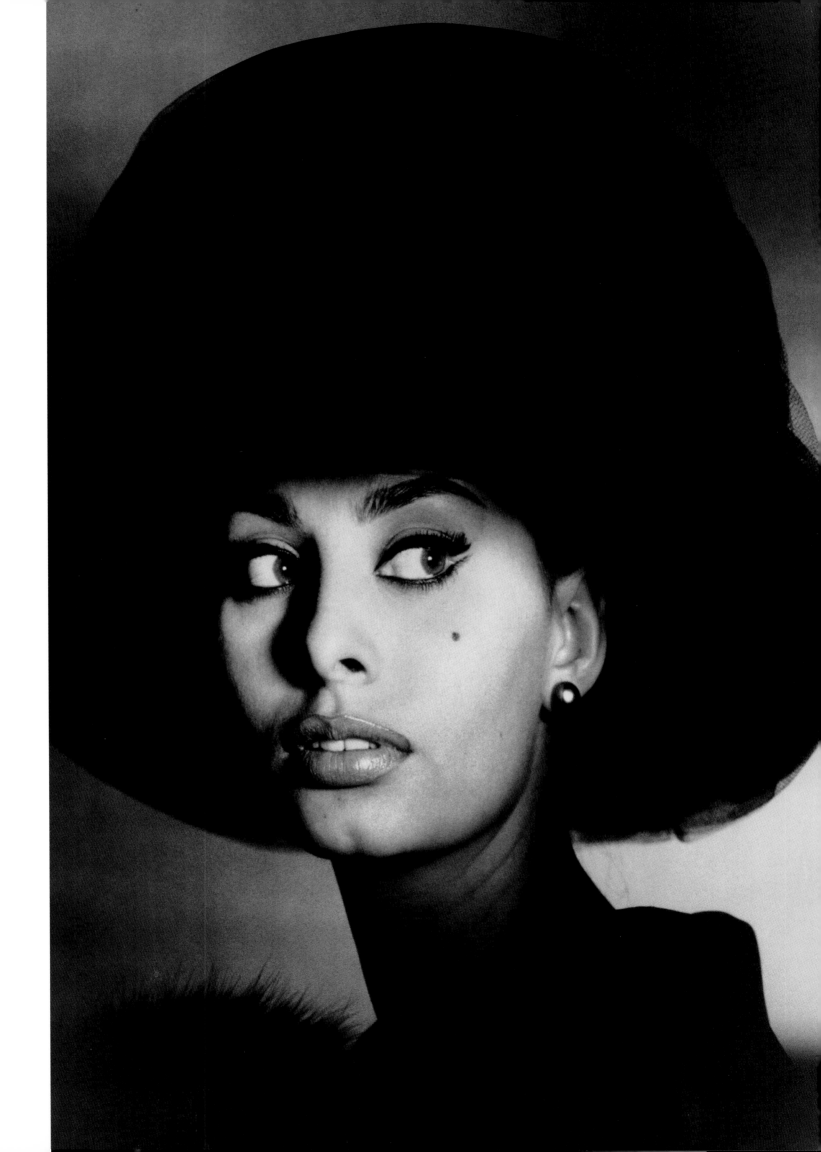

A 17th-century Tuscan bed and
18th-century frescoes (*below left*)
in the master bedroom.

The facade of the guesthouse
(*below*) is dotted with baroque sculptures.
Photographs by Snowdon, 1970.

JULIE and LUKE JANKLOW
NEW YORK CITY

previous spread:
The drawing room of Luke and Julie
Janklow's West Village, Manhattan, town house,
with 16th-century mantels and furniture by
Jansen, Karl Springer, and Vladimir Kagan.

In the garden, August Janklow starts a water fight.
Photographs by François Halard, 2007.

uke and Julie Janklow's house is one of the most spectacular in Greenwich Village. It has taken the couple two years to rebuild and decorate it, using only an architect because Julie wanted to design the house herself. Her inspiration came from the Barbra Streisand remake of *A Star Is Born.* "They have this crazy mansion in the Hollywood Hills with giant fireplaces, no furniture, and just guitars and a piano," she says. "It's so glam, so grand, and yet totally underdone."

It's seven o'clock, and Julie has invited a group of friends for a dinner party. They gather in the first-floor salon, which has the feel of a modern ballroom: fourteen-foot ceilings; white marble floors; two huge sixteenth-century stone mantels; three sets of double French windows looking onto the street; sofas and tables by Jansen; 1970s goatskin Karl Springer side tables; custom-made coyote rugs. The finishing touch is a white baby-grand Steinway piano. Oh, and for rainy Saturday afternoons, there's a movie projector in the ceiling.

Later, Julie leads the way downstairs to her mirrored dining room. Antique gold sconces on the wall are lit with candles, and an old Danish candelabra hangs over the dining table, occasionally dripping hot wax. Luke declares "free seating," and everyone sits next to their friends.

Supersize hamburgers, hot dogs, and veggie burgers are served on silver platters, and the mood is decidedly teenage—a much-needed antidote to the endless round of formal dinners their guests frequent in New York. As the evening progresses, Julie introduces the Name Game: She has written the names of famous people on Post-it notes and sticks notes on her guests' foreheads; they then have to guess who they are. At half past midnight, Julie turns up the music, and the party heads outside to dance in the garden. . . .

—PLUM SYKES, *September 2007*

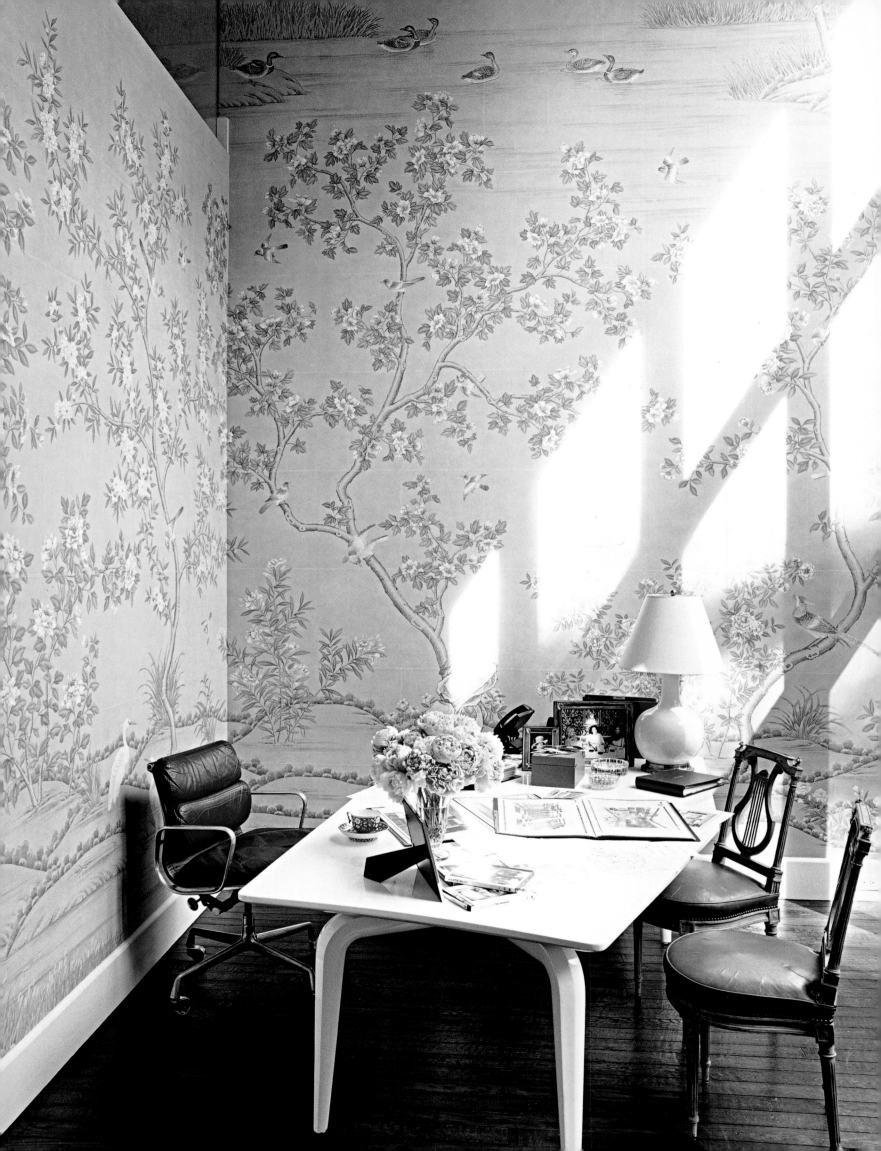

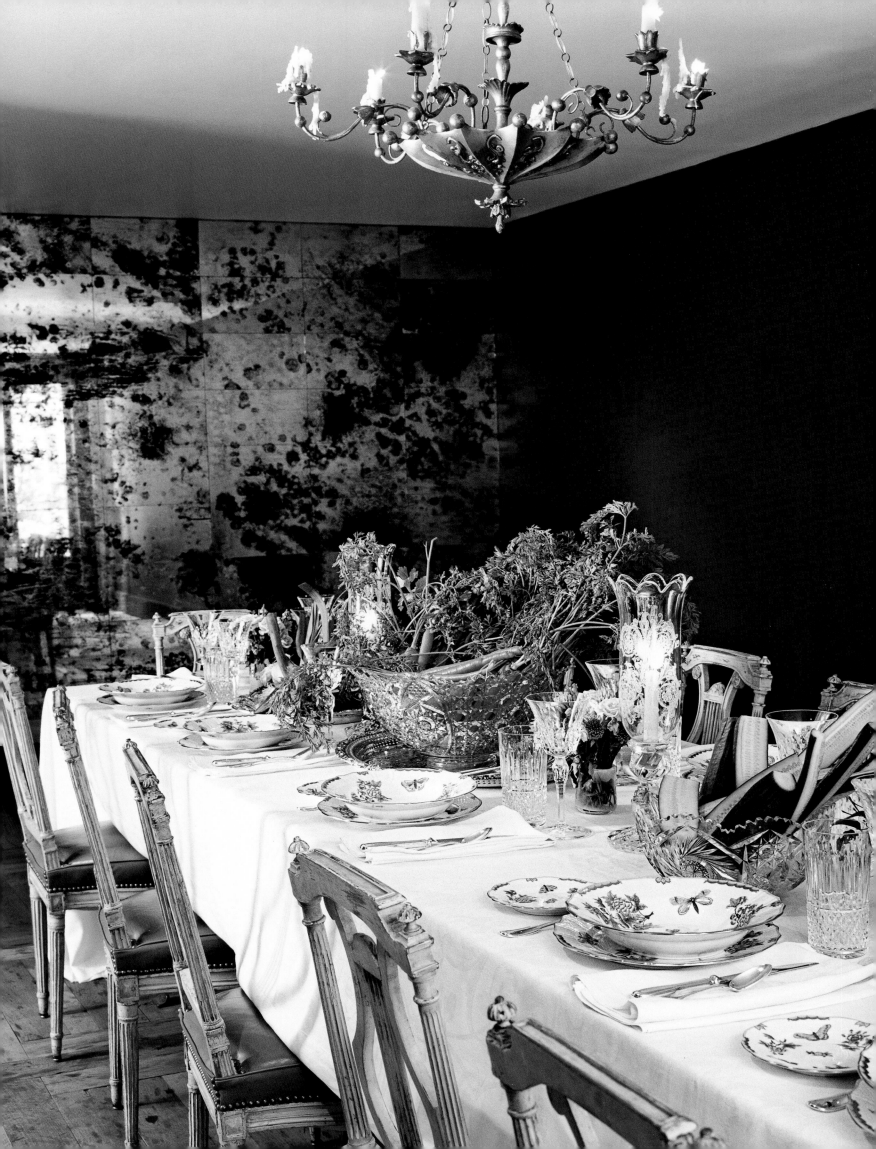

Shalom Harlow
Raised by hippies in Ontario, Canada, trained
as a dancer, and discovered at a Cure concert,
she was one of the great supermodels of
the 1990s. Bruce Weber photographed Harlow
in Pierre Balmain Haute Couture in 1995.

MUSES
AND
MODELS

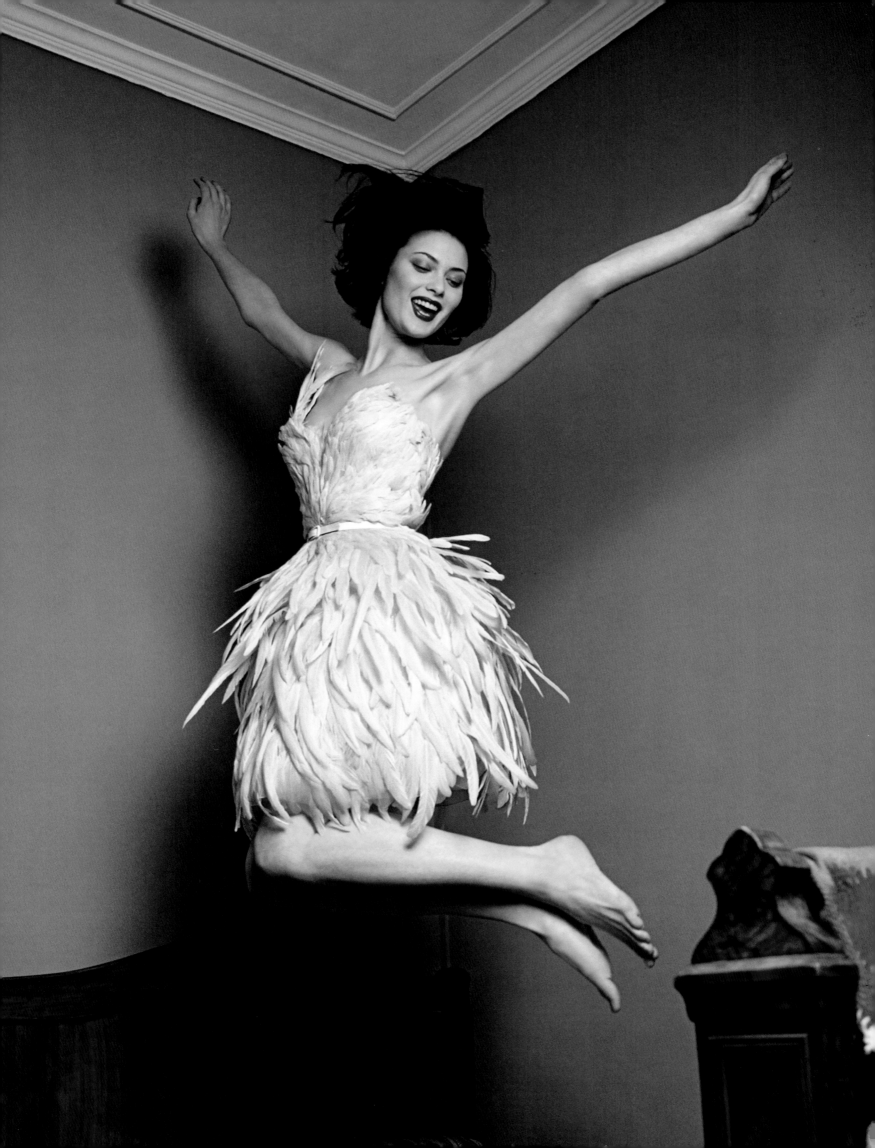

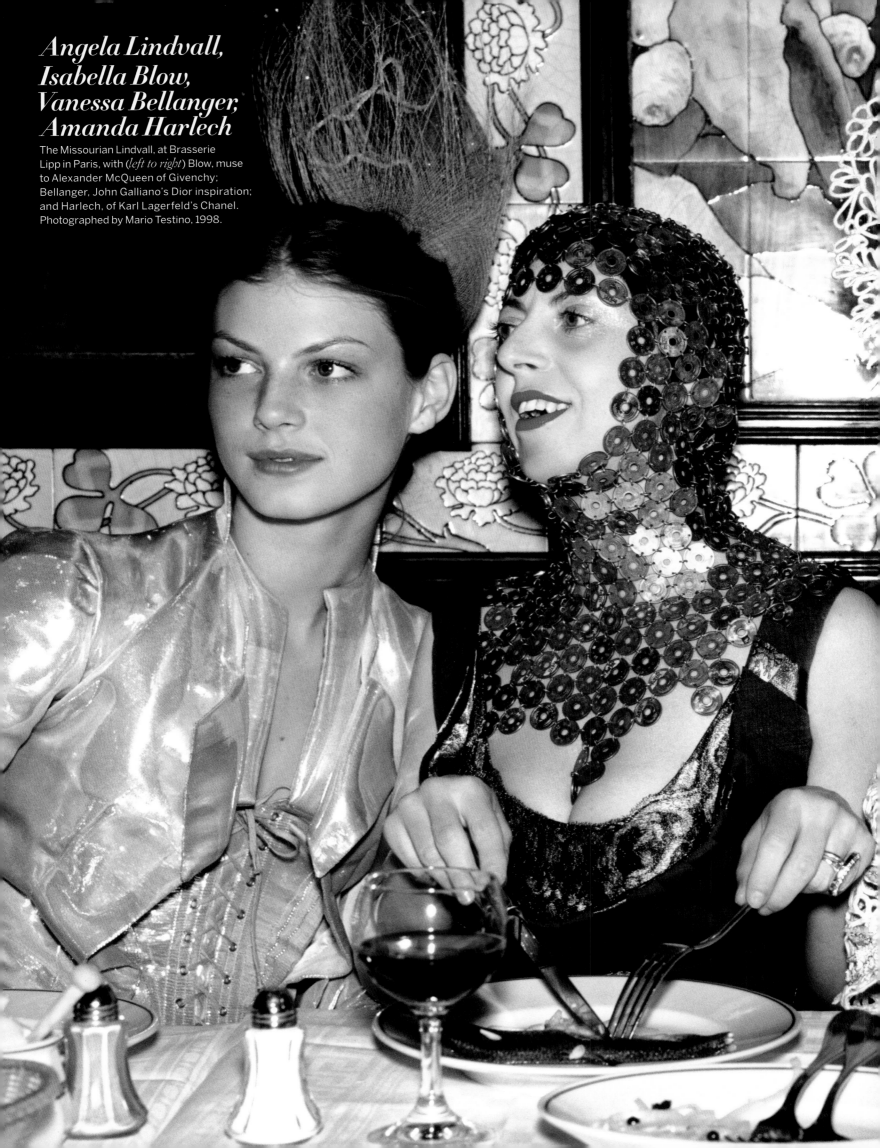

Angela Lindvall, Isabella Blow, Vanessa Bellanger, Amanda Harlech

The Missourian Lindvall, at Brasserie Lipp in Paris, with (*left to right*) Blow, muse to Alexander McQueen of Givenchy; Bellanger, John Galliano's Dior inspiration; and Harlech, of Karl Lagerfeld's Chanel. Photographed by Mario Testino, 1998.

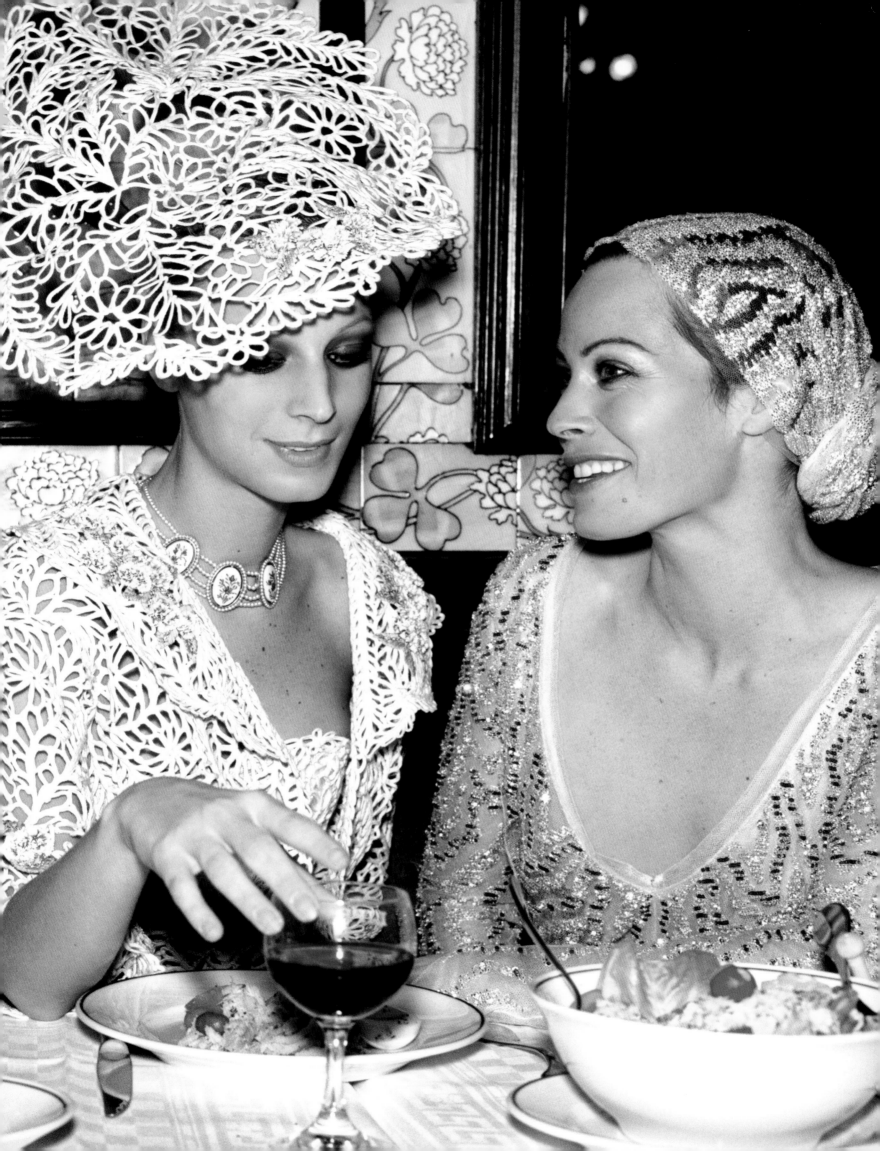

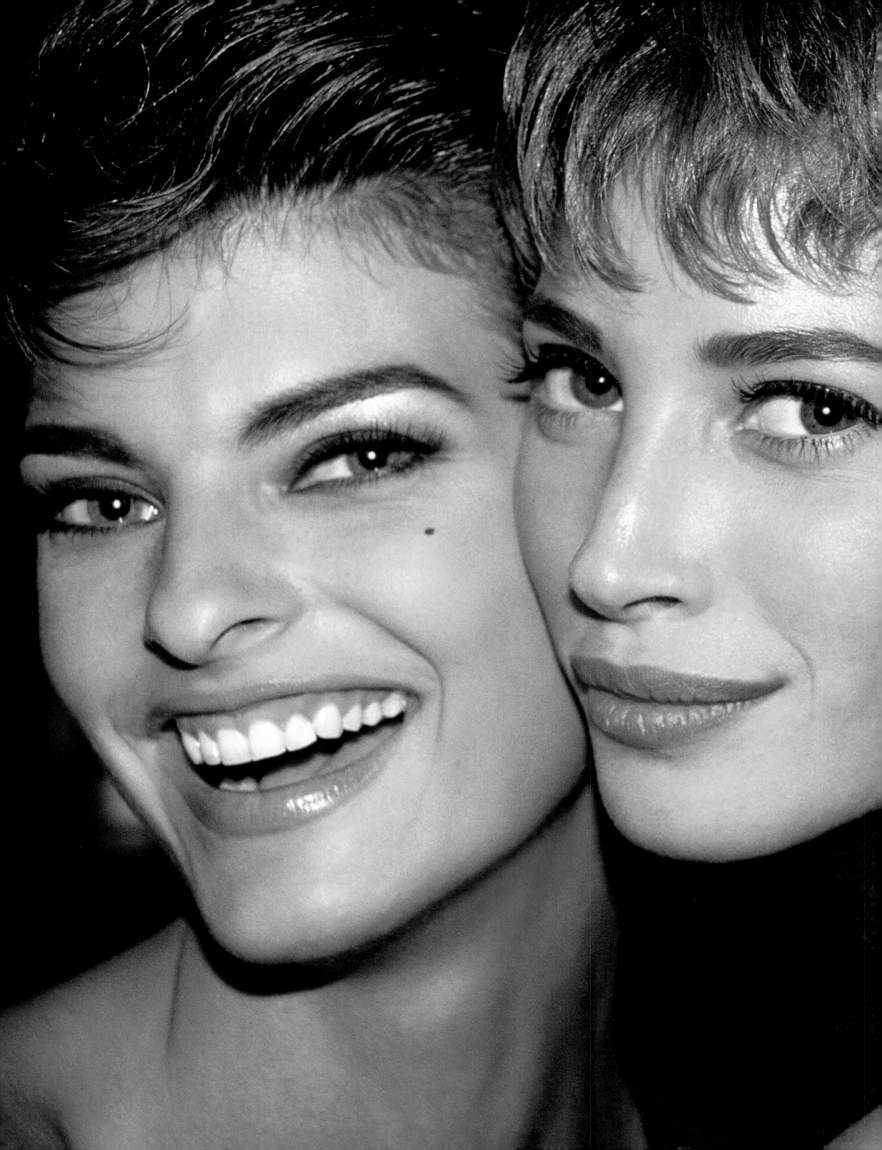

"We don't vogue, we are *Vogue*," said Linda Evangelista (*far left*), with her best friend, Christy Turlington, at a party for Gianni Versace. Photographed by Roxanne Lowit, 1990.

LINDA EVANGELISTA and CHRISTY TURLINGTON

One Saturday night in New York, Linda Evangelista and Christy Turlington were out with their usual posse of photographers and models at the Roxy, a huge nightclub in lower Manhattan, to swing—literally.

After a little coaxing, the two supermodels and best friends climbed onto the Roxy's infamous swing, which hangs from the ceiling down into the center of the dance floor. Linda got on first; then Christy mounted the swing, straddling Linda's lap. Face-to-face, the two women, pushed by clubgoers, sailed through the air in disco revelry, screaming and laughing to everyone's delight.

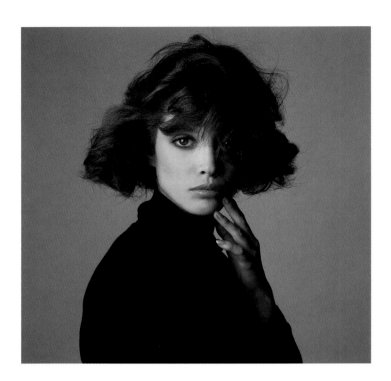

It made the papers the following Monday in a way that would have made, say, Andy Warhol wish he had been there.

"I'm still hearing about the swing episode," says Linda six months later. "If I had known it was going to be such a big deal, I probably wouldn't have done it."

Come on, Linda. Of course you would have. Making a scene is what being a big-time, ridiculously overpaid celebrity model is all about.

Not since the seventies have two models who aren't dating Mick Jagger been so internationally recognized as Linda Evangelista and Christy Turlington are. What makes their fame beyond the fashion world even more impressive is that neither has gone, or plans to go, to Hollywood (e.g., Isabella Rossellini, Andie MacDowell), and neither is married to a rock star (e.g., Paulina Porizkova). They are famous merely as faces. And now, as "best friends."

The fact that they are physically similar creatures—from the same dark, vaguely ethnic cloth—has also added to the intrigue. Theirs is the look of the hour: brunette, short hair, olive skin, and faintly slanty eyes. It's a classic beauty that relates to a different era, inviting multiple comparisons to Hollywood legends. Christy has been likened to Leslie Caron, Audrey Hepburn, and Faye Dunaway. Linda gets Elizabeth Taylor, Ava Gardner, Sophia Loren, Gina Lollobrigida.

After a self-conscious struggle to explain their much-sought-after looks, Christy finally says, "We are not typical classic American beauties, for sure. When I see pictures of Linda, I always think that she looks like a *model,* like the way models were supposed to look 40 years ago."

Linda—with those frighteningly perfect penciled eyebrows, that funny upper-lip-only smile, and sharp android nose coming together on a face with an incalculable net worth—gets more to the point. "For so long it was always blonde-haired, blue-eyed button noses. That kind of model is only capable of one look. Christy and I are versatile. You can put *fashion* on us."

Linda is, at first, somewhat reserved, perhaps the result of her straight-A, good-Catholic-girl upbringing. Her parents, both from Italy, raised her in St. Catharines, Ontario. By eleven, she was already obsessed with fashion magazines and being a model.

After modeling for a local agency, she entered the Miss Teen Niagara pageant in 1978 and lost. "I didn't even place," she says, without a trace of humor. "I was only able to start telling this story a few months ago." There was, in classic model-success-story form, an Elite scout in the audience, whom she didn't call until two years later. By nineteen, she was a cover girl living in Paris. She has been working steadily since.

Her supermodel status, however, can be traced back to

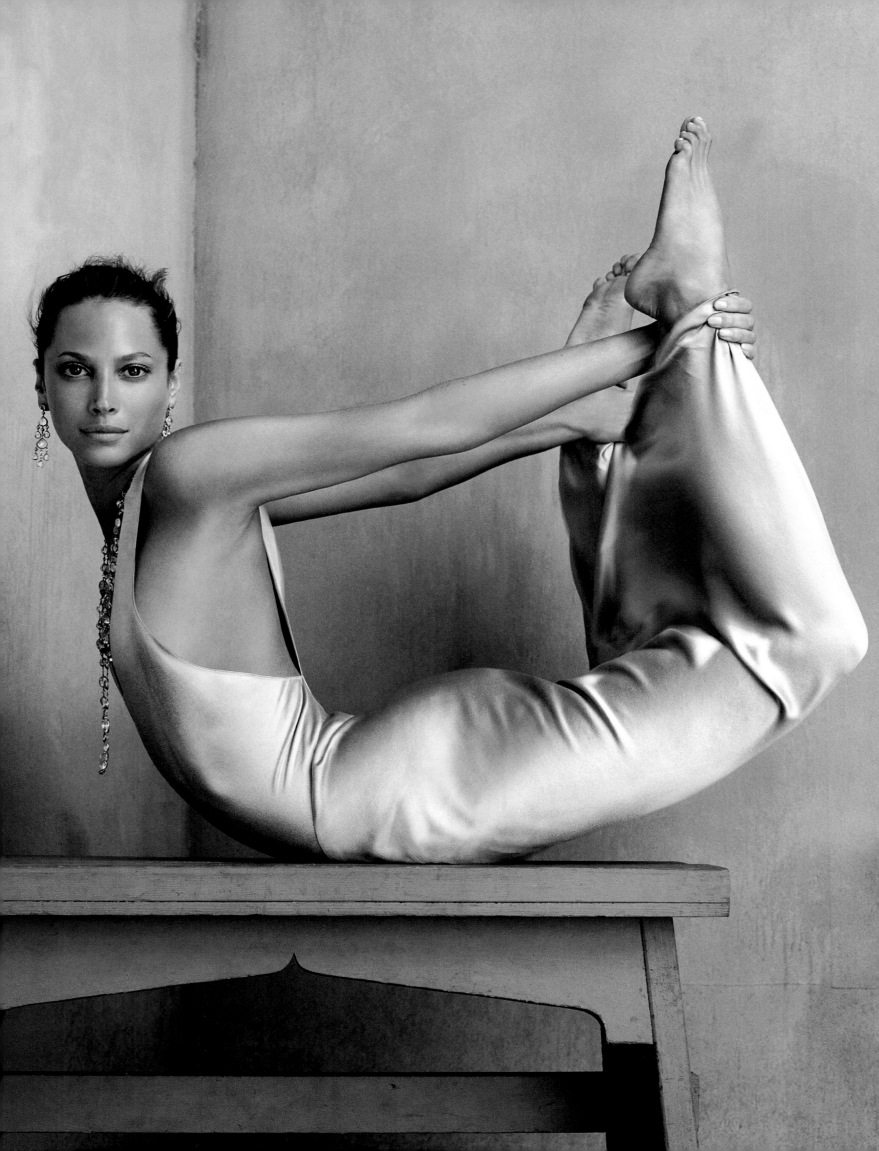

the day two years ago when she cut her hair off, inspiring more look-alikes with her haircut than Twiggy. Today there is even a wig sold in England called "Evangelista."

"I was flattered by the first hundred people that cut their hair off to look like me," says Linda, with utter confidence.

If Linda Evangelista's grown-up personality is consistent with that of a girl who dreamed of being a model early on, then Christy Turlington's seems just the opposite.

Modeling had not crossed her mind until it was suggested to her when she was fifteen. Today she's just as blasé. Christy was born and raised in the East Bay area of San Francisco; her father is American and her mother El Salvadoran. While she was competing in a horse show, a photographer took her picture and sent it to an agency affiliated with Ford. Almost immediately she was thrust into the world of high-stakes modeling, and moved to New York at eighteen.

It was after signing a contract with Calvin Klein and moving to L.A. for eighteen months that she became friends with Linda. They met, as most models do, on a photo shoot. Then, through their friend photographer Steven Meisel, they started hanging out together.

"It was uncomfortable at first," admits Christy, "because I worked with Steven a lot, and Linda was sort of his new girl."

However, when Christy came to New York, she moved in with Linda before buying her own apartment. "That's how we got really close. We're together all the time," Christy says.

They are all too aware that their ride at the top won't last forever. "Linda and I are really getting a push right now," says

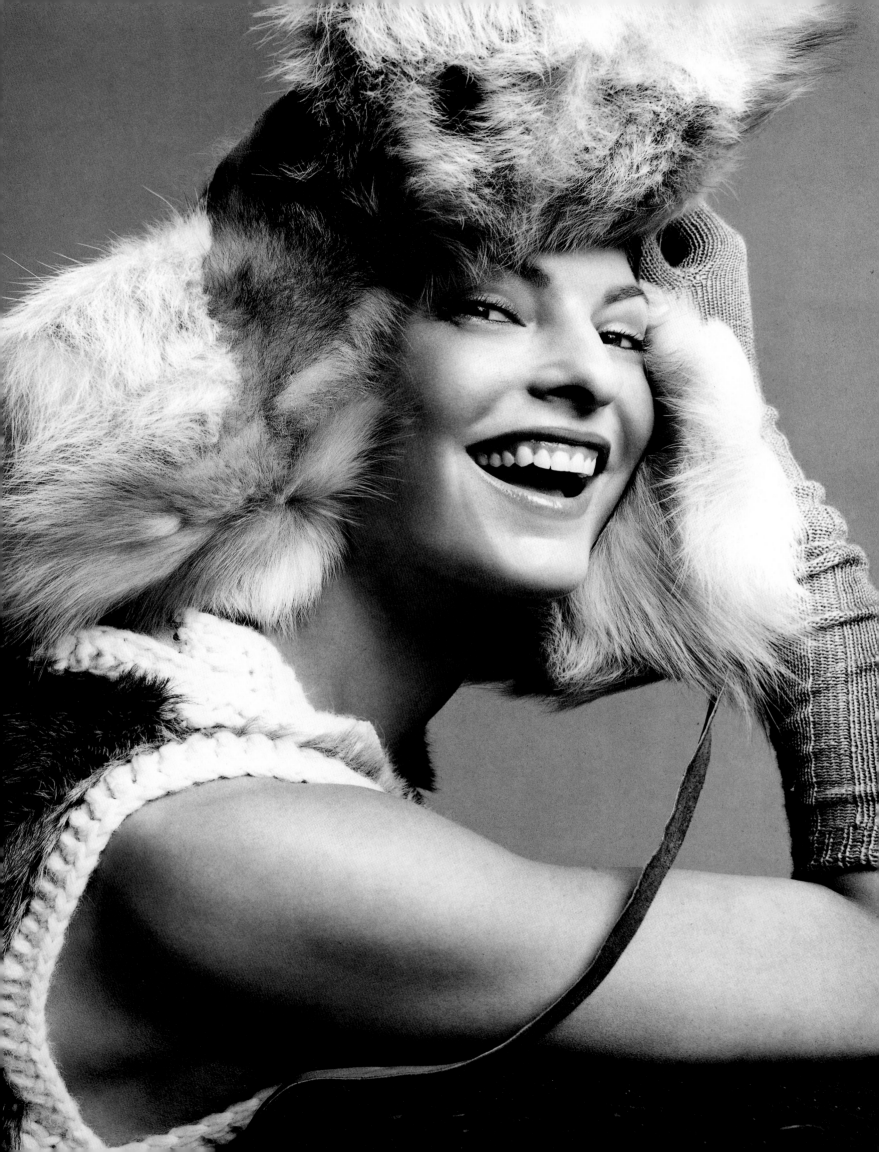

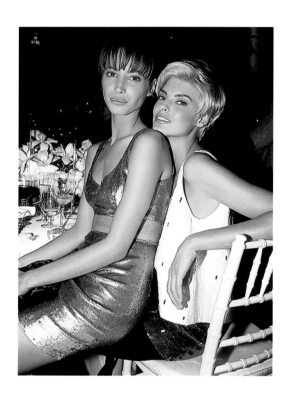

The December 1999 millennium cover by Annie Leibovitz included top models from three decades (*left to right*): Kate Moss, Gisele Bündchen, Lauren Hutton, Iman, and Naomi Campbell.

Turlington and Evangelista (*below left*) at a charity party in New York in 1990. Photographed by Nick Elgar.

Christy, "but we keep joking soon they're not going to want to look at us anymore. Someone asked us if we ever think about what we're going to do when it's over."

Christy has given it some thought. "Actually, I want to be a writer. I've taken classes at UCLA." Linda seems less prepared, though less ambitious. "That's the scariest part. I have no idea what I *can* do. I'm investing so I won't ever have to work again."

For now, they needn't worry about it. The girls of the minute are having fun, seeing the world, battling jet lag, and looking good. "You can feel very guilty about making so much money when you're having fun," says Christy. So they joke about it. Says Linda, laughing, "We have this expression, Christy and I [*pause for effect*]: We don't wake up for less than $10,000 a day."

—JONATHAN VAN METER, *October 1990*

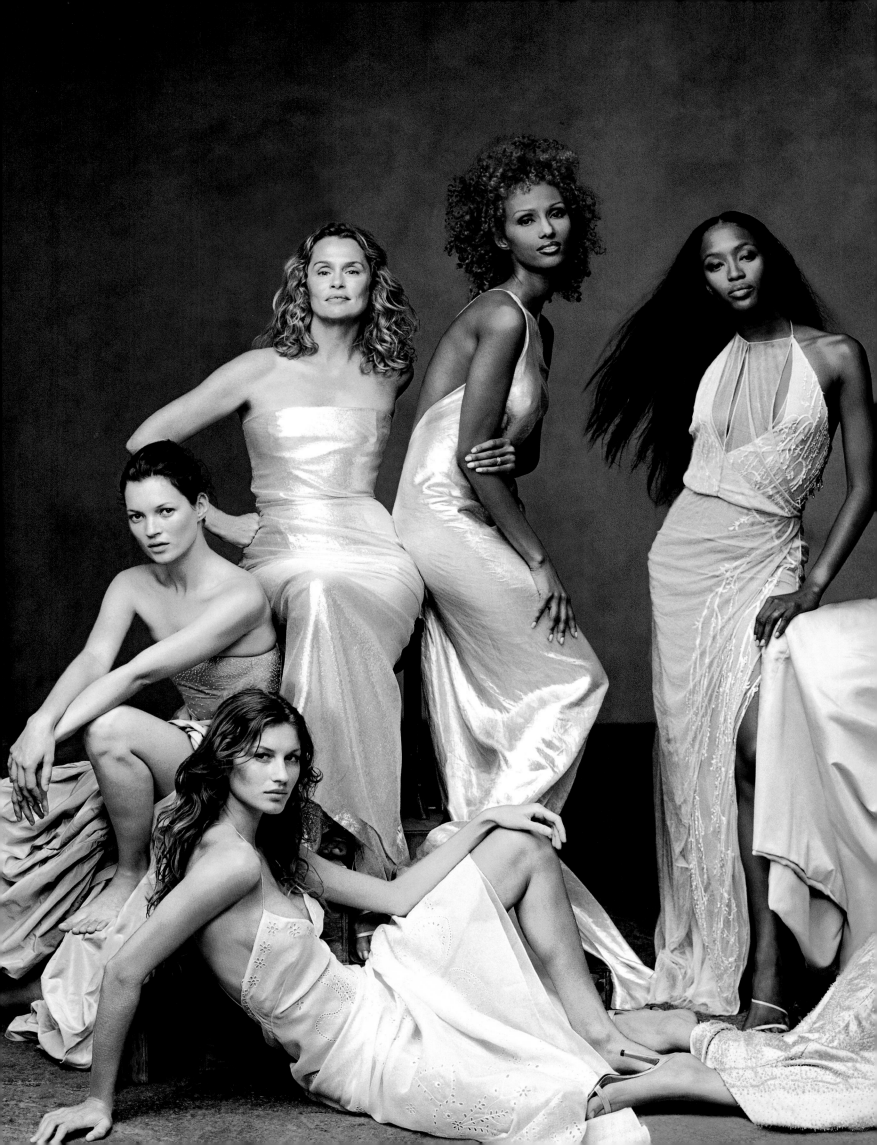

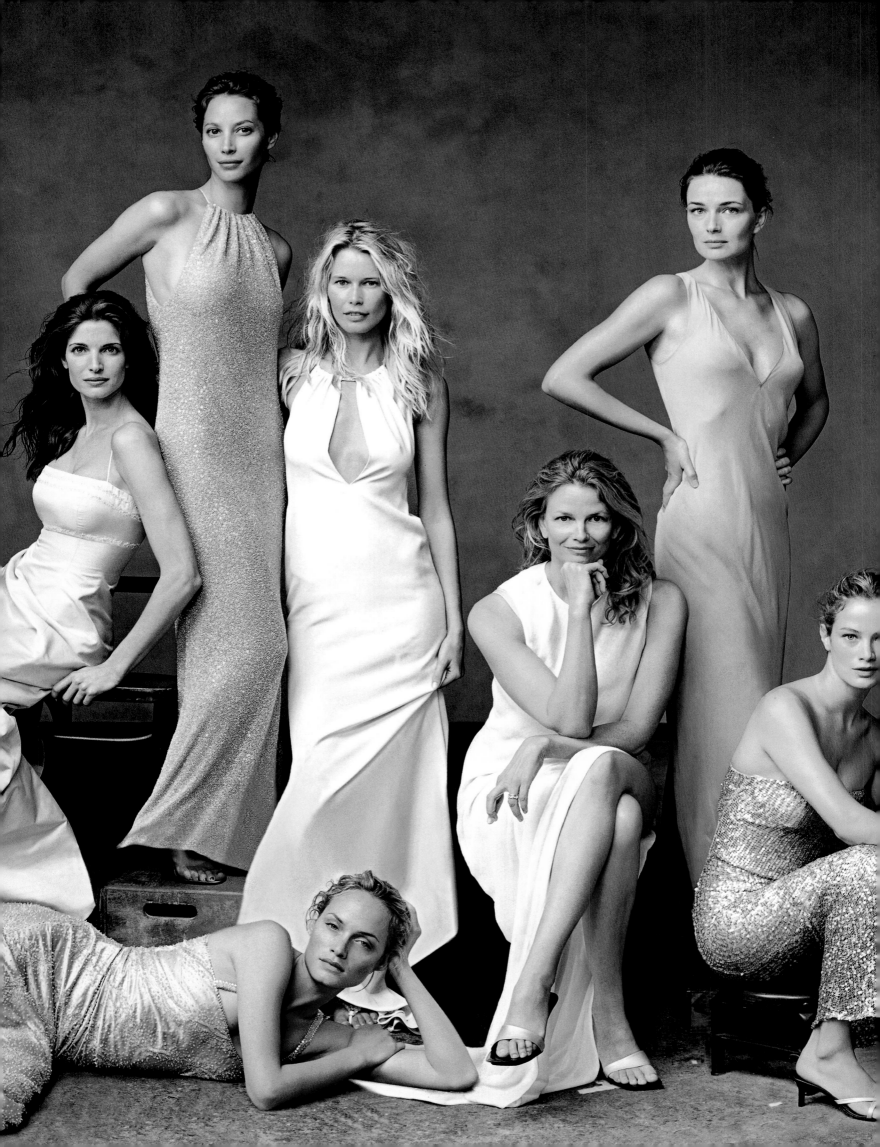

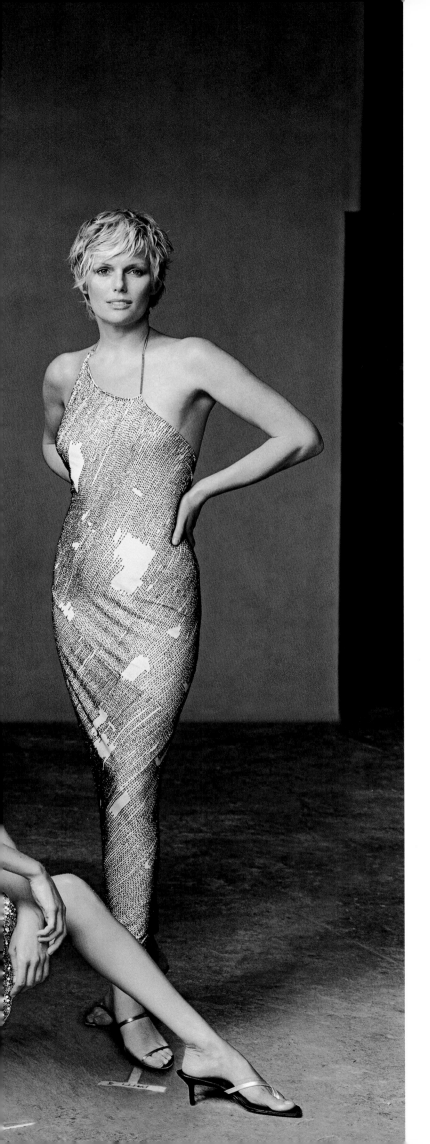

The cover folded out to reveal the rest of the pantheon (*left to right*): Stephanie Seymour, Christy Turlington, Claudia Schiffer, Amber Valletta, Lisa Taylor, Paulina Porizkova, Carolyn Murphy, and Patti Hansen.

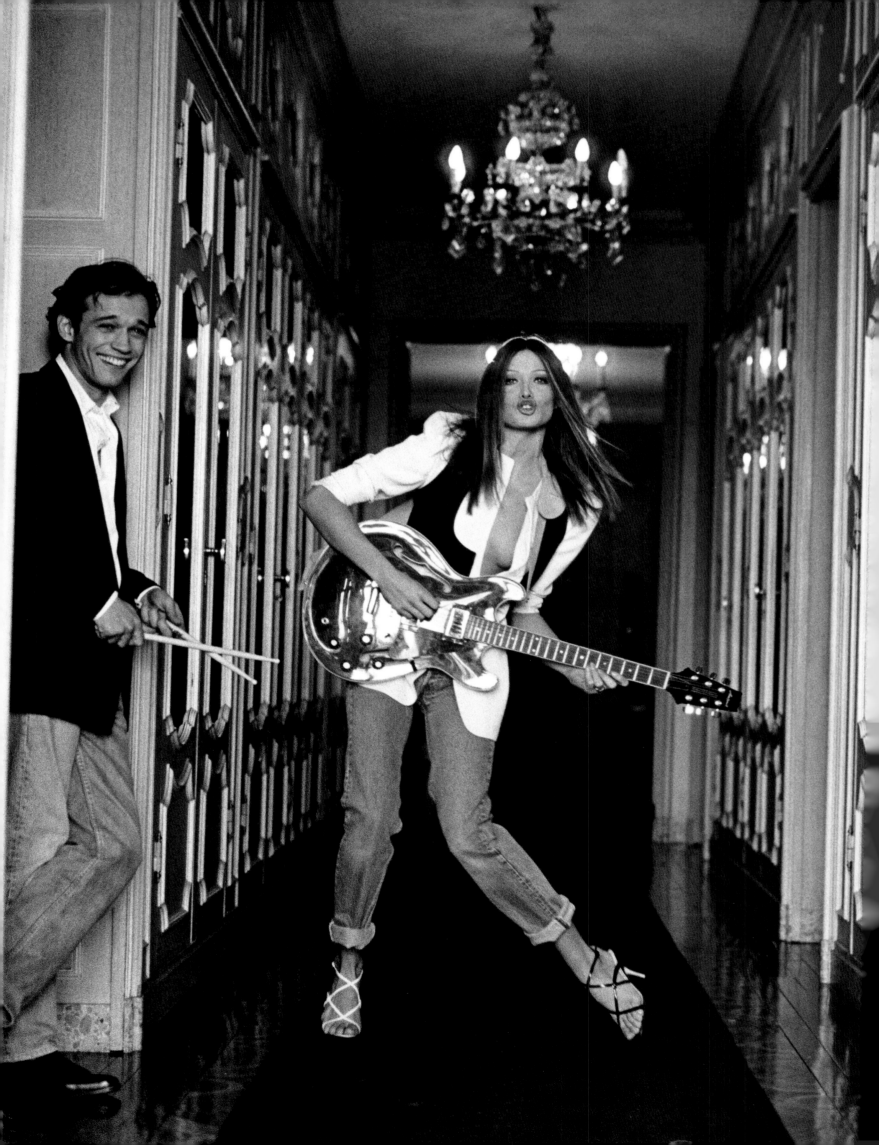

Carla Bruni

At 24, the model and singer-songwriter
posed with her then-beau, the French actor
Vincent Perez, in the Paris apartment
of her parents. (In 2008, she married
French president Nicolas Sarkozy.)
Photographed by Dewey Nicks, 1993.

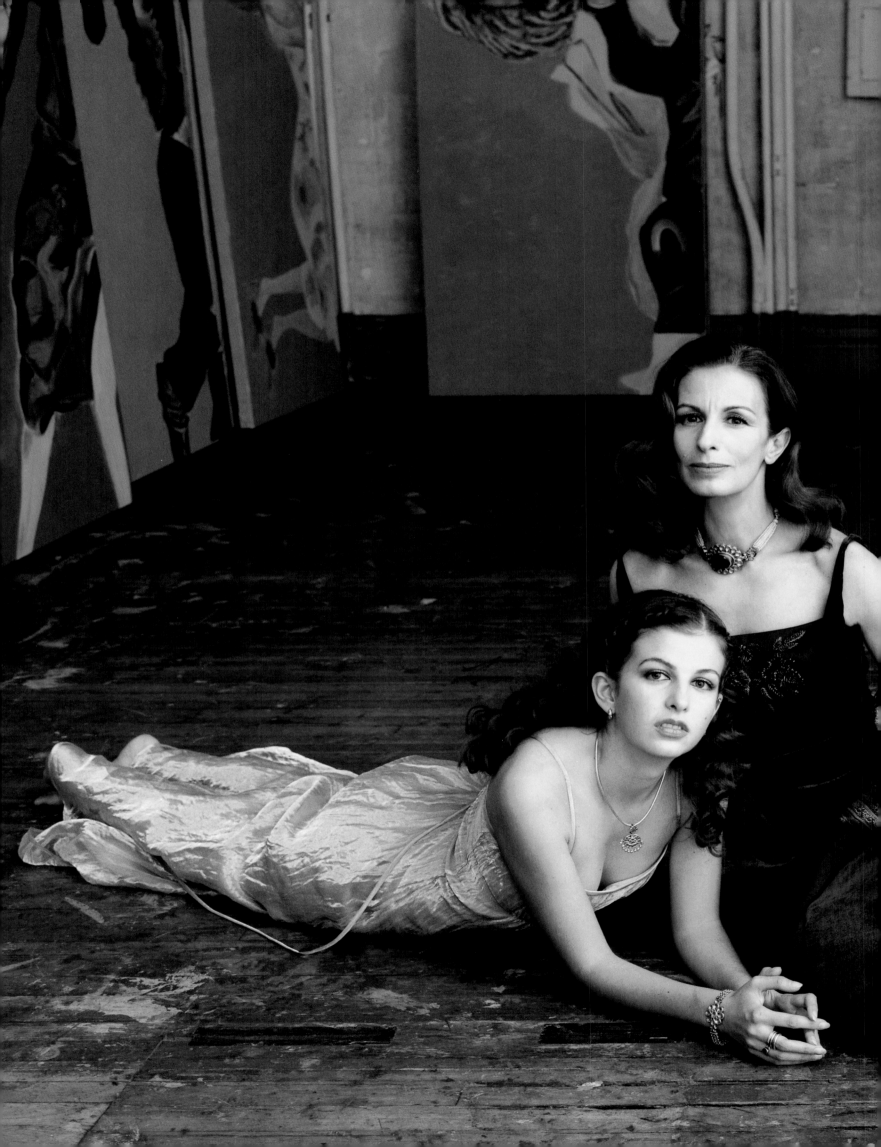

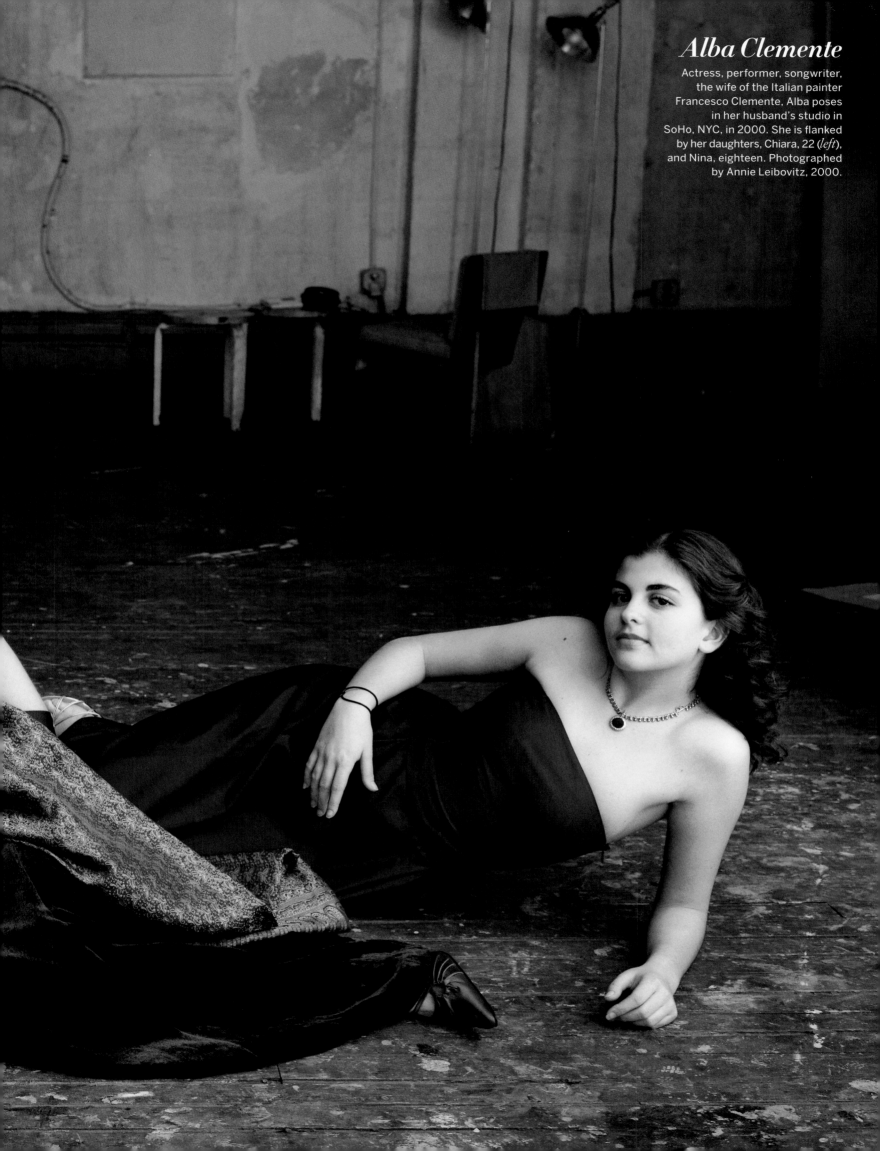

Alba Clemente

Actress, performer, songwriter, the wife of the Italian painter Francesco Clemente, Alba poses in her husband's studio in SoHo, NYC, in 2000. She is flanked by her daughters, Chiara, 22 (*left*), and Nina, eighteen. Photographed by Annie Leibovitz, 2000.

IMAN

iman was the superstar of the seventies. From the moment that photographer Peter Beard spotted the eighteen-year-old political-science student on a street in Nairobi, Kenya, her iconic status was assured. At a mythopoeic press conference in 1975, Beard presented Iman as a piece of exotic fauna from the heart of Africa: a surnameless tribal princess.

She was smart enough to quit modeling in 1989, while still in hot demand. She left New York for Los Angeles with Zulekha, her then ten-year-old daughter from her marriage to former NBA star Spencer Haywood. They divorced in 1986. She briefly trod the well-worn model path from runway to soundstage, but after a couple of successes—notably *No Way Out,* with Kevin Costner—she began to think about launching a business, Iman Cosmetics. She also began to think about David Bowie, whom she met in 1990 and married two years later.

I now know she was pregnant when we initially met; struggling through the tricky first trimester, battling the seesaw of emotions that attend any late pregnancy. (She'll be 45 in July.) You couldn't tell. She fizzes like a string of firecrackers. Well, Bowie knew, obviously. He had started walking around with such an idiotically blissed-out smile pasted on his face that Iman says she told him to cool it: "People are going to think you're back on drugs!" He says their longed-for baby is already "beautiful," even though it isn't due till August. "Some friends asked him, 'Have you done up the nursery yet?' " Iman says. "He said, 'Yeah—there's the crib, and that's my bed.' He wants to be in the same room as the baby."

—VICKI WOODS, *April 2000*

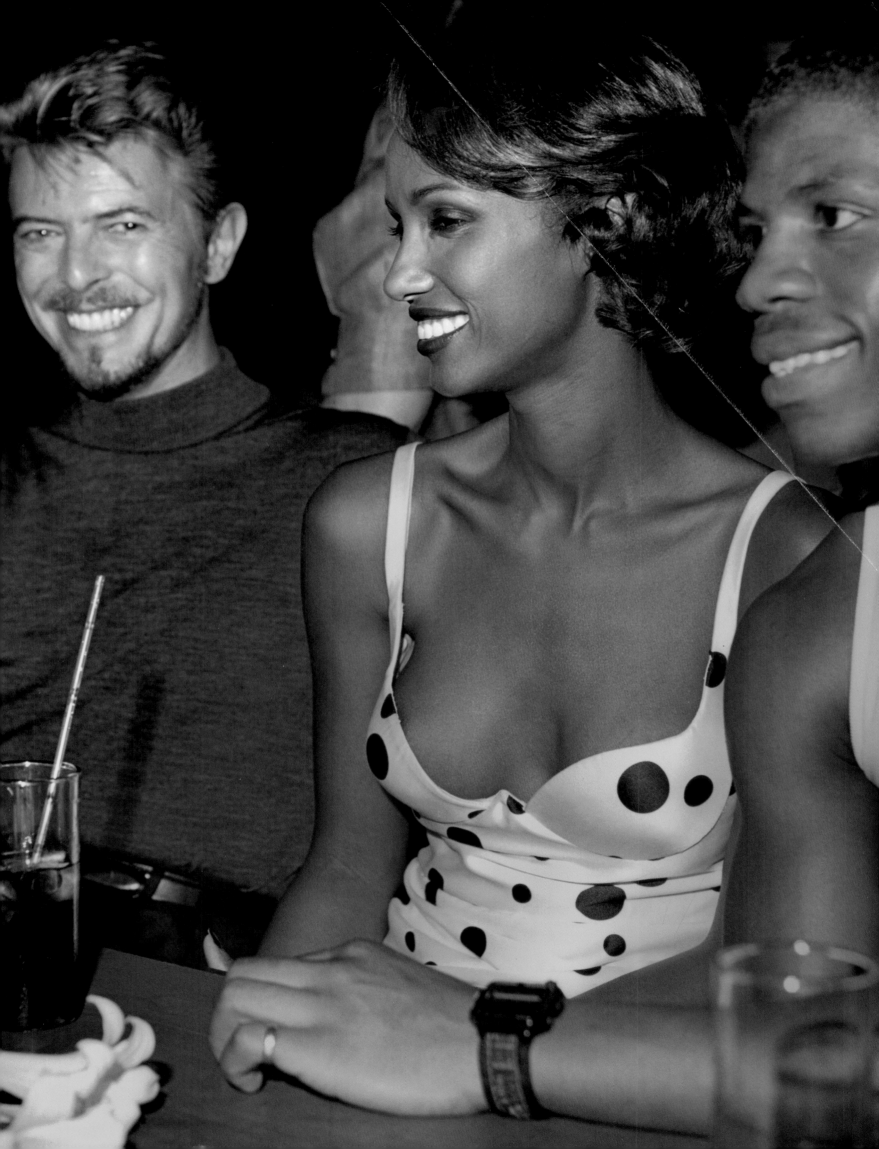

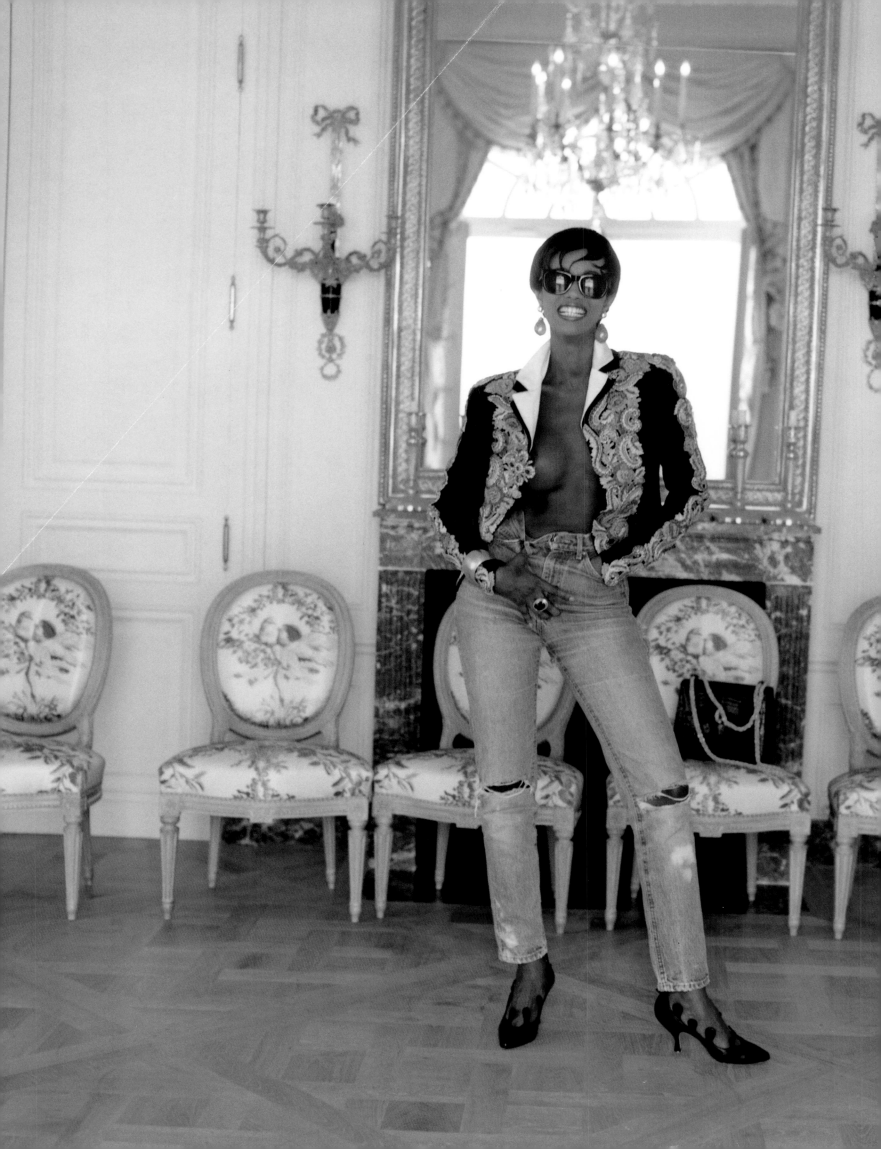

Iman Mohamed Abdulmajid in
a Chanel Haute Couture jacket (*left*)
and earrings (*below*).
Photographs by Helmut Newton, 1989.

─────────────

following pages:
A classic portrait (*left*). Bowie and Iman,
wearing Chanel Haute Couture,
on a beach in South Africa in 1995 (*right*).
Photographs by Bruce Weber.

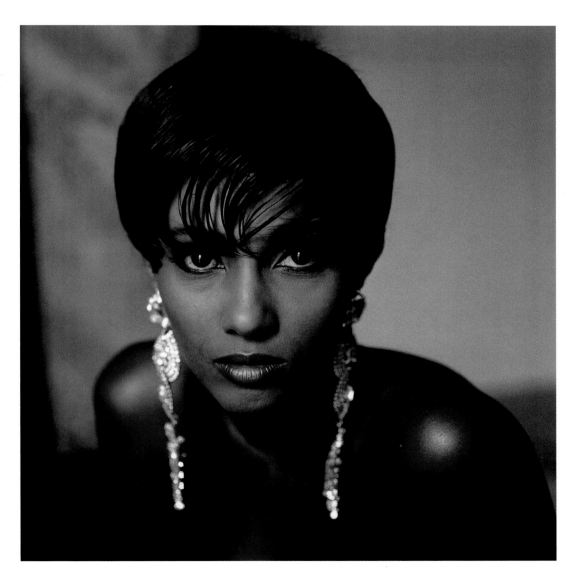

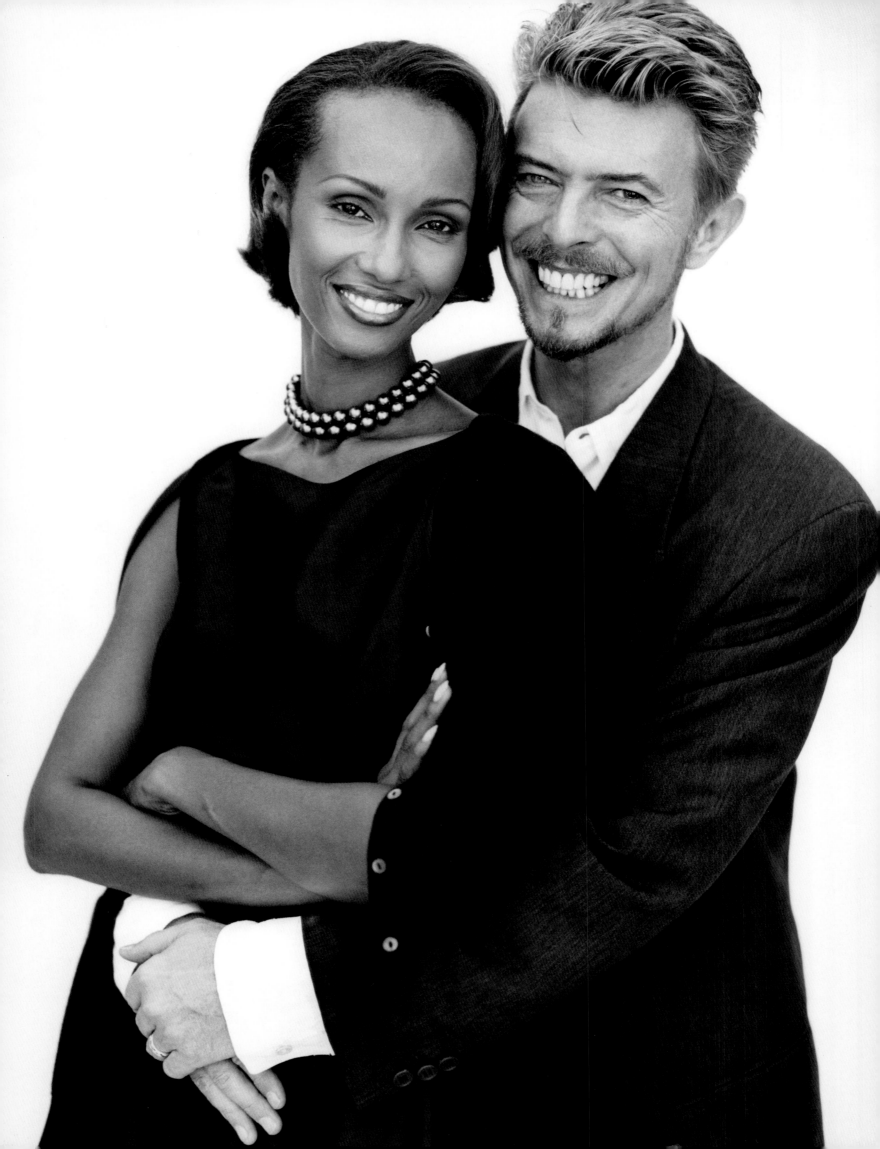

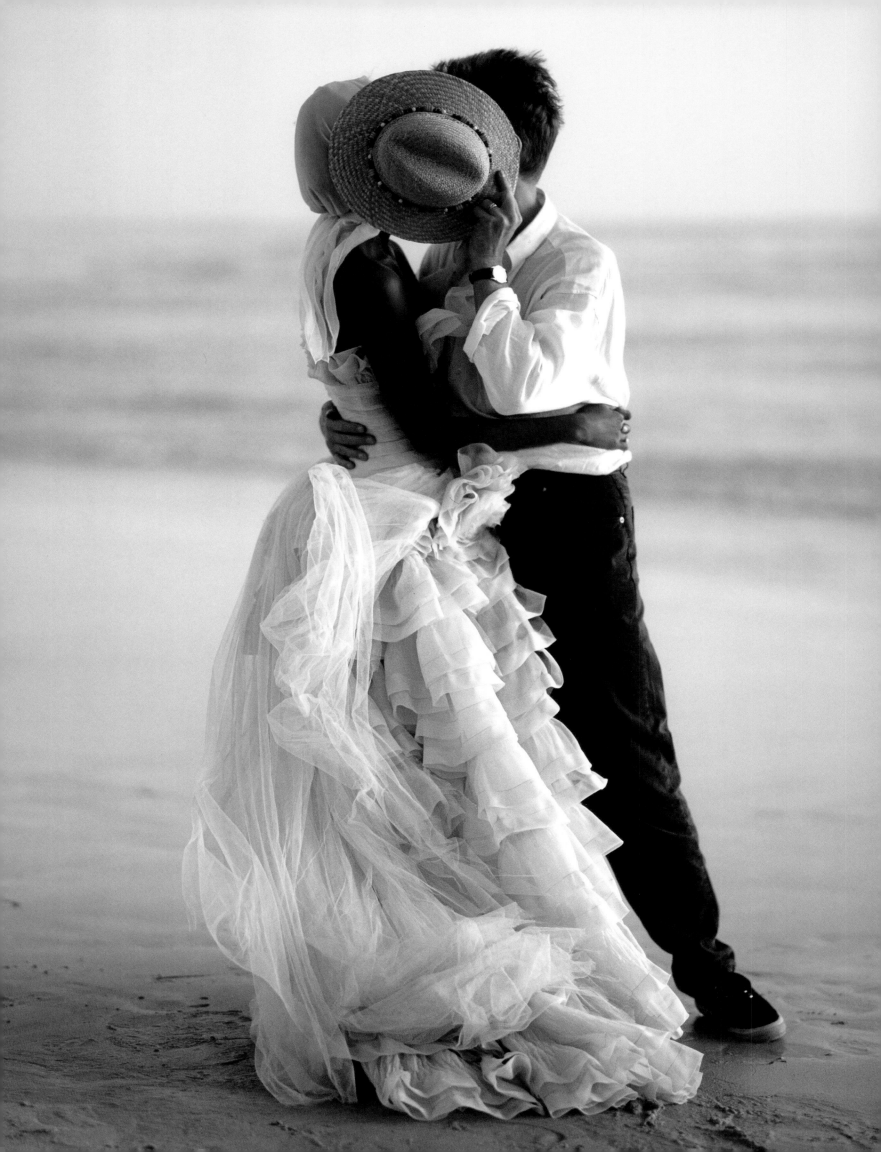

PENELOPE TREE

a walking fantasy, Penelope Tree projects the spirit of the hour—an elongated, exaggeratedly huge-eyed, beautiful doodle drawn by a wistful couturier searching for the ideal girl. Seventeen, slim as a rake, slender-shouldered, lithe, she is affectionate, enthusiastic, witty, allusive, rueful, ranging over everything from Rasputin to modern poetry. She loves the thirties—"the people, the Round Table at the Algonquin, Dorothy Parker and Robert Benchley; the movies, especially W. C. Fields; and I love the clothes because of the materials. . . . Anywhere from 1880 to 1940-ish is interesting."

Two of the main reasons for her poise, manners, and conversation are her parents, Ronald and Marietta Tree. Her father was a member of Parliament for twelve years, and her mother was for some time the United States representative to the Human Rights Commission of the United Nations. Penelope's maternal grandfather was Malcolm Endicott Peabody, the Episcopal bishop of Central New York; her grandmother was prominent in civil rights; her uncle was the Democratic governor of Massachusetts; and her great-grandfather founded Groton School. Part English, part American, she is as at home in New York as in London or Barbados, where she spends a holiday every year at her parents' house, Heron Bay. "The house," said Penelope, "looks as though it had been there forever, since before time began. It is my dream house, the most beautiful place I think I have ever seen. It was built in 1947, by my parents and the architect Geoffrey Jellicoe, all of white coral—as most houses are in Barbados. Coral doesn't burn or blow down, it seems eternal; the elements don't hurt it, yet each year it grows more beautiful, with plants and little living things growing out, and over, and around it." Most of the furniture was made by local carpenters, and the Italian pieces were copied from furniture in the Palazzo Ca' Rezzonico in Venice. The morning room is a favorite Tree hangout. Penelope explains, "It's a kind of repository for shells, really—with a shell-shaped mirror and alcoves and lots of shells all around the room. People write letters here, read, and in theory everyone adds to the collection of shells by giving some of the pretty ones they have found on the beach. In practice everyone plunders like mad—me especially—for presents to bring back to New York."

Penelope Tree went to the United Nations International School in New York for her final school year. This autumn she starts at Sarah Lawrence "because it is very strong in English. And they don't have any exams and marks systems." Though she seems mildly surprised by the rush of photographers who try to book her for sittings, she finds modeling a nice balance to school. "I've met people I love whom I probably would never have met otherwise, and I think the camera is the most exciting art implement since the paintbrush."

—POLLY DEVLIN, *October 1967; July 1968*

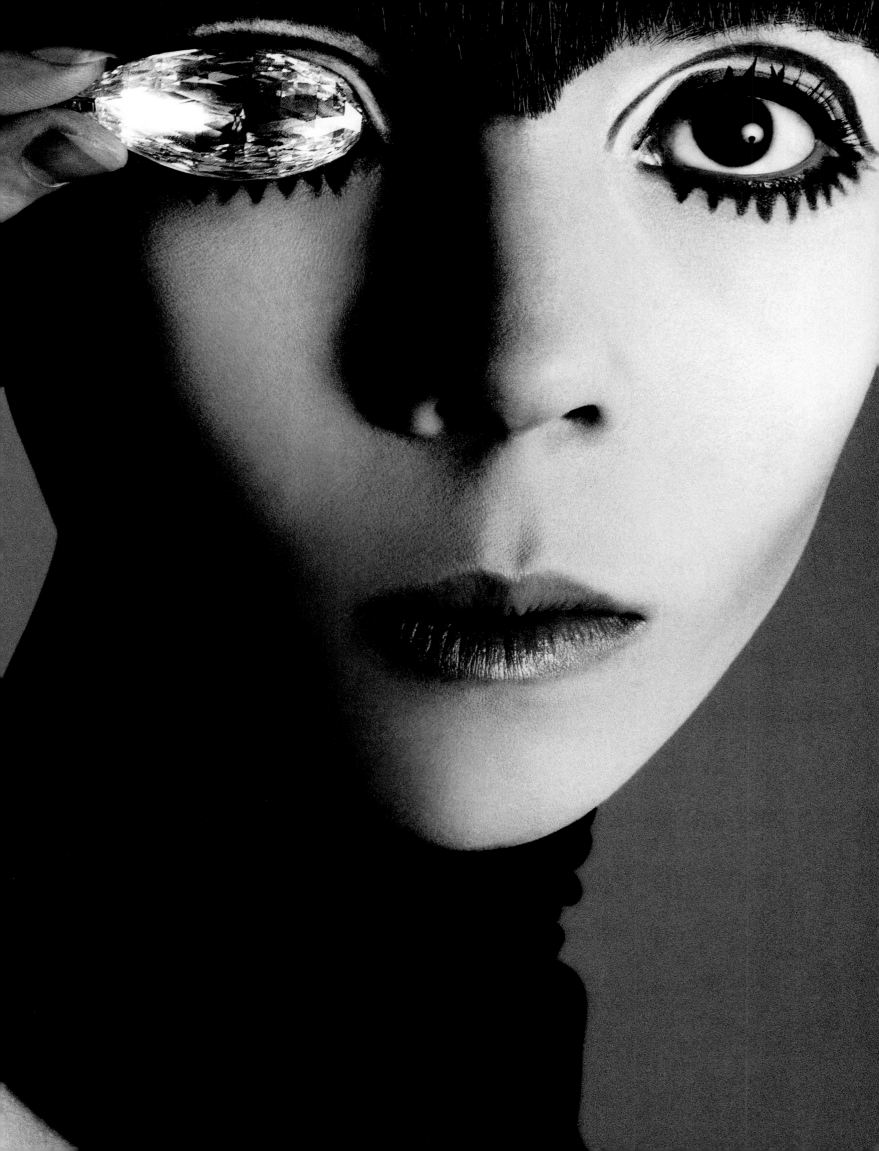

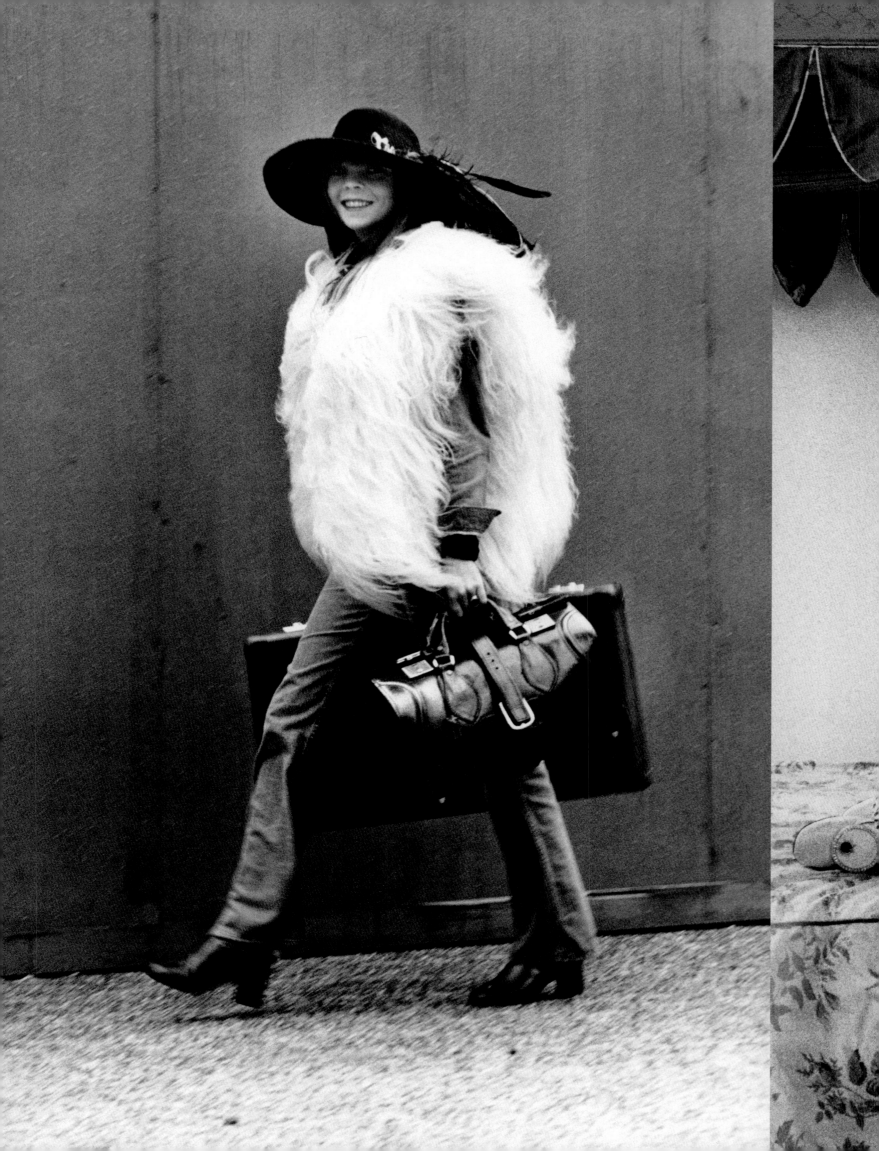

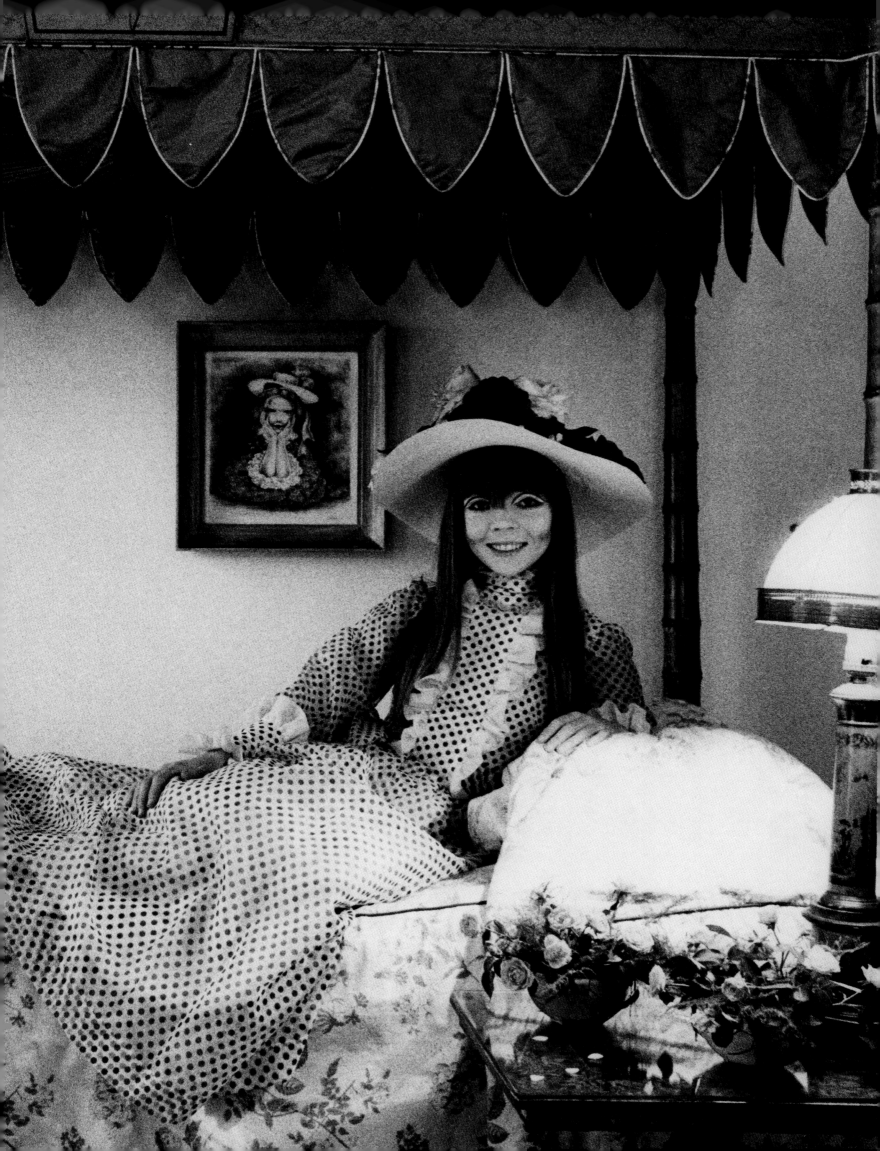

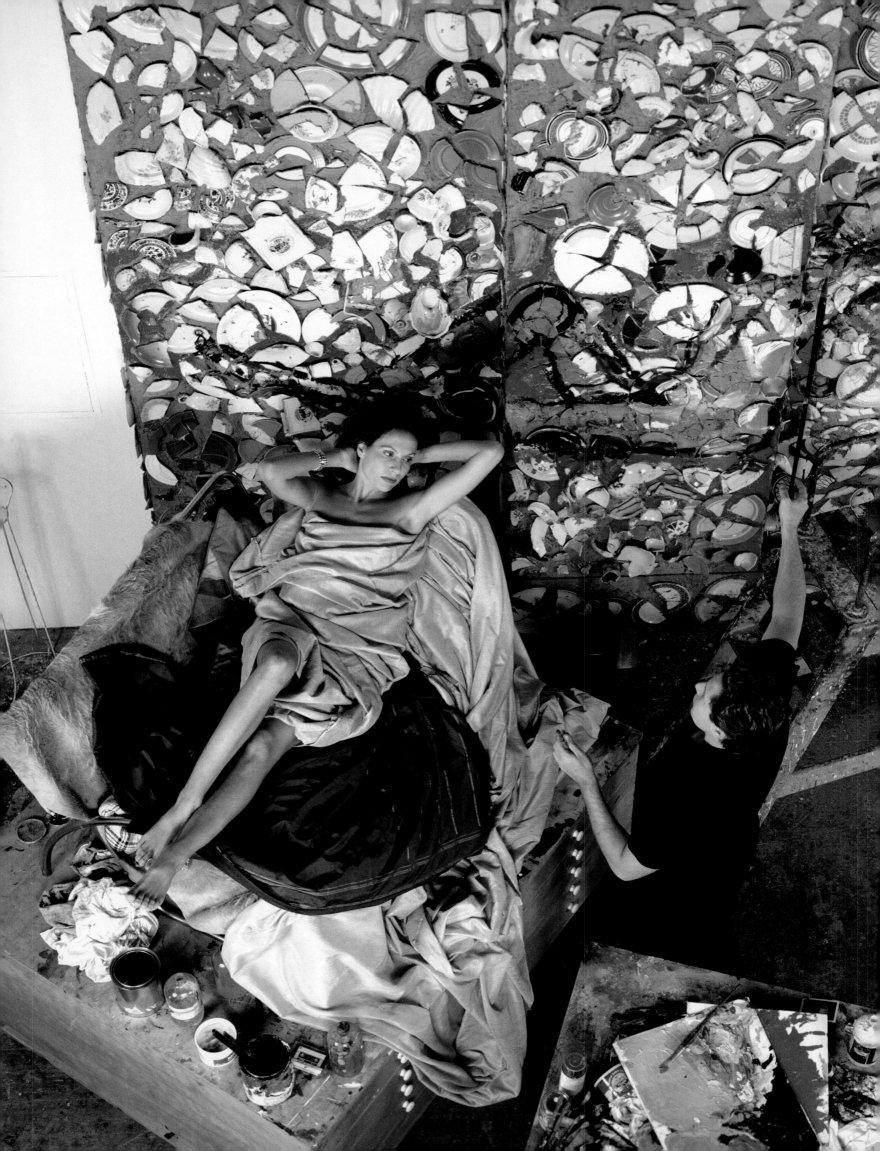

JACQUELINE SCHNABEL

jacqueline Schnabel, née Beaurang, was born to bourgeois splendors in Belgium, where she was raised outside Antwerp in a house whose manicured gardens were created by Jacques Wirtz, the most distinguished of European landscape architects. She may have felt a sense of gentle rebellion against what she once described as "quiet Europe" and a childhood manse where there was "nothing falling apart at all!" But if her parents were the height of urbanity, an adventurous spirit runs through her veins, too. Her mother, Anne, a supremely elegant, chiseled beauty, was not only a fashion aficionada but also a dashing aviatrix—the first woman to pilot a helicopter across the English Channel.

Her mother's fashion instincts have been passed on to Jacqueline. At nineteen she was running the Brussels outpost of the ultrahip Fiorucci. In 1988 she opened Manhattan's Azzedine Alaïa boutique, in the newly discovered wilds of SoHo. (She laid wooden railway sleepers for floorboards that added drama but were a hazard for the vertiginously heeled clientele.)

With her sculpted features, Alaïa-friendly figure, and a languid drawl that spoke of finishing schools, this rangy, patrician beauty (her uncle was a prime minister of Belgium) was perfectly cast to play artist's muse. "We're in the middle of this thing that gets bigger every day," she told *Vogue* in 1985, speaking of living in the eye of the storm created by her husband, Julian's, "cyclonic success" in that electric art-world moment.

"They were a very, very glamorous couple," recalls the artist Peter McGough. "He was this powerhouse of creativity and bravado and interest and talent. She was so intimidating to look at; a camera couldn't capture her outrageous beauty. Like Greta Garbo, but she was the sweetest person. She made this very cozy home." The Schnabels reinvented the way artists lived, first in the loft on Twentieth Street that had been Julian's studio and was rapidly expanded for grandiose family living. As in his work, Julian Schnabel's decorating vocabulary was all about patina, operatic scale, and high impact; his wife brought her own brand of eclecticism and European refinement to the mix.

Together, and in all their houses (including the stately West Village brownstone that Jacqueline moved into after the couple's 1993 divorce and that *Vogue* described as "a homey madhouse of inspired logic bursting with life and art and children and dogs"), the Schnabels evolved a wildly sophisticated interior aesthetic—blending gutsy but quirky furniture, *objets,* and art of magisterial presence and exotic pedigree, occasionally in a state of poetic dereliction, and generally conforming to a painterly palette of semiprecious-stone colors. Schnabel admits that she puts her atmospheric roomscapes together "without too much thought—it's more instinct than trying to match things. I like this, and I like something else, and they're not things that would traditionally go together."

In Jacqueline's world, lovely things are there to be used and loved. For she is the ultimate hippie de luxe, and her houses and decorating—even if filled with special and precious things—are primarily *machines à habiter.*

—HAMISH BOWLES, *January 2007*

Cher posed with her husband, Sonny Bono, for Richard Avedon in August 1972, at the peak of their television variety show's popularity.

CHER

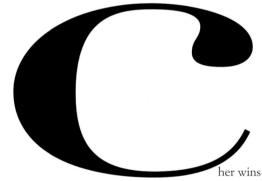

Cher wins as she loses—at full blast. She will never knuckle under to the embalming meekness of quiet good taste or humdrum propriety; she's a bugle-beaded rebel, a well-toned pagan who refuses to surrender her garter belt.

Cher is the object of much small-town chatter; she's back-fence heaven, eternally provocative. Even at her most misguided, she refuses to disappoint.

Cher has lived many lives and outlived many noses and scandals. She is not a Bowie-like chameleon or that much-abused term, a survivor. Cher simply can't stop being herself, and that is her charm. She is never a bore; we can always savor the wig and the outfit. Cher is in her prime, but then she's always in her prime. She has outlasted at least six presidents and Lord knows how many pairs of spike heels; we can only look forward to her ensemble 20-odd years from now, when she receives Kennedy Center Honors.

—PAUL RUDNICK, *December 1990*

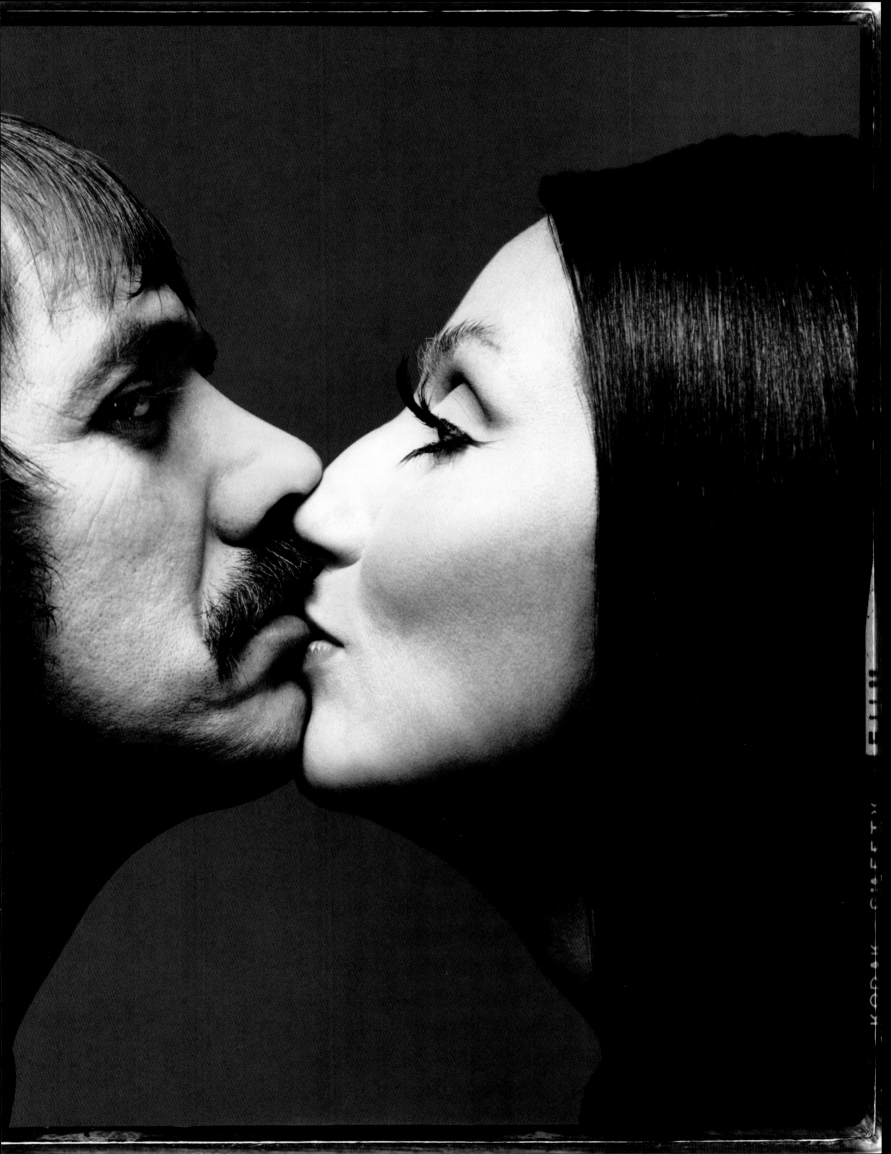

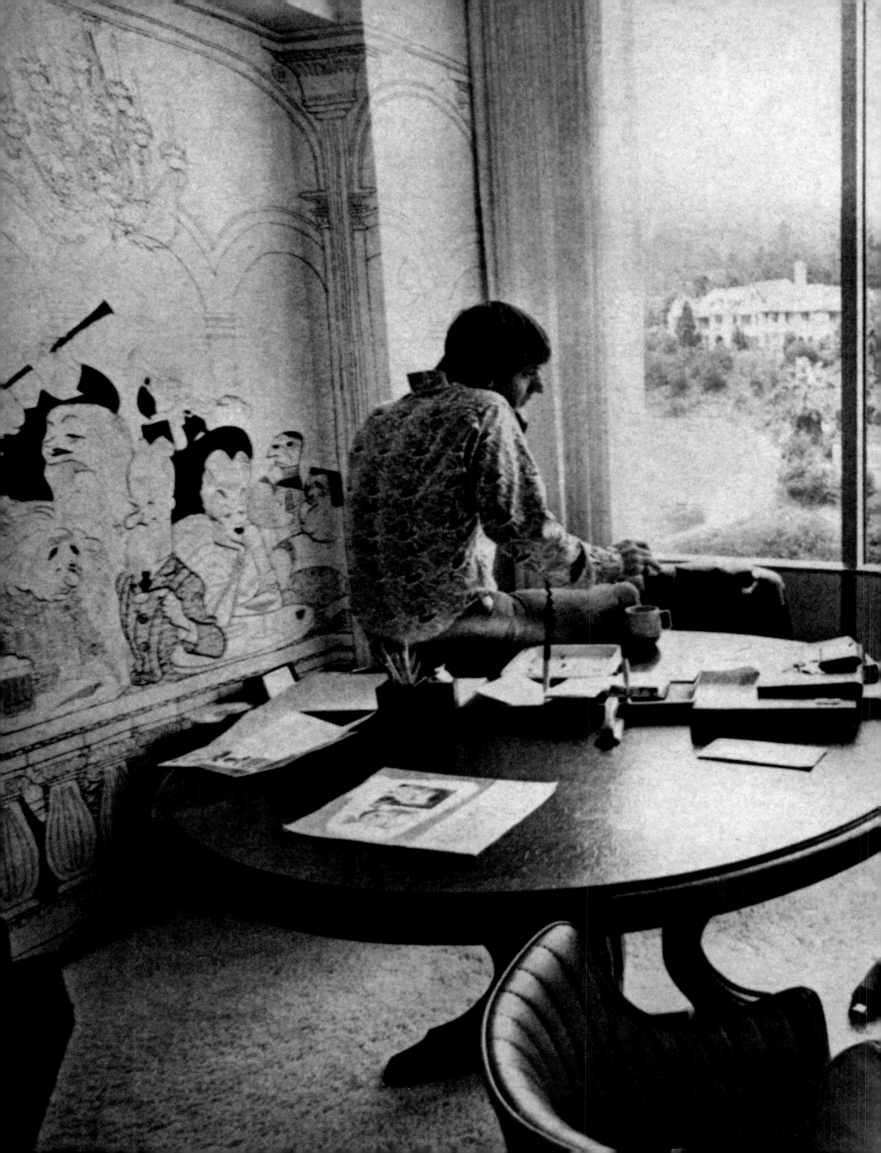

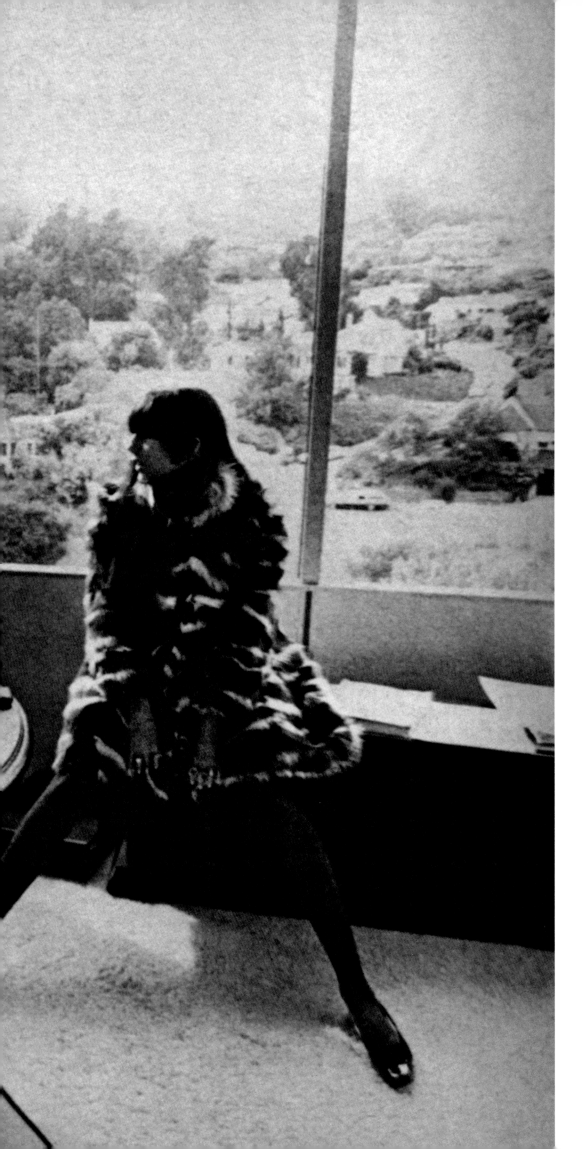

Cherilyn Sarkisian met a record producer in a coffee shop in Los Angeles when she was sixteen, and within a few years "I Got You Babe" had made pop stars out of Sonny and Cher. They were photographed in Sonny's office on Sunset Strip by Bob Willoughby in 1967.

331

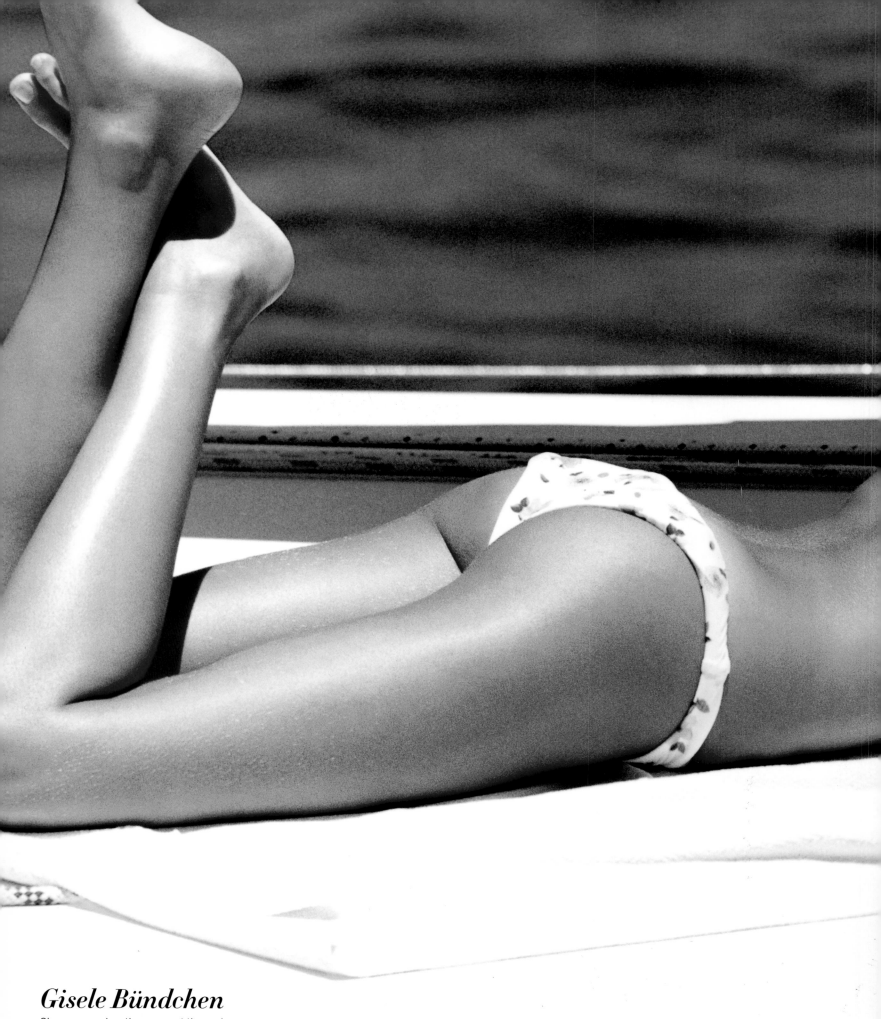

Gisele Bündchen

She appeared on the scene at the end
of the 1990s, inspiring the craze for Brazilian
girls and marking the return of a more
curvaceous ideal in fashion. She wore
just bikini bottoms in a 2000 story
about Rio, photographed by Mario Testino.

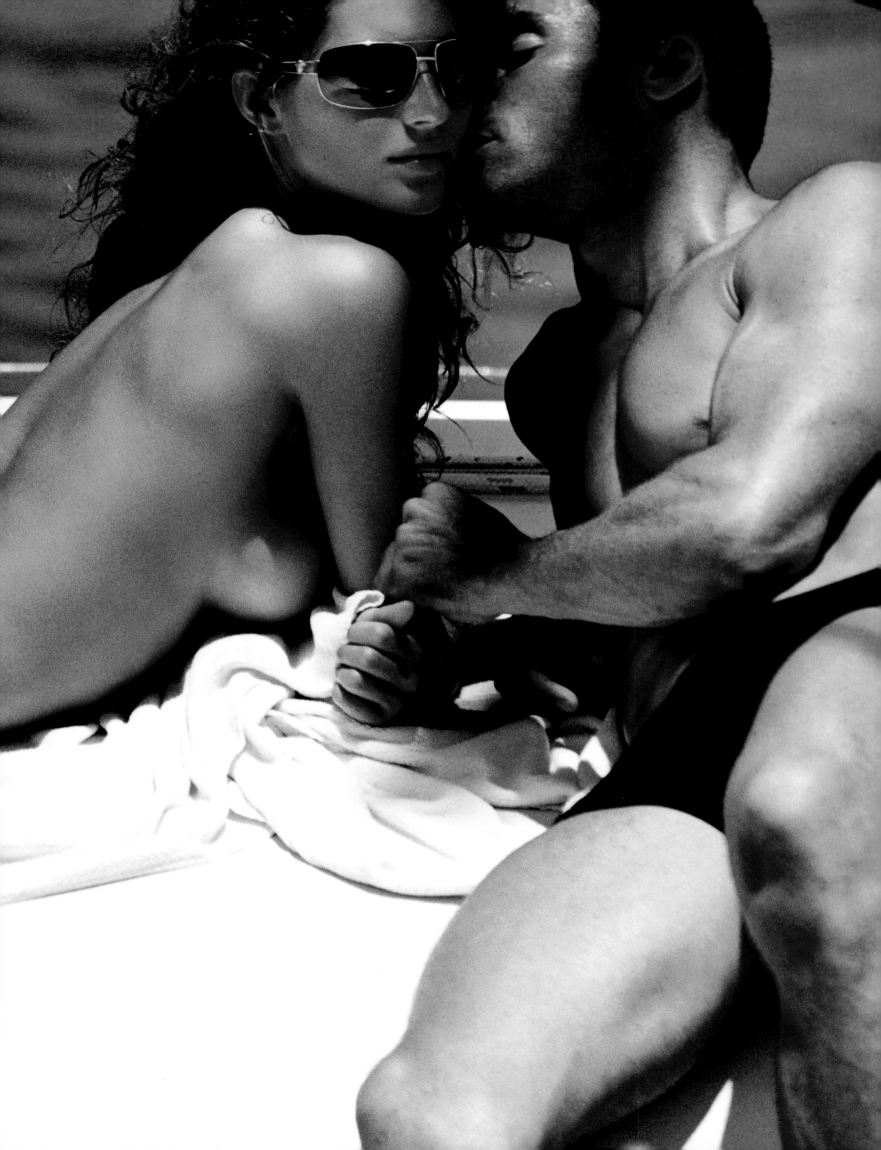

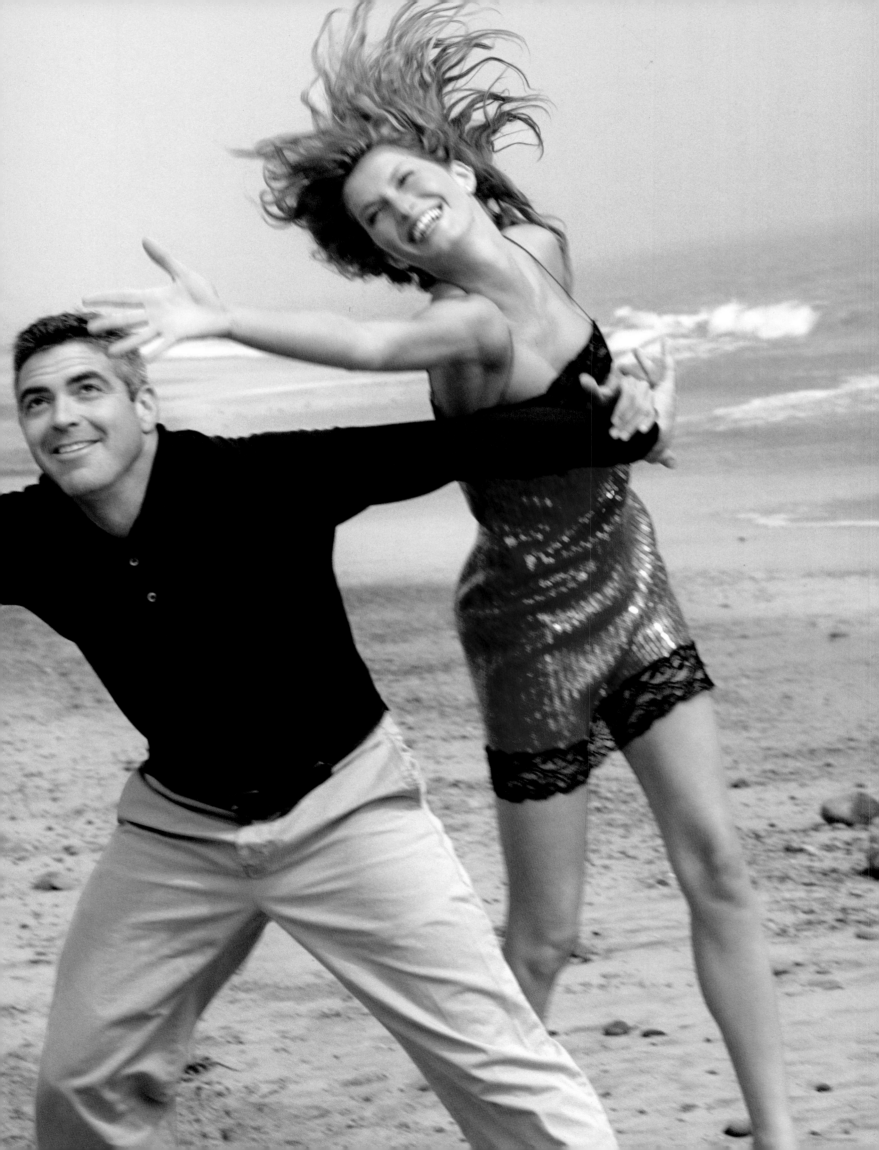

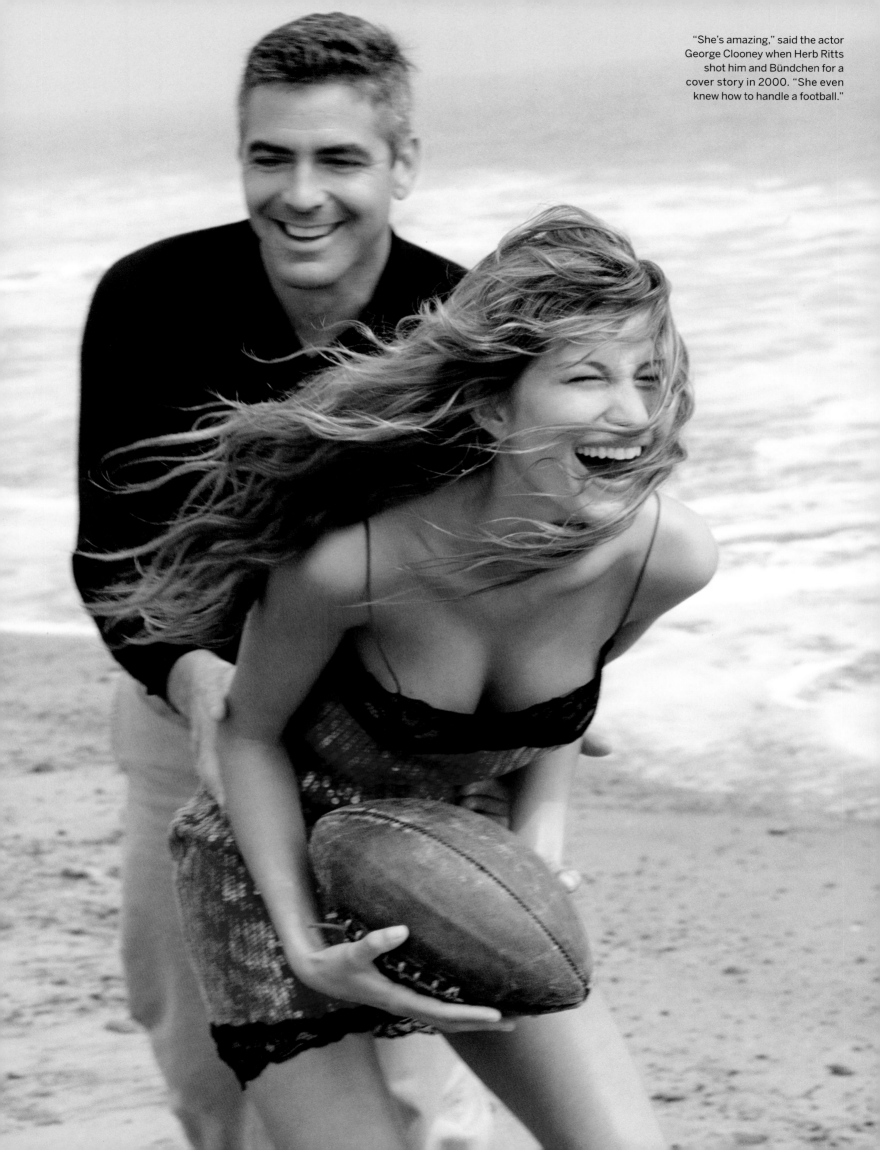

"She's amazing," said the actor George Clooney when Herb Ritts shot him and Bündchen for a cover story in 2000. "She even knew how to handle a football."

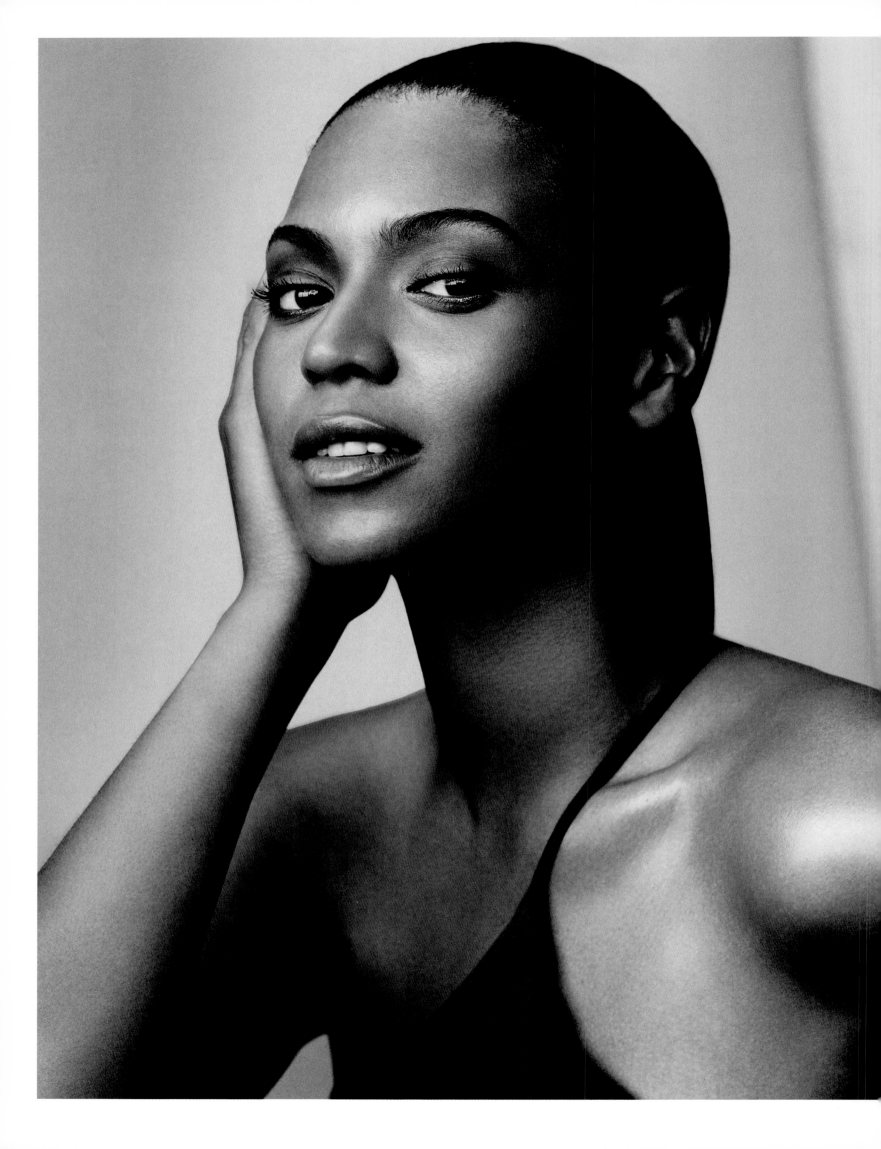

Beyoncé

The Grammy Award winner
from Texas started 2009 with
back-to-back performances
at the presidential Inauguration
and the Academy Awards.
"I think of Beyoncé as a
modern-day warrior," said
the French designer
Thierry Mugler, who did
the costumes for her
I Am . . . Sasha Fierce tour.
"A free spirit and a free woman.
She will surpass her iconic
stature to become a legend."
Photographed by
Mario Testino, 2009.

Model, actress, traveler,
Hutton was photographed by
Richard Avedon in June 1973.

LAUREN HUTTON

1auren Hutton is guided by a private inner radar. She models to make money, has starred in one movie a year for three years to make money, and, for love and no money, travels six months a year. This drives agents who believe clients should stay put around the bend. Lauren—around the bend of the Amazon River or laughing with Pygmies or chasing bugs in Nepal, butterflies in Bali, and bats in the Seychelles—sympathizes with the agents to the point of trying to keep her nose from peeling.

"Like Holly Golightly, Lauren leads the life she wants," said Eileen Ford, who took Lauren on in 1966 as a model at the Ford agency. "Unlike Holly Golightly's, her head is screwed on right." With the heroine of *Breakfast at Tiffany's* Lauren shares something else: a breakfast time at Tiffany's. When Lauren came from Florida to start a life of travel (she had borrowed $200 and booked a place on a freighter to Africa), she hit New York at 7:30 Sunday morning; and remembering little from a former fling with the city (except that she tipped a cabdriver ten cents and he threw it at her), she asked to be dropped at Fifty-seventh Street and Fifth Avenue. "There I was on an empty street corner with everything I owned—college test papers, old sneakers—in two suitcases, crying." How she got off the corner is less important than her arrival there. Lauren dares everything, gets out of predicaments as they boil up. Lauren is, in fact, Tom Sawyer, 1973—a year when Tom Sawyer could readily be a girl. She is adventurous, imaginative, jaunty, ethical in an old-fashioned Golden Rule manner, direct, and brave. She is impetuous, too, jumping into scrapes and then getting out of them by sheer refusal to be trapped in raw deals. From a flashy film start at the top in *Paper Lion* and a quick step to playing opposite Robert Redford in *Little Fauss and Big Halsy,* Lauren, after one more film, *Pieces of Dreams,* and a fourth not yet released, hit a bramble of legal entanglements and contract conflicts. Lauren-style, she dug her heels in and stuck out the troubles, refusing to give in to what she considered to be unfair demands.

In the clear at last, Lauren Hutton now takes her film career as a challenge. She'll make it or bust. Why? "Who doesn't want to be a movie star?" she asked, shrugging, her hands deep in her gray-flannel pants pockets. That's half an answer, her friends think. Anything Lauren does, she does with whole heart, rejecting, improving, tearing apart, and doing again. Anything mediocre she dismisses as "bourgie," unsparing in knocking her own image as she is generous about others'. "She is one of the wittiest and tenderest girls I know, without a phony bone in her body," said Ford. "But I still don't know what made me take her." For Lauren is anything but a classical beauty. Her nose flies west; her mouth flies north; she can cross her left eye at will. She *made* herself beautiful by learning, watching, willing.

—KATE LLOYD, *June 1973*

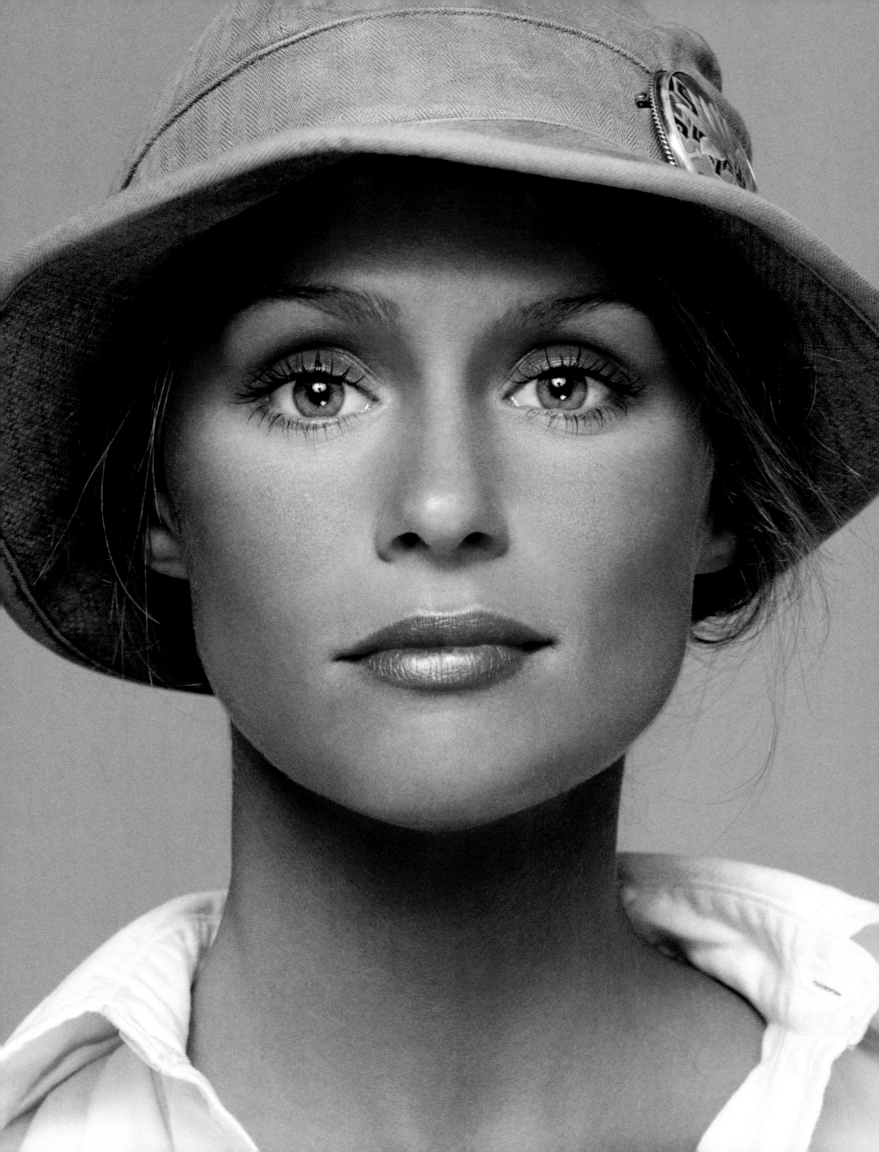

NAOMI CAMPBELL

n aomi
Campbell is riding in the back of a Town Car in Miami Beach,
bodyguard up front, on the way to be photographed by Helmut
Newton. Campbell is famous for many things—a major body; her
magic runway boom-boom; a monstrous temper; a taste for dark,
stormy older men; a cell-phone addiction; and (due largely to said
addiction) a tendency toward lateness that is globally legendary.

She was born on May 22, 1970, in Streatham, a neighbor-
hood in South London. Her part-Chinese father, unnamed on
her birth certificate, left when her Jamaican-born, London-
raised mother, Valerie, was four months pregnant. Unmarried
and only nineteen, Valerie left Naomi with a nanny and set out
traveling all over Europe with the dance troupe Fantastica, send-
ing money home to keep Naomi in dance classes, too. Valerie's
ambitions for her daughter paid off; when Naomi was ten, she
was accepted into the prestigious Italia Conti stage school in
London, where she studied ballet.

Campbell doesn't talk easily about her childhood: Growing
up black in the seventies with no father and an errant mother
could not have been easy. "When I was at school, I gave as good
as I got," she once told a reporter. "If they threw stones at me, I
threw stones at them. I would stick up for myself." Some things,
obviously, have not changed.

At fifteen, she was discovered. "I was in Covent Garden," she says. "I was going home after school, and I stopped off at my girlfriend's to have ice cream, and this lady, Beth Boldt, tapped me on the shoulder and said, 'Do you want to model?' "

During the photo shoot, I notice that Campbell has the letters FB hennaed on her upper arm. I will later find out that the letters stand for Flavio Briatore, the 48-year-old Italian industrialist and former head of the Benetton Formula One auto-racing empire.

"Who's FB?"

"My fiancé."

"How long have you been together?"

"Three months. I love him dearly. I've always been a great romantic, and I've always wanted to find the right man, and I hope, every time I enter into a relationship, that this is going to be the one. I've never been so happy."

"You went out with Robert De Niro. Are you still friends?"

"I have the utmost respect for him. I learned so much from him. I was with him for four years. He really taught me how a man should be treated and about discretion, quality time, not being famous for just being famous. He had a big influence on me. We have a great friendship."

"Do you hang out with Joe Pesci and Jack Nicholson? Are those two friends?"

"Yes, they're friends. I've known Joe for eight years. They're tough, they're meant to be the bad guys, but they're the *best* guys."

"Do you think they like you because you're a 'bad girl'?"

"I think they like me because I'm honest. They trust me. They talk to me. Till the day I die, I would never let anything they say pass my lips. We can't really hurt each other; we have to protect each other. And they're not 'yes' people: I can ask them a question and get an honest answer."

"It's interesting that you're drawn to these older, very masculine men."

"Yeah, because I'm a very strong person, and I need that type of man to handle me. I don't want to be the woman wearing the pants, ever. I don't like that at all. I want the man to wear the pants. And for me it works better to be with older men because I've lived my life in such a short span of time—more than a woman of 45 has. So it works for me to be with someone who has experienced as much as I've experienced. There're no games to be played."

At the end of the shoot, Campbell and I share a car to the airport. I ask what color her eyes are. "My eyes are cosmetic," she says. "It's like makeup. I change them all the time." She laughs and then stares out the window. "It's like Herb Ritts always says to me, 'When I look to shoot you, I don't think of you as a black girl.' You can make people believe you are whatever color you want to be."

"What do you think when somebody says, 'I don't think of you as a black girl'?" I ask.

"I think it's a weird thing to say. I always say, 'Well, I *am* black.' But I also know exactly what I'm doing and when I'm doing it to make them think that. It's not like I'm doing it to make them think that I'm white. I'm doing it to prove a point. There shouldn't be a discrimination of 'I can't use you as a model because you're black.' That's my point."

—JONATHAN VAN METER, *March 1999*

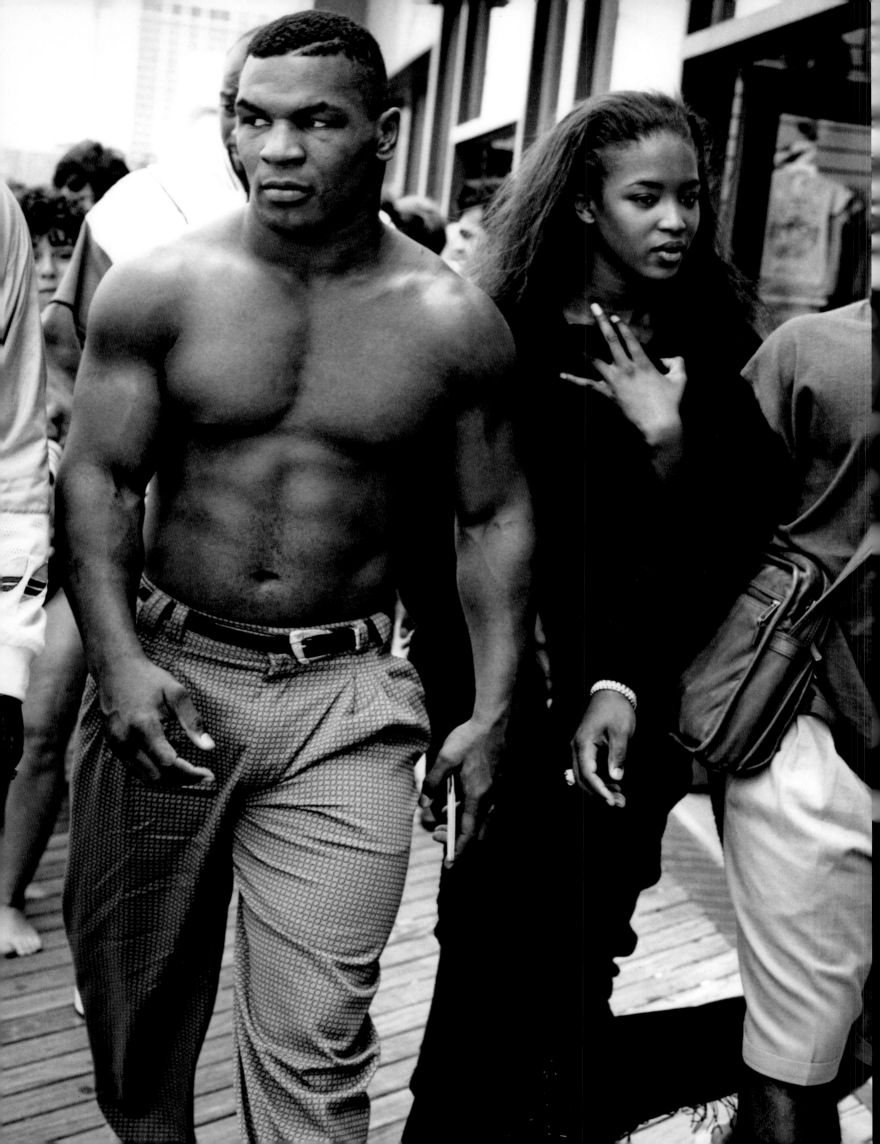

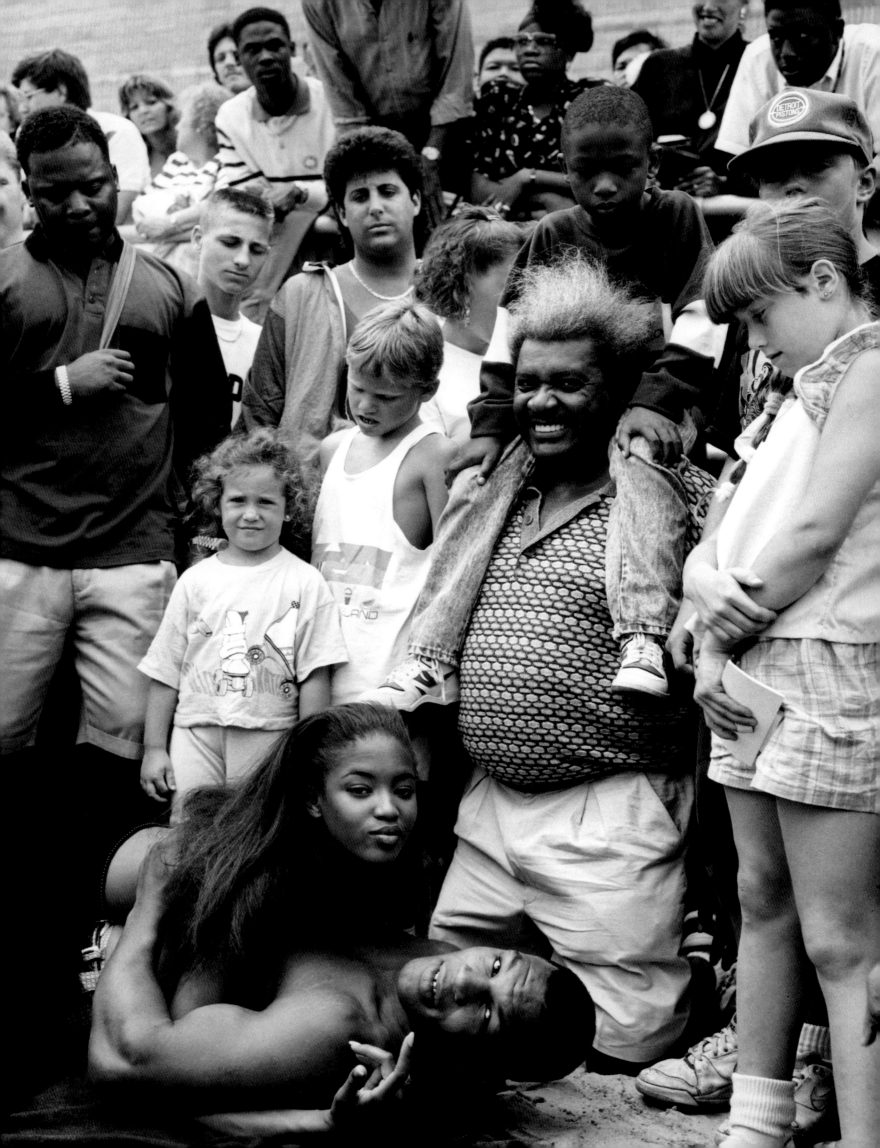

SHALOM HARLOW
and
AMBER VALLETTA

previous pages:
Shalom Harlow (*left*), 1995,
and Amber Valletta (*right*), 1994.
Photographs by Herb Ritts.

———————————

Valletta, photographed by
Mario Testino in Rio, May 1997.

hey say it's over.
That the supermodels are finished. That the time has finally
come for Linda and Christy and Naomi and Cindy and Claudia
to button up their Chanel jackets, grab their Hermès bags, and
Concorde off into the sunset.

The models who now appear poised to personify the
spirit of the late nineties—Amber Valletta, Shalom Harlow,
Kirsty Hume, and Stella Tennant—arrived too late to be in-
toxicated by the excesses of the eighties. If the supermodels
learned to walk the walk at Chanel, wearing killer stilettos and
big-shouldered power suits with glistening gold buttons, this
generation climbs onto the Kaiser's catwalk wearing Sabrina
pumps and baggy chinos.

"These girls are very weightless—not in the physical sense,
but they give the impression that nothing is really serious," says
Karl Lagerfeld. "They are not obsessed with fame." "Fashion
is changing," adds Donatella Versace. "It's going back to more
reality. You don't see too many Claudia Schiffer or Naomi
Campbell look-alikes on the street. But you might see an Amber
or a Shalom."

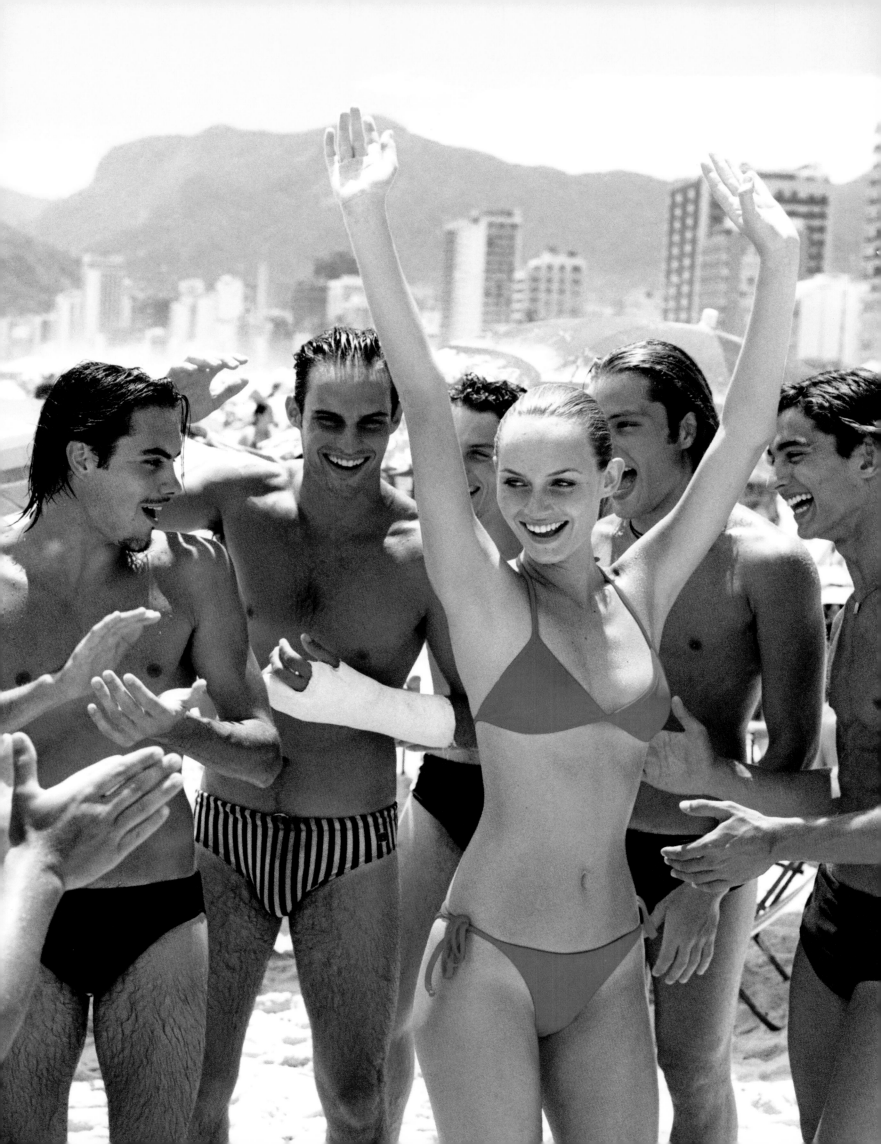

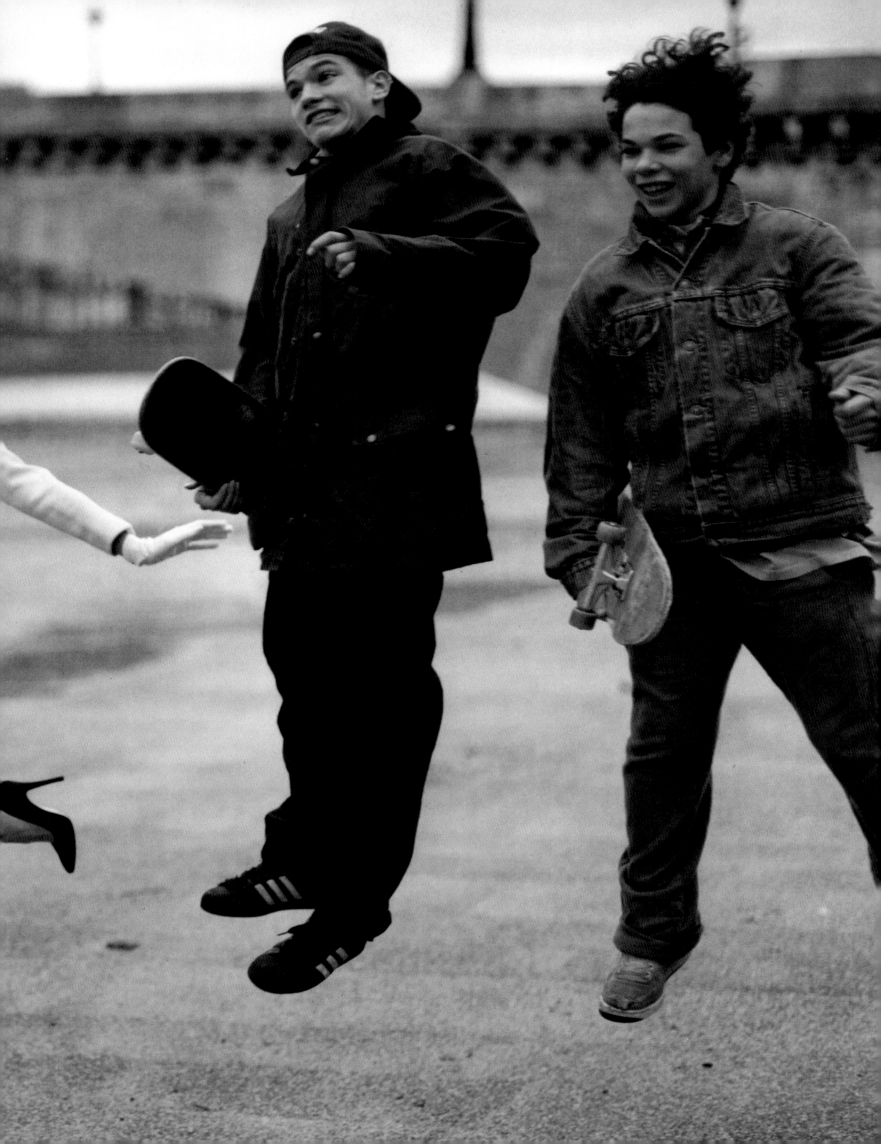

previous spread:
Harlow wears
Gianni Versace haute
couture in Paris.
Photographed by
Bruce Weber, 1995.

Harlow in Chanel
Couture. Photographed
by Bruce Weber, 1995.

Valletta (*left*) in Liza
Bruce. Photographed
by Herb Ritts, 1994.

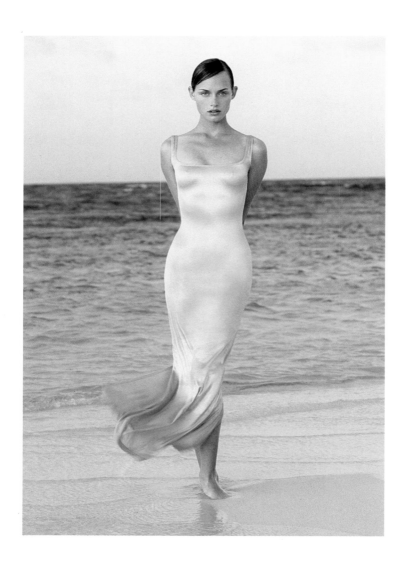

If the enthusiastic support of such influential designers establishes "the new girls" as the heirs apparent to the original supermodels, they are reluctant to accept the legacy. "The difference between the supermodels and us is our down-to-earthness," says 22-year-old Harlow. "We make a conscious effort not to let the stardom go to our head." Adds Valletta, also 22, "I've gotten out of bed a lot of days for a lot less than $10,000."

The new generation also knows that their lottery-like good fortune comes at a high price. "I've sold my youth," says Harlow, a sobering remark echoed by Valletta. And if they sometimes come across as somewhat more fragile than fabulous, perhaps it is because there was little in their pasts to prepare them for what was to come.

Valletta was born in Arizona in 1974. When she was two, her father moved to California and her mother moved to Oklahoma, where she supported herself and her daughter by waitressing. When Amber was fifteen, her mother enrolled her in a local modeling school, which Amber thought "goofy." But she got work at local malls, where she was paid $150 a Saturday. After a summer of go-sees in Milan, Amber returned to Oklahoma, finished high school a year early, and hied back to Milan. Two months later she moved to Paris, where her big break came when she cut off her shoulder-length hair, which transformed her into a gamine.

Harlow was born outside Toronto, three weeks after her parents were forced to flee revolutionary Grenada, where they had gone, according to their daughter, "to birth me in a nice way and preach the word of God." In Canada, Shalom's missionary father set up a shelter for homeless men. But he left home when Shalom was eleven. To pay for her dance lessons, Shalom got a paper route. At a Cure concert in Toronto, the sixteen-year-old was approached by a modeling agent. A year later, she packed for Paris.

The "new girls" see a critical difference between being a supermodel and being a model: One is a life; the other is a job. As Harlow puts it, "Sometimes when people walk up to me on the street and ask, 'Are you Shalom?' I'll say, 'Not today.' "

— CHARLES GANDEE, *March 1996*

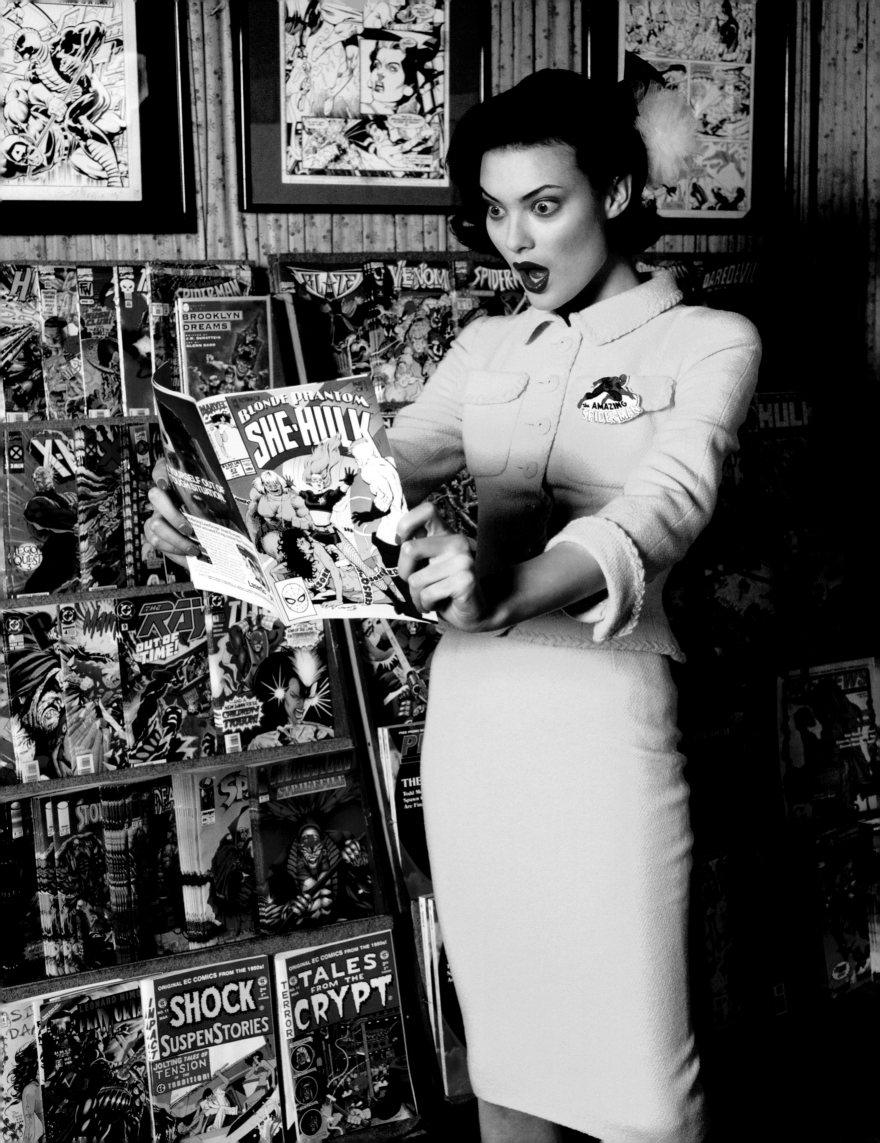

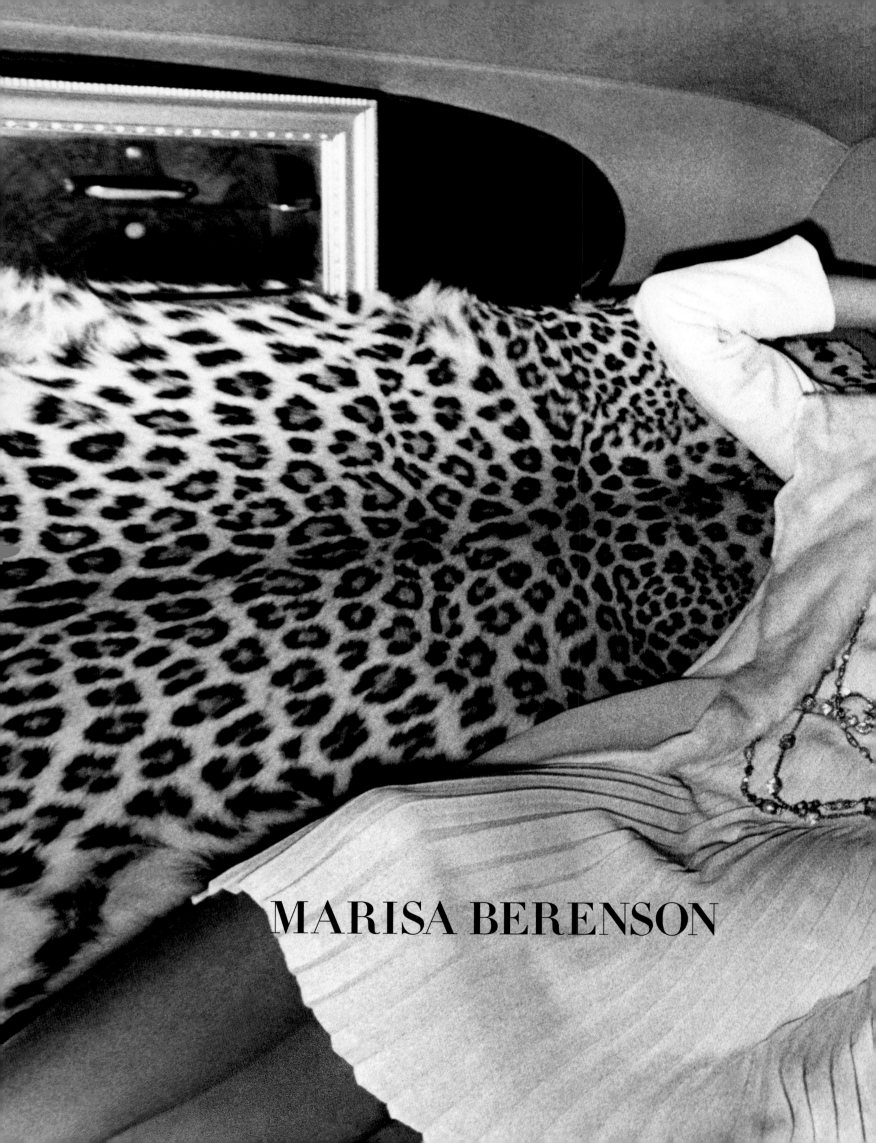

MARISA BERENSON

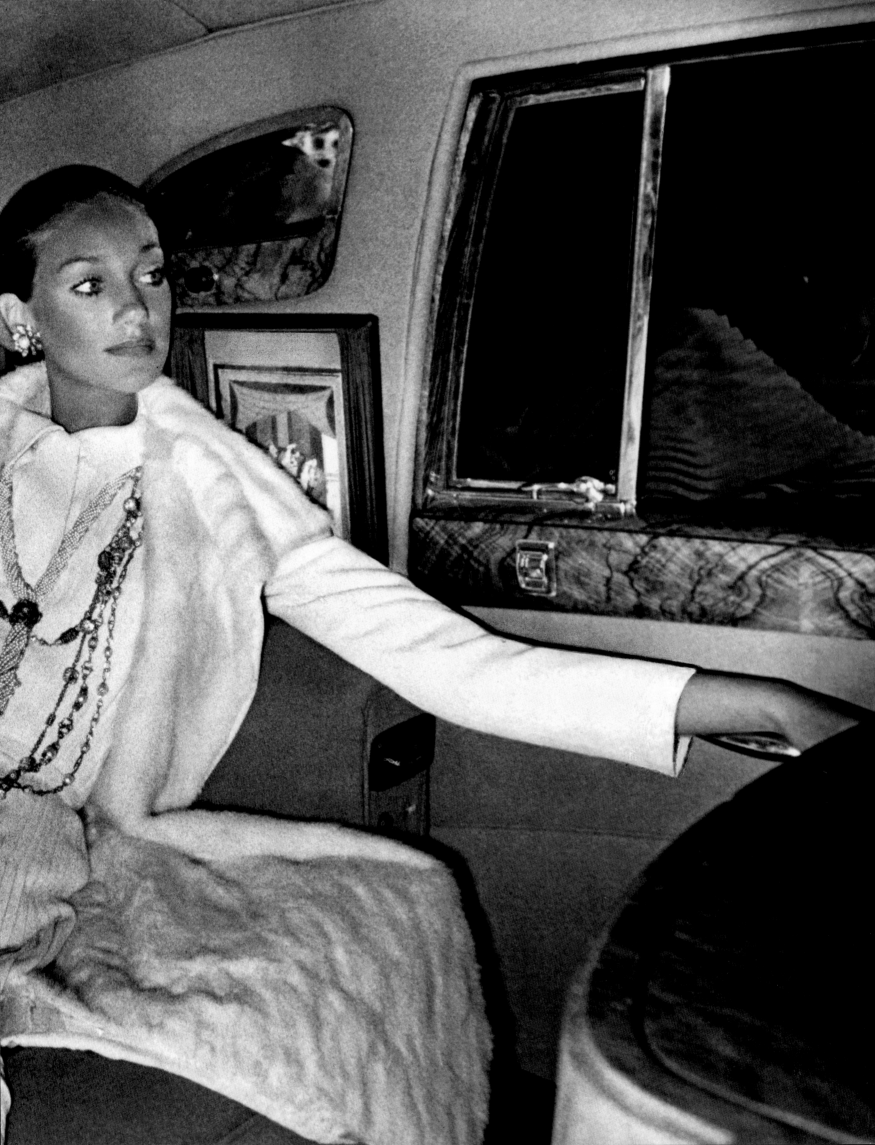

previous spread:
The granddaughter of Elsa Schiaparelli wore Chanel for *Vogue* in 1969. Photographed by her then-beau, Arnaud de Rosnay, in his car.

Her sister, the photographer Berry Berenson, snapped her in Yves Saint Laurent's *saharienne* mini on the streets of St.-Tropez in 1969.

V ittoria Marisa Schiaparelli Berenson made her *Vogue* debut in 1947, wearing a christening dress designed by her grandmother the flamboyant couturier Elsa Schiaparelli and "a tricorne in shocking-pink satin with pearl embroidery copied from a painting in the Louvre." She has rarely been out of the magazine's sights since.

"Who's on next?" queried the magazine in 1965, and answered with a Penati shot of the arrestingly beautiful eighteen-year-old Marisa, noting her "tawny skin, big green eyes, a voice full of smiles," and that she "skis a lot, paints, [is] wild about dancing, 'mad clothes,' a career as a model." Beloved by Diana Vreeland, Marisa became one of the iconic, idiosyncratic faces that defined *Vogue*'s Youthquake years. "The 1960s wasn't an era of classic blonde, blue-eyed beauties," Berenson told *Vogue* in 2004. "We were all very different-looking, with strong personalities."

"Born an Aquarian, Marisa changes outrageously—moods, clothes, ideas," the magazine wrote in 1972. "I'm so many different people, I must express them all," Marisa declared. "I have incredible opposites. I'm always changing, out of fantasy, out of boredom." Her chameleon features and moods were reflected in an astonishing range of images and eventually led to a big-screen career, including memorable roles in *Death in Venice, Cabaret,* and *Barry Lyndon.* For *Vogue* she was "one of the international breed of young women that defies instant definition. Her mid-Atlantic accent betrays schooling in Switzerland, England, and Italy—her zest is American, her savvy European, her beauty known to the world. She is Someone, as the French say. . . . She walks into a room, tall, supple, as yielding as a willow branch."

—HAMISH BOWLES, *2009*

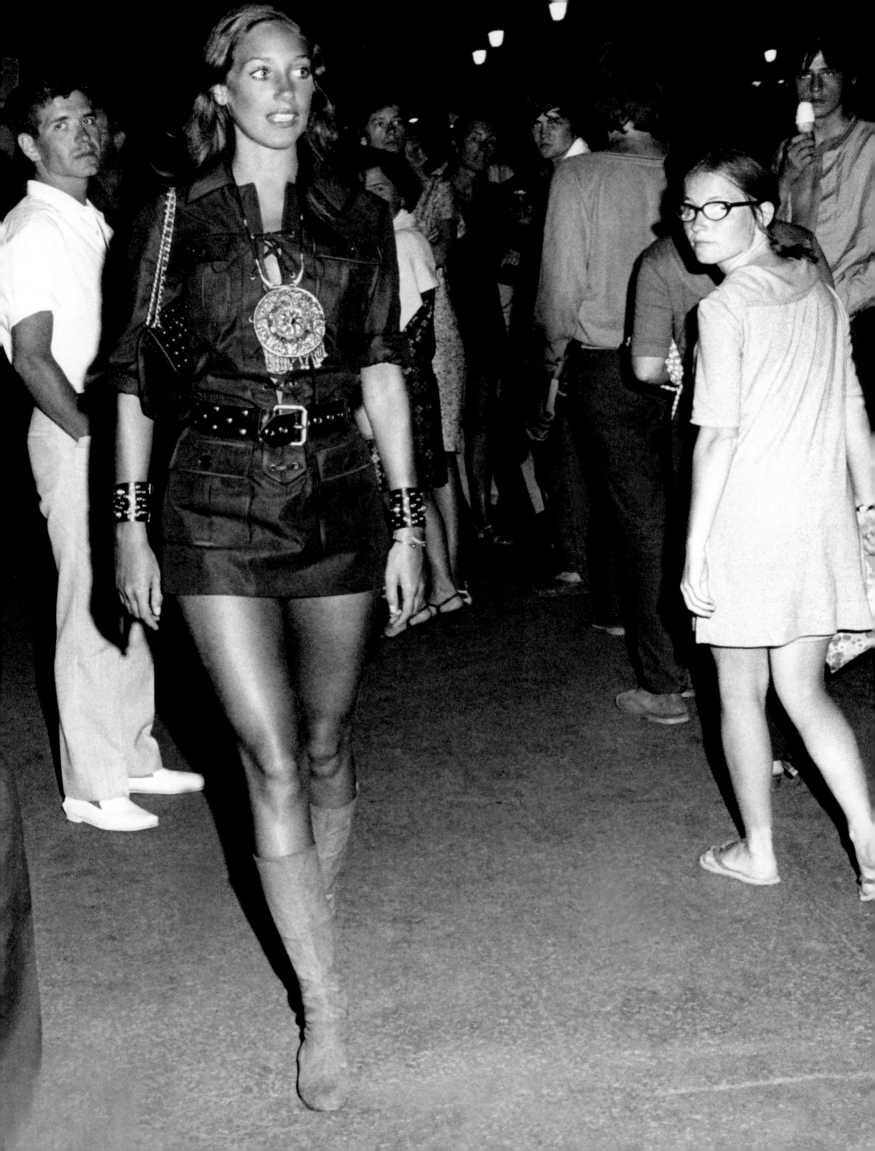

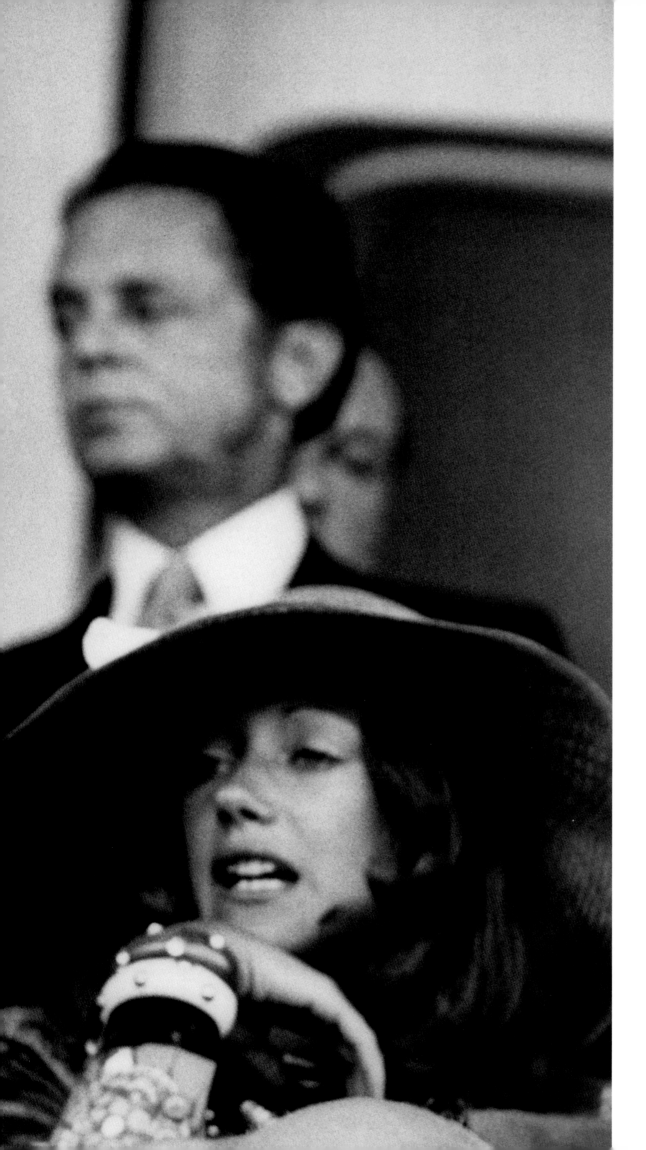

Baron Guy de Rothschild
and Baron Alexis de Redé (*right*)
stood behind Marisa as
she watched the races with
her *Cabaret* costar
Liza Minnelli at Deauville in 1971.
Photographed by Jack Nisberg.

Vodianova with her husband, Justin Portman.
Photographed by Steven Klein, 2003.

NATALIA VODIANOVA

She has a face to fall in love with: wide-set blue eyes, tip-tilted nose, succulent pout with the sweetest hint of an overbite, the peachy curve of a baby cheek, and the level gaze of a woman. Unthreatening yet unsettling. You're compelled to look, and look again—not just because of the overwhelming prettiness but also because of the jolt of recognition. See her, and the similarities start scrolling: Kate Moss in the nineties, Brooke Shields in the eighties, Jean Shrimpton in the sixties. A computer could morph them all together into one archetypal child/woman, but in real life, only one representative ever arrives per generation. And here, fresh from the former USSR, is Natalia Vodianova, a 21-year-old blessed with the kind of photo-genetics guaranteed to throw fashion for a loop.

As if her appearance weren't enough, Natalia Vodianova's story is so romantic, she's already a girl on the brink of legend. On the one hand, she's a spot-on contemporary role model: a supersuccessful young New York working mother with a husband, baby, and home life. On the other, she's the heroine of a magical Russian rags-to-riches fairy tale. At fifteen, Natalia left home to fend for herself by selling fruit in a market in the industrial town of Nizhniy Novgorod, 250 miles east of Moscow. At seventeen, she left Russia to try her luck as a model in Paris. At nineteen, she fell in love with the son of an English viscount, had his baby, and within three months was starring in the hit YSL fall show. At 20, she returned to her homeland to marry her man in a three-day extravaganza of a wedding that set St. Petersburg alight. Oh, and then she got the Calvin Klein contract. . . .

—SARAH MOWER, *February 2003*

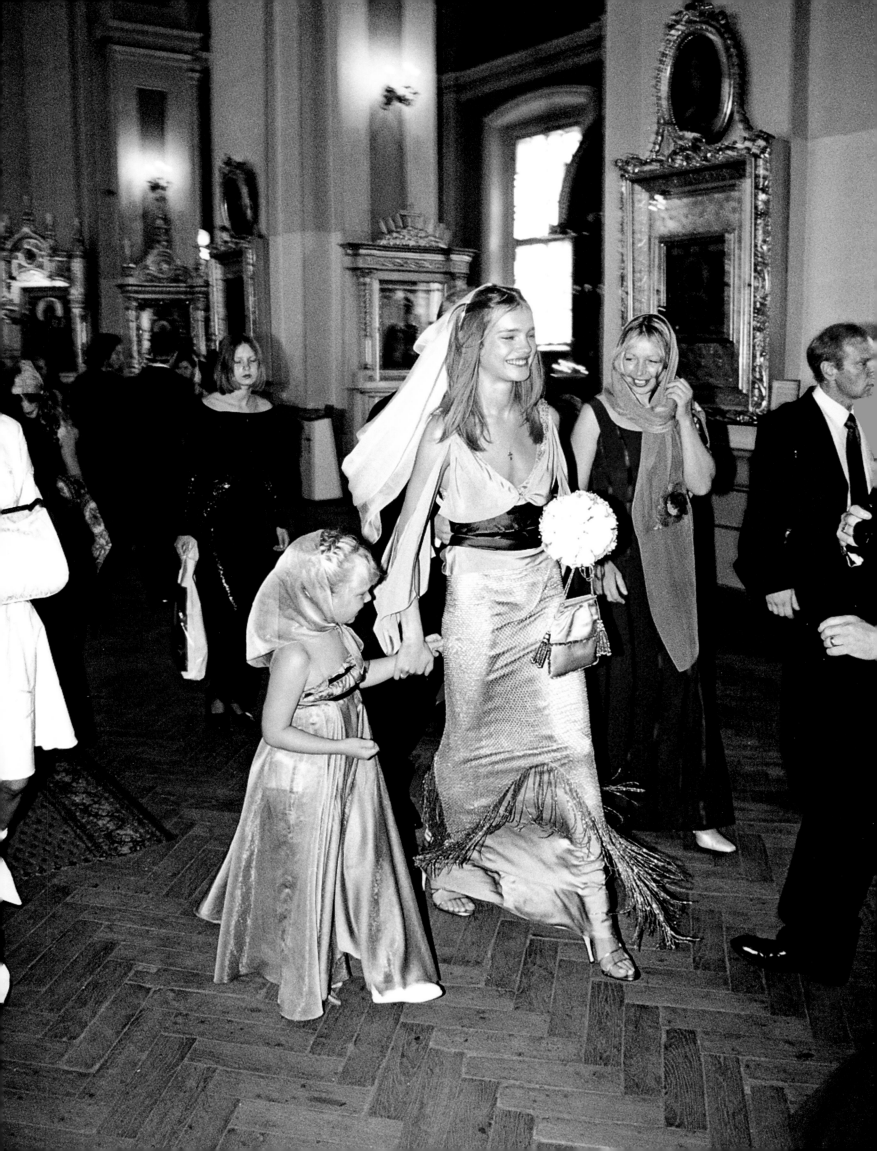

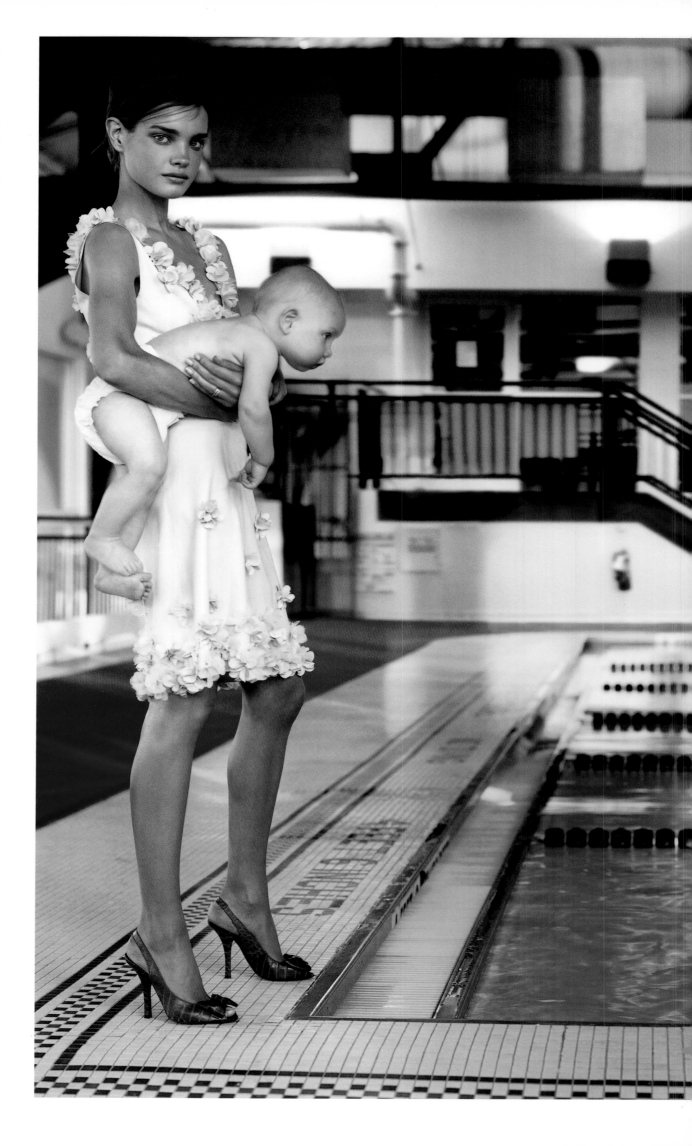

previous pages:
Mario Testino photographed Vodianova, wearing Lanvin, with two of her children, Lucas, age six, and Viktor, age one, in 2008 (*left*). She wore Tom Ford for Gucci on her wedding day in St. Petersburg on September 1, 2002. Her six-year-old sister, Kristina, was her attendant (*right*); photographed by Mike Penn.

Three months after their firstborn, Lucas, arrived, the 20-year-old mother returned to the Paris runways. Photographed in Louis Vuitton by Steven Klein, 2003.

CINDY CRAWFORD

it is Labor Day in Los Angeles, and no one—certainly no one famous—is working, except for a small mob crammed into a tiny room in Ma Maison Sofitel, where Cindy Crawford, supermodel, rising television star, and wife of Richard Gere, is being made up: She is about to tape a segment of MTV's *House of Style,* a wildly successful show that has made her the network's most popular personality. The subject is the paparazzi, and the interviews include one with the *National Enquirer,* which has just published paparazzi shots (taken with a long lens from a boat) of *Vogue*'s own photo shoot of Cindy and Richard on the beach. Cindy is concentrating on choosing a look that will send the right signal: a pin-striped Ralph Lauren suit and a Brooks Brothers blue-and-white striped shirt. And the hair, announces Syd the Hairdresser, will get "the smooth professional look."

If there is one thing that Cindy Crawford is in absolute control of, it is her career. She has a $7 million contract with Revlon; her own exercise video, which, she says, "takes Jane Fonda further"; and an enormously successful pinup calendar from which half her proceeds go to research and aid for leukemia, the disease that killed her brother as a child.

Cindy Crawford is the woman almost every man in the world would like to possess. As for the calendars—they've all got

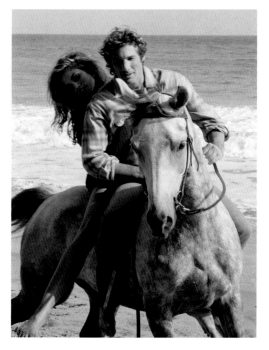

them. She could barely shoot a stand-up on the sidewalk outside the *National Enquirer* office for all the commotion around her. Japanese tourists, guys in pickups, guys in Porsches, they all stopped: "Cindeeee! Cindeeeee!" MTV comedian Denis Leary says on the air he wants to watch her eat Eskimo Pies naked on the roof of the Empire State Building and warns, "I think you hear me knocking, Richard, and I think I'm coming in."

At the MTV Awards that evening, Mick Jagger passes by the crowds outside virtually unnoticed; Annie Lennox gets polite applause. Cindy Crawford walks by in a Versace S & M number, her hair piled high, and the fans and media go insane. In the group of horribly dressed people with not very good hair and bad skin that passes for the event's rock royalty, Cindy is the only real queen. She struts past the ropes, teases the fans by running toward them, mugs with Kris Kross, thrusts out a hip, and puts on attitude for the radio reporters who shove their mikes in her face. "You too busy for an annoying little radio reporter?" She flashes a grin. "You're not so little, but you're annoying." But she gives them all sound bites, signs calendars, poses for pictures. "Work it, baby," her MTV camera crew yells. "Strike the pose." And she does, clearly enjoying herself.

—JULIA REED, *November 1992*

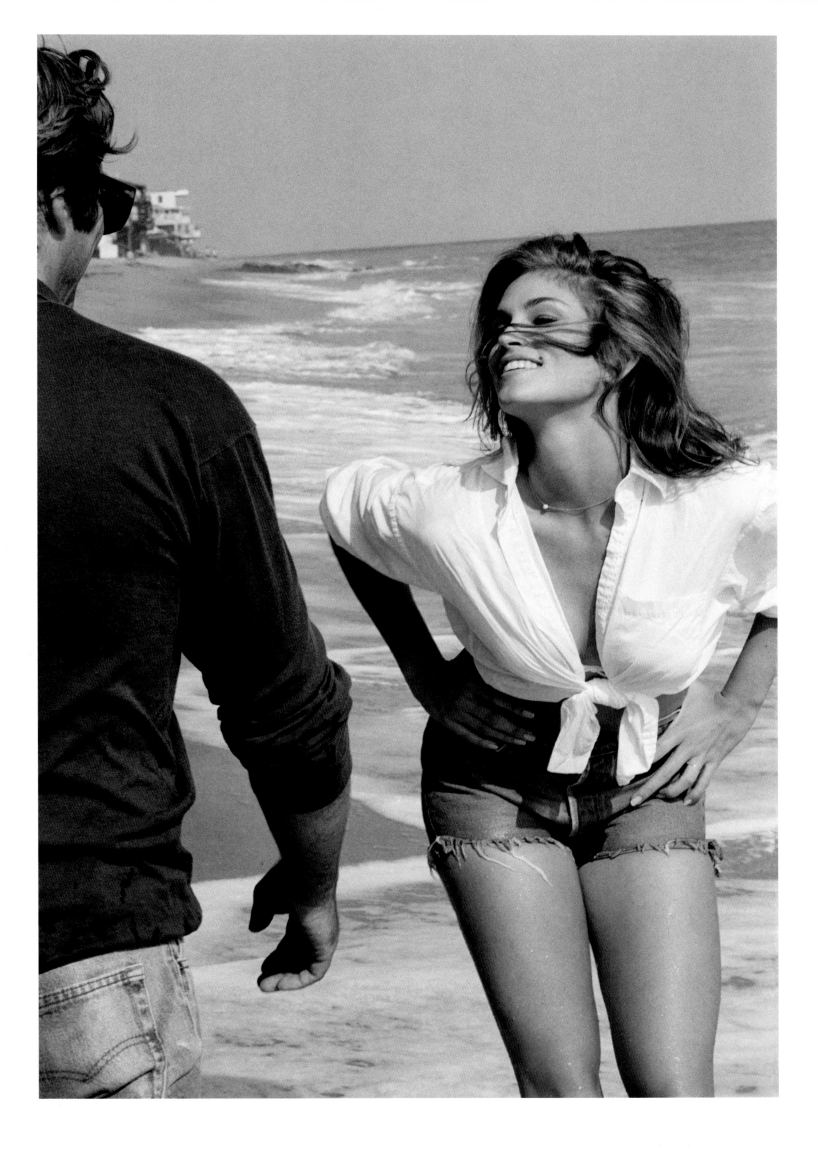

Crawford made an effortless transition to
television in the early 1990s as host of
MTV's *House of Style*—becoming
one of the first models to take charge of her
own brand. She modeled swimwear in
Monte Carlo for Helmut Newton in 1991.

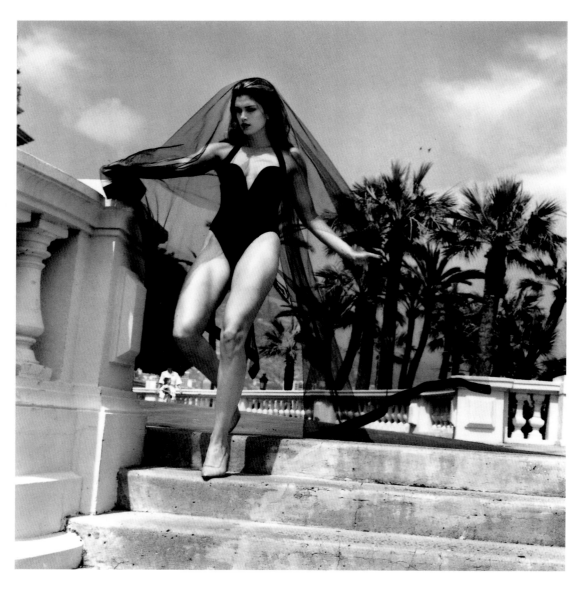

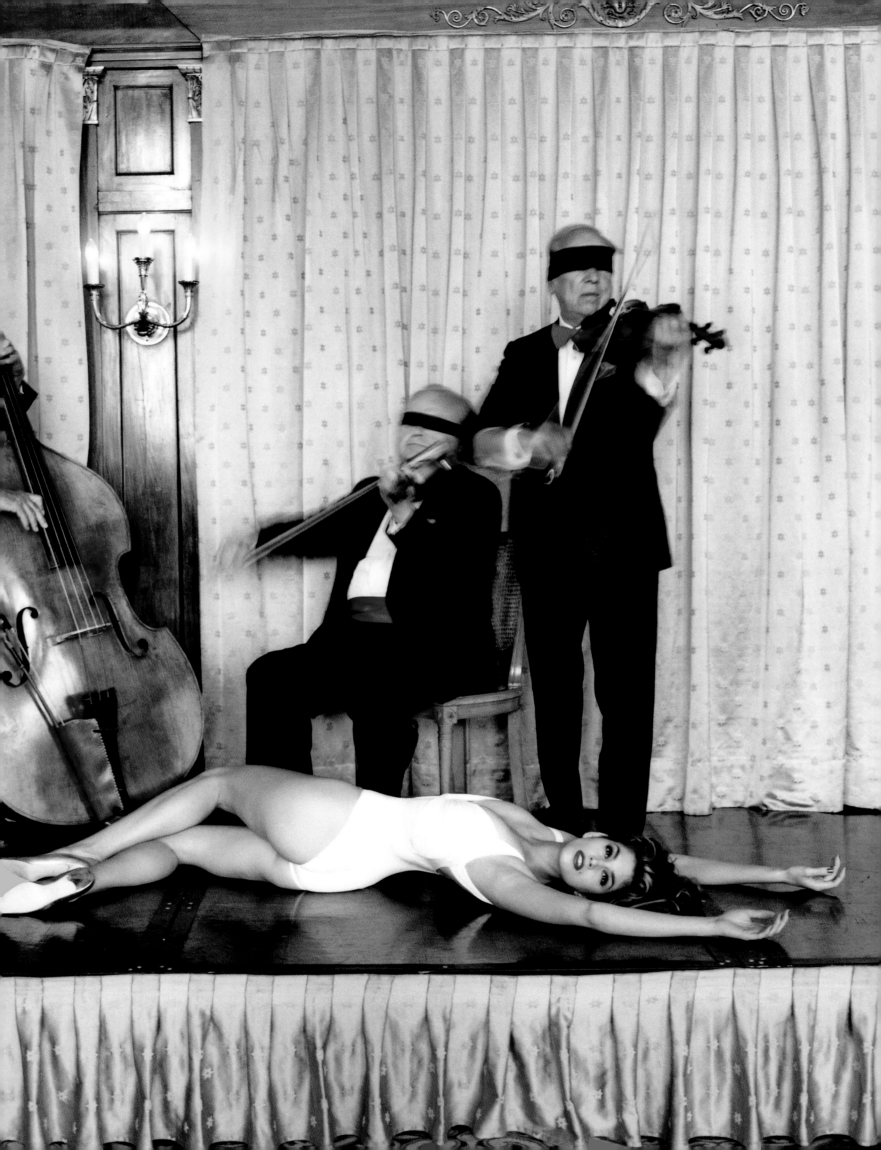

VERUSCHKA

Veruschka is the most beautiful woman in the whole world. There's never enough of her. Each encounter is unfulfilled and unforgettable. It has nothing to do with ordinary life. The last time I photographed her she said, "Goodbye for now," and then she didn't come back for five years. When she finally walked in, I felt as if we'd both been waiting every day of those years between. I couldn't disappoint her.

I love looking at her through the dressing-room door. It's usually pretty crowded in there, and she sits at the dressing table with her tea and honey, naked, oblivious to hairdressers, fashion editors, and assistants, making up her face with a Japanese paintbrush.

She'll cover her breasts in front of some and not in front of others. That selectivity has implications of intimacy and trust. She's sensitive to the fact that she's undressed and you're there and it's full of nuances which she will neither deny nor resolve. They become resolved in the work.

I love talking with her because of that voice: deep, unimaginably soft, and, for a romantic girl, remarkably unsentimental, which gives romance its real power. She knows the value of a quiet, two-hour conversation before going on the set. The time is never wasted. Her skin is like litmus paper for her feelings. She's all made up and ready and, as we sit together, her skin gets very warm in color and then, suddenly, it drains. The second the color leaves her face, I know she's ready to work.

Veruschka is the only woman I permit to look at herself in

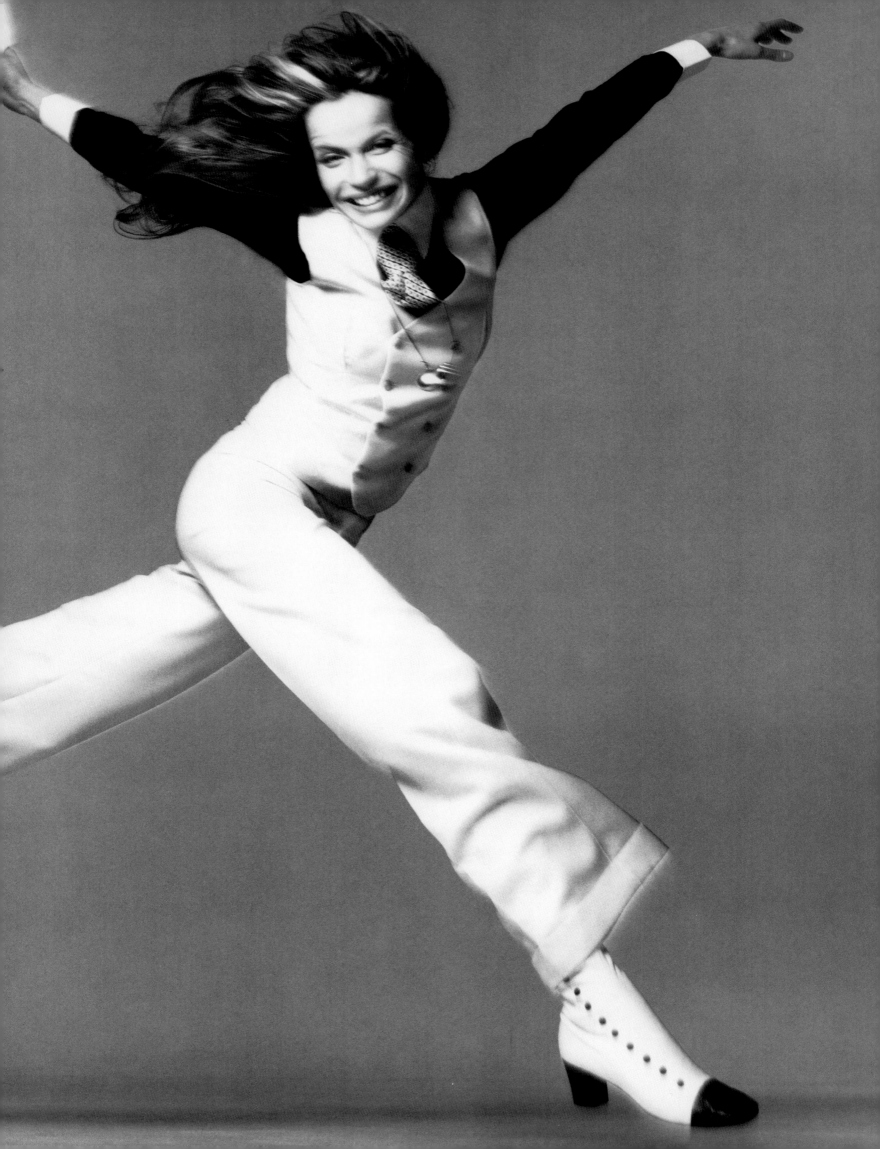

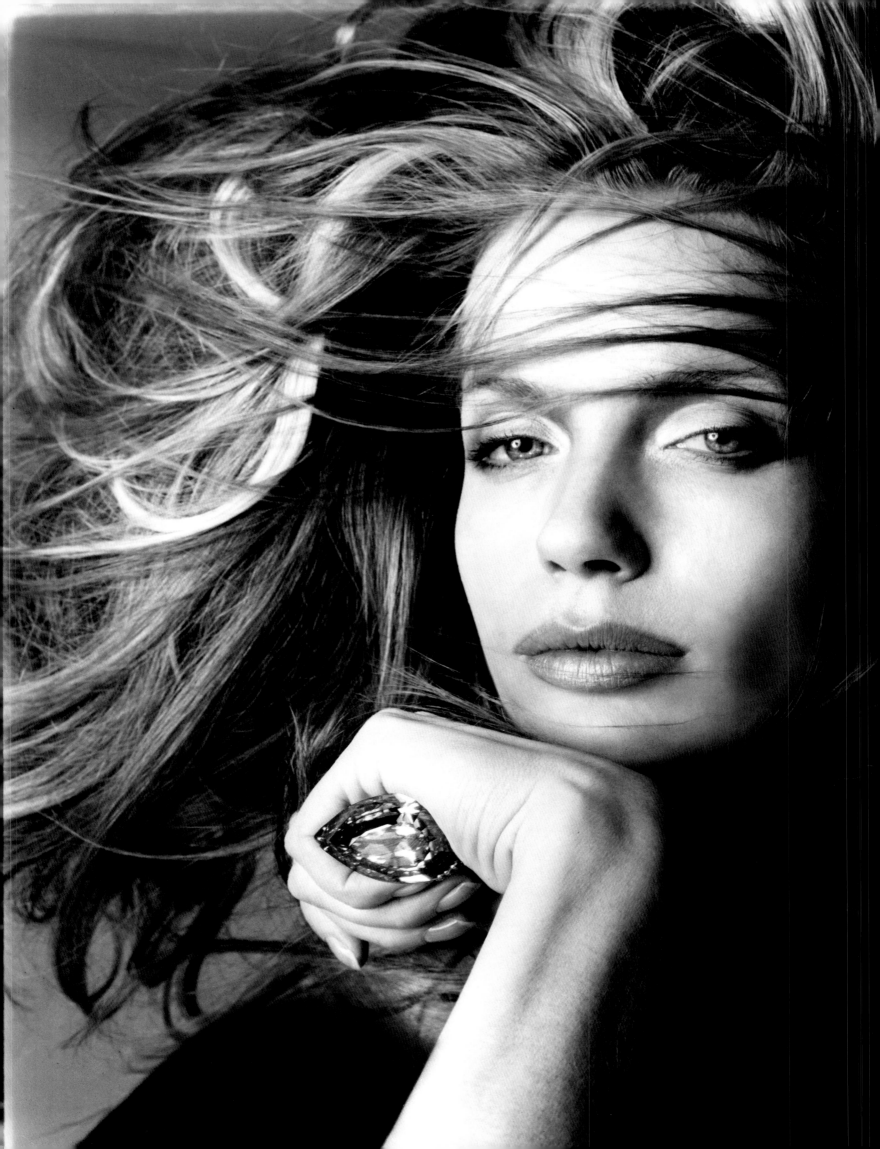

Avedon photographed her holding the
Great Chrysanthemum Diamond
(104.15 carats) in March 1972 and in the
Yoga Nidrasana pose (*below*), wearing
a Giorgio di Sant'Angelo diaper wrap suit.

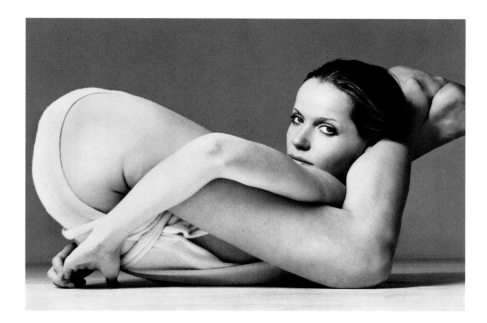

the mirror while I'm photographing her. The mirror makes most women aware of their weaknesses and, in trying to correct them, they come up with evasions, hiding arms that seem too thin or hips that seem too wide. Veruschka knows what's peculiar to her that's beautiful, and she works to bring it forward. It's wonderful to see her searching for and emphasizing her irregularities.

There are times during a sitting when she turns to look at me or at the camera and, without so much as lifting an eyebrow or curving her mouth, smiles, challenges. It's like the opposite of the Dylan song, "I'll let you be in my dream if I can be in yours." That seems to be what most people need. But not Veruschka. She'll let you look into her dream but she wouldn't fit in yours.

There's a profoundly moving moment at the end of every sitting with Veruschka when I say, "I think I've got it." She looks at me with a startled expression that comes very quickly across her face. Ending the sitting, which is something only I can do, is like an interruption. I feel as if I am taking her away from work that, for her, will always be unfinished.

It's impossible to be beautiful without being moving and impossible to be moving without a sense of irony. Veruschka makes me laugh a lot. She makes everybody laugh. Being beautiful in her way demands something, and you must extend yourself to meet the challenge or know that a kind of splendor is lost to you forever.

—RICHARD AVEDON, *May 1972*

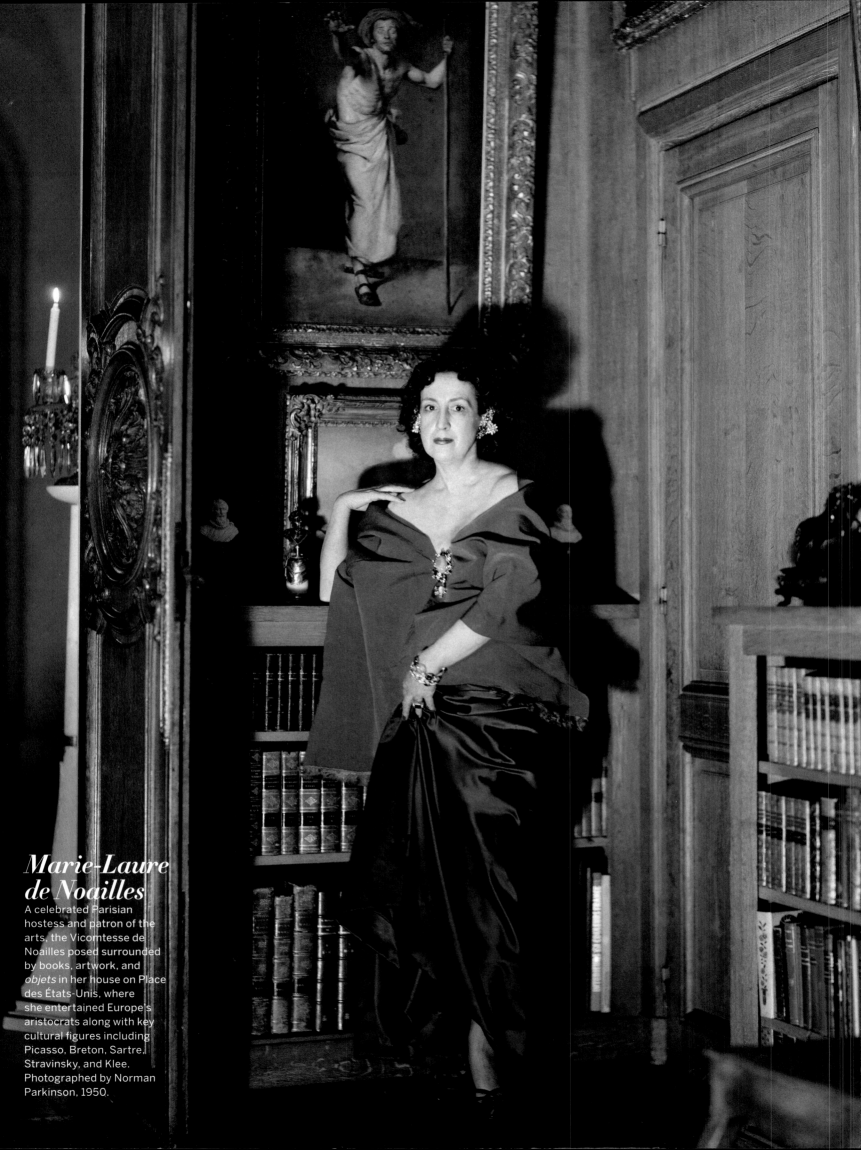

Marie-Laure de Noailles

A celebrated Parisian hostess and patron of the arts, the Vicomtesse de Noailles posed surrounded by books, artwork, and *objets* in her house on Place des États-Unis, where she entertained Europe's aristocrats along with key cultural figures including Picasso, Breton, Sartre, Stravinsky, and Klee. Photographed by Norman Parkinson, 1950.

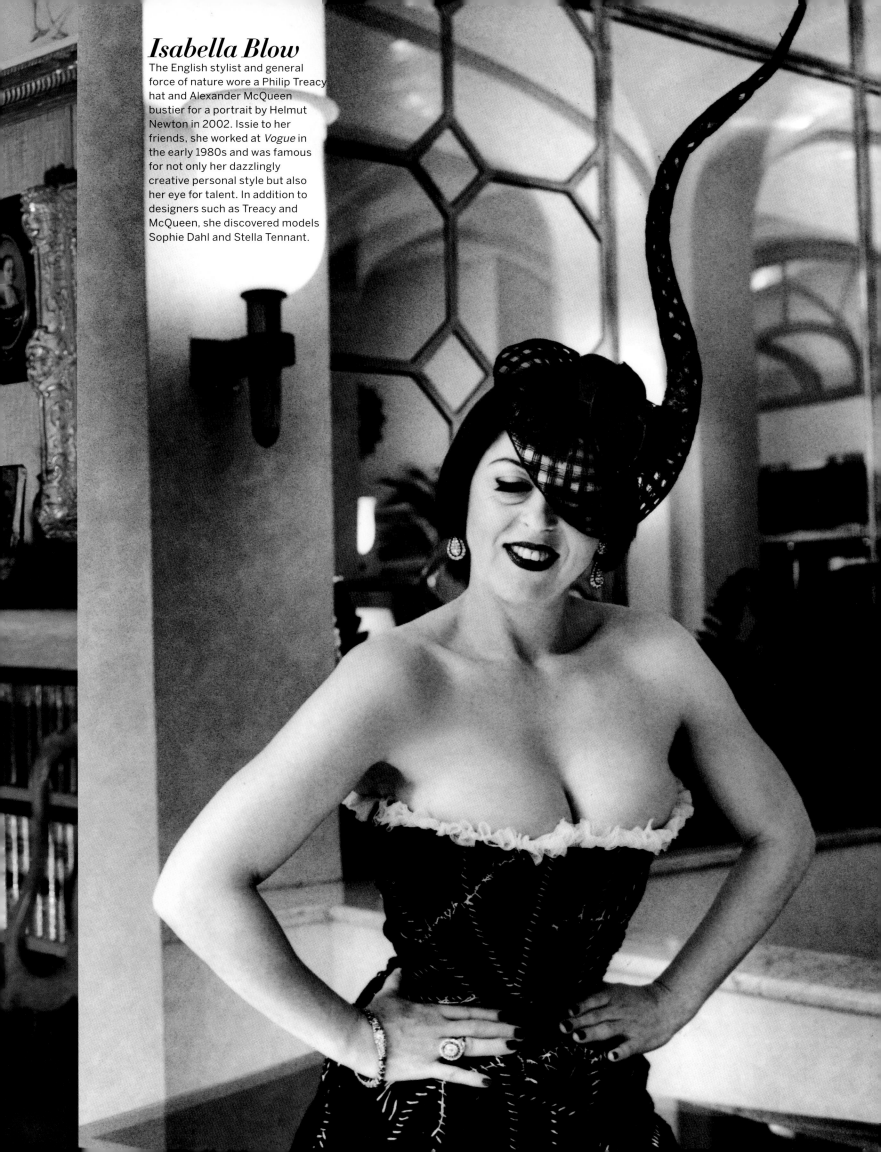

Isabella Blow

The English stylist and general force of nature wore a Philip Treacy hat and Alexander McQueen bustier for a portrait by Helmut Newton in 2002. Issie to her friends, she worked at *Vogue* in the early 1980s and was famous for not only her dazzlingly creative personal style but also her eye for talent. In addition to designers such as Treacy and McQueen, she discovered models Sophie Dahl and Stella Tennant.

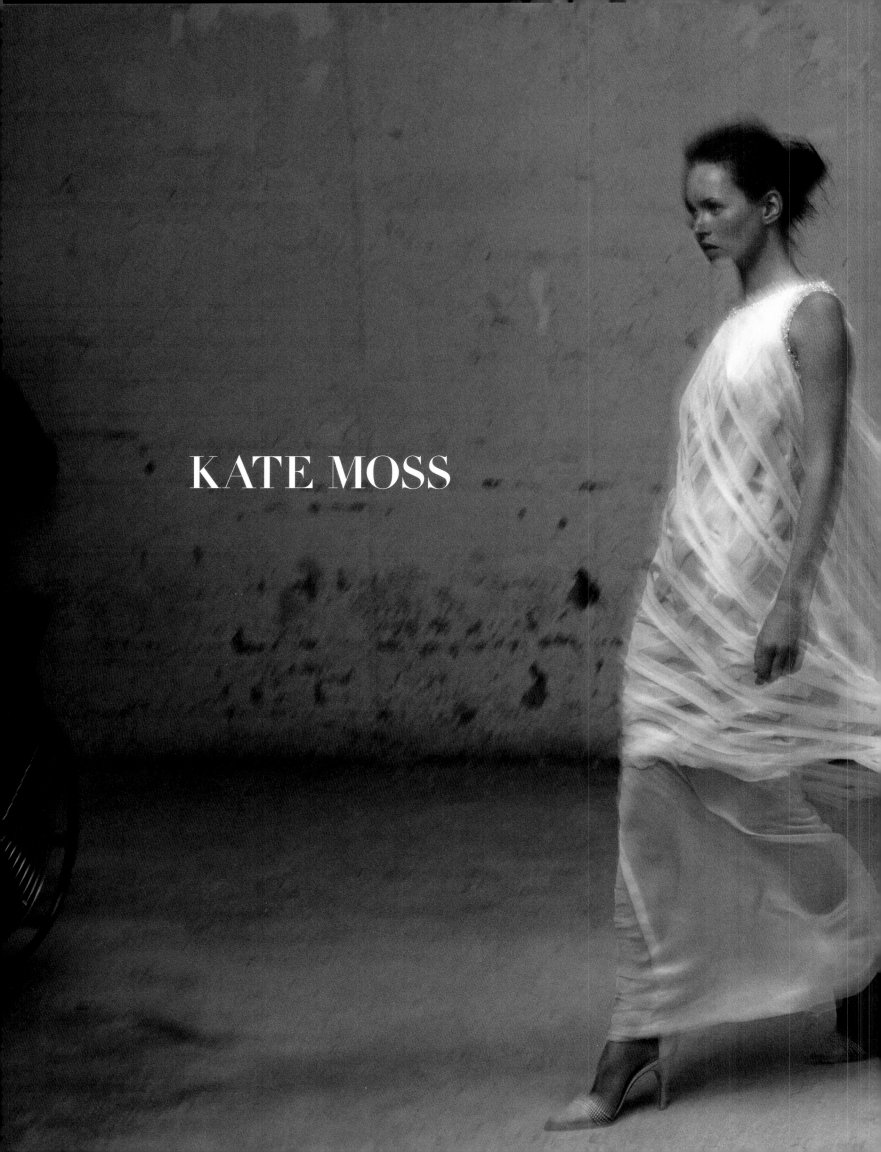

KATE MOSS

previous spread:
In Paris, wearing
Chanel Haute Couture.
Photographed by
Annie Leibovitz, 1999.

Moss in a pool hall
outside Phan Thiet, Vietnam.

Wearing a dress
by Karl Lagerfeld for
Chloé (*left*).
Photographs by
Bruce Weber, 1996.

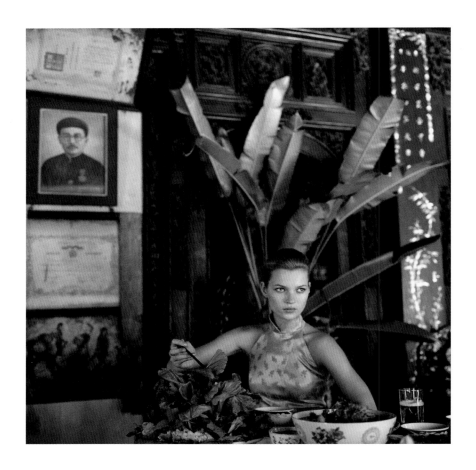

K

Kate Moss artlessly but single-handedly changed the face of fashion and beauty in America. Kate didn't just represent a change of clothes, she embodied the massive change of attitude that signaled the close of the eighties and its brash style and ushered in the low-key nineties. Out went "designer" designer clothes; in came vintage. Out went Hervé Léger; in came Helmut Lang. Out went Thierry Mugler; in came Marc Jacobs. She brought grunge to America after signing a contract with Calvin Klein at the age of eighteen (some say Calvin made Kate. Others say Kate made Calvin cool). An icon for her generation, Kate was the ultimate embodiment of "reality," as her look was then dubbed.

Kate made being young and looking broke seem glamorous. She made a supermodel in a Chanel suit getting on a Concorde look hopelessly old-fashioned. Although she became one, Kate killed the supermodel. Post-Kate, models and "real women" were allowed to be small (Moss is a refreshingly normal, unthreatening five foot seven), weird-looking (Stella Tennant, Karen Elson), breastless (Maggie Rizer)—anything, as long as they didn't look like eighties supermodels. But while Kate was

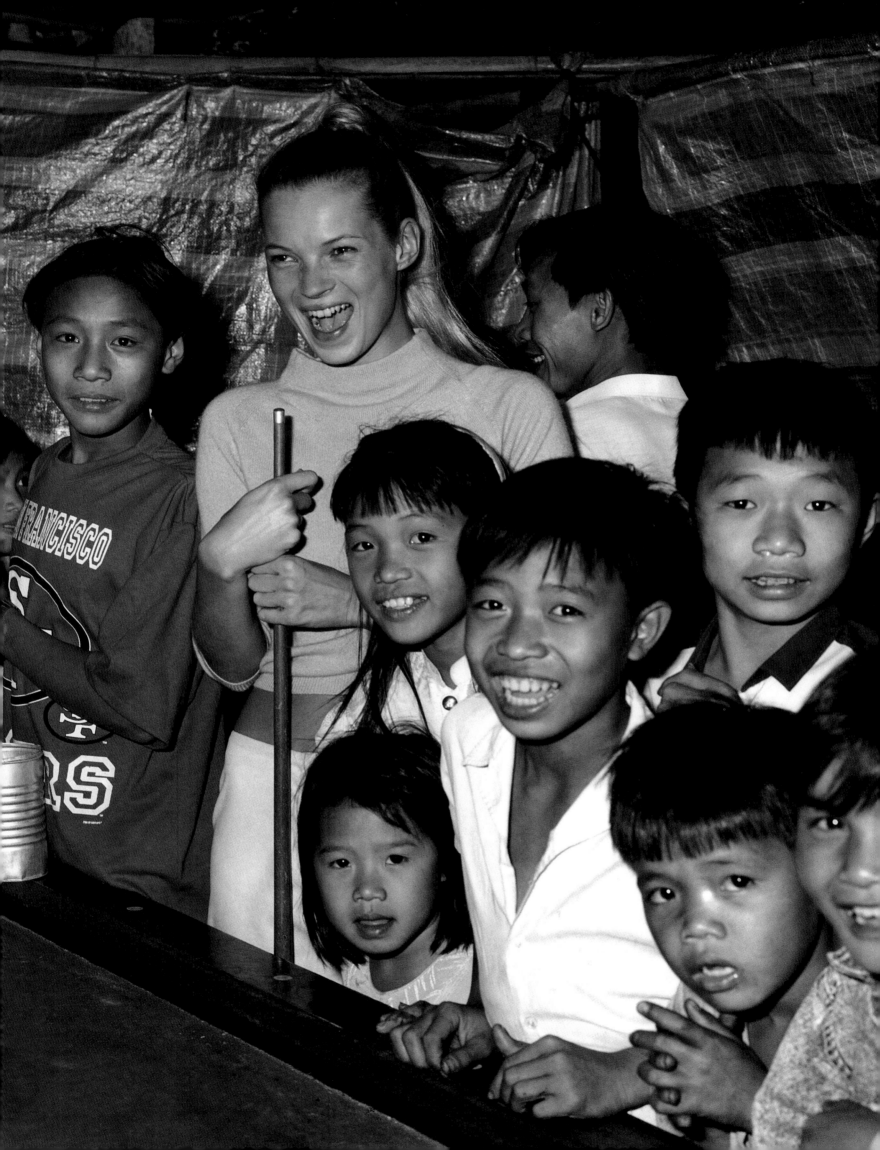

the supermodels' Dr. Death, nailing up their coffin for good, she became the world's most intriguing celebrity model, and there hasn't been another to rival her since.

Seventies babies are not interested in looking rich. They just want to look cool. That doesn't mean they don't appreciate luxury; they do. But they don't wear it literally. If Kate wears diamond-and-pearl estate earrings, it's with jeans or a torn mini, not with an evening gown. If she's wearing an evening gown, she's very likely to add a denim jacket or punky bag to skew the look from classic to original.

The Kate Story is now fashion history. She grew up in Croydon, England—a working-class, suburban town that nevertheless had a big influence on her style. When she was a teenager, "it was all about Vivienne Westwood: a crotch mini and a Vivienne Westwood T-shirt and the proper Sex shoes," she remembers. At fourteen, Moss was "discovered" in an airport by a model agent. She lived with photographer Corinne Day between the ages of fifteen and seventeen. Day photographed her for the cover of *The Face* in 1990, launching a whole new look. Moss hit America when Calvin Klein hired her and she appeared in countless ad campaigns, the most memorable being Mario Sorrenti's Calvin Klein Obsession ads. Ever savvy in her choices, Moss never walked the runway for anyone who did not bring something to her image while she was bringing something to theirs.

Apart from the face, the body, and her talent to supersede the whims of fashion, Moss's style comes as much from her personality as anywhere else. Irrelevant as it may sound to the way she looks, Moss has a cool personality. It's very important: One cannot *look* cool without *being* cool. Without attitude there is no style. Moss is the ultimate London girl, constantly whispering dangerous gossip right behind someone's back, flirting with other people's boyfriends while hugging their girlfriends, calling everyone "Darlin' " whether she's known them five minutes or five years, casually discussing her various trips to rehab and AA while sipping a drink. Even the way she talks is cool. She doesn't use those tired old words like *chic* or *eclectic* or *boho* to describe fashion. She uses the word *gorge* (short for *gorgeous* in London-girl speak). Her diamonds are gorge. Her silver-sequined evening bag the size of a Post-it note is gorge.

After years of wanting them, Kate finally owns the Vivienne Westwood Sex shoes she dreamed of as a teenager: divinely tarty black leather pumps with an outrageously high heel that gives the foot an orgasmic arch. What on earth is she going to wear them with? She gives the Kate look—cute little heart face, naughty smile, laughing eyes. She giggles. Then she looks faux serious and responds, "Nothing." She will, of course, look gorge.

—PLUM SYKES, *August 2001*

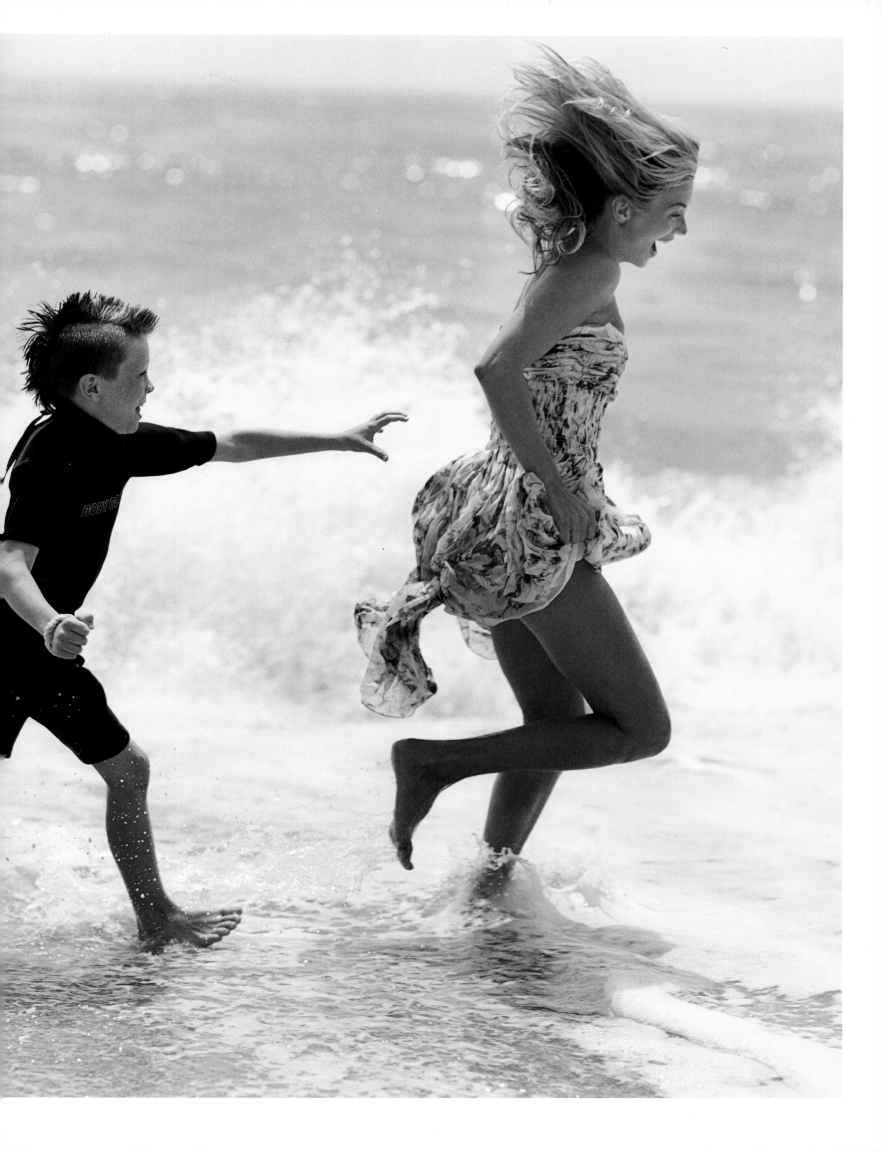

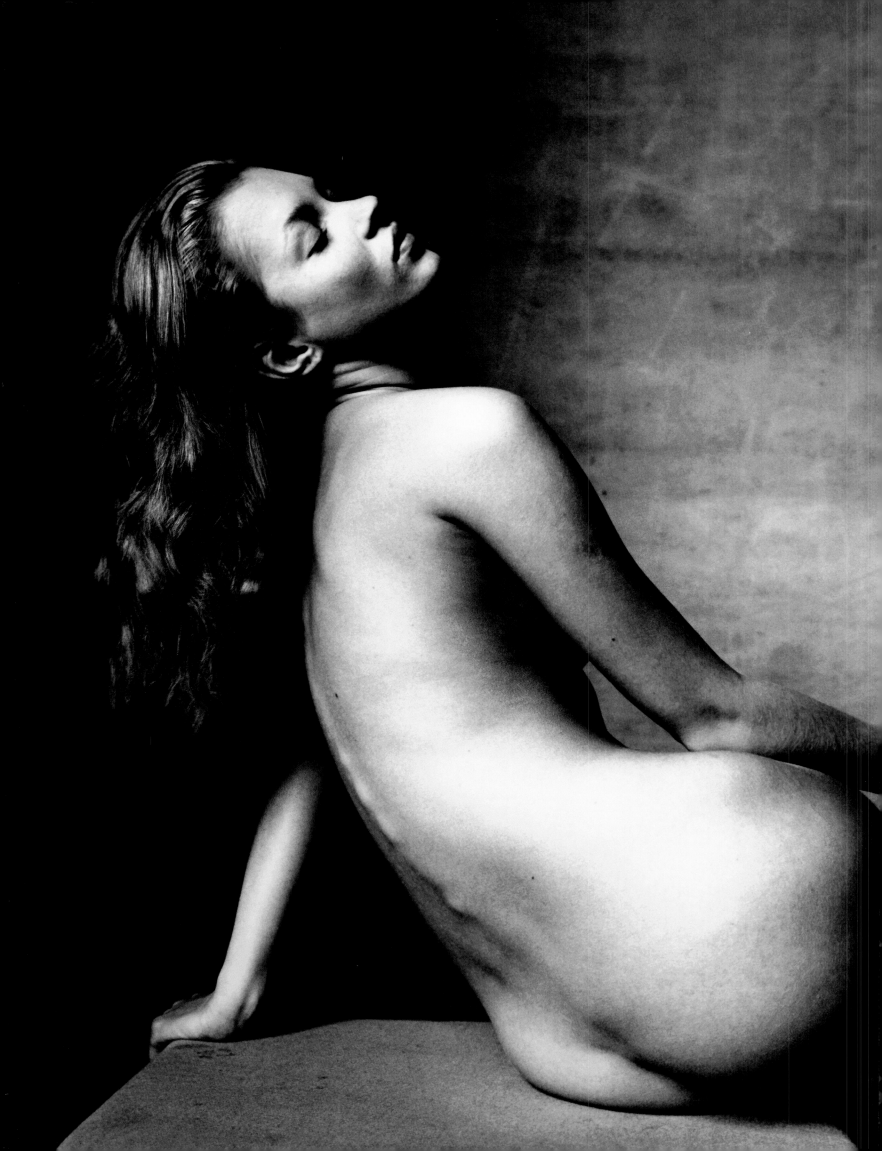

Moss, photographed by Irving Penn, 1996.

PHOTOGRAPHY CREDITS

All images below copyright © of the Condé Nast Archive unless otherwise noted.

© **Slim Aarons**/Stringer/Getty Images: 87; © **Lorenzo Agius**: 59; **Marella Agnelli**/Condé Nast Archive:
233, 234, 236; © **Evan Agostini**/Getty Images: 169, 174; **Richard Avedon**/ © The Richard Avedon Foundation:
34–35, 188–189, 195, 323, 328–329, 339, 372–375; **Cecil Beaton**/Condé Nast Archive: 9, 11 (*top right,
middle right*), 13, 110; **Cecil Beaton**/Courtesy of Cecil Beaton Studio Archive at Sotheby's: 11 (*middle left*),
22–23; © **Jonathan Becker**: flap (*bottom*), v, 62–63, 72–75, 78–79, 106–109, 112, 114–115,
133, 152, 156–157; **Berry Berenson**/Condé Nast Archive: 359; © **Eric Boman**: 99, 103–104, 238–243,
249–251, 276–278; **T. Breslin**/Condé Nast Archive: 45; © **Larry Busacca**/Getty Images: 178 (*top*);
Patrice Calmettes/Condé Nast Archive: 324; © **Pascal Chevallier**: flap (*top*), 275; **Henry Clarke**/
Condé Nast Archive: 8; **Howell Conant**/Condé Nast Archive: 15; Courtesy of Condé Nast
Archive: 228, 230–232, 235, 237, 274; **Nick De Morgoli**/Condé Nast Archive: 5, 84–86;
Arnaud de Rosnay/Condé Nast Archive: 356–357; © **Robert Doisneau**/RAPHO/Eyedea: 111, 113;
Eggarter/Condé Nast Archive: 20; © **Nick Elgar**/London Features: 308; © **Arthur Elgort**: 19; **Arthur Elgort**/
Condé Nast Archive: 116–119, 121–123, 178 (*bottom*), 190, 192–193, 244–245; © **Elliott Erwitt**/Magnum
Photos: 137–138; © **Robert Fairer**: 11 (*bottom right, bottom middle*), 27, 135, 148–151, 166–167, 172, 176,
253–257, 388, 390; **Billy Farrell**/ © patrickmcmullan.com: 177; **Lawrence Fried**/Condé Nast Archive:
10 (*top middle, bottom middle, bottom left*), 139–145; **Toni Frissell**/Condé Nast Archive: 153;
© **Toni Frissell**/Courtesy of the Library of Congress: 154–155 (*top*), 155 (*bottom*);
© **Toni Frissell**: 154 (*bottom*), 158–159; © **François Halard**: 24, 101, 246–248, 290–293, 296–297;
© **Mary Hilliard**: 96–98, 100, 102, 105; **Horst P. Horst**/Condé Nast Archive: 25, 32–33,
41, 54–56, 58, 64–65, 268–273; **George Hoyningen-Huene**/Condé Nast Archive: 11 (*bottom left*);
© **Dimitrios Kambouris**/WireImage: front of jacket; © **Steven Klein**: 146–147, 305, 362–363, 366–367;

Gabrielle "Coco" Chanel demonstrated the cut of a sleeve for Alexander Liberman's camera in 1951, two years before she reopened the fashion house that had made her a legend between the wars.

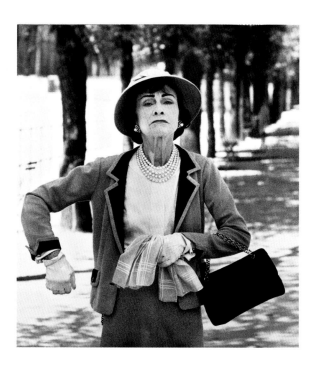

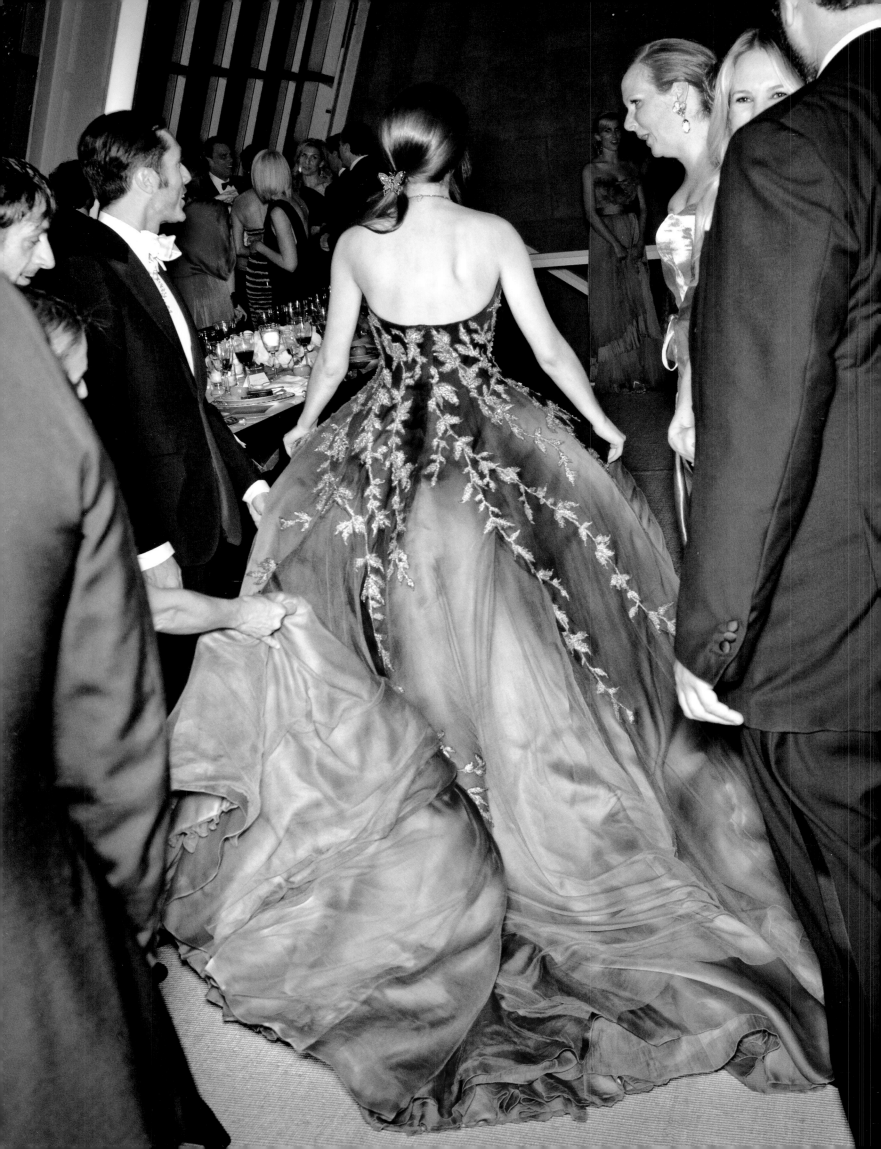

Taking a break from Columbia University, Bee Shaffer made her way through the "Superheroes: Fashion and Fantasy" Costume Institute gala in a voluminous wisteria organza gown designed for her by Olivier Theyskens for Nina Ricci. Photographed by Robert Fairer, 2008.

following page:
Gisele Bündchen was caught mid-flight on the dance floor at the Metropolitan Museum's Costume Institute "Goddess" gala in 2003. Photographed by Robert Fairer.

ACKNOWLEDGMENTS

This book is a celebration not only of its subjects but of the extraordinary photographers and writers who have immortalized them for a century and more. The inspired photographers whose remarkable talents have captured images, studied or fleeting, of the beautiful people, their parties, and their environments, include Slim Aarons, Lorenzo Agius, Marella Agnelli, Evan Agostini, Richard Avedon, Cecil Beaton, Jonathan Becker, Berry Berenson, Eric Boman, T. Breslin, Larry Busacca, Patrice Calmettes, Pascal Chevallier, Henry Clarke, Howell Conant, Nick De Morgoli, Arnaud de Rosnay, Robert Doisneau, Eggarter, Nick Elgar, Arthur Elgort, Elliott Erwitt, Robert Fairer, Billy Farrell, Lawrence Fried, Toni Frissell, François Halard, Mary Hilliard, Horst P. Horst, George Hoyningen-Huene, Dimitrios Kambouris, Steven Klein, Annie Leibovitz, Alexander Liberman, Patrick Lichfield, Peter Lindbergh, Michael Lisnet, Remie Lohse, Roxanne Lowit, Craig McDean, Steven Meisel, Helmut Newton, Dewey Nicks, Jack Nisberg, Jean Pagliuso, Norman Parkinson, Irving Penn, Mike Penn, Denis Piel, Herb Ritts, Abbie Rowe, Norman Jean Roy, Mary Russell, Richard Rutledge, Enzo Sellerio, Mark Shaw, Snowdon, Isabel Snyder, Kristen Somody, Edward Steichen, Bob Stone, Christopher Simon Sykes, Mario Testino, Hannah Thomson, Bruce Weber, and Bob Willoughby. Thanks are also due to June Newton and Norma Stevens.

Often as evocative and potent as the images they complement are the words penned by writers who include Richard Avedon (multitasking), Joan Juliet Buck, Truman Capote, Polly Devlin, Charles Gandee, Georgina Howell, Leo Lerman, Kate Lloyd, Stephanie Mansfield, Sarah Mower, William Norwich, Julia Reed, Paul Rudnick, Marina Rust, Sally Singer, Gloria Steinem, Jeffrey Steingarten, Michael Specter, Plum Sykes, André Leon Talley, Vicki Woods, Jonathan Van Meter, and Francis Wyndham.

At *Vogue,* our very special thanks are due to Anna Wintour, who conceived and guided the project. Art director Charles Churchward brought his elegant and discriminating eye to the visual identity of the book and to the keen selection of images from an embarrassment of choices. The editorial instincts of Laurie Jones and the astute business acumen of Christiane Mack were likewise invaluable. The contributions of the editors Riza Cruz, Chris Knutsen, Eve MacSweeney, Bess Rattray, and Valerie Steiker were vital, and we are also enormously grateful to Genevieve Bahrenburg, Megan Conway, Molly Creeden, Jane Herman, Florence Kane, Stephanie LaCava, Sophie Pera, and Kimberly Straub.

Thanks are also due to the supremely efficient production, art, photo, research, and copy-editing teams, including David Byars, Christine Edwards, Barbara Kean, Caroline Kirk, Leslie Lipton, Phyllis Rifield, Jason Roe, Joyce Rubin, Susan Sedman, Michelle Van Alstyne, Mimi Vu, Pamela Vu, and Emily Wardwell.

Our interns, Kirsten Chilstrom, Tess Cohen, Cole DeLaune, Marguerite Imbert, and Natacha De Oliveira, were indefatigable.

From the outset, the enthusiasm and support of Calvin Klein Inc. has been unconditional and generous, and our gratitude to the company and to Malcolm Carfrae is boundless.

At Knopf, we wish to thank our editor, Shelley Wanger, for her enthusiasm and passion for the project. We are grateful to Sonny Mehta and Pat Johnson, and would also like to thank Andy Hughes, Lydia Buechler, Victoria Pearson, and Ken Schneider.

HAMISH BOWLES and ALEXANDRA KOTUR

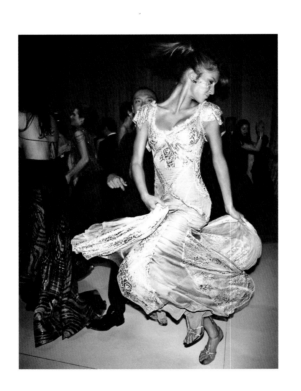